Hitler's Northern Utopia

Hitler's Northern Utopia

Building the New Order in Occupied Norway

DESPINA STRATIGAKOS

Princeton University Press | Princeton and Oxford

Requests for permission to reproduce material from this
work should be sent to permissions@press.princeton.edu
Published by Princeton University Press, 41 William Street,
Princeton, New Jersey 08540
In the United Kingdom: Princeton University Press, 6 Oxford Street,
Woodstock, Oxfordshire OX20 1TR
press.princeton.edu

Jacket illustrations: (*front top*) Scenery observed by Adolf Hitler on board
the *Deutschland* in the Norwegian fjords, April 1934 (detail). *Adolf Hitler:
Bilder aus dem Leben des Führers.* Altona/Bahrenfeld: Cigaretten-Bilderdienst,
1936; and (*front bottom and back*): Undated model of Narvik's reconstruct-
ed center, with obelisks in front of the marching square by the *Parteihaus*
(detail). Lars Olof Larsson Collection, Kiel.

ISBN 978-0-691-19821-7
ISBN (e-book) 978-0-691-21090-2
British Library Cataloging-in-Publication Data is available

Designed by Chris Crochetière, BW&A Books, Inc.
This book has been composed in Dante, Futura, and Avenir typefaces.
Printed on acid-free paper. ∞
Printed in the United States of America.

10 9 8 7 6 5 4 3 2

To my father
for lessons on politics and politicians
and on reading between the lines

Contents

Acknowledgments

The germ of this book goes back many years, to a chance encounter in the German Federal Archives in Berlin. While researching another subject, I came across a file about Hitler's secret plans to build a city in occupied Norway. I knew nothing about the Nazis' building projects in this northern country and could find little in the history books to enlighten me. In the long interval between that initial discovery and the completion of this manuscript, I was joined by many colleagues and friends in the quest to unravel an archival mystery.

The project was launched at the "Art in Battle" conference held in Bergen in August 2014, which brought together an international group of scholars to explore how art was used for propaganda during the Nazi occupation of Norway. I would like to thank the organizers and participants for encouraging me to turn the fragmentary story about architecture that I presented there into a full-fledged book: Line Daatland, Terje Emberland, Matthew Feldman, Christian Fuhrmeister, Anita Kongssund, Gregory Maertz, Dag Solhjell, Erik Tonning, James van Dyke, and Eirik Vassenden. I am also grateful to Shelley Hornstein, Paul Jaskot, Barbara Miller Lane, and Clarence B. Sheffield Jr. for their enthusiasm and support in the project's exploratory stages.

Over three consecutive summers, from 2015 to 2017, Lars Olof Larsson opened his collection and home to me in Kiel. His unstinting help with my research has profoundly shaped the book. In Oslo, Ketil Gjølme Andersen welcomed me with a personal tour of an exhibition he curated on the Organisation Todt and, later, shared his writings and offered feedback on mine. Mari Lending hosted me in Oslo and connected me to her professional networks. At the Army Museum

in Trondheim, Frode Lindgjerdet spent hours guiding me through their archival collections and tracking down additional local sources. Michael Stokke shared his research on prisoners of war in Øysand. Helga Stave Tvinnereim went above and beyond in closing some research gaps concerning Sverre Pedersen. I am grateful for my fabulous research assistants, who pursued images and texts while completing their own graduate studies in history and architecture: Sophia Clark, Ingrid Roede, and Alexander Tunby Rosseland.

A number of organizations have generously supported my research and writing. I received grants to travel to archives in Germany, Norway, and the United States from the Graham Foundation for Advanced Studies in the Fine Arts, the American-Scandinavian Foundation, and the American Philosophical Society. In 2016–17, I had the honor of being a member of the Institute for Advanced Study in Princeton. During that year, in IAS workshops and lunchtime conversations, the formless mound of research collected on archival trips was distilled and refined into book chapters. I am indebted to Yve-Alain Bois as well as to Roland Betancourt, Malcolm Bull, Emine Fetvaci, Yu-chih Lai, Rebecca Maloy, Daniel Sherman, and Nancy Sinkoff. After my return to the University at Buffalo, Robert Shibley and Charles Zukoski ensured that I would have the time I needed to complete the whole.

At Princeton University Press, I had the pleasure to work once again with Michelle Komie. Her many contributions to this book, including lively meals in Lambertville, made this project a joy. The manuscript's two anonymous readers gave excellent advice on structuring the narrative. I owe a special debt to Nancy Eklund Later, who, with wit, elegance, and a sure step, accompanied me through the thickets of writing. Credit for the smooth finish goes to Lauren Lepow and her fine editorial skills.

To the friends and family members who turned up in Berlin, Oslo, Trondheim, and other places—thank you for getting me out of the archive. I am glad I had the chance to walk the shores of Øysand on a freezing day in August, bowl in a former German submarine bunker in Trondheim, and listen to jazz in Molde. We should do it again.

Hitler's Northern Utopia

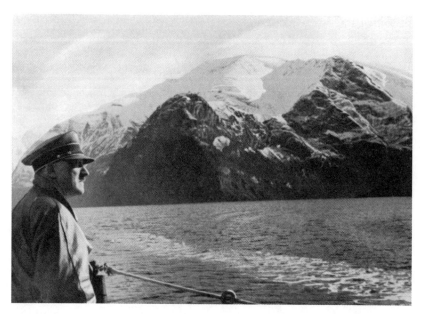

i.1. Adolf Hitler observes the scenery on board the *Deutschland* in the Norwegian fjords, April 1934.

Introduction
Hitler in the Fjords

The weather was exceptionally beautiful on Thursday, April 12, 1934, when Hitler cruised into the Sogne Fjord on Norway's west coast (fig. i.1). He was sailing on the *Deutschland*, Germany's new pocket battleship, accompanied by naval commander in chief Admiral Erich Raeder and defense minister Colonel General Werner von Blomberg. The voyage was not publicized, surprising Germans and Norwegians alike when news of it leaked to the press. It was Hitler's first journey abroad since becoming chancellor, yet no one could say what he was doing in Norway.

The Norwegian government had been given little warning that the *Deutschland* was coming. German Foreign Office records in Berlin reveal a hastily planned trip. A telegram sent to the German Embassy in Oslo on April 7 asked that the local government be informed of the ship's training exercises, which might involve passage through Norway's territorial sea. There was no intention to enter the country's inland waters, which required permission from the Norwegian government.[1]

But a last-minute change of plans to tour the Sogne Fjord in order to show "guests" on board its "scenic beauty" left German diplomats in Oslo scrambling to alert Norwegian authorities before the battleship entered the fjord at 7:30 a.m. on April 12. A German Foreign Office memo composed later that day now described the voyage as a "short vacation" for the Führer, the admiral, and the defense minister, and made clear their intention to travel "quasi-incognito," without flying their respective flags. As a result, they expected the presence of the ship to garner little attention from the Norwegian side.[2]

The secret of who was on board was quickly exposed, however, when a Norwegian pilot, Martin Karlsen, embarked to navigate the heavy cruiser through the fjord and was greeted by a smiling Hitler. Interviewed by the Norwegian newspaper *Tidens Tegn* (Sign of the Times), Karlsen enthused over the German chancellor and star passenger: "He went around the deck and talked to everyone, sailors and officers, and their rank did not seem to matter to him. Everyone on board really liked him—at least, that is my impression. I thought he was a pleasant and convivial man. . . . He was so modest, and the only medal that hung on his suit was the Iron Cross that he was awarded during the world war for personal valor. He was easygoing and friendly with the sailors on board. Moreover, his behavior was completely similar toward the generals and the subordinates."[3]

Little wonder that Germany's right-wing newspapers eagerly picked up the story of the smitten pilot.[4] Importantly, they left out any mention of an article that appeared in *Tidens Tegn* alongside the Martin Karlsen interview, bearing the headline "Is There a Political Backstory to Hitler's Norwegian Trip?" The journalist wrote that the notable absence of Nazi Party officials on board and the presence of Blomberg and Raeder gave credence to rumors that the purpose of the cruise was to discuss the future of Germany's military, a subject that had provoked "severe disagreements" between Ernst Röhm (head of the paramilitary Sturmabteilung, or SA) and the Reichswehr leadership, particularly Blomberg.[5] Indeed, historians have speculated that it was on this voyage that Hitler agreed to address the threat to the military, and to his own position, posed by the defiant SA, resulting in the bloody liquidation of the organization's leaders and hundreds of political opponents eleven weeks later during what became known as the Night of the Long Knives.[6]

In his interview, Karlsen did not hint at any darker preoccupations troubling the Führer. Instead, he portrayed Hitler as delighted and mesmerized by his encounter with the Norwegian landscape, standing on deck "without stirring" and watching for hours. "Hitler," he reported, "spent practically all his time at the bridge and enthused like a little boy over the mountains and the magnificent weather. . . . He was particularly impressed by the beauty of Balestrand, of which, as he recounted, he had heard so much, and which became famous throughout Germany owing to the emperor's visits."[7] The *Deutschland* stopped briefly at Balestrand but did not dock. This picturesque village, jutting out

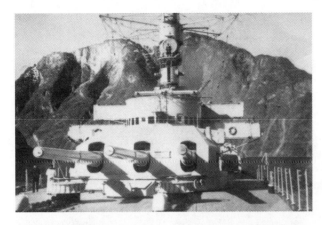

i.2. The *Deutschland* photographed against Norwegian mountains, April 1934.

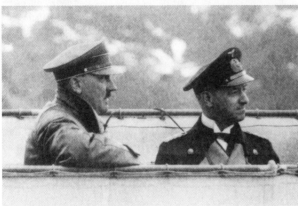

i.3. Hitler and Erich Raeder on board the *Deutschland* in April 1934. Admiral Raeder would later press Hitler to invade Norway to ensure his navy access to Norwegian ports.

into the blue waters of the fjord, had been a favorite destination of Emperor Wilhelm II on his annual summer trips to Norway. Here, while on vacation in July 1914, he helped steer Europe into war. Compelled to return to Berlin by a nervous German government, he never saw his beloved Norway again.[8] *Bergens Tidende* (Bergen Times), which broke the story of Hitler's visit, connected the kaiser's final voyage north with the chancellor's inaugural foray abroad, alluding to a history coming full circle.[9]

Across from Balestrand, the *Deutschland* passed the colossal statue of legendary Viking hero Frithiof, which Emperor Wilhelm II erected above Vangsnes in the summer of 1913 as a gift to the Norwegian people.[10] The cruiser then sailed to the hamlet of Gudvangen, at the end of the Nærøy Fjord. Hitler did not make it quite as far as Stalheim, another regular destination of the kaiser, who stayed at its grand hotel many times. Finally, the *Deutschland* proceeded down the adjoining Aurlands

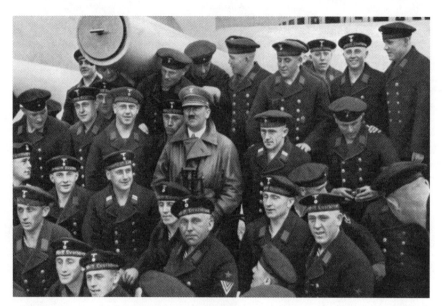

i.4. Hitler with sailors on board the *Deutschland*, April 1934.

Fjord, with its snow-covered peaks and waterfalls, before exiting the Sogne Fjord and sailing southward.[11]

The next day, Friday, April 13, with a different Norwegian pilot on board, the *Deutschland* continued its voyage, entering the Hardanger Fjord. The ship traveled its entire length to reach Odda, another of the kaiser's favorite places, and on the way back paused at the village of Ulvik. As they had the previous day, the *Deutschland*'s passengers remained on board at all times. The Norwegian pilot disembarked in Leirvik, and the ship headed out to sea, arriving in Hamburg on Saturday, April 14, four days after its departure. *Bergens Tidende* reported that "the Führer and his entourage were highly impressed by the western Norwegian fjords' mighty nature, and the Reich chancellor appeared to want to repeat the visit at an opportune time." The article concluded by noting that the glorious weather had allowed the fjords to present themselves "most advantageously, although one could have wished the Reich chancellor to see these areas slightly later, when the fruit trees are in bloom."[12]

Hitler's photographer, Heinrich Hoffmann, documented the *Deutschland*'s voyage in the fjords (figs. i.1–i.4).[13] His photographs capture the dramatic power of the Norwegian landscape, which he juxtaposed with the *Deutschland*'s enormous guns. Hitler appears frequently on deck

gazing at the fjords in the company of Raeder and Blomberg. The sailors energetically swab the deck and perform gymnastics in the spring weather. Everyone seems to be having a wonderful time.

German battleships continued to sail into Norwegian waters that spring and summer. The *Deutschland* returned to the Sogne and Hardanger fjords just two weeks after Hitler's trip, this time accompanied by the cruiser *Leipzig*. In total, twelve battleships sailed into Norwegian waters between mid-April and mid-July 1934. These visits became problematic after the horrifying violence and lawlessness of the Night of the Long Knives turned public opinion in Norway sharply against Berlin. On July 4, 1934, just days after the massacre had ended, the German fleet flagship *Schleswig-Holstein* docked in Oslo. Workers and Communist Party members protested, and police turned back demonstrators attempting to reach the battleship. As a secret report prepared by the German ambassador to Norway disclosed, King Haakon VII was furious that the ship and fleet commander had appeared in Oslo so soon after the slaughter, "as if nothing at all had happened in Germany," and with a total disregard for the mood then prevailing among Norwegians, considering it "an imposition on the Norwegian government and on him personally." At first the Norwegian king refused to receive the fleet commander, as was customary, but relented at the last moment to avoid a diplomatic insult. Nevertheless, he let it be known that he hoped "very much" that no German warship would arrive in Oslo in the years to come. Given his majesty's displeasure, German officials reluctantly and quietly decided to keep their battleships out of Norwegian waters "for the time being."[14]

No amount of protest from the king, however, could turn back the German battleships and warplanes that invaded Norway six years later. The dawn attack on April 9, 1940, code-named Operation Weserübung (Weser Exercise), caught the Norwegians by surprise. Within hours Germans had seized control of major coastal towns. King Haakon VII and the Norwegian government refused the German demand that they surrender, escaping from Oslo into the interior of the country and eventually to Tromsø in the north; from there, on June 7, they left for England and exile. On June 10, the remaining Norwegian troops on the mainland capitulated. The campaign for Norway was over, with Germany occupying the entire country.

On April 24, 1940, even as the fighting in Norway continued, Hitler appointed forty-one-year-old Josef Terboven, *Gauleiter* (district leader)

of Essen, as the head of the civilian occupation regime, the Reichs-kommissariat (Reich Commissariat). As a reward for his collaboration, Vidkun Quisling, leader of Norway's fascist party Nasjonal Samling (National Unity), was eventually named head of a puppet Norwegian government.[15] General Nikolaus von Falkenhorst served as the military commander of the very large German army of occupation, the needs of which placed a heavy economic burden on Norway's population of three million people, who were expected to shoulder the costs. Falken-horst, who was in charge of all military aspects of the occupation, clashed with Terboven over his brutal policies, which he believed alien-ated the Norwegian people. Neither controlled the SS or its dreaded Gestapo, which functioned independently in Norway. This tangle of organizational structures, typical of the Nazi state more broadly, pro-duced confusion, inefficiencies, and tensions among the occupational authorities.

Above these competing interests and voices stood Hitler, with his own vision and agenda for Norway. As Winston Churchill later wrote, Hitler's naval strategy focused obsessively on Norway, which he be-lieved would be the "zone of destiny in this war."[16] Convinced of the danger of an Allied invasion of Norway, a fear stoked by repeated Brit-ish commando raids, Hitler ordered additional troops and resources to Norway, as well as the fortification of its coastline, in an effort to make the country an impregnable northern fortress. Defensive struc-tures mushroomed along thousands of kilometers of coastline, from the Oslo Fjord in the southeast to the border with the Soviet Union in the far north. The manpower needed to build and maintain these de-fenses was enormous. A German war correspondent, writing in Janu-ary 1941, described the resinous scent of freshly cut fir wood that filled the air "throughout Norway, from Oslo to Kirkenes."[17] Norway's for-ests were being razed to build barracks for hundreds of thousands of German soldiers.

But what Hitler saw in Norway went far beyond the fortress. Among the vast construction projects undertaken during the occupation, not all were driven by immediate wartime needs. Many, in fact, were in-tended for the period *following* the war, when the Nazis expected to reign supreme over Europe. Despite promises made to Quisling of Nor-way's eventual independence, Hitler had no intention of withdrawing. In the military and civilian building projects explored in this book, we see the German occupiers taking root in Norway and creating a space

for themselves as rulers of a Nordic empire that stretched beyond the Arctic Circle. Alongside this physical appropriation, we also witness the imaginary construction of Norway as a place that belonged to the invading Nazis, who sought to naturalize themselves as the saviors and rightful inhabitants of this northern land.

Today, as we look back on the war period, the intensity of building in occupied Norway often comes as a surprise, even to Norwegians themselves. Except for the massive fortifications along the coasts, visual evidence of Nazi construction is no longer immediately apparent. What we see—or, rather, do not see—is hard to reconcile with the view from the archives, which reveals frenetic building activity almost from the moment the Germans arrived. Those efforts transformed not only the landscape but also the labor market. In the summer of 1942, for example, every fifth Norwegian worker was employed on a German construction site.[18] So where, we might ask, did it all go?

To begin with, not all of the Nazis' building schemes were realized by 1945. After Germany invaded the Soviet Union in 1941, construction materials grew scarce in Norway as resources were diverted to the eastern front. Some ambitious building projects had to be downsized or deferred. Yet even these unfinished plans have a great deal to tell us about how Hitler and other Nazi leaders envisioned laying out the Greater German Reich in the far north. So, too, do the extensive infrastructure projects the occupiers undertook in Norway. Infrastructure in all its forms was vitally important in the Nazis' determination to connect the peripheries of Europe to Berlin, the intended political and economic heart of their global empire. Yet such projects are commonly overlooked today as physical relics of the past.

Our preconceptions of what a National Socialist–built landscape looks like have also played a role in what we see. In Germany, Albert Speer's colossal schemes for Germania (Berlin redesigned as a fitting imperial capital), as well as his Reich Chancellery and Nuremberg Rally Grounds, reinforce the idea that Third Reich architecture was driven solely by the desire to dwarf people into submission through its sheer monumentality.[19] In Eastern Europe, Hitler's belief in the racial inferiority of the region's Slavic and Jewish peoples and cultures justified a horrific tabula rasa approach—wiping the slate clean to create an all-new Germanic landscape, in which "subhumans" would be replaced by "supermen," and all physical traces of the "unclean" would be erased or pushed into the dark margins of a New Order. In the context of this

well-documented history, we do not expect Nazi architecture to blend or coexist with its surroundings.

Norway, however, was neither Germany nor Eastern Europe. The Nazis considered Norwegians to be racially superior to Germans, and admired—even envied—their Viking origins. As fellow Nordic brothers, the Norwegians were to be treated differently from other conquered nations. In instructing Terboven on his new role, Hitler told him, "You will give me no greater pleasure than by making a friend of these people."[20] To that end Norwegians were to be convinced rather than compelled—steered gently toward the glorious National Socialist future that they did not yet realize they wanted. Norwegian engineers and architects were brought to Germany to be trained in the forms and technologies of the New Order, which they were expected to adapt to their northern context. Although an alignment between metropole and periphery was considered necessary, it was clear to all that an Arctic fishing village differed from Berlin. Creating the physical conditions for a National Socialist revolution in Norway would thus involve developing novel forms and types of architecture in response to native landscapes and traditions. This more subtle approach was expected to be powerful and effective not despite but by virtue of these adaptations.

I begin this book by surveying the newspapers of the era to understand how the occupation of Norway—and Norway itself—was presented to German readers. This overview is facilitated by the work of the Reich Commissariat's Department of Public Enlightenment and Propaganda, whose staff clipped articles about Norway from German newspapers across Europe and arranged them into binders by theme, such as "Norway in the New Europe." Since many of these newspapers are long defunct and difficult to find, this collection, held by the National Archives of Norway in Oslo, offers rare insights into the crafting of a space of imagination for German audiences encountering, through these press stories, the northernmost periphery of Hitler's empire.

Chapter 2 plumbs the role played by infrastructure in the creation of a Nordic empire, whether in the form of a scenic highway connecting Trondheim to Berlin or in the form of a pipeline of Aryan babies meant to improve Germany's genetic stock. The ostensible desire to knit together Norwegians and Germans conveyed through such infrastructure projects is challenged in chapter 3, which explores Hitler's patronage of *Soldatenheime*, cultural and recreational centers for German soldiers stationed in Norway's remote regions. These elaborate buildings were

designed to reinforce the men's German identities and thus prevent them from "going native" in the wild North. Both chapters 2 and 3 are anchored in the Organisation Todt collection of the National Archives of Norway in Oslo. Comprising the records of the paramilitary engineering division responsible for much of the construction in occupied Norway, this vast archive opened to researchers in 2011. The wealth of fresh materials it offers—including letters, maps, photographs, invoices, reports, and much more—directly shapes the stories told in this book.

Albert Speer sought to leave his own mark on the development of National Socialist architecture in occupied Norway. Chapter 4 examines Speer's collaboration with the Norwegian architects and planners entrusted with rebuilding twenty-three Norwegian towns damaged in the 1940 invasion. Invited by Speer to tour Nazi Germany, the Norwegian architects were expected to bring home with them National Socialist ideals of town planning and thus forge suitable urban settings for a new society. Chapter 5 delves into a special commission given by Hitler to Speer: the design of a major German city outside of Trondheim, a new settlement that would enable the rulers to create their own myths of origin in the North. Plans for the city, as well as for the immense new naval base it would serve, were kept strictly confidential for fear of provoking unrest among Norwegians. Both chapters 4 and 5 draw on the unpublished papers of Hans Stephan, held in a private collection. Stephan worked closely with Speer in Berlin and served as his representative in Norway, traveling back and forth between the two countries to advance the rebuilding of Norwegian towns and to quietly make preparations for Hitler's secret city in the North.

From these and other archival sources emerges the Nazis' vision of the North and their place within it as the new Vikings, conquering with military weapons and engineering skills. More broadly, the projects documented here shed light on how Hitler and his henchmen foresaw the future world colonized under the swastika, which they had begun to build in Norway. As illuminating as they may be, these sources are distinctly one-sided, giving voice to German illusions and ambitions. This book thus should not be read as a general or balanced history of the occupation.[21] Rather, the Norway envisioned by the Nazis and explored in this book is a *fantasy*, and a dangerous one. The Nazi perspective does not capture the realities experienced by the occupied or the ways in which Norwegians resisted the appropriation and abuse of their land. It also pays little heed to the extreme suffering of the prisoners of

war deported from Eastern Europe to build Hitler's northern utopia. A large and growing body of scholarship, mostly by Norwegian historians, has made clear the tremendous human cost of the Nazis' dreams of remaking the North—from the prisoners worked to death to the German-fathered babies abandoned after the war. When Hitler sailed into the fjords on his battleship on a sunny day in April 1934, few could have imagined the nightmare that would follow when the Führer, liking what he saw, decided to come back at an opportune time.

1 Romanticizing the North

German Press Accounts of Norway under the Nazis

In September 1940, Nazi journalist and cultural critic Bruno Roemisch sat in the orchestra section of the National Theater in Oslo reminiscing about the German invasion of Norway five months earlier. He had stood outside the same building on the afternoon of April 10 as German troops, which had entered the capital the previous day, hauled loads of hay into the theater to create provisional bedding for themselves. Amid a group of Norwegian onlookers, Roemisch overheard one "fat bourgeoise" grumble, "Just look at those damn Germans! First they chase away our king and then they turn our beautiful National Theater into a barn."[1]

Inside the now pristine theater, Roemisch could only marvel at "what has become of this barn in the short time since." The anger expressed by the Norwegian bystander seemed to belong to "another world." Time, the "great quick-change artist," had swept it away, replacing the "throaty snores" of the soldiers with "the delicate violin notes of Lehár's *The Merry Widow*," Hitler's favorite operetta. The National Theater's rebirth, Roemisch maintained, was representative of the capital as a whole and of Norway more broadly. Economic recovery, happiness, and optimism flourished everywhere. Roemisch saw the metamorphosis in the busy port, where unemployment had been banished, and along Karl Johans Street, where stylish women carrying shopping parcels smiled easy, uncomplicated smiles. Their mood, Roemisch asserted, was contagious: all of Oslo was in good spirits. Having

experienced a "fall upwards" with the German occupation, life in Norway was better than ever.[2]

Roemisch's account of the country's resurgence, published in the *Krakauer Zeitung* (Kraków Newspaper), the Nazi newspaper of occupied Poland, is easy to dismiss as just more fervid propaganda meant to bolster support for Hitler's New Order, the radical and massive reorganization of Europe. What suggests that such narratives deserve more serious attention, however, is their pervasiveness in the Nazi-controlled German-language press of Europe. German readers from Kirkenes to Vienna and Brussels to Riga consumed thousands of positive stories regarding Norway's progress under the occupation.[3] Taken as a whole, this literature represents a type of collective wish fulfillment: the creation on the page of the North as a vast space of possibility, where Hitler's racial utopia could be imagined and carried out. But more than just fantasy, the articles also captured the crafting and implementation of policies designed to bring about Europe's transformation in the wake of Hitler's victorious armies. An examination of these articles reveals how Norway emerged in the eyes of Germans as a testing ground for a new racial empire based on the collaboration of Nordic peoples.

Beginning soon after the invasion, stories about Norway produced by the Nazi-controlled press introduced German readers to Hitler's northernmost acquisition through accounts of its towns, people, and resources. Whereas substantial propaganda had prepared Germans for the Nazi occupation of the Sudetenland and the war with Poland, there had been little warning that Hitler would open a northern front. The occupying armed forces in Norway were exceptionally large; as a consequence, many Germans had family or friends stationed there. Press coverage about this foreign country suddenly under German control sought to assuage anxiety and satisfy curiosity among readers at home. With almost 450,000 German soldiers and civilians living in Norway during the height of the occupation, there was also a built-in audience for new German-language newspapers and journals published there. In May 1940, even before Norwegian forces capitulated, Nazi publisher Max Amann launched *Deutsche Zeitung in Norwegen* (German Newspaper in Norway), an Oslo-based daily with a large circulation. Beginning in October 1940, the Wehrmacht in Norway published its own newspaper, *Wacht im Norden* (Northern Watch), which it distributed free of charge to German soldiers. Terboven's commissariat inaugu-

rated *Deutsche Monatshefte in Norwegen* (German Monthly in Norway), a richly illustrated magazine focused on social and cultural issues, in November 1940 (see plate 1).[4] These publications provide extensive information on the occupation, but always filtered through the lens of military censorship and the press limitations on what and how journalists could report imposed by the Reich Commissariat's Department of Public Enlightenment and Propaganda.

Accounts of Wehrmacht soldiers contributing to Norway's improvement undoubtedly fostered among German readers a sense of their own role in a broader racial mission, tying efforts abroad to those on the home front. On April 9, 1941, an article on the anniversary of the Norwegian invasion that emphasized the hard work being carried out by German soldiers in the far north appeared in the *Straubinger Tagblatt* (Straubing Daily News).[5] The newspaper served the residents of Straubing, a small town in Lower Bavaria on the Danube with a long and brutal history of pogroms dating back to the fourteenth century. When Hitler seized power in 1933, the small community of Straubing Jews became targets of violence, including murder. After the town synagogue was ransacked during the national November pogrom of 1938 known as Kristallnacht, or the Night of Broken Glass, most were forced to emigrate. Those left behind because of age or poverty were almost all deported to the east in 1942 in the pursuit of making Straubing *judenfrei*, free of Jews.[6]

It is in this context that townsfolk picked up their local newspaper and read the words of Colonel General Nikolaus von Falkenhorst, Wehrmacht commander in Norway, lauding the men of the northern watch. Falkenhorst emphasized that Germany had been forced to occupy Norway to defend against British interference. Even so, he insisted, his armies were not conquerors but rather friendly peacekeepers and nation builders, constructing new roads, railways, bridges, and other infrastructure that would allow Norway to develop economically and participate fully in the New Order. These projects had eradicated unemployment, and the introduction of German technology, German labor, and a "German tempo" had given Norway's people the stimulus and knowledge they needed to modernize their nation. Falkenhorst also praised the benefits the civilian population derived from the Wehrmacht's "spiritual care work," which allowed the Norwegians "to experience the tremendous rhythm of German cultural activity, which does

not rest even in wartime." Thus, he concluded, German armed forces, through their pioneering work in Norway, were forging "a new era for the Norwegian people in a pacified Europe."[7]

Race defined the new era imagined by the German occupiers and tied the "work" of the Wehrmacht soldiers in Norway to that of the townsfolk in Straubing. Hitler's vision of a Germanic empire that would unite all of Europe under the rule of a superior Germanic race depended on a mystical faith in the power of Nordic blood. As Hitler claimed in *Mein Kampf*, Nordic blood could be "poisoned" by reproducing with inferior races. This adulteration, in his view, explained the decline of the great civilizations of the ancient world, particularly Greece and Rome, which he believed to be Nordic—a blond, blue-eyed Aryan race—in origin.[8] Conversely, blood could be strengthened through breeding with better genetic stock, and none had purer Nordic blood, according to Nazi eugenicists, than Norwegians. The Nazis' desire to protect Nordic blood justified mass genocide on the one hand and pronatalist measures on the other.

The notion of a racial hierarchy with Norwegians at its apex had already been popularized in Germany in the 1920s through the work of Hans Friedrich Karl Günther, a German nationalist and right-wing ideologue who wrote popular books on racial theory for the general public. Günther, who married a Norwegian woman and lived for a time in Norway, exalted the Norwegians. He believed that they had preserved the genetic superiority and nobility of the Nordic race because of their geographical isolation from the Continent and through their ongoing connection with rural culture.[9] In his best-selling 1922 book *Rassenkunde des deutschen Volkes* (Racial Studies of the German People), Günther ascribed to the Nordic man a sense of adventurousness, truthfulness, and justice; a strong feeling for landscape; a heroic and creative temperament; iron willpower and good judgment; and, importantly, an exceptional ability to conquer and lead.[10] That very ability to subjugate other peoples, however, had also diminished the Nordic man through intermarriage. Günther estimated that Norwegians possessed more than 70 to 80 percent pure Nordic blood, while Germans themselves retained only 50 to 60 percent in their veins.[11] In his 1925 book *Der Nordische Gedanke unter den Deutschen* (The Nordic Idea among the Germans), he promoted selective breeding in order to genetically improve the German population through "Aufnordung" (re-nordification), augmenting its Nordic elements.[12] Günther's theories deeply influenced

Heinrich Himmler, who made *Nordische Gedanke* required reading for his SS members, all of whom claimed a Nordic/Aryan lineage "untainted" by Jewish blood.[13]

Günther used photography to create a "visual code" that concretized his racial ideas and made them more accessible to a wide audience.[14] The idealized Nordic type that he presented to readers had a tall and slender build, blond hair, light rosy skin, long skull, thin face, narrow nose, and light blue or gray eyes.[15] In the 1930s and '40s, Erna Lendvai-Dircksen, a National Socialist photographer for the eugenicist journal *Volk und Rasse* (People and Race), issued a popular series of photobooks under the titles *Das deutsche Volksgesicht* (The Face of the German People) and *Das germanische Volksgesicht* (The Face of the Germanic People) that sought to capture the essential physiognomies of Nordic peoples in Germany and beyond. The 1942 volume on Norway, with its black-and-white pictures of people, architecture, and landscapes, further romanticized Günther's theory of the formative connection between race and environment.[16]

Lendvai-Dircksen framed her human subjects to convey a sense of dignity. The images of natural landscapes and villages also included in the book embedded the people in a timeless rural context; cities and urban dwellers were nowhere to be seen (figs. 1.1–1.4). Photographs of a medieval sun-cross gravestone and a stave wooden church reminded viewers of the subjects' Viking roots, a past also romanticized in Lendvai-Dirksen's foreword.[17] She painted a vision in highly nostalgic terms of a primitive but noble existence on the land that was threatened by emigration and the loss of the "best valorous blood" of the race. She wrote, "Norway's greatest wealth lies precisely in the purity of its Germanic blood." That blood, she contended, lived on in the landowning peasants who were still bound to the soil and thus protected from the damaging "influences of Anglo-American civilization."[18]

In this narrative of endangered Nordic blood, Norway's German occupiers emerged as guardians of a vitally precious life source needed for the renewal of the Nordic race. Like warrior knights, they had come to protect the racial Holy Grail. And while the perceived threats came from many quarters, the most culpable and dangerous agents in the plot to destroy Nordic blood were the Jews and the Marxists, the same enemies Hitler had long demonized in Germany. In the November 1941 issue of *Deutsche Monatshefte in Norwegen*, Heinrich Meyer, a member of Dresden's Genetic Health Appellate Court (which heard

1.1. Erna Lendvai-Dircksen's *Das germanische Volksgesicht: Norwegen* offered a highly romanticized vision of Norway and its people, in tune with National Socialist ideals. This photograph, which appeared in the book opposite the man in 1.2, shows the farmstead above the Gudbrand Valley where, according to legend, the real-life model for Ibsen's Peer Gynt lived.

appeals of compulsory sterilization orders), published an article with the sensationalist title "Norway's People on the Brink of Extinction?" There, he blamed the twentieth-century decrease in Norway's birthrate on "foreign elements, especially Jewish-influenced propaganda, that for decades have been free to try to coldly annihilate the Norwegian *Volk* by propagating small families through so-called sex education, by ridi-

1.2. Erna Lendvai-Dircksen, photograph with the caption "Farmer from the kin of Peer Gynt."

culing an abundance of children, and by preventing effective measures to encourage child-rich families." The family planning clinics established across Norway in the 1920s and '30s by birth-control advocate Katti Anker Møller particularly drew his ire. He claimed that "Marxist organizations" controlled them, a reference to the support that Møller had received from Norway's socialist and communist parties in her efforts to help poor women control their fertility and thus better care for themselves and their children.[19] In April 1941, the Reich Commissariat

1.3. Erna Lendvai-Dircksen, photograph of Setesdal, a valley in southern Norway.

closed the family planning clinics in Norway, just as Hitler had done in Germany in 1933, also alleging the need to protect the *Volk* from "Jewish-Bolshevist" sex reform.[20]

But Meyer, who wrote positively about the changes happening in Nazi Germany, also blamed Norwegians for their lack of racial consciousness. The declining birthrates across Western Europe were connected, he maintained, to a widespread mental and spiritual deterioration. Healthy nations did not want for babies. "In the end," he wrote,

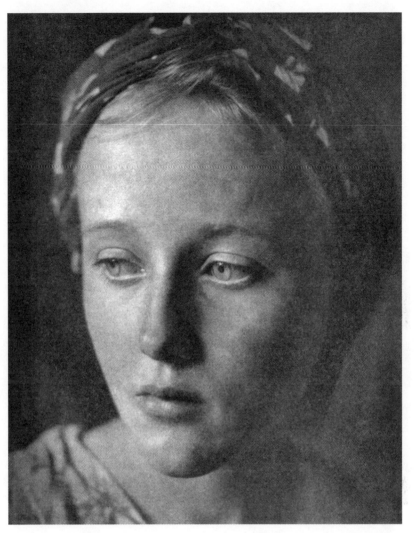

1.4. Erna Lendvai-Dircksen, "A farmer's daughter from Setesdal." This image appeared opposite the landscape depicted in 1.3.

"this is about *Weltanschauung* and *Lebenswillen* [worldview and will to live]. Increasing the birthrate of a *Volk* means increasing their vitality." Germany, which was experiencing an upswing in the number of births, was proof, Meyer believed, that spiritual recovery bolstered the people's will for life and for children.[21] Having saved themselves from the brink, Germans would now save Norwegians as well.

For Hitler, the greatest bellwether of racial decline was art. Accordingly, German correspondents in Norway paid close attention to its

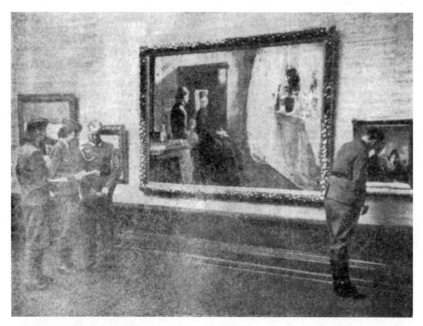

1.5. German officers by Edvard Munch's *Spring* in the exhibition *Art and Non-Art* in the National Gallery in Oslo, 1942. Photograph by PK.-Ehlert.

museums, bookstores, theaters, and concert halls to demonstrate both the need for and benefits of the occupation.[22] Their reporting, while repeating arguments about cultural degeneracy honed in Nazi Germany in the 1930s, also made allowances for the sensitivities of Norwegians, whom the Nazis wanted to reform but not alienate. Thus Edvard Munch, a Norwegian artist whose works had been included in the notorious 1937 *Degenerate Art* exhibition in Munich and removed from German public museum collections, was lauded as a great Nordic painter in the German occupation press in Norway.[23] His paintings were included in the sanctioned "art" section of the *Art and Non-Art* exhibition instigated by Norwegian culture minister Gulbrand Lunde (an outspoken nationalist ideologue in the fascist party Nasjonal Samling), which opened in April 1942 at the National Gallery in Oslo (fig. 1.5).[24] In 1943, on the occasion of Munch's eightieth birthday, Walter Passarge, the director of the Kunsthalle Mannheim, published an adulatory essay in *Deutsche Zeitung in Norwegen* praising the artist as the very manifestation of the Nordic spirit. In 1937, Passarge had seen his own museum's collections purged of degenerate art, including works by Munch.[25]

Oslo, as a symbol of Norway's social and moral decline before the arrival of the Wehrmacht, was a favorite target of Nazi journalists. Medieval in origin, Oslo had expanded rapidly in the nineteenth century, like many other European capitals. In May 1942, the *Deutsche Zeitung in Norwegen* published an article under the headline "Can Oslo Become More Beautiful?" blaming earlier authorities for being too weak to control growth and rein in capitalist speculation. As the author noted, when industrialization had taken hold around 1840, factories and workers' slums had sprouted "like mushrooms" along the Akerselva, the river flowing through the city. Tenement buildings had been constructed quickly and shoddily of cheap materials, reaping large profits for the owners but misery for the tenants. Little attention was paid to the natural setting of the city, and greenery disappeared.[26] For many National Socialist critics, Oslo's ugliness and despoliation mirrored a deeper racial condition.

A month after the article was published, Wilhelm Brepohl, a journalist and leading voice in Nazi Germany on race and migration, questioned whether the "melting pot" of Oslo was genuinely Norwegian. In an essay appearing in *Deutsche Monatshefte in Norwegen*, Brepohl explained that after the First World War Norway became deeply estranged from continental Europe and Germany, aligning itself instead with England and the United States. Political left-wing forces, influential for decades, had done everything possible to "completely erase awareness that a good deal of Norway's accomplishments have arisen on German foundations." Oslo's educated classes, Brepohl continued, had become spiritually alienated and had little left in them of the Northern man's spirit. They had no interest in or feel for the far north of the country. Indeed, their estrangement was so complete that the capital's residents had little connection anymore even to their own history. As a result, the Old Norse Poetic Edda, with its stories of Norse gods and heroes, "is considered completely foreign, and the Vikings are regarded as pirates and so judged." Brepohl mocked those intellectuals who, no longer able to find themselves in their folkish past, turned instead to the self-revelations of (Jewish) psychoanalysis. "This Oslo," he wrote, "is not Norway."[27]

But Brepohl had yet more evidence to offer of Oslo's abnormality. Namely, more women than men migrated to the capital from other parts of Norway, resulting in a surplus of women. This feminine excess, Brepohl claimed, considerably influenced the "mentality and character"

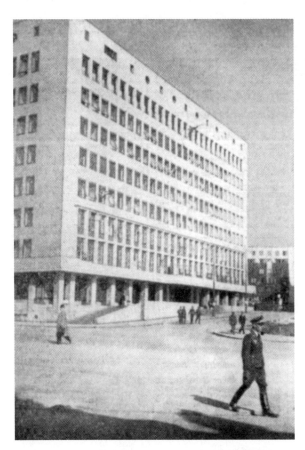

1.6. A German officer walks by a modern office building in Oslo. The photograph appeared in *Wacht im Norden* in August 1942 with a caption that noted the building's "cold austerity."

of the city. Most of the new female migrants were single, independent office employees with high demands. "These women," he wrote, "are heavily influenced by Americanism." Their impact was visible in the growth of Oslo's restaurants and shops, places of frivolity and pleasure. The newcomers found their role models in the illustrated magazines, with their images of "sweet, simple girls with stupid sex appeal." This debased world of women was unimaginable in the rural countryside, which preserved the "healthy energies" of the *Volk*. "Thus the women are further proof," he concluded, "that Oslo is not Norway."[28]

Other Nazi writers pointed to Oslo's contemporary buildings as evidence of its racial and national alienation (fig. 1.6). By turning its back on history and embracing functionalism—an international design style despised by Hitler and condemned by Nazi ideologues as rootless, Jewish, and Marxist—Oslo had transformed itself into a shiny but character-

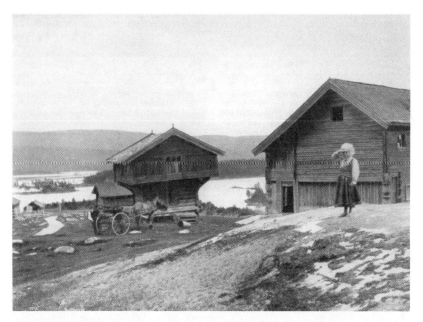
1.7. An unidentified farmstead with a *stabbur* (elevated storehouse) in the background.

less non-place. Journalist August Hoppe succinctly captured this view in his essay on Oslo as an "upstart among world cities," published in the August 1, 1942, issue of *Wacht im Norden*. "Here is a city," he wrote, "that, like no other, has captured the pomp and splendor of its time to the point of dubiousness and ultimate exaggeration, a great and bold improvisation on the mindlessly borrowed, copied, and appropriated." Echoing Brepohl, Hoppe criticized the Americanness of Oslo's modernity, including the nearly completed city hall, which he dismissed as an American-style cube, in reference to New York City skyscrapers. (The Nazis hated this "weird and alien" edifice, with its massive twin towers, and, after the invasion, halted construction with the intention of converting the building to a commercial purpose, to which they argued it was better suited.)[29] Hoppe also mocked the lipsticked "flappers" of Oslo; he caricatured their prototype as a woman who is "1.65 meters tall, weighs 53 kilograms, sports a Greta Garbo hairstyle, knows twenty-five cocktail recipes, and lectures her parents about her views on psychoanalysis." At the same time, Hoppe, who was then in his early twenties and writing for young soldiers, could not quite hide an attraction to modern Oslo, with its lively street life and "lithesome girls"—an attraction the middle-aged Brepohl apparently did not share.[30]

If it was potentially fraught for German journalists to write about Oslo's glamorous women and skyscrapers, the same did not hold true for Norway's traditional wooden architecture. In the countryside they found the antithesis to the capital's modernist buildings—the "true form" of the North that had grown organically from the soil. That "true form" was present in the plank and log houses that could be traced back to the Vikings, the timber stave churches with their rich portal carvings and dragons' heads, and the beautiful *stabbur* (elevated store-houses), some hundreds of years old, where farmers' wives stored food and household goods (fig. 1.7). These folkish structures, National Socialist writers proclaimed, embodied the "real Norway."[31]

Yet the interest in exploring the "authentic" North through such buildings went beyond a desire to define for readers what was truly Norwegian in contrast to the Americanized "melting pot" of Oslo. The racial and cultural purity of the countryside had been a central trope in prewar Nazi journalism, which idealized Germany's rural population as the bulwark against urban degeneration and the source for national renewal. After the invasion of Norway, German writers extended the conceit to include this new territory. In doing so, they added a coloniz-ing twist to bolster their own claims to a Northern lineage.[32] A corporal named Kramm contributed an article to *Wacht im Norden* with the title "Where Do We Find the Nordic in the North?" in which he portrayed the "buildings of older Norwegian culture" as "the great portals" to the nation's soul. Kramm asserted that when standing before them, the German soldier experienced a sense of déjà vu and recognition.[33]

For Hermann Phleps, a German architect and historian of timber structures, such feelings of familiarity were not coincidental. In a 1941 article published in *Deutsche Monatshefte in Norwegen*, he analyzed farm buildings in rural Scandinavia and in the Germanic Alps; he claimed that their similarities were due to the common racial ancestry of the builders (see fig. 1.7). Members of the Nordic race who had migrated southward in the remote past, Phleps explained, had preserved the forms from their ancestral lands deep within their collective racial memory.[34] In short, the buildings were tangible proof of a common ori-gin: Germans, like Norwegians, were of the North, even if they did not live there anymore. In such narratives, the North was not a direction or geographical location but rather a spirit carried in the blood.[35]

The desire to assert a claim on the North also applied to Norway's stone architecture, but in this case with the perceived influence flowing

in the opposite direction. Monumental stone architecture arrived late in Norway, around the eleventh century, with religious missionaries and masons from England and northern France. This was not, however, the story that Nazi journalists wanted to tell: they insisted instead on German influence in the development of Norway's stone buildings. In December 1941, Bruno Roemisch published an article in *Deutsche Monatshefte in Norwegen* titled "German Architecture in Norway." Everywhere around him, he saw the legacy of German builders, even if the evidence contradicted his views. He credited the twelfth-century St. Mary's Church in Bergen to the German inhabitants of the Hanseatic League's *Kontor,* or trading enclave. In fact, these German merchants settled in Bergen significantly later. In 1408 they obtained St. Mary's Church for their own use, after which time it was popularly known as the German Church.[36] Roemisch manipulated this history to attribute the building's construction to the merchants. Similarly, he cast an appropriating eye on Trondheim's Nidaros Cathedral, the largest stone cathedral in Scandinavia, which was erected over the grave of Saint Olav, patron saint of Norway. Begun in the twelfth century, it is the oldest medieval building in Norway, although most of the visible cathedral dates to the nineteenth century. While admitting that the origins of the church's construction were shrouded in mystery, Roemisch added that "existing building traces appear to suggest that the original design of the Trondheim Cathedral looked to and found its model in the famous church architecture of medieval Rhineland society; Speyer Cathedral comes to mind."[37] Historians, however, trace the church's early influences to England.[38]

Perhaps more than any other building in Norway, Nidaros Cathedral captured the Nazi imagination. Roemisch was not the only Nazi journalist eager to apply a German stamp to this, the country's most important cultural monument, steeped in national significance. A full-page article in the June 25, 1942, issue of *Deutsche Zeitung in Norwegen* celebrated the contributions of German-born Heinrich Ernst Schirmer, who was active in Norway for forty-five years and led the cathedral's nineteenth-century restoration. The author claimed that after the building had burned in 1719, there had been little interest among Norwegians in salvaging the ruins, and it was only thanks to Schirmer that the cathedral had been rebuilt. "Nobody remembered the past," the author asserted, and "the oldest cultural center in Norway and the tradition associated with it were forgotten." Realizing that the Norwegian

people had "not the slightest understanding for this cultural task," the architect mustered "untiring energy and creativity" to raise awareness and save the building. Admittedly, Schirmer was a zealous proponent of the project and played a central role in the restoration. But his approach to preservation was heavily criticized (then and now); he was forced to resign not long after the restoration work began, and replaced by a Norwegian architect. The church had never been forgotten or abandoned by Norwegians—to the contrary, it had remained a strong source for national identity, which prompted the restoration.[39] The journalistic portrayal of Schirmer as a lone, heroic savior and of Norwegians as apathetic dunderheads sought to culturally appropriate Norway's heritage on the basis not only of the work done by the German architect but also of the claim that Germans were better able to recognize and protect the heritage of the North.[40]

Despite the misrepresentations and distortions, stories in the Nazi press about the impact of German builders on Norwegian cities pointed to a significant history of architectural influence. Schirmer designed churches, hospitals, a prison, schools, railway stations, a museum, and residences that indelibly shaped nineteenth-century Oslo. A full-page article in the July 2, 1942, issue of *Deutsche Zeitung in Norwegen* celebrated his architecture with lavish illustrations.[41] In Bergen, the German *Kontor* left behind Bryggen, the medieval German quarter with its long rows of colorful gabled structures, which through centuries of meticulous rebuilding had preserved older indigenous forms. Bryggen also spoke to German journalists of their countrymen's "firm footing" in the North and responsibility for the city's "glorious heyday."[42] Indeed, the German occupation press regularly offered travelogues that seemed intended as much to introduce German readers to Norwegian towns as to explore their German histories and urban footprints. A feature on Tromsø for the *Deutsche Zeitung in Norwegen*, for example, emphasized the Germans' historic presence in the northern Norwegian town that in the nineteenth century developed a vibrant international community as a center of fishing and tourism, and as a stopping point to and from the Arctic. The reporter wandered the town's streets looking for German buildings and German names on house doors.[43] Through their histories of Norway's architecture—whether timber or stone, medieval or modern, rural or urban—National Socialist writers thus attempted to legitimize and historicize the German presence, turning the occupation into a homecoming.

To the dismay of the Germans, Norwegians did not see things the same way. Their anger and resistance to the occupation was handled gingerly by the German press for fear of exposing the fiction of Nordic solidarity and thereby undermining support for Germany's mission, among the troops and among readers at home. Yet soldiers stationed in Norway could hardly fail to notice the hostility directed toward them by their racial "brothers." The editors of *Wacht im Norden* addressed this tension in 1941 under the headline "Why Some Norwegians Do Not Understand."[44] The timing of the article is revealing: published on August 16, it appeared soon after Terboven, furious at the popularity and effect of BBC broadcasts from London that encouraged Norwegians to resist the German occupation, issued an order to confiscate civilian radios in Norway. Within a week of the August 1 decree, Norwegians were forced to surrender their radios, leaving them feeling stripped of "their one remaining link to the outside world." Listening to broadcasts on clandestine receivers became punishable by death, and in 1942 the first executions took place for listening to and spreading BBC information, with five Norwegians executed in Trondheim, four of them Jews.[45]

The *Wacht im Norden* article began by addressing soldiers directly and acknowledging their experiences: "All of you who, in one way or another, have encountered the Norwegian people will have sadly experienced that the Norwegian often does not or will not understand us." The author blamed "English money and English propaganda" for poisoning Norwegians against the Germans. But there were also historical and cultural reasons for these misapprehensions, the author maintained. Norwegians could not comprehend "our hatred of the Jews" because Jews were newcomers in Norway and had not yet revealed their "true" nature. Lacking the Germans' "own bitterest experience," Norwegians could still perceive the Jews they knew as "such nice people." The author reminded his soldier-readers of the loyalty they owed to Hitler for having brought them together as a community to fight such perils and to collectively build their future. Yet none of this would have been possible, the author continued, without the discipline of the German people. By contrast, Norwegians, under the influence of the English (a "megalomaniacal mixed race"), had repressed their natural Germanic impulses and grown egoistical, spoiled, and undisciplined. Having been pacifists for so long, Norwegians bore little resemblance anymore to their battle-tested Viking ancestors and could no longer understand "our martial attitude." It was only natural,

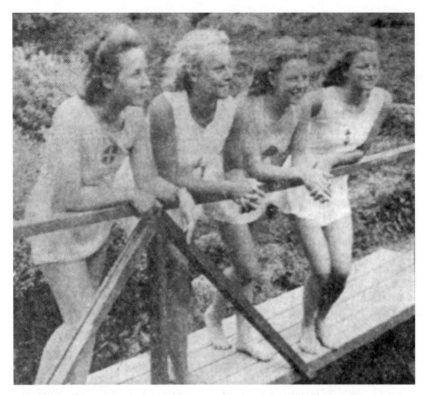

1.8. Members of the Bund Deutscher Mädel (League of German Girls) traveled from northern Germany to Lillehammer to meet their Norwegian counterparts in the summer of 1941. An article about the trip published in the Kiel-based newspaper *Nordische Rundschau* included this image with the caption "Schleswig Holsteiners and Norwegians get along well."

the author concluded, that the weak (Norwegians) should be resentful of the strong (Germans), especially when a nagging voice deep within them whispered that it should be otherwise.[46] In this anxious reinscription of Nazi ideology, the article inadvertently revealed an awareness that Norwegian skepticism posed a real threat to the occupying soldiers and to their faith in the Nazi mission.

Yet such negative coverage was rare, with German journalists preferring to portray the relationship between Norwegians and their occupiers in a far more positive light. Hitler's regime had developed National Socialist educational and social programs to mold German youth for their roles in the New Order; with territorial expansion, this ideological grooming was extended to the "desirable" youth of conquered nations. Stories about exchange programs, particularly involving youth and designed to foster a sense of racial solidarity, gave readers hope

of overcoming the differences among Nordic brothers. In June 1941, for example, a summer camp for Norwegian and German girls opened in Lillehammer (fig. 1.8).[47] In April 1942, a group of young Norwegian women arrived in Germany to live and work on farms and thereby broaden their agricultural and racial education. Later that summer, a reporter for the *Deutsche Zeitung in Norwegen* gushed that the Norwegians had encountered Germany "with open hearts" and, in the few months they had spent there, "learned to love and appreciate Adolf Hitler's Germany." He noted how "flaxen-haired Ella from Stange" praised German milk production, Dagny from Brøttum learned about vegetable crops, and Borghild from Snarum, who had thirty-seven cows of her own, focused on horticulture. The author envisioned these "fresh" and "cheerful" women returning to Norway as ambassadors for the New Germany, having forged lifelong "bonds of friendship."[48]

The image of sunny Norwegian milkmaids falling in love with Hitler's Germany surely warmed the hearts of German readers. Likewise, stories about how the occupation had "saved" Norway's young people from a path of moral, cultural, and racial destruction reinforced the narrative of benevolent rule. This theme dominated newspaper accounts of the implementation of an obligatory Norwegian Labor Service and its effect on Norwegian youth. German readers were already well acquainted with such programs. In 1935, Hitler had introduced the compulsory Reich Labor Service (Reichsarbeitsdienst or RAD), an important ideological tool to instill militaristic discipline and a Nazi worldview in young men. After the invasion, thousands of RAD men arrived in Norway as auxiliary troops for the Wehrmacht, repairing bridges and ports, clearing snow from northern roads, and improving other infrastructure.[49] When, in April 1941, the Norwegian administration, under pressure from Terboven, instituted its own mandatory labor service, the German press hailed the development in terms recalling earlier propaganda about the Reich Labor Service, which had emphasized the need to regenerate youth through contact with the land and harden male bodies through physical labor. During the summer of 1941, Norwegian labor service conscripts helped to gather agricultural harvests, compensating for the labor shortages created by the Wehrmacht's vast construction projects.[50]

Carl Gilfert praised the impact of Norway's labor service on its young people. The author of the virulently antisemitic text "Ghetto Jews and Vermin Belong Together" was invited, along with other

German journalists, to Norway in the summer of 1942 to observe the progress of the labor service one year after its implementation.[51] In an article with the romantic title "Reflections amid White Nights," he began by describing the "decadent" urban life of the 1930s, when Norwegian youth danced to American jazz music in an Oslo degraded by Americanized architecture. Gilfert portrayed these "swing kids" (as the Nazis called them) as unpatriotic and spoiled, averse to hard work and discipline: "Work, labor service, no, how ridiculous and unfashionable, we're dancing swing!" By contrast, Gilfert imagined a farmer and his children in the Norwegian countryside who "knew nothing of swing" and who, struggling to work the land, "looked in vain for help." Fortunately, Gilfert maintained, Quisling's regime, with assistance from the Germans, had reversed this deplorable state of affairs through the compulsory labor service, which instilled values of community to unite youth across Norway for the common good and educate them in their duty "to be mainstays of the coming Europe."[52]

The German press was eager to explore the role of occupied Norway within this new Europe, giving its readers the impression of a mutually beneficial arrangement. Economically, the invasion had devastated Norway, not only through the physical destruction of its towns and infrastructure but also by rupturing its international trading relations, particularly with the United Kingdom, its main trading partner. Before the war, Norway had the highest level of imports per capita of any nation in Europe, relying on other countries for food, fuel, and raw materials. Its trade imbalance was offset by its shipping and whaling revenues, as well as by exports of timber and wood products, fish, and mineral ores and metals.[53] Norway's merchant marine was the fourth largest in the world and by far the most modern. When the invasion began on April 9, 1940, 80 percent of the fleet was outside the country. Norway's government in exile ordered captains to sail for neutral ports and then requisitioned the ships, which became its major contribution to the Allied war effort.[54] In occupied Norway, food, fuel, and other vital resources grew scarce and were rationed: by 1941 official food rations in Norway amounted to just sixteen hundred calories per day, but even these allotments were difficult to obtain. "Endless lines to nowhere" became a common feature of urban life, as city dwellers sought to use their coupons, often without success. Some city dwellers turned to growing their own food or foraging in forests for mushrooms and other plants. In summer, employers let their staff take time off during

the week to collect berries.[55] German journalists attempted to spin the growing crisis by claiming that the occupation was steering Norway toward a better path of economic self-determination.

As it so often did, the Nazi press blamed England for Norway's hard times. According to the National Socialist worldview, Norway had been made into an economic colony by a corrupt and profiteering England, which was dominated by a Jewish kleptocracy. These foreign business concerns had—among other abuses—kept Norway dependent on British coal by obstructing the development of the country's immense hydroelectric resources. As a result, Norwegians who now found themselves unable to heat their homes could thank Churchill and his Jewish backers. (Some reports also pointed a finger at Norway's former politicians for being too complacent in the face of English exploitation, preferring their "whiskey and bridge" to protecting their own people.) By contrast, these same journalists portrayed Hitler's New Order as the foundation for mutual support and cooperation among Germany's economic partners, who would be organized into a *Grossraumwirtschaft*, a European trading bloc under German control. The war, they insisted, had given Norway the impetus to break free of its economic servitude and reorient itself, away from the West and England and toward the south and its "natural" connection to the European continent, particularly Central Europe. With help from Germany, Norway would finally realize the vastness of its economic potential. For example, by fully developing its "white coal" (hydroelectric) power, Norway would be able to provide the energy needs for all of Northern Europe.[56]

Indeed, Nazi-controlled newspapers were full of self-congratulatory stories about the economic benefits to Norway of the occupation. Many boasted of the disappearance of unemployment, although this was hardly indicative of a healthy economy. With Germans ruthlessly exploiting Norway's resources to benefit the war effort, Norway's standard of living plummeted.[57] Yet even as Norwegians went hungry, National Socialist press reports celebrated German food imports, which they falsely asserted kept Norwegian stomachs full, and the bumper crops in Norway that they claimed resulted from the application of superior German agricultural methods. National Socialist writers maintained that the changes driven by the occupation were part of a social and economic revolution so profound that Norwegians—focused on their immediate "egoistic" needs—could not fully grasp it. Any hardships, as far as they were acknowledged, were presented as positive

developments. Thus the author of a 1942 article claimed that with meat in short supply, some Norwegians were learning for the first time just how delicious fish was. Similarly, having less whiskey available was a good thing, as it enhanced Norwegians' work productivity.[58]

The Nazi-controlled press also hailed Norway's reorientation southward as a political liberation, despite the obvious contradiction of the country's occupation by a foreign power—a reality that the Germans denied by insisting that they came "as friends" to aid in Norway's defense. In 1943, the *Thüringer Allgemeine Zeitung* (Thuringia General News), a newspaper headquartered in Erfurt, reported on "the awakening of the Germanic sense of community" in Norway and portrayed the Germans as finally liberating Norway from the centuries-long colonial yoke of Denmark and Sweden. The article mocked the Danish-born Norwegian king, Haakon VII, for being unable to speak Norwegian with his subjects (apparently missing the irony that Terboven governed in German). The desire to paint Denmark and Sweden, both of which remained trading partners with Norway during the occupation, as colonial oppressors underscored the determination of Nazi ideologues, even when they spoke of a Nordic brotherhood, to make Germany the center of the New Order and of all future political and cultural allegiances.[59]

According to the Nazi-controlled press, the German occupation had also saved Norway from the threat of Marxism. The presence of Norwegian volunteers fighting alongside German forces on the Russian front since 1941 prompted cheers from National Socialist writers. Although they admitted the numbers were small, reporters nonetheless attributed great "symbolic and moral" significance to these fighters, because their willingness to join "demonstrates solidarity with Germany and Europe's struggle." Moreover, the direct encounter with Russian Bolshevism was expected to convince Norwegians that the Soviet Union, not Germany, was their true foe, and that England had been ready to deliver them into their enemy's hands.[60]

But the claims of liberation from political evils went even further than this. According to the National Socialist press, Norway's reorientation southward also encompassed a realignment with authoritarianism and the "Führer principle." This was portrayed as a development toward responsibility and away from "aping British parliamentarism." In March 1942, a month after Terboven appointed Quisling minister president of Norway, an article published in the Ludwigshafen-based *NSZ-Westmark* (Western March National Socialist Newspaper) asserted

that Quisling's regime had come to power "completely legitimately" and enjoyed a "concentration of power" unknown by any predecessor. Readers were assured that this power was put to "good use" addressing the nation's current problems and preparing its place in the Greater European community.[61]

In reality, Quisling remained subordinate to Terboven throughout the occupation. Norwegians detested him and reviled his supposed "good" works, such as his failed attempts to Nazify Norway's churches and schools. Terboven hardly had a better opinion of Quisling and would have liked to remove him. But Quisling had Hitler's backing and was able to remain in power until Norway's liberation in May 1945. Quisling was well known to Norwegians before the invasion, having served as Norway's minister of defense in the early 1930s. In 1933, he became *Fører* (leader) of the Nasjonal Samling, which modeled itself on European fascist parties but had little electoral success in Norway. As the invasion was in progress on April 9, 1940, Quisling attempted a coup d'état over the radio, proclaiming himself prime minister and ordering Norwegians to end mobilization against the Germans, thus becoming known as the nation's archtraitor. When Hitler realized how little support Quisling had among the Norwegian people, he installed Terboven as governor. Quisling served as the head of a puppet cabinet appointed by Terboven in September 1940 and, in February 1942, was named minister president. Quisling proved a useful and willing ally, even publicly sanctioning the unpopular deportation of the small community of Norwegian Jews in late 1942 and early 1943.[62] To German readers who knew little about the actual political situation in Norway, Quisling could be presented as proof of other countries' willingness to follow in Germany's path, and of the great Germanic awakening happening across Europe.

An article that appeared in February 1942 in *Thorner Freiheit* (Thorn Freedom), a National Socialist daily published in the occupied Polish city of Toruń (German name: Thorn), hailed the positive relations between Norway and Germany's leaders. Quisling was then in Berlin to meet with Hitler on his first official visit as the new minister president. Despite the sometimes unprepossessing impression Quisling made— Goebbels was distinctly underwhelmed after meeting him—the article began by describing the Norwegian leader as physically embodying "the best strengths of his northern homeland. Tall, broad-shouldered, and powerful, Vidkun Quisling towers over his surroundings. Beneath

the straight blond hair, brushed slightly across the broad forehead, there is clarity and determination in the receptive face, whose light blond eyebrows and blue eyes underscore the impression of openness." At a press conference in Berlin, Quisling, asked by an Italian reporter about the Berlin-Rome axis, replied that "as soon as Norway regained her full freedom and independence, the axis could be extended as far as Oslo and much farther north, and that Norway was also prepared to join the pact with Germany, Italy and Japan." These words, as well as any hint of resentment about the occupation, were omitted from the *Thorner Freiheit* article, which quoted Quisling as fully committed to the New Order in Europe: "Norway, too, wants to make its fraternal contribution to the coming together of Germanic racially related states for the good of Europe." It also quoted him as stating (in "effortless German") that although Norway welcomed good relations with its Scandinavian neighbors, it wished to work directly with Germany. Readers were thus left with the impression of a frictionless "Nordic collaboration," with Germany as its accepted center.[63]

Less than eighteen months earlier, Bruno Roemisch, sitting in the National Theater in Oslo, had reassured his readers that Norwegians had already forgotten about the hay and snoring soldiers; now these stories about Quisling in Berlin tried to convince German readers of another turning point, when enemies transformed into allies. As noted by a writer for the *Westfälische Landeszeitung—Rote Erde* (Westphalian State Gazette—Red Earth), a Nazi Party newspaper published in Dortmund, Quisling's warm reception was widely reported by Berlin correspondents of the Norwegian press. Even the most "pigheaded" Norwegians, he claimed, could no longer doubt who was in charge or what path the country would follow going forward. Although the National Socialist revolution in Norway would take years to complete, the state visit represented a decisive breakthrough, "the full import" of which some Norwegians would realize only in a time to come.[64]

This was not, of course, the first time a Nazi newspaper had declared a milestone in Norway's conversion to the New Order following the invasion. Indeed, the thousands of articles about Norway published in the German-language press in occupied Europe represent a vast mapping project tracking, turn by turn, Norwegians' reorientation toward Hitler's Germany—while largely ignoring the sticking points and resistance. Through these press efforts to illustrate Norway's progress, the far north grew less alien and less distant as German journalists and

readers reenvisioned it as an approachable and even familiar place. Reports on the policies being implemented in Norway, such as the closure of family planning clinics or the creation of a mandatory labor service, allowed Germans to see the realignment process happening in real time. Concurrently, the North emerged as a place of spiritual return for Germans, a homeland that already and always belonged to them. Taken as a whole, this literature helped to construct the space of a new racial imagination: a Nordic brotherhood that stretched from blood cells to the sweeping geography of empire.

Despite this impression of geopolitical and racial harmony created by the press, when the German occupiers turned to physically constructing the promised empire of Nordic brothers, their efforts exposed deep ambiguities and contradictions in relation to their officially stated beliefs and intentions. Although some infrastructural and architectural projects did strive to eradicate distance—to knit Norwegians and Germans closer together—others created spaces of segregation and hierarchy. Viewed in their entirety, these projects also demonstrate the immense effort and resources required to "coordinate" the North, in terms of both winning over its peoples and transforming its cities and landscapes. Despite the stories printed by the Nazi-controlled press, building the New Order in Norway was anything but seamless.

2 Norway in the New Order
Infrastructure Building from Superhighways to Superbabies

The summer before Germany invaded Norway, "a tall, blue-eyed Teuton" and his wife set out to drive from Cologne, where they lived, to the North Cape, at the northern tip of the Norwegian mainland. A German engineer and explorer, Vitalis Pantenburg wrote extensively about Europe's northern fringes and, particularly, about the Arctic, a part of the globe with which he was obsessed and on which he was considered a leading expert. In a seven-part series published in early 1941 in Cologne's leading newspaper, the *Kölnische Zeitung*, Pantenburg described the Norwegian landscapes through which they passed as well as their natural resources, history, and people. At the center of his story was the road, which served not only as a facilitator of travel but also as a definer of civilizations.[1]

Along the roads, the author saw beauty, danger, and missed opportunities. The beauty emanated from abundant waterfalls, blue-black fjords, ancient forests, pink skies, and traditional timber architecture. The danger lurked mostly in the mountain roads' steep drops and hairpin turns, but also, on occasion, in political resentments, such as those that surfaced in Bergen when the couple stopped at a hotel and vandals smashed their car. The missed opportunities, by contrast, were everywhere. Pantenburg perceived these especially in northern Norway, where half-built roads and railways isolated the population and hindered the development of natural resources, tourism, and more intensive settlement. The couple's main route—Riksvei 50, a nearly three-thousand-kilometer highway connecting southern and northern Norway (Oslo-Trondheim-Kirkenes)—also proved a disappointment.

Despite years of effort, by 1939 the Norwegian government had yet to complete it. The rudimentary and dangerous conditions in the north-land prompted a warning to German readers that this was "no ideal highway in our sense of the word." Indeed, in the first of the published articles, Pantenburg described his trip from Germany to the Arctic as a voyage in infrastructural and cultural devolution, with the advanced civilizations of industry and concrete highways in the south giving way, over thousands of kilometers, to the dirt paths of nomadic reindeer herders in the far north.[2]

For Pantenburg, who, unbeknownst to readers, was also a Nazi spy, the solution was not a little more paving here and there.[3] Rather, he advocated "vigorously taking charge" of infrastructure development in northern Norway in order to bring the region into the modern era. By the time his travelogue was published, some sixteen months after his road trip, his countrymen had already begun this monumental task, but on a broader scale than even Pantenburg had imagined. A military intelligence map of major building sites in Norway in 1942 and 1943, drawn up by the exiled Norwegian Armed Forces in London, reveals a country transformed—from top to bottom—into a vast construction zone.[4] Over the course of the occupation, Germans built military defenses and installations, roads, bridges, tunnels, railroads, airfields, docks, power stations, and facilities for commercial and industrial uses. The astronomical cost of these projects made Norway the only occupied country in Europe where Germany invested more resources than it withdrew.[5]

Today, the most conspicuous of the Nazis' infrastructure projects in Norway are found along its long coastline, in the remnants of the fortifications and heavy artillery batteries that made up the northern boundary of the Atlantic Wall (fig. 2.1 and see plate 2). Hitler ordered construction of this extensive system of defenses, which stretched five thousand kilometers from Kirkenes to the Pyrenees, in 1942 to protect against a feared Allied invasion from the sea. Hundreds of thousands of men labored on the structures, which consumed vast amounts of steel and concrete. Within two years, more than fifteen thousand bunkers manned by thousands of German soldiers were in place. Nazi propagandists vaunted the impregnability of this fortification program. And yet when the invasion did arrive on D-Day, June 6, 1944, on the beaches of Normandy in France, Allied troops breached the Atlantic Wall within hours.[6] In the massive reinforced concrete structures left

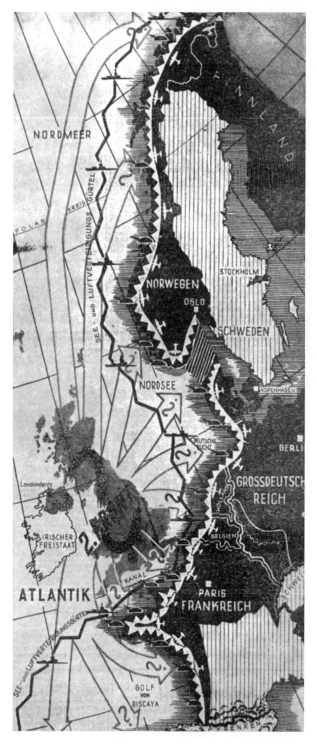

2.1. Map of the "impregnable" Atlantic Wall published in the *Deutsche Zeitung in Norwegen* in September 1942.

behind, many too solidly built to be demolished after the war, Hitler inadvertently realized his desire to create future architectural ruins that would far outlast his empire—even if he had imagined that these would be vine-covered art museums and victory monuments, not rotting bunkers and fortifications.[7]

Hitler entrusted the building of the Atlantic Wall to the Organisation Todt (OT), a semimilitarized group of engineers indispensable to Hitler's war and occupation efforts. Referred to in Allied intelligence reports as "Germany's second army," the OT controlled 1.5 million workers across occupied Europe, from Norway to the Balkans, France to Russia, at its peak in 1944.[8] By that time, the majority of laborers were not German, as had been the case before the war, but instead people from occupied countries, many of whom had been coerced into service. Additionally, prisoners of war (the bulk from the Soviet Union) were forced into heavy labor on OT projects. Thousands died from starvation and disease or at the hands of sadistic guards.[9]

Inhuman methods and treatment advanced the Nazis' construction projects on an unprecedented scale. In the reluctantly admiring words of a 1945 British intelligence report, the organization "carried out in the space of a little over five years, the most impressive building programme since Roman times."[10] Fritz Todt, a civil engineer and administrator whom Hitler had named inspector general of German roadways in 1933, led the organization, which coalesced in 1938 as priorities shifted from building the autobahn to constructing the West Wall (or Siegfried Line, as the Allies called it), a network of defensive structures along Germany's western border. With the outbreak of war, "the OT assumed a more exclusively military character."[11] In March 1940, Todt was appointed Reich minister of armaments and munitions, giving him substantial control over the war economy.

Todt, a committed National Socialist who joined the Nazi Party in 1922, believed that technology and engineering drove cultural and racial evolution. In 1936 he opened a school at the Plassenburg, a castle in Bavaria, to educate engineers and technicians about the artistic, racial, and political dimensions of their work. Those selected for training took courses on National Socialist ideology, performed calisthenics, and listened to classical music. They were taught that engineers did not solve technical problems; rather, they resolved social questions. They did so through technology, which had its own beauty complementing that of nature and culture.[12] In his travelogue Pantenburg similarly portrayed

the engineer as an adventurous figure who was attentive to beauty and confident in his ability and prerogative to improve the world around him. When in 1942 the Organisation Todt established itself in Norway and Denmark, the name it gave the subordinate division—the Viking Taskforce—made clear that engineers would be the world's new conquerors.

If the most conspicuous of the Nazi infrastructure projects in Norway served immediate defensive aims, those projects intended to shape the nation's long-term destiny as part of the Greater German Reich—the engineering of civilization that so interested Todt—are today harder to see. They include the gleaming highways that Pantenburg craved but also modern telecommunications, fish-processing plants, aluminum smelters and refineries, and much more—an entire network of public works as well as commercial and industrial facilities deemed necessary to bring Norway into the expanded economic and political zone envisioned in Hitler's reordering of Europe. Many of these projects, begun or completed under the Germans, remain in use today, hidden in plain sight. A road or bridge does not declare itself "Nazi built" in the same manner as a gigantic gun emplacement. During the occupation, however, such infrastructure projects were highly visible and celebrated in the Nazi-controlled media in Germany and Norway.

Road building in particular emerged as a favorite theme, allowing writers to laud both the triumph of the German will and Norwegian-German cooperation. The November 1940 cover of *Deutsche Monatshefte in Norwegen*, the Reich Commissariat's newly launched magazine, illustrated the process of bringing Norway into the Greater German Reich through expanded transportation networks, with all paths leading to Berlin, the hub of the new empire (fig. 2.2). The accompanying article, "Now You Can Drive to the North," penned by Dr. Leschke, transport head for the Reich Commissariat, seemed to relish the Herculean task of carving out roads from a wild and dangerous landscape. Leschke emphasized the vastness of the terrain to be subdued and enclosed: "Norway is nearly 2,000 kilometers long, with a population density of just 8 inhabitants per square kilometer—in comparison to 135 in Germany—and torn apart by fjords on the coast and by mountains inland." If Norway were folded southward, he noted, its length would stretch almost to Gibraltar. Add to this a harsh climate that in winter buried roads in the north under snowdrifts, and readers could begin to grasp the enormity of the challenge at hand.[13]

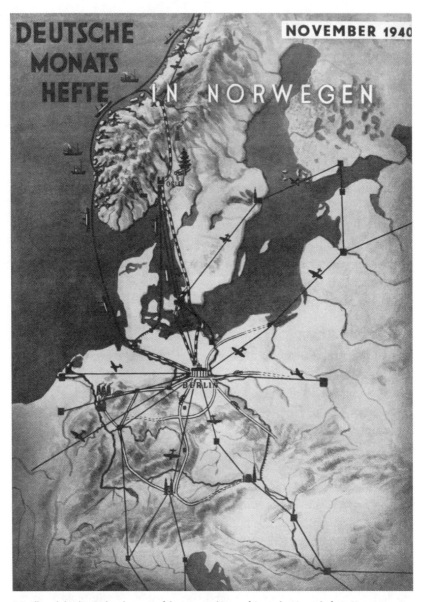

DEUTSCHE
MONATS
HEFTE

NOVEMBER 1940

IN NORWEGEN

OSLO

BERLIN

2.2. All roads lead to Berlin: the cover of the inaugural issue of *Deutsche Monatshefte in Norwegen*, published in November 1940.

Given these obstacles, why build roads? Leschke admitted that Norway had natural waterways and harbors to serve settlements along its coastlines. But even there, he expected the motorcar on coastal roads to replace the ship because sea travel was too slow.[14] This equating of progress with mobility and speed had permeated European colonial

infrastructure projects of the nineteenth and twentieth centuries.[15] Indeed, Nazi journalists such as Pantenburg described northern Norway as a colony of the more industrially advanced southern Norway.[16] For Leschke and other German officials, the development of roads served not only to foster economic productivity and political integration but also to synchronize Norway with the dynamic tempo of the Third Reich—an empire united by mind-set and rhythm as much as by geography.[17] In 1934, Hitler himself had called the car "the most modern means of transport."[18]

As Leschke acknowledged, the Norwegians had long planned to expand and improve their roads. In 1926, the Norwegian Ministry of Transport had prepared a one-billion-kroner plan for new state roads with two principal goals in mind: the completion of a road between Trondheim and Kirkenes, and the connection of networks of existing roads between Oslo and the west coast. But the Norwegians had been unable to complete the plan—defeated, Leschke claimed, by the mountainous landscapes and the unwillingness or inability of successive Norwegian governments to commit the necessary resources. As a result, road construction had not kept up with traffic demands, and drivers had to cope with dangerous curves, narrow roads, unsafe bridges, lack of paving, and gaps in the thoroughfares. Then came "a turning point" in 1940, with the arrival of the Germans.[19]

Leschke credited Reich Commissar Terboven's recognition of the critical importance of transportation to Norway's economic growth for providing the necessary push to complete the work. He made the occupiers' interest in road building appear altruistic by omitting any mention of their intent to divert future wealth and resources southward to Germany. Leschke also suggested that the Germans possessed the will to take on the monumental task of road construction that Norwegian politicians in the interwar years had lacked (fig. 2.3). Strong commitment from the German side, including the deployment of German troops and engineers, encouraged the Norwegians to invest their own resources, and the outcome of this "good" Norwegian-German cooperation was the rapid completion of projects that had languished for decades.[20] In short, Leschke portrayed the development of roads as the harbinger of a new kind of modernity in Norway characterized by political determination, engineering prowess, economic growth, and racial brotherhood.

Despite his self-serving account, Leschke was not wrong about the

2.3. View of a mountainside road in the Reich Commissariat's photographic collection, illustrating the challenges of road building along Norway's fjords.

occupiers' determination to advance road building in Norway, especially in the north. At the time of the invasion, Norway possessed a forty-two-thousand-kilometer network of roads, but gaps remained along major north-south and east-west arteries. The Norwegian Roads Administration, under the supervision of the Reich Commissariat, upgraded this network. This included extending sections of Riksvei 50, which Pantenburg had traveled in 1939, to create a nearly continuous overland connection, with the exception of ten ferry passages, between Trondheim and Kirkenes. In the spring and summer of 1940, these road-improvement schemes in Norway involved the employment of thirty-one thousand men and cost eighty million kroner.[21]

An article published in the *Danziger Vorposten* (the Nazi Party newspaper in Danzig) in September 1940 celebrated the imminent completion of Riksvei 50 to Kirkenes. The text, based on remarks made by Terboven at a reception for German journalists, foregrounded the role played by Wehrmacht engineers and soldiers in the project's realization. It failed to mention—as, presumably, did Terboven—how much the Norwegians had accomplished before the invasion, even if gaps remained and some sections were open only in summer. The article boasted that, in short order, there would be "for the first time in the history of Norway a land bridge to the northernmost part of Europe."

This corralling of the distant north was projected to bring economic development to the region, which had hitherto been limited by its dependence on slow-moving sea traffic. In fact, and despite the altruistic portrayal, the completion of Riksvei 50 was driven foremost by the desire for a year-round supply route to the German armed forces in the Arctic.[22]

The creation of a land bridge to the far north, even if propelled by military needs, fueled dreams of tourist revenues and experiences that would follow in the wake of the new infrastructure when peace returned. In his 1941 travelogue, Pantenburg blamed poor roads and a lack of facilities for the dismal state of leisure travel in northern Norway. Prior to the war, tourism represented an important industry for Norway. In 1939, the country earned seventy-two million kroner from tourists, just behind income earned from the export of fish (eighty-six million) and paper (eighty million).[23] But for Pantenburg and other Nazi ideologues, tourism was also important for another reason: it allowed Germans to familiarize themselves with the landscapes of their expanded empire. Norway had long been an important destination for wealthy German tourists. During the 1930s, Kraft durch Freude (Strength through Joy), the Nazi leisure and tourism organization, advertised inexpensive cruises of the Norwegian fjords to German workers using a slogan that played on the earlier trips and privilege of Wilhelm II: "We are all emperors now" (see plate 3).[24] A 1942 article about the official Norwegian Travel Agency in Berlin predicted that demand for travel to Norway would be greater than ever after Germany won the war, because the occupation had "acquainted thousands of Germans [that is, soldiers] with Norway's scenic attractions."[25]

While the war continued, however, the tourism industry in Norway suffered. Severe restrictions on fuel and on the private use of transportation affected automobile, train, and bus travel. Just how dire transportation conditions in Norway became is evident not only in the bans themselves but also in the propaganda surrounding them. In 1943, for example, personal travel on trains was restricted to a distance of no more than thirty kilometers. An article about the new regulation warned Norwegians that resisting such decrees weakened the war effort against "the danger from the east" and led to the shedding of even more of "the best German and Norwegian blood": the consequence of joyriding, in other words, was racial annihilation.[26] Although the thirty-kilometer rule resulted from the worsening economic conditions

following the turn to total war in 1943, transportation prohibitions had been instituted soon after the invasion and were widespread. When Hans Stephan, Albert Speer's representative, came to Norway in the summer of 1941 to discuss the reconstruction of war-damaged cities, he was outraged to discover that even he was refused a car for his travel, having instead to make do with trains.[27]

Nonetheless, agencies and writers continued to promote the idea of travel to Norway to German audiences. In its office on Unter den Linden, Berlin's grand boulevard, the Norwegian Travel Agency handed out brochures designed to whet Berliners' appetites for travel to northern parts of the empire.[28] German soldiers and war correspondents in Norway, standing in as tourists, wrote travel narratives for German newspapers and magazines describing a country of rustic towns and wildly romantic landscapes.[29] Public lectures on Norway became popular, with Pantenburg himself recounting his Norwegian adventures to eager audiences, complete with color slides that vividly re-created his journey on the road.[30]

Historians have emphasized the important role played by this type of virtual consumption in Nazi Germany, which allowed people to consume, if only in fantasy, a product or experience promised to them imminently, in a utopia "just around the corner."[31] The dream of mass motoring and tourism, already emerging in the twenties, intensified as Hitler declared his intention to build autobahns (superhighways) and manufacture a people's car, the Volkswagen, which would allow all Germans, even workers, to explore their country in joyful leisure. Propaganda represented these aspirations as something that went beyond individual pleasure to encompass a collective racial good. Knitted together by cars and highways, the population would draw closer together, strengthening the *Volksgemeinschaft*, or people's community. Hundreds of thousands of Germans opened saving accounts to purchase the new cars, even though none received one during the Third Reich.[32]

Following the invasion of Norway, Hitler expanded northward his vision of the integrative power of cars. He ordered the creation of a superhighway in Norway that would stretch from Trondheim through Oslo to Halden, on the border with Sweden. Eventually, the autobahn would be continued southward through Sweden and Denmark to connect with the German autobahn at Fehmarn, an island near Lübeck. The Norwegian autobahn would thus form "the northernmost segment

of a great Germanic north-south road," which, according to Hitler, would reach from Trondheim to Klagenfurt in the south of Austria.[33]

Todt, who had overseen the building of the autobahn in Germany, was put in charge of the Norwegian project. In September 1940, he convened a small group of engineers, organized as a unit (the Autobahn Group) within the Reich Commissariat Engineering and Transport Department in Oslo, to begin the planning. The group's members came from construction management offices for the autobahns in Germany and Austria. Although the group stated their intention to collaborate with Norwegian road construction authorities on the highway project, they kept the initial planning phase firmly in their own hands. Todt's engineers clearly harbored mistrust of their Norwegian counterparts, who they feared would focus excessively on the economical and functional aspects of the superhighway, to the detriment of Todt's imperative to design artistically, in a manner that captured the beauty of the Norwegian landscape. In order, however, to lay the groundwork for future collaboration on the Norwegian autobahn, Todt invited thirty Norwegian engineers to train for five months, over the winter and spring of 1941, in German and Austrian autobahn offices. Despite this outreach to his Norwegian colleagues, all final decisions on the design of the autobahn would still rest with Todt.[34]

In March 1941, the Autobahn Group submitted a preliminary proposal for the Norwegian superhighway to Todt for approval. The lead engineer, Dr. Walter Heide, wrote in his accompanying report that "Reich Minister Todt was very keen to exploit the scenic beauty of Norway through the autobahn." The "Great Road of the North," as Heide referred to it, was expected to draw "a mighty stream of tourists" to Norway, who would thereby gain access to "the truly impressive experience of the Norwegian landscape." In Heide's account, these lucky visitors would follow in the wake of the pioneering engineers, who faced many hurdles in laying out the great road. In some of the more remote places, engineers had had to rely on maps that were imprecise and, in some cases, based on century-old information. The site inspections they conducted had been risky and difficult: a serious car accident involving two of the group's members delayed plans, and with the arrival of winter some of their work had to be carried out on skis. Although arduous, this form of transportation had an advantage: as Heide noted, it helped them discover beautiful skiing areas in the vicinity of the proposed highway.[35]

The group's engineers had considered various possible routes for the four-lane autobahn connecting Trondheim, Oslo, and Halden. Heide described the technical difficulties associated with each option, including heavy snowdrifts and steep rock cliffs, as well as the scenic advantages each offered, such as glorious views of lakes and sun-drenched valleys. In some cases, these scenic possibilities took precedence over the ease of construction. Heide also proposed places for rest stops and even hotels along the highway, and he speculated that such facilities would encourage the development of new tourist areas, with hiking, water sports, and other attractions. The style of these buildings, Heide wrote, should harmonize with the landscape and regional architectural traditions.[36]

The emphasis on the beauty of the Norwegian superhighway is not surprising. In designing the German autobahn, Todt had also emphasized its aesthetic potential (see plate 4). He believed that roads should be raised to the level of works of art, and he encouraged German engineers to channel their creative power as artists. The regime's propagandists likened the superhighways to world wonders, such as the Acropolis in Athens and the pharaohs' pyramids—eternal monuments admired for both their beauty and their technical ingenuity.[37] With Hitler's enthusiastic input, Todt designed one of the most scenic segments of the autobahn: the route from Munich to Salzburg. Hitler frequently traveled this stretch of highway when he visited his country house on the Obersalzberg in the German Alps. In laying out the route, Todt maximized panoramic views of lakes and mountains. He also insisted that his landscape architects avoid plantings that interfered with the fast-moving gaze of the driver. Indeed, so important was this scenic experience that even safety took a back seat: dangerous conditions would be tolerated in exchange for beautiful views. The "visual consumption" of these carefully staged landscapes took priority over the strict functionality of getting from one place to another.[38]

Echoing Todt's belief that technology complemented nature, Nazi propaganda about the German autobahn asserted that the roads made accessible, without damaging, indigenous environments. In reality, the "German" landscapes that the autobahn presented to drivers were highly constructed by Todt and his collaborators according to their own ideas of native beauty. Designers sought a balance of definitive German landscape features, such as a forest, valley, and meadow, which were to be experienced as "a natural landscape unit." The surrounding

habitat torn up to construct the highway was carefully replanted. For Alwin Seifert, the autobahn's chief landscape architect, this presented an opportunity to improve the condition of the surrounding environs by making them more "authentically" German through the introduction of native (versus foreign) species. Todt shared a nationalistic view of the autobahn, but clashed with Seifert over the cost of applying a strict "German-to-the-core" approach to its landscape design.[39]

The nationalistic ideology driving the German autobahn produced a different approach to highway building in occupied countries. At a speech Todt gave to his autobahn architects at Plassenburg Castle in August 1940, he stated that he had no intention to "make a big effort" to salvage Poland's "remnants of landscape beauty." The autobahn there would have instead a more militaristic style. In Belgium, too, a functional approach would dominate the design of the new autobahn, which would proceed from Germany to the channel coast "in a relatively straightforward course."[40] The aesthetic highway, with its exciting curves and natural panoramas, was reserved for Germany and Austria, and conquered countries did not deserve the extra effort required to create infrastructure-as-artwork. Yet there was a notable exception. That Norway was considered worthy of a German-style autobahn, with its costly attention to beauty, reflects its special status as a Nordic country, underpinning the vision of the "Great Road of the North" as an ideological and transportation axis unifying two Germanic peoples.

The Norwegian autobahn also shared with its German predecessor a certain vagueness of purpose. A 1942 article in the right-wing German newspaper *Rheinisch-Westfälische Zeitung* (Rhine-Westphalia News) discussing Norway's infrastructure development under the occupation claimed that "everyone has accepted the need for the construction of autobahns." But it failed to explain why such superhighways were needed or what function they would fulfill, beyond making Norway's "great natural beauty" accessible to foreigners traveling by land.[41] Even the 1941 report submitted by Heide to Todt heightens curiosity about the true aims of the project. It shows that the German engineers planning the autobahn to Trondheim considered routes that would have paralleled, along long stretches, already-existing major roads.[42]

Unlike the roads built to supply and transport German armed forces in northern Norway, the autobahn was not envisioned for military purposes. Heide's report reveals that Wehrmacht commanders in Norway

were consulted about possible autobahn routes, but their involvement in the planning appears to have been minimal. In one instance, military concerns were overridden by other considerations. Heide noted that the Luftwaffe had asked that a stretch of the autobahn passing by Gardermoen, the Luftwaffe airport, be diverted eastward for reasons having to do with camouflage. This would have complicated the construction process and deprived drivers of a view of Lake Hurdal. The planners also anticipated that the airport would open to commercial traffic after a German victory, and wanted the autobahn route to provide future clientele an efficient connection between the airport and Oslo. For these reasons, the Luftwaffe's request was denied. As in Germany, in Norway the autobahn was above all a project intended for peacetime civilian use.[43]

To understand the impetus for the creation of the autobahn in Norway, we do well to briefly consider claims made by Nazi propagandists about the autobahn in Germany and the subsequent unraveling of those myths under the scrutiny of historians. Celebrated as a work-creation project, for example, the autobahn in Germany had, in fact, a negligible impact on unemployment.[44] Miserable working conditions and low pay led to strikes, and as the economy improved, workers left in droves, creating a labor shortage. In 1940 Todt received permission to use ten thousand prisoners of war; additionally, some four thousand Jewish forced laborers, mostly from Poland, were put to work on German autobahn construction sites until mid-1942.[45]

Scholars have likewise questioned the assertion that the superhighways boosted tourism. This claim assumed an access to cars that Germans did not enjoy. In 1935, there were only 16 vehicles per 1,000 people in Germany, among the lowest rates in Europe. In comparison, there were 204 vehicles per 1,000 people in the United States.[46] The autobahn segments that were completed in Germany were mostly empty. The national railway company had exclusive rights to operate bus routes on the autobahn and encouraged group excursions for those who could not afford a car. But travel by bus was sometimes longer and more expensive than by train, and the success of such routes was mixed. Even with the opening of the spectacular Munich-Salzburg segment, evidence that the autobahn increased overnight tourism in the region is hard to find.[47]

Nazi publicists further claimed that the autobahn, which was reserved for the exclusive use of motor vehicles, made driving safer. Driv-

ers did not have to worry about navigating intersections, train crossings, pedestrians, bicycles, or horse-drawn carts. Good engineering design—such as the roadways' gentle curves, generous lanes, even surfaces, and broad median strips that separated opposing traffic—was supposed to prevent accidents. Beautiful plantings and scenic views would keep the motorist engaged and alert, avoiding the dangers of boredom and fatigue. Confident and secure, drivers could thus relax and enjoy the pleasures of driving. But this propaganda glossed over the serious hazards. The autobahn, which initially did not have a speed limit, produced an alarmingly high toll of traffic fatalities. Hitler angrily blamed the deaths on speeders, whom he branded "enemies of the people."[48]

Dismissing the false or misleading claims made about the German autobahn, historians contend that the superhighways' main value was propagandistic: the roads symbolized the regime's dynamic modernity and its ability to get the nation working and moving after the Great Depression. When construction began on the autobahn's first section, from Frankfurt to Darmstadt, in September 1933, Hitler was photographed at the ground-breaking ceremony sweating and shoveling dirt—the dictator as the nation's chief worker. Other such publicity stunts followed, and over the years propaganda celebrating the autobahn took many different forms, appearing in magazines, radio, movies, novels, paintings, music, and even board games. As propaganda, there is no question that the autobahns were an enormous success—so much so that even after the war, "Hitler's highways" were remembered by many Germans "as one of the regime's positive accomplishments."[49]

Having seduced Germans with his dreams of magnificent infrastructure, Hitler attempted to repeat this political feat in Norway. Nazi propagandists, writing in the Norwegian press, used the Norwegian autobahn to promote a positive message about an unpopular occupation. An October 1940 article about the planned superhighway published in *Fritt Folk*, the Norwegian fascist party's newspaper, touted its economic advantages, including the projected employment of twenty thousand men; this, despite the fact that the Wehrmacht's massive building schemes had created a shortage of construction workers in Norway—a problem the autobahn would only have worsened. The writer also hailed the autobahn as the "El Dorado of all motor enthusiasts," a magical ribbon of space that made driving fast and fun, and that reshaped the geography of Europe, putting Trondheim next door to Constantinople.[50]

This glowing tone was not limited to party hacks. An article by Norwegian engineer Otto Kahrs, published in November 1940 in Norway's *Teknisk Ukeblad* (Technical Weekly), repeated many of the claims made for the German autobahn by Nazi propagandists. Kahrs argued that the planned superhighway in Norway would reduce unemployment, boost tourism, and make driving safer, more efficient, and cheaper. He marveled that the driving time between Oslo and Trondheim would be reduced by at least half, to five hours. (Kahrs seemed unperturbed that this savings in travel time would come at an astronomical financial cost: as he noted in the article, the projected expense of constructing the autobahn was six hundred to eight hundred million kroner.) By learning German methods, moreover, Norwegian engineers would broaden their horizons and build technically better and more aesthetically pleasing roads in the future.[51] The message and enthusiasm voiced by Kahrs demonstrates how the occupiers hoped to use the autobahn to symbolically and literally build a path to Norwegians, winning over the hearts of the conquered.

Yet the autobahn in Norway was about more than seducing Norwegians. We must also consider its function in the context of a car-centric Greater German Reich—an empire that Hitler, an avid motorist, imagined could be experienced from the wheel of a car. A September 1940 German newspaper article about the new transportation infrastructure under construction in Europe predicted a network of highways spreading in all directions.[52] In the following years, the Generalplan Ost, or General Plan East—the Nazis' master plan for the resettlement of Central and Eastern Europe—put autobahns at the heart of colonization and the "Europeanization" of the Asiatic steppe. It foresaw the influx of millions of Germans into the annexed areas of Poland and the western Soviet Union, which were to be emptied of their Slavic and Baltic peoples through genocide and ethnic cleansing. As Hitler explained to Todt in October 1941, the autobahns would stretch eastward into these new territories as far as the Caucasus. Along the superhighways, new German cities would be laid out (in Hitler's words) like "a string of pearls." Importantly, the autobahns would avoid former Soviet cities (that is, the ones that would not be destroyed outright), leaving them to "vegetate in their filth." Not only would these decaying places be kept far from the German highways and cities; Germans would also be forbidden to enter them, Hitler informed Todt.[53] Such routes were thus conceived as tethers connecting the emerging peripheries to Berlin, the empire's

capital, while also creating new hinterlands associated with the racially unacceptable.

Hitler believed that the experience of driving through new territories would forge a strong sense of identification for the German civilians following in the Wehrmacht's wake. A month earlier, in another conversation with Todt that took place at the Wolf's Lair (the Führer's East Prussia headquarters) on September 19, 1941—the day the Germans took Kiev—Hitler articulated the role that the autobahns to Norway, Crimea, and other parts of the empire would play after the war. He stated that "after the war, *deutsche Volksgenosse* (German fellow countrymen) with their Volkswagens must be given the opportunity to see the conquered territories for themselves, for then they will be ready to potentially fight for them." Driving, Hitler continued, would make of everyman a colonialist. And in this sense, the autobahn's role would differ from that of any other form of transportation: "only by driving on the road do you get to know a country. The railway bridges spaces, but the road opens them up."[54]

Hitler was not the first to imagine a supernetwork of highways across Europe. At the first International Road Congress, held in 1931 in Geneva, delegates proposed a pan-European network encompassing fourteen thousand kilometers of highways. Italian engineer Piero Puricelli, who constructed Europe's first motorway (an *autostrada* near Milan) in the 1920s, authored the plan. The vision articulated at Geneva, of independent nations cooperating to build infrastructure together, was radically different from Hitler's idea of infrastructure as empire building. For Nazi ideologues, a continental network of expressways was about much more than binding geography. Specifically, the highways helped Germans "to think in large spaces again"—that is, to conceptualize the *Grossraum* (a unified continental bloc) at the core of Hitler's vision of an expanded spatial sphere of German influence. The autobahns were thus tools as much of imagination and indoctrination as of transportation.[55]

Within this web of superhighways, the "Great Road of the North" was envisioned as a means to unify Nordic peoples (in this case, Germans and Scandinavians) once separated by geography. Additionally, a significant—and perhaps decisive—reason for building the autobahn in Norway was to connect Germans in the old Reich with those in the new. In July 1940, Hitler ordered the creation of a new German city near Trondheim.[56] The autobahn would have connected this northern

German settlement to Oslo and thence to Germany. More than just a physical corridor, the road represented a symbolic lifeline between the Germans who resettled near Trondheim and their brethren in the mother country. When Todt visited Hitler at the Wolf's Lair on that September day in 1941, planning for the superhighway had just entered its second year. Discussing plans for Trondheim, Hitler seemed impatient for tangible progress. His words impressed upon his chief engineer the autobahn's critical necessity.[57] Because the development of a new German city in Norway was a secret project, this rationale for the autobahn was never made public.

Finally, we must consider the pursuit of an autobahn in Norway from the perspective of the desire to assert control over nature and to display the engineer's mastery, which had characterized the construction of the autobahn in Germany. The comparison of Hitler's works to the Acropolis and Egyptian pyramids, although ludicrous, emphasized the superhighways as tremendous technical feats—a view that persisted after the war. In Norway, the even greater challenges posed by its difficult terrain would have made the propaganda rewards of successfully completing this megaproject all that much sweeter. Building the "Great Road of the North" would have glorified the occupiers' power to subdue an alien space and to make it their own.

For in their taming and appropriating of Norway's geography, it was German engineers who decided on what constituted the "typical" character of Norwegian landscapes. Although German articles presented the autobahn as "opening up" or making accessible Norway's natural beauty, the reality was that the experiencing of this beauty would have been highly constructed, just as it had been in the designing of the autobahn in Germany. In crafting panoramas Todt's engineers chose routes according to their views of a wild and picturesque Norway: they framed expansive views of mountains, valleys, lakes, and other natural scenery for the delectation of the imagined automobile driver speeding through space. A rare mention in Heide's report of the inclusion of an urban landscape—views of Oslo along a stretch of the highway following the shore of the Oslo Fjord—framed it from a distance, as a scenic object in nature.[58] By using the autobahn like a brush to paint the Norwegian landscapes they wanted to see, Todt and his engineers made them their own. German tourists arriving in the future from the old Reich—the primary group of users envisioned in German newspaper accounts for this project—would re-create, through their experiences of

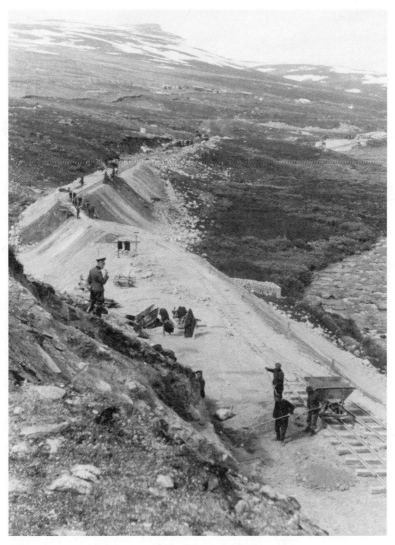

2.4. A polar railway construction site in Saltfjellet, a bleak mountain plateau in northern Norway crossed by the Arctic Circle. A Nazi officer, smoking a pipe, looks on as prisoners of war work. The elevation of the track was designed to protect the train from snowdrifts. This undated photograph (along with 2.5) was taken by the Organisation Todt for internal use only, not for publication.

driving, the engineer's visual mastery and appropriation of the northernmost lands of Hitler's empire.[59]

The desire to shape a new political geography may have driven another of Hitler's major infrastructure projects in Norway: the construction of a polar railroad (figs. 2.4 and 2.5). The Führer's obsession with

2.5. Clearing snow from a polar railway construction site in Saltfjellet at the end of June 1944.

building a railroad from Mo i Rana to Kirkenes, a route of twelve hundred kilometers through fjords, mountains, and tundra, frustrated his advisers and later perplexed historians. Hitler believed that the railroad demonstrated his strategic genius and would solve two problems at once: the transport and supply of troops on the Murmansk front, and the protection of shipments to Germany of iron ore and nickel (originating in Sweden and Finland, respectively) from Allied naval attack along the Norwegian coast. Yet the strategic value of the project was doubtful from the beginning. Despite Hitler's absurd belief that the railroad could be completed in eighteen months, its construction would have taken many years, well beyond the Germans' projection of the end of the war. From an economic vantage point, moreover, it made little sense to transport by rail a material as heavy as iron ore, which would have dramatically raised the cost for steel producers in Germany.[60] More immediately, the railway's construction devoured resources, prompting economists within the Reich Commissariat to warn Terboven against the "outrageous and unacceptable" expenditures. But Terboven did not have the power to stop the railway, nor did he want to, since it quickly became one of Hitler's favorite infrastructure projects. The Führer stubbornly refused to abandon it, insisting that construction "be con-

tinued with urgency" even as German troops retreated from northern Norway in November 1944.[61]

As with the transcontinental superhighway, Hitler did not invent the idea of a railroad to the Arctic. Decades earlier, the Norwegian State Railways (NSB) had explored plans to build a northern line (Nordland Railway) as far as Kirkenes and, by 1940, had completed the track to Mosjøen, some seventy kilometers southwest of Mo i Rana. Nonetheless, Norway's railway infrastructure remained among the least developed in Europe at the time of the invasion. Nazi propagandists portrayed this situation as another instance of the weakness of the former democratic Norwegian government, which had failed to muster the resources and determination to serve its people—and the ability, by contrast, of Hitler and his engineers to get the job done (fig. 2.6). In fact, the myriad challenges of railroad construction in the rugged terrain and the resulting exorbitant costs made the sea a far better transportation option.[62]

After the German takeover of Norway, interest in developing a northern railway intensified. But it was the launch of Operation Barbarossa and the invasion of the Soviet Union in 1941 that ignited the race to build a line to Kirkenes, with first the German Armed Forces and later the Organisation Todt assuming control of the project. Beyond the sheer costs of construction, which risked disrupting the Norwegian economy, the railway's progress was impeded by the difficulty of obtaining building materials, especially steel, from Germany. The transportation space available for shipping from Germany to Norway, already filled to capacity, could not meet the demand. The problem was exacerbated by the tonnage required for the polar railroad, which placed demands on shipping greater than those of any other project in Norway. Prioritizing shipments for the railroad threatened to derail the many other construction projects under way in Norway, which were also undersupplied. To get around the problem of insufficient shipping space for Norway, Hitler suggested the creation of a fleet of small supply ships, leading to the development of mass-produced concrete ships.[63]

Hitler's own advisers recognized the impossibility and destructiveness of the Führer's polar railway fantasy and attempted to dissuade him from pursuing it. In the fall of 1941, when Hitler first proposed extending the railway to Kirkenes, Todt took an inspection flight over Finnmark, realized the project would involve building a mountain railroad, and returned to tell Hitler he would have to abandon the

2.6. This work scene, by an unknown artist, illustrated an article on railway construction in northern Norway published in February 1941 in the Wehrmacht newspaper *Wacht im Norden*. The article boasted that with the help of German railway engineers and soldiers, construction of an Arctic railroad that Norwegian engineers had estimated would take ten years to build would be completed in just two. As the German author stated, "We calculate at different scales."

idea.[64] After Albert Speer was appointed minister of armament and war production and head of the OT following Todt's death in an airplane crash in February 1942, Hitler made clear to him that the polar railway was a top priority and should be pursued "as energetically as possible." Although Speer was able to improve the shipping situation that spring and free up more tonnage to keep railway construction going, the turn to total war a year later brought new pressures. In February 1943, Hitler reluctantly agreed to give up the idea of extending the railway through the wilderness of Lapland to Kirkenes. Narvik became the new terminus, although the scale of the project still represented an immense drain on labor and resources. Speer later claimed that he had quietly slowed down the construction process "so as not to interfere with other economic priorities." As a result, he endured "constant harassment from Hitler who saw the railway from a much wider perspective than the merely economic one."[65]

Why, then, did Hitler pursue the polar railway with such monomaniacal intent? Historians have looked beyond Hitler's arguments about Norway's defense to focus on the symbolic meaning of the railway within the dictator's larger political vision. Economist Alan Milward, writing in the 1970s, argued that the railroad stood for the new Europe Hitler planned to create, and thus he fought doggedly to preserve it in spite of its strategic and economic impracticality. Milward maintained that "the railway was an artery of the new Europe which could not be abandoned."[66] Historian Ketil Gjølme Andersen has underscored that view more recently, arguing that the polar railroad expressed "the Third Reich's politics of space." Given how many years it would take to complete it, "the project only made sense in a long-term perspective: it was part of Hitler's highflying ideas of the German *Grossraum*. If the polar railroad was connected to the existing Murmansk railroad, there would be a continuous railroad connection between Oslo and St. Petersburg."[67]

At the heart of this ideological geography, which bound land to race, were laboring physical bodies. Human bodies were intricately caught up in the infrastructure systems needed for the creation of the New Order in Norway. And this entanglement was not tangential, a by-product of the scale of the infrastructure projects. Rather, human bodies were inseparable from the role infrastructure played in promoting the Nazis' goal of *Aufnordung*, the re-nordification of the genetic pool in Europe. As explored in chapter 1, justifications for the political,

economic, and cultural reordering of Europe relied on a belief in the imminent collapse and necessary defense of the Nordic race. German occupiers in Norway employed the barbaric conditions of building infrastructure in Arctic conditions to rid themselves of bodies considered harmful to *Aufnordung*, while first deriving whatever economic benefit they could from their labor. These "disposable" bodies drove infrastructure creation in Norway.

During the occupation, more than 130,000 forced laborers and prisoners of war were transported to Norway to work on German construction sites. Approximately 17,000 of them died. The majority were prisoners of war from the Soviet Union (100,000), followed by Yugoslavia and Poland.[68] In the eyes of Hitler and other Nazi leaders, some Slavic populations—above all, Russians, Serbians, and Poles—were racially inferior *Untermenschen* or subhumans. They posed a racial threat to Aryan populations because of their "Asiatic barbarity," expressed in a lack of culture, and their fecundity, overwhelming their less fertile Aryan neighbors. At the same time, their numbers and expendability made them useful as beasts of burden, carrying out the backbreaking work of the Greater German Reich.[69]

Despite the rosy predictions Terboven made in his September 1940 press conference to German journalists eager to praise the occupiers for accomplishing what the Norwegians could not, the completion of Riksvei 50 was not imminent. Indeed, the following year, the expansion of Norwegian roads stagnated as manpower declined sharply. Few Norwegians were willing to labor on road building and snow clearing in the far north, especially when they could earn more for other construction work. In November 1941, Hitler ordered the completion of Riksvei 50 from Bodø to Kirkenes by the fall of 1942.[70] The following month British commando raids on Vågsøy and the Lofoten Islands led Hitler to decree the reinforcement of Norway's coastal defenses. All the while, he refused to halt construction on the polar railroad. As the Führer's demands for these and other massive infrastructural projects mounted, tens of thousands of prisoners of war were brought to Norway, beginning in late 1941, to alleviate the labor shortage.[71]

The OT's reliance on the prisoners of war necessitated the creation of a new infrastructure in Norway: during the war, five hundred POW camps were established across Norway, most in the farthest northern counties (figs. 2.7 and 2.8). This infrastructure of camps managed the flow of "disposable" laboring bodies building the roads and railways

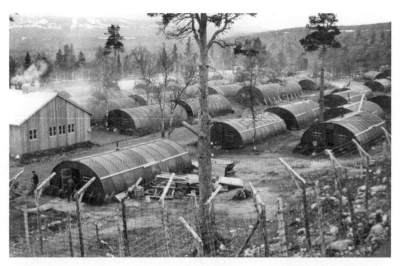
2.7. Barracks in the Lønsdal prisoner-of-war camp in Saltfjellet. Note the barbed wire fence surrounding the camp. This undated photograph was taken by the Organisation Todt for internal use only.

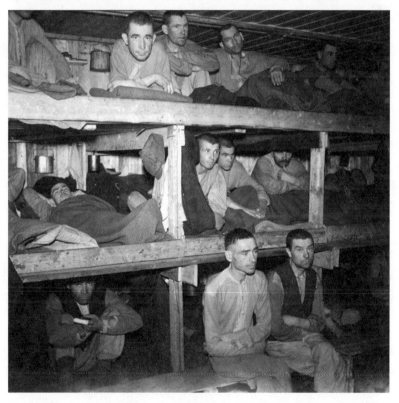
2.8. Soviet prisoners of war in their barracks in Bjørnelva camp in Saltfjellet, photographed by Leiv Kreyberg after liberation.

defining the *Grossraum*. As historian Marianne Soleim notes, the horrendous conditions and lack of food made them "virtual death camps." In the summer of 1942, some 900 Yugoslav prisoners were brought to the Beisfjord camp, outside Narvik, to work on OT road construction sites. After an apparent outbreak of typhus, many were too ill to work. On July 17, the SS—including Norwegian members of the Hird, the paramilitary force loyal to Quisling—forced anyone they considered to be sick to dig their own graves, and they then shot them. Prisoners who had been unable to stand were left in the barracks where they were burned alive when the buildings were set on fire. A total of 287 men were executed, and the incident became known as the Beisfjord massacre. The healthy survivors were transferred to the OT camp at Øvre Jernvann, where most soon succumbed to disease. Within a period of four months, 748 of the original 900 prisoners had died.[72]

A few weeks after the massacre, SS chief physician in occupied Norway Dr. Bauer made an inspection visit to the northern camps and was appalled at what he discovered. As he wrote in his report, the prisoners were so hungry that they were eating out of garbage cans and dying of food poisoning. Many were half-naked and had no shoes. They performed long hours of arduous labor in the rain and snow, with nowhere to get warm. The unheated barracks, moreover, were infested with lice and overcrowded, with no means to isolate the sick. Beyond harming the workers, these conditions also threatened the health of the soldiers who guarded them.[73]

Bauer made many recommendations, from providing the prisoners with underwear to installing stoves in their barracks. But from his own descriptions of his interactions with camp officials, it is clear that he faced resistance to any kind of investment in the prisoners' well-being. Even after Bauer's visit, medical treatment in the camps routinely consisted of a bullet. Construction of a new section of Riksvei 50 northeast of the village of Rognan in the district of Saltdal, just above the Arctic Circle, claimed the lives of over a thousand prisoners from Yugoslavia, Poland, and the Soviet Union—many at the hands of SS and Hird guards.[74] Today, this stretch is known as the "Blood Road" for its violent history, captured in the story of Miloš Banjac, a Yugoslav prisoner of war shot by a guard while trying to escape on July 14, 1943. His brother used the dead man's blood to paint a cross on the rock wall next to his body. That gesture is remembered and repeated now in red paint.[75]

The murderous treatment of prisoners of war on construction sites

facilitated the Nazis' goal of *Aufnordung* by eliminating "dangerous" Slavic bodies. At the other extreme of this ideological spectrum, the reproductive bodies of Norwegian women constituted precious building blocks in the Nazis' plan for a racial empire. These laboring female bodies harbored a vital raw material—Aryan blood and fetuses—needed by the Fatherland, an import more valuable than any other within this ideological framework. The introduction of the *Lebensborn* (wellspring of life) program to Norway, which sought to direct the production and flow of babies born to Norwegian women and German soldiers, must be considered alongside other infrastructure networks implemented by the occupiers in their quest to forge the New Order in Europe. Unlike the massive construction projects of the Organisation Todt, however, this was infrastructure at a cellular level.

The *Lebensborn* program began in Germany in 1935 under Heinrich Himmler, head of the SS, as an effort to increase the number of births of Aryan babies and thereby strengthen the racial health of the German population. It represents the inverse of the genocidal policies formulated and carried out by the SS, which similarly aimed to improve Europe's racial stock, but by eliminating perceived threats to the genetic pool. The *Lebensborn* program targeted single Aryan mothers, who were promised secrecy and protection as well as adoptive homes among "good" SS families for their newborns. In fact, these children were often difficult to place, since SS families questioned the moral character of mothers who had children out of wedlock and, moreover, were willing to give them up.[76]

Disappointed with the *Lebensborn* program's low participation rates, Himmler began to look outside Germany's traditional borders to reinforce the nation's Aryan blood. Beginning with the outbreak of war, and accelerating with the invasion of the Soviet Union in 1941 and mounting battlefield losses, the *Lebensborn* program was extended to kidnapping "racially valuable" young children (that is, those deemed to possess Aryan racial characteristics) from occupied countries. The intention was to resettle them in Germany within families that would reeducate them and raise them as "German" children. Historians estimate the number of children stolen in Europe to be between fifty thousand and three hundred thousand.[77]

In December 1940, SS leader and Gestapo chief Wilhelm Rediess, who worked closely with Terboven in occupied Norway, wrote to Himmler to address political and legal concerns in anticipation of a

wave of births of children fathered by German soldiers. Rediess wanted to secure these babies as German assets and, with strong support from Terboven, proposed the creation of *Lebensborn* facilities in Norway.[78] Since the Nazis believed that Norwegians (with the exception of the aboriginal Sámi in the far north) were among the purest Nordic peoples racially, the babies born of the union of Norwegian women and German soldiers were considered highly valuable, serving to upgrade the Aryan blood of the German population.[79] In February 1941, Himmler, Terboven, and Wehrmacht commanders in Norway met and agreed to establish a branch of the *Lebensborn* program in Norway to care for the soldiers' children.[80]

The *Lebensborn* registers kept by the German authorities in Norway contain the names of about seventy-five hundred women. Scorned by their families and local communities as "German tarts" and traitors, these women found refuge and support through the *Lebensborn* program.[81] Expectant mothers judged to be racially valuable were housed before and after the birth, cared for by medical staff, and given clothes and a pram for the baby. The German doctors (most working for the Wehrmacht) and nurses selected to run the institutions were trained to decide on the worthiness of the mother and child to the *Volk*. This assessment was based on a genealogical review of both parents, a medical and moral examination of the mother, the physical appearance of the father, and a medical examination of the newborn.[82]

The institutions were organized hierarchically: "mothers and babies of supposedly superior biological quality received much better care than babies of supposedly low quality." This hierarchy, which was kept secret from the mothers, also determined "which of the children were to be sent to Germany to be raised in good SS families." Only children appraised as worthy of Germanization—based on extensive research not only of their racial health and ancestry, but also of the political inclinations of the parents—would be sent to Germany for adoption. Such children invariably had blond hair, blue eyes, and fair skin. Over the course of the war, about four hundred *Lebensborn* children were sent from Norway to Germany. Some were retrieved by their fathers or adopted into families, but many lived in orphanages, often being moved from one institution to the next.[83]

With the demand for accommodations in Norway growing urgent in the spring of 1941, the *Lebensborn* authorities began to acquire and repurpose buildings for their mission. In August 1941, Heim Hurdal

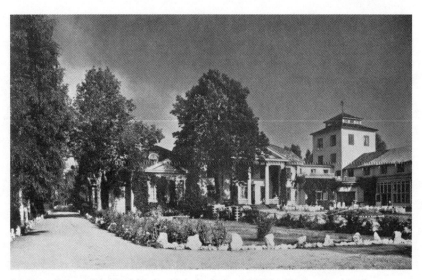

2.9. Manor house at Heim Hurdal Verk published in Rediess's 1943 booklet *Sword and Cradle*.

Verk opened in a former resort, with a private park and manor house, north of Oslo (figs. 2.9 and 2.10). It was the first *Lebensborn* home established outside Germany and Austria, as well as the first of twelve such facilities to be opened throughout Norway during the occupation—more than in Germany itself (nine) and far more than in any other occupied country. (France and Belgium, by comparison, had just one *Lebensborn* home each, reflecting the occupiers' low racial estimation of their people.) By the war's end, places for about 450 children and 280 mothers had been created in Norway, but even this was not enough. More *Lebensborn* facilities were planned and still under construction as late as March 1945, weeks before German capitulation.[84]

The *Lebensborn* institutions functioned as maternity homes, nurseries, and orphanages, and operated with a staff that grew to about three hundred, including Germans and Norwegians. It was an expensive program to maintain, with the annual budget reaching 6.2 million Reichsmarks in the final year of the war. This figure underscores how precious this "Nordic blood" was to the Nazi regime, as measured by the high costs associated not only with the mothers' prenatal care and delivery but also with looking after the babies given up for adoption.[85]

Although Norwegian mothers were kept in the dark about many aspects of the *Lebensborn* program—such as the possibility that the children they gave up for adoption might be taken to Germany—its

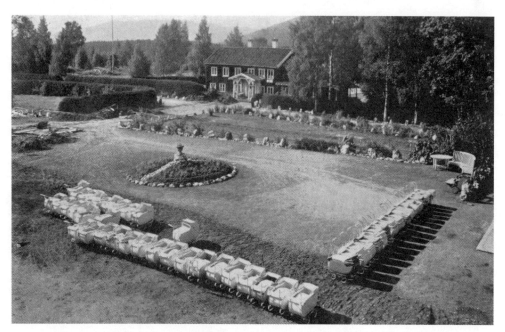

2.10. View of the forecourt with baby carriages at Heim Hurdal Verk published in Rediess's 1943 booklet *Sword and Cradle*.

existence was not exactly a secret. In 1943 Rediess published *Schwert und Wiege* (Sword and Cradle), a slim book about the *Lebensborn* mission in Norway that framed it as a plan to save the Norwegians from their own protracted decline (brought on by emigration and "degenerate" foreign influences) and as a means to forge the New Europe on the foundation of superior Nordic blood. The book, filled with photographs (some in color) of blond babies, was dedicated to "every mother of good blood" (fig. 2.11 and see plate 5). According to Rediess, their babies—whom the *Lebensborn* organization would save from being aborted—would form the battalions of the future, defending the lands the German armies had conquered.[86]

Rediess's book also richly illustrated the luxurious facilities awaiting pregnant Norwegian women in the *Lebensborn* program. Many of the homes had been set up in former tourist hotels, including some of the most famous in the country. The spectacular Stalheim Hotel, for example, located near Voss and intended to serve women from Bergen, had hosted Kaiser Wilhelm II many times on his summer visits to Norway.[87] Tourist guidebooks of that era lauded the hotel's scenic beauty. *Bennett's Handbook for Travellers in Norway*, published in 1902, described it as "one of the finest hotels in the interior of Norway, having a situation

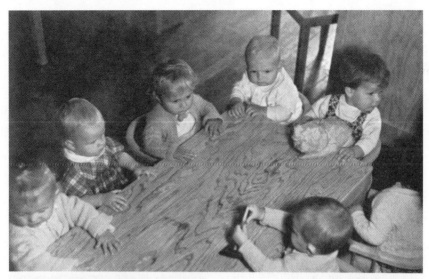

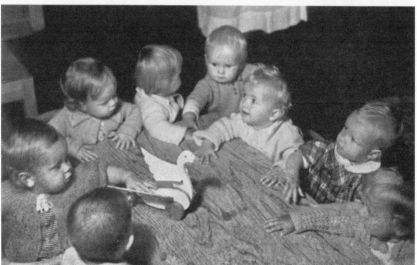

2.11. A page from Rediess's booklet *Sword and Cradle* illustrating a group of babies at a *Lebensborn* home in Norway.

unsurpassed in grandeur by any other. . . . From the verandahs of the hotel a most impressive view is obtained of the dark *Nærødal* [Nærøy Valley], surrounded by high mountains."[88] Rediess's book echoed this language, describing the home's location "surrounded by high mountains" as "one of the most beautiful landscapes of Norway." Initially the Nazis had intended to transform the hotel into a maternity home. In the end, they outfitted it as an orphanage, raising the question of how much the babies were capable of enjoying the panoramic views Rediess illustrated in his booklet.[89] Rediess's intended audience, of course, comprised not the babies but rather their parents, presumably including SS soldiers and Norwegian women who might become *Lebensborn* participants. The many photographs depicting elegant *Lebensborn* facilities gave Rediess's book the feel of a brochure for a deluxe tourist stay, with the outcome being a baby rather than a suntan.

But the former tourist function of many of the *Lebensborn* homes and the travel-guide language used by Rediess is misleading. Focusing on the scale of these buildings makes clear that the more fitting analogy is not leisure resorts but rather industrial infrastructure: the scale of the facilities set up by the *Lebensborn* program reflected its ambition to create a vast pipeline of Aryan genes flowing from Norway to Germany. Heim Godthaab, for example, a large stone sanatorium built in 1925 in Bærum (near Oslo), was refitted as an orphanage with space for two hundred children (fig. 2.12). It also served as a hub for the broader system. Children from other homes intended for adoption were sent to Godthaab before being transported to Germany, making the home the de facto "port of shipment" for *Lebensborn* children leaving Norway.[90]

Beyond serving to collect and process Aryan children, *Lebensborn* orphanages controlled quality by shielding children from supposedly negative Norwegian influences. The children who lived in Heim Godthaab, Rediess reassured his readers, were raised according to German values. Thus they began to grasp the meaning of community even as babies. Children learned to keep themselves busy and to subordinate themselves to the group. Even the youngest, Rediess noted with satisfaction, quickly learned that crying or screaming had no effect. Therefore, few wails broke the stillness of the orphanage. The German father-soldier who left his child behind could rest assured that in the home "everything is geared . . . to forming a German person who will later be a valuable member of the national community."[91]

This training extended beyond the babies to encompass Norwegian mothers who planned to keep their children and perhaps emigrate to join the baby's father in Germany. *Lebensborn* authorities wanted to make sure that the child would continue to be raised according to German standards. Indeed, a mother found wanting in her care or circumstances risked losing her child. Home visits by *Lebensborn* officials after the birth verified that the child was being raised "in our [that is, German] manner." But the process of training the Norwegian mother—and, specifically, instilling a "German mind-set"—began much earlier.[91]

Ideally, the expectant mother was removed from her normal milieu and installed in a maternity home as early in the pregnancy as possible. While awaiting the birth, she took courses in cooking, sewing, handicrafts, and home decoration. Additionally, she received instruction on caring for her infant as well as on the physical, social, and psychological development of the child. The curriculum was similar to that of Reich Bride Schools, which had been created in Germany for women engaged to SS men. But a Norwegian woman was also expected to develop a sense of her own Germanic identity, and for this she received German language instruction and listened to lectures on German culture, even learning to sing German folk songs while knitting for German soldiers. When she completed her training, she earned a certificate from the Reich Mothers' Service. All the while, and without her knowledge, the expectant mother was also being observed by the *Lebensborn* staff to determine the quality of her character.[93]

As noted earlier, the hierarchical nature of the *Lebensborn* program extended to the maternity homes themselves, which reflected the clients' differing status—even though the pregnant women had no idea they had been ranked. The most valuable mothers were housed at Heim Klekken in Hønefoss (northwest of Oslo), a hotel that was transformed in early 1942 into a first-class *Lebensborn* home for thirty-six mothers and sixty babies. The hotel, which had been destroyed in the 1940 invasion, had been completely rebuilt by its owners and had been open barely two weeks before the Germans decided to seize it and convert it into a maternity home. Splendidly appointed and fully modern, it was considered the flagship of the *Lebensborn* institutions in Norway (figs. 2.13 and 2.14).[94]

The architecture office of the Reich Commissariat undertook the refurbishing of buildings for the *Lebensborn* program. In August 1942,

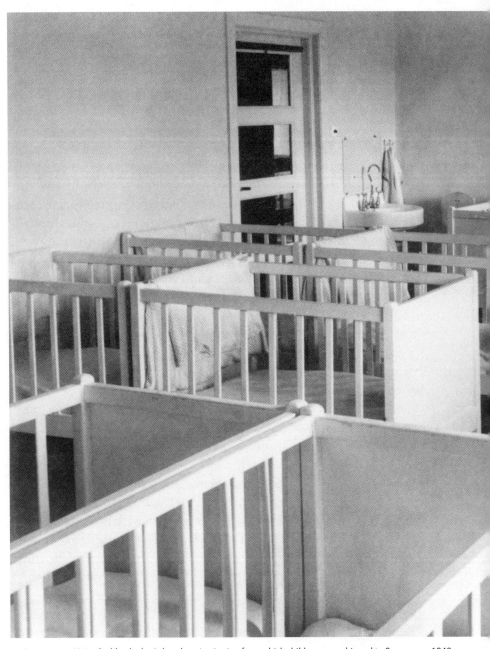

2.12. Nursery in Heim Godthaab, the *Lebensborn* institution from which children were shipped to Germany, c. 1942.

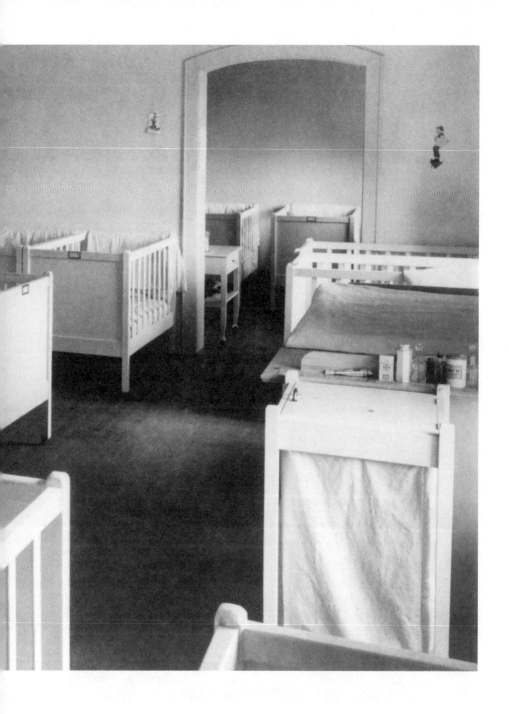

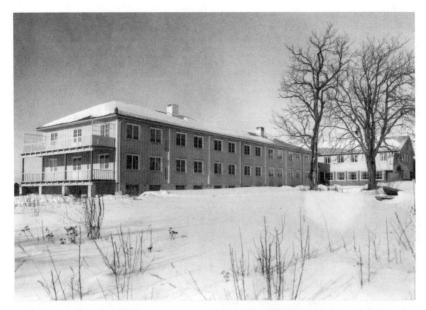

2.13. View of Heim Klekken, where the most racially valuable mothers were housed, c. 1942.

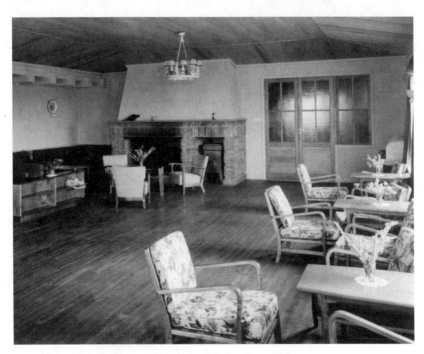

2.14. Interior of Heim Klekken, c. 1942. Photograph by Henriksen and Steen.

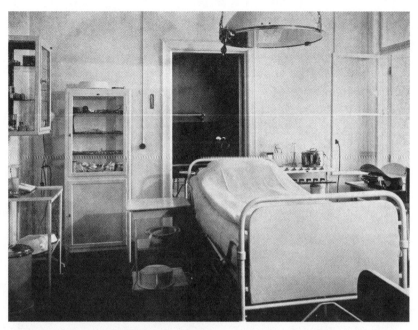

2.15. Delivery room at Heim Hurdal Verk illustrated in Rediess's *Sword and Cradle*. This antiseptic image conveyed the modernity of the medical facilities.

it calculated the total cost for the renovation and setting up of four facilities (Hurdal Verk, Klekken, Godthaab, and Stalheim), including medical equipment, at eight hundred thousand kroner.[95] In the Reich Commissariat's priority list of building projects, the *Lebensborn* facilities competed for resources with other construction projects. In the spring of 1942, at the urging of Rediess, the *Lebensborn* projects were accorded top priority status owing to the lack of facilities to accommodate the ever-growing numbers of Norwegian women pregnant by German soldiers.[96] While many of the renovations undertaken addressed functional needs—for example, the installation of delivery and examination rooms (fig. 2.15), new heating to keep newborns warm, or a garage to park a fleet of baby carriages—some of the work carried out was notably cosmetic. Wallpaper was replaced, floors and veranda furniture given a new coat of paint, and attractive lamps purchased, among other decorative embellishments. Thus at a time of great shortages of construction materials and labor, the Reich Commissariat architects were concerned about making the homes *nice* for the expectant mothers and babies, which underscores the high value of the *Lebensborn* assets.[97]

When the war ended, the status of these mothers and children reversed, and they became pariahs. After five years of a brutal occupation, Norwegians marked as collaborators, including women who had slept with German men ("horizontal collaborators"), faced a nation's hatred and contempt. Historians estimate that around forty thousand women, or about 10 percent of the Norwegian female population between the ages of fifteen and thirty, had German boyfriends during the war.[98] Although the women had not broken any laws, Norwegian authorities were determined to punish them. An estimated fourteen thousand women were arrested and imprisoned around the country in the spring and summer of 1945. Two to three thousand women who had married German men were stripped of their Norwegian citizenship and interned in camps with their children as they awaited deportation to Germany—a harsh sentence at a time when Germans lived in ruins and confronted hunger and disease.[99]

As many as twelve thousand children had been born to German fathers in Norway during the occupation, about eight thousand of whom were registered as *Lebensborn*—records Norwegian authorities used after the war to identify this unwanted population. Already in 1943, in response to Rediess's book, a group of Norwegian politicians in exile had formed a committee to decide the postliberation fate of the "war children," as they were officially called (or "German brats" in common parlance), and whether they and their mothers would be forced to leave Norway. When the Norwegian government returned to Oslo in the summer of 1945, it appointed a committee to deal with the war children. Opinions among Norwegians ranged from open hostility, some fearing that the children would grow up to become a German fifth column, to those who saw the children as innocent victims.[100] Some in the medical professions questioned their mental fitness. Ørnulf Ødegård, a leading Norwegian psychiatrist hired by the committee to assess the mental condition of children fathered by German soldiers, estimated that half of the women who had slept with Germans "were probably mentally retarded," and that many of the German soldiers who had slept with "subnormal girlfriends" were also mentally deficient. This line of reasoning led Ødegård to conclude that about half of the war children "might be mentally retarded and hereditarily inferior." Tragically, the children once tested by the Nazis to determine their human value on the basis of their genes were again assessed on these terms by Norwegian authorities. Although not everyone on the committee accepted Ødegård's as-

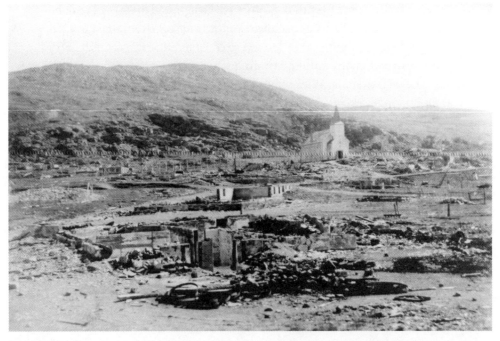

2.16. Honningsvåg, a seaport in the North Cape district, in ruins in the summer of 1945. The 1885 white wooden church survived the scorched-earth destruction and was used by returning inhabitants as a communal shelter and bakery. Today, in the rebuilt town, it remains a powerful symbol of the people's resilience.

sessment, his views were published by one of the committee's doctors, which helped to spread the impression among the Norwegian population that there was something wrong with the war children.[101]

When peace returned, more than five hundred children were still living in *Lebensborn* homes in Norway, and the former owners of the buildings wanted their properties returned to them. In the summer and fall of 1945, most children were removed, being either returned to their mothers, adopted, or sent to orphanages throughout the country. Twenty-seven children housed at Godthaab were deemed by the German staff to be "imbeciles," and were institutionalized, some for life. Decades later, in 1990, questions were raised as to whether these children had, in fact, been impaired. The hundreds of *Lebensborn* children who had been sent to Germany, and who were still Norwegian citizens, were overlooked during the immediate postwar years. In 1947 an international relief organization working in Germany asked about the return of these children to Norway, which prompted Norwegian authorities to collaborate with the Norwegian Red Cross to bring them home. How-

ever, only fifty were eventually returned. Others had died, could not be traced, or lived in Russian-occupied zones, and some remained in Germany when their living situations were considered positive. Of the fifty who returned, many suffered trauma when they were separated from their new German families to be sent to orphanages in Norway, where they no longer spoke the language. Some lived in various institutions until adulthood.[102] Only in recent decades has Norway confronted the tragic legacy of the *Lebensborn* program and the victimization of the children once elevated, and then scorned, for their genes.

The suffering of the *Lebensborn* children and of the prisoners of war underscores the deep human cost of the Nazis' infrastructure projects in Norway designed to lay the foundations of a racial empire. In press stories about gleaming highways or other infrastructural developments, Nazi propagandists fabricated an altogether different reality, of the occupiers' altruism in helping their Nordic brothers. German engineering and technology would lift the Norwegians out of their infrastructural poverty and bring them into the New Order. Wild and distant geographies would be tamed and made accessible, drawing the North into Berlin's orbit. At the same time, the vast new spaces of the *Grossraum* would be defined and made comprehensible. Previously untapped resources would be harnessed for the creation of new wealth. But when the war turned against the Nazis, the self-serving and destructive impulses at the core of this vision emerged with vicious clarity.

In October 1944, Hitler ordered Operation Nordlicht (Northern Light), the withdrawal of German troops from northern Norway east of the Lyngen Fjord. To prevent the Red Army from receiving any support, the entire population was also forced to evacuate by ship, leaving behind everything they owned. Retreating soldiers, following scorched-earth commands, set fire to homes, schools, hospitals, shops, and factories, and blew up bridges, ferries, ports, and other infrastructure. Nothing was to be left standing that could be of use to the Russians, not even a cowshed. The county of Finnmark and the northern part of the county of Troms—an area larger than Denmark—were reduced to a charred wasteland (fig. 2.16). For six weeks, 250,000 German troops marched west and south along Riksvei 50, destroying it behind them so that the Red Army could not follow.[103] Just five years had passed since Pantenburg had taken the same route, in the opposite direction, on his way to the North Cape. The magnificent Arctic infrastructure that he had foretold, and that thousands had died to realize, now lay in ashes.

3 Islands of Germanness
Soldiers' Homes in Occupied Norway

On Sunday evening, February 2, 1941, Germans listening to the *Wunschkonzert für die Wehrmacht* (Request Concert for the Armed Forces), an immensely popular music program broadcast weekly on German radio, heard Joseph Goebbels make a passionate appeal on behalf of the Führer himself. He called on the home front to support German troops by donating to the construction of *Soldatenheime*, or soldiers' homes, in Norway. These were not residences. Rather, they were cultural and recreational centers, where an off-duty soldier could watch a movie, write a letter to a sweetheart, drink beer with friends, and learn a craft such as woodworking. Centers like this had been created in Germany after Hitler reintroduced compulsory military service in 1935, as well as in occupied France and the Low Countries, but they were needed urgently, and above all else, in Norway: "In this country of vast distances and of hard winter," stated Goebbels, "even the best barrack is no substitute for a soldiers' home." To that end, Hitler had donated a million Reichsmarks toward the construction of soldiers' homes in Norway, and Goebbels encouraged all Germans to follow his example by making their own gifts.[1]

Listeners were undoubtedly impressed: a million Reichsmarks was a great deal of money and reinforced the significance of this issue for the Führer. The *Wunschkonzert* was the ideal medium for such an appeal. The show strove to foster a sense of intimacy between the soldiers on the front and the homeland audience, which came together once a week to listen as a *Volksgemeinschaft*, or people's community. Orchestras and famous performers played music requested by the soldiers, interspersed among interludes of humorous or heartwarming stories,

messages from soldiers and their families, and donation appeals, especially for the families of the fallen.[2] The soldiers' homes in Norway exemplified the materialization of a bond of mutual love and obligation that the radio show aimed to foster among audiences in Germany and soldiers listening from their posts. The homes' champions imagined them as a piece of Germany on foreign soil—a place where the soldier could retreat from an alien and hostile environment and, for a few hours, find himself back in the homeland.

Hitler's determination to make Norway a bastion against Allied invasion resulted in an exceptionally large occupation force. Averaging around 300,000 German troops, the number rose to nearly 450,000 (including 25,000 German civilians) by war's end.[3] At the peak of the occupation, "for almost every eighth Norwegian there was one German soldier, and in the sparsely populated Finnmark this disproportion was even greater."[4] Because of the size of the German presence and the country's low population density, especially in the middle and northern regions, the German military could not meet its need for housing, recreational, and administrative structures solely by requisitioning civilian buildings. The situation was exacerbated in some of the remote locations occupied by the Germans for their strategic value: two thousand soldiers, for example, manned the artillery batteries at Djupvik, in the upper Lyngen Fjord, overwhelming the Arctic village's two hundred residents.[5]

Many German soldiers posted to Norway's northern regions struggled with the solitude and boredom. Articles written at the time about the need for soldiers' homes discussed the effects of isolation and long, dark winters on soldier morale.[6] These were legitimate concerns. Research on seasonal affective disorder among US Army soldiers in Alaska, for example, indicates that high northern latitudes may increase both the incidence and the severity of this form of winter depression, especially among young men.[7] German soldiers also suffered from "Arctic melancholy." In 1942, the armed forces attempted to address this by rotating troops stationed in the north with those in the south. Nonetheless, as the war continued, suicide rates climbed.[8] A German reporter writing in 1942 about the "blessing" of a newly opened soldiers' home in Hammerfest described how the troops struggled to cope with being "surrounded by harsh nature and an even harsher climate," as well as with being so far away from family and friends. (He refrained from mentioning, however, how these difficulties were compounded by the

soldiers' position as occupiers facing a hostile local population.) Making matters worse, distractions were hard to come by in "small, lonely places" such as this Arctic town: "Here you will find no spacious restaurants, no cafés-concerts, no museums, no theater."[9]

A change in climatic conditions heightened the sense of urgency for soldiers' welfare. Europe was experiencing unusually cold winters. In January 1941, temperatures in mid- and southern Norway hit record lows, reaching minus 47.5 degrees Celsius in Røros.[10] Rudolf Schmitz, a German soldier posted in Norway, wrote to his mother that month telling her of comrades who had suffered frostbitten limbs owing to the extreme cold.[11] Two years later, looking back on that deep freeze, an account of the genesis of the soldiers' homes program noted how critically important the availability of recreational spaces had been in maintaining soldier morale.[12] These unusual conditions may have played a role in the timing of Goebbels's announcement, soon after temperatures plunged, of a new initiative for soldiers' homes.

But if the weather hurried things along, the initial catalyst for the soldiers' homes arose earlier and under different circumstances. In the spring of 1940, with the approval of the Führer and the Armed Forces High Command, Dr. Leonardo Conti and Gertrud Scholtz-Klink founded, and subsequently led, the Arbeitsgemeinschaft für Soldatenheime (Council for Soldiers' Homes), which was based in Berlin.[13] Conti, a fanatical Nazi, was the Reich health leader, and had a broad mandate over the nation's health and medicine. Scholtz-Klink, as Reich women's leader and the top female Nazi official, headed a number of national women's organizations. Council members included representatives of the German Labor Front, National Socialist People's Welfare (the powerful Nazi Party public welfare organization), German Red Cross, and, at least nominally, Goebbels and Heinrich Himmler (fig. 3.1).[14] The council thus brought together various leaders and organizations with a stake in soldier welfare in an attempt to centrally coordinate their efforts.

The formation of the Council for Soldiers' Homes coincided with the armed forces' decision, in June 1940, to establish soldiers' homes in newly occupied Denmark and Norway. These were to be set up in rented or requisitioned buildings, such as cafés and hotels, with small budgets (thirty-five hundred Reichsmarks per soldiers' home) envisioned for their outfitting.[15] Originally, the Council for Soldiers' Homes claimed only a supportive role, consulting with the armed forces on the

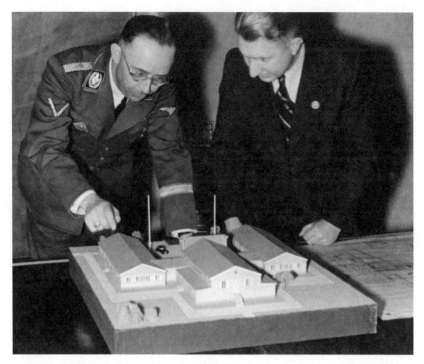

3.1. Undated photograph of Heinrich Himmler (left) and Edgar Haller reviewing a model for a soldiers' home, with a building plan beside it. Haller, who became a Nazi Party member in 1928, wears his Golden Party Badge, a merit awarded to those with membership numbers under 100,000 and with continuous, devoted service to the party.

selection, furnishing, management, and staffing of these facilities. But as the shortage of suitable building stock in Norway rapidly became evident, the group turned its attention to wholesale construction.[16] The Labor Front took the lead through its Kraft durch Freude (Strength through Joy) division, which had been providing the troops with leisure programs since 1935.[17] Edgar Haller, a senior publicist for the Labor Front who had been transferred from Berlin to oversee Strength through Joy's Oslo office, was designated the Beauftragte für Soldatenheime (commissioner for soldiers' homes) in Norway.[18]

Haller, who emerged as a passionate and outspoken champion of soldiers' homes in Norway, quickly set up a collaborative with Norwegian architects, engineers, and firms to carry out the projects. The fact that Germans and Norwegians worked together on this mission was important to Haller, and something that he would emphasize in subsequent publicity. (He neglected to say, however, that the participating

Norwegians were undoubtedly motivated less by a desire to help German soldiers than by the substantial profits to be made.) Haller was also enormously proud of the design of the resulting structures, for which he claimed primary credit, even though he was not an architect. The design process began in September 1940 and proceeded at an intensive pace. By early October Haller had signed his first contracts for soldiers' homes.[19] By December seven homes had been ordered, with construction already under way on some sites.[20]

Around this time, Hitler, in the presence of Robert Ley, head of the Labor Front, thoroughly reviewed models and building plans of the soldiers' homes. According to Haller, Hitler declared the physical layout ideal, with the large workroom for arts and crafts activities playing an important role in that assessment. A former soldier with artistic aspirations, Hitler seemingly appreciated the union of military life and self-cultivation that this space represented. Haller recounted that Hitler then ordered work on the soldiers' homes to continue through all means possible.[21] On behalf of the Labor Front, Ley pledged to Hitler that they would build ten soldiers' homes at a value of six hundred thousand Reichsmarks each, or six million Reichsmarks in total. To this stupendous gift, the Führer added his own contribution of a million Reichsmarks in cash, as later announced by Goebbels.[22]

As with so many architectural projects in which Hitler became invested, the scheme rapidly expanded in scale. Going far beyond Ley's pledge, Hitler ordered that one hundred soldiers' homes be built in Norway, which would have left hardly a town in the entire country without one.[23] Ultimately, by war's end, at least twenty—and perhaps as many as twenty-six—had been erected.[24] Although Hitler's goal of dotting the Norwegian landscape with such structures was thus not fully realized, the projects are worth close examination because, unlike repurposed buildings in other occupied countries, they were developed specifically as a new form of architecture that would shape and define German identity in an expanded territorial realm—not only in times of war but also in times of peace.

Patronage at the highest levels did not prevent frictions from appearing early in the project. Ley's and Hitler's donations, although significant, covered only part of the immense construction expenses involved in building soldiers' homes. The Labor Front subsequently exerted pressure on the armed forces to contribute their own resources to the projects, creating tensions that were further aggravated by the

lack of clarity over the ownership of the soldiers' homes.[25] As restrictions on construction in Norway tightened during the occupation, these disagreements created serious impediments to carrying out Hitler's orders.

But the strains between the armed forces and the Labor Front went beyond economic concerns. Even when the military was willing to collaborate with civilian groups for the care of its soldiers, it always insisted that it could handle its own needs. In Norway, in addition to the tens of thousands of barracks it erected to house German troops, the military built *Kameradschaftshäuser* (fellowship houses), modest facilities—usually a repurposed barrack—where soldiers could read a newspaper, play board games, and otherwise pass their off-duty hours. The Labor Front, in its campaign for soldiers' homes in Norway, publicly declared that these spaces were insufficient, and that the troops were suffering. At the same time, the solution it proposed was of a vastly different scale from that adopted in other occupied countries. In Belgium, France, and the Netherlands, German military commanders had converted existing residential and commercial buildings into soldiers' homes (run by German Red Cross sisters, with programming provided by Strength through Joy).[26] Although this was also possible in Norway's more populous towns, in smaller settlements—because of either their size or the damage they had suffered in the invasion—suitable structures rarely existed.[27] The sheer number of buildings requisitioned for housing the troops also reduced the available stock. But this deficit of ready-made spaces also created an opportunity to develop something grander and more encompassing, which clearly fired the imaginations of Hitler and Ley. For the military, by contrast, those escalating visions posed a potential challenge to its boundaries and authority, if the homes—now to be established by the Labor Front—were to become a center around which a soldier's life revolved. This is not to say that the armed forces did not welcome better facilities, but rather that they approached the Labor Front's offer with caution and determination to maintain control over their own troops.[28]

Planning for carrying out Hitler's ambitious order to build one hundred soldiers' homes began in December 1940, with an assessment by the Reich Commissariat of the materials needed and of projected costs based on Haller's drawings and models. Because the military's construction of barracks had devastated Norway's timber supply, the wood for all but ten of the soldiers' homes would have to be imported

from Sweden, and the cost for this alone was estimated at 6.5 million Swedish krona.[29] Goebbels, on a visit to Oslo that same month, had an in-depth discussion with Reich Commissar Josef Terboven about how to get the homes constructed, and offered to help.[30] This led to the expansion of the soldiers' homes program into a national *Volksaktion*, or people's campaign, making it a highly visible undertaking. Beyond his radio solicitation, Goebbels ordered a series of advertising efforts, including slides shown before film screenings in German theaters, and headlining articles published in German newspapers and magazines.[31] The campaign, launched in early February 1941 on the heels of the cold snap, was especially well timed to garner attention and sympathy, and the German public gave generously. The scale of the soldiers' homes initiative also attracted the notice of the international press. The *Christian Science Monitor*, reporting on Goebbels's appeal, warned that the Nazis were building *permanent* centers in Norway.[32] And it was correct: an internal Reich Commissariat memo noted that the soldiers' homes were intended for places that were "to remain under long-term military occupation."[33]

The task that Goebbels thus laid out before Germans in this *Volksaktion* for Norway—to build expansive, bright spaces for legions of soldiers, dispersed over great distances and terrains ranging from tundra to forest—was truly monumental. Because of the large number of buildings required, the Council for Soldiers' Homes decided to create a series of types (rather than commission individual designs), which could be more efficiently mass-produced. This approach would also ensure that the homes were of uniform quality. Three main models were developed: Type A, the largest, measured 1,800 square meters (19,375 square feet) and was intended for 1,200 users, followed by Type B at 1,300 square meters (13,993 square feet) for 600 users, and Type C at 700 square meters (7,535 square feet) for 300 users. The kernel of all three types was a theater, the most spacious being that of Type A, which held 800 seats. Around the theater were arranged a restaurant-pub and recreation and activities rooms. All the soldiers' homes were made of wood; prefabricated panels were constructed at factories in Fredrikstad, in southern Norway, and shipped to their destinations, where the buildings were assembled on-site under an architect's supervision, at a location chosen in consultation with the armed forces.[34]

Berlin journalist Bruno Roemisch, reporting from Oslo on the soldiers' homes just days after Goebbels urged Germans to fund them,

stressed the enormity of the undertaking. Referring to the plan to build one hundred structures, he stated that never in Norwegian history had there been such a "colossal" building project. Roemisch was particularly taken with the size of the soldiers' homes, claiming that, among Norwegian timber buildings, the Type A model was surpassed only by the former royal residence, the Stiftsgården, in Trondheim, the country's largest wooden palace. In fact, so large were the soldiers' homes, Roemisch continued, that they did not always fit into the landscape, requiring cliffs to be dynamited to make space for them.[35] This boast about size (typical of Nazi hyperbole and reinforcing the superiority of all things German) suggested just how well German soldiers were being treated in the occupied territories—only one step down from royalty.

In Roemisch's account, the pounding of the Norwegian landscape into submission also implied the greater technical expertise and derring-do of the occupiers. A story in the *Deutsche Zeitung in Norwegen* explicitly made this point in its discussion of the innovative construction methods employed to build the soldiers' homes. It noted that large building projects in Norway had until then been undertaken only in the summer. But because the need for soldiers' homes was pressing, Germans had developed new tools and techniques to work through the winter months, such as using large boilers to heat the raw materials to make concrete. Floodlights illuminated the construction site so that work could be carried out in the winter twilight. Amazed at the work pace, a Norwegian engineer joked: "We usually needed two years of calculating and drawing and a year of building. Now everything happens in just a few days!"[36] Although these words were attributed to a Norwegian, they spoke to German prejudice, openly expressed in the press, that Norwegians were too traditional and narrow in their thinking. In this account, the soldiers' homes thus symbolized the powers of the Nazi superhero, the engineer, who vanquished all rivals, from conservative, stuck-in-the-snow locals to the terrible forces of nature.

Behind this mighty figure was an even greater force: the will of the Führer. As the German press reported, Hitler was not only a generous donor to the soldiers' homes; he also remained an engaged and informed client. As readers learned, he had personally reviewed the models and approved the designs.[37] The soldiers' homes thus represented an ideal Third Reich building project from the perspective of Nazi propagandists, blending the will and artistic skills of the Führer,

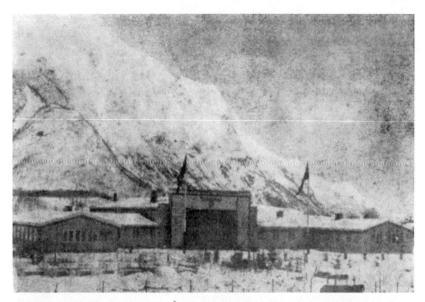

3.2. The first soldiers' home in Norway, in Åndalsnes, where British troops landed in April 1940 in the Allied attempt to defeat the German invasion. The population of Åndalsnes was twelve hundred in 1940, the same capacity for this soldiers' home, revealing how some small towns were swamped by the size of the occupying armed forces.

the heartfelt sacrifice of Germany's people and soldiers, territorial expansion, and Nazi "science."

Given his personal involvement, it is surprising that Hitler failed to mention the project to his first architect. In the spring of 1941, Albert Speer was unpleasantly shocked to belatedly discover the soldiers' homes, then under construction. He and his colleague Hans Stephan were in the midst of delicate negotiations with Norwegian architects over the rebuilding of towns damaged in the invasion. Speer was upset to learn that, without his having been consulted, the soldiers' homes were encroaching on these ongoing plans, threatening their integrity.

In a letter to Terboven written on April 17, 1941, Speer laid out his objections to the soldiers' homes. He criticized the buildings' "barrack-like character" and "rigid layout" and the way they were imposed indiscriminately on different sites without attention to topography or the broader urban context. The unfortunate location of the homes under construction in Narvik and Åndalsnes, he complained, would make it difficult to incorporate them into an integrated townscape that blended buildings with landscape.[38] The imposing size of the two soldiers' homes, even in mountainous surroundings (fig. 3.2), no doubt compounded the sense of

disunity. The Type A model had been chosen for Åndalsnes, while for Narvik (see fig. 3.8) an even larger version—Type D, measuring a full 2,000 square meters (21,528 square feet)—had been specially created to accommodate 1,300 men.[39]

Speer's diplomatic letter was careful not to overtly criticize the Labor Front in its complaints about the design flaws. Yet at a meeting in Berlin attended by Speer, Stephan, and Reich Commissariat chief architect Edgar Luther, held just two days before Speer wrote to Terboven, a more disdainful attitude prevailed. The men ridiculed the Labor Front for having "boasted in press publications that halves of mountains had to be blown away to make the design fit."[40] Rather than deeming this an impressive testament to the occupier's willpower or skills, as the newspaper accounts described above adjudged, the three architects viewed it as an embarrassing show of design incompetence.

As is obvious from his own architecture, Speer did not shy away from massive buildings that dominated the landscape. Beyond his annoyance at not having been consulted, and at the potential disruption to his own work, Speer's objection to the soldiers' homes suggests an issue with the *kind* of monumentality at play. In his concurrent discussions with Norwegian architects on the planned reconstruction of damaged Norwegian towns, Speer was trying to move them toward a monumentality that reinforced the National Socialist ideology of *Volksgemeinschaft*.[41] While this, too, represented an architecture of power, a town's inhabitants were meant to identify with and internalize it. The soldiers' homes, by contrast, as symbols of an occupying force, told a blunt story about dominance (made explicit by the Labor Front's propaganda) that Speer may have found ideologically damaging. Rather than bolster the notion of *Volksgemeinschaft*, the massive soldiers' homes, unintegrated into the town plans, declared themselves to be the masters' house.

That the soldiers' homes were designed partly by a Norwegian architect might have further displeased Speer. He had little confidence in the abilities of his Norwegian colleagues, telling Stephan and Luther that they had to be brought into line with German thinking.[42] Fritz Jordan (1892–1981) had opened his own firm in Oslo in 1922 and was in his late forties when, from September 1940 to spring 1941, he collaborated with Haller on the soldiers' homes.[43] Even though Haller was not a licensed architect, he listed himself on contracts as the originator of the designs, with Jordan as the draftsman.[44] In a description given by Jordan of their working process, he stated that Haller had determined the

form of the building, and that he had developed drawings and models on that basis.[45] Nevertheless, Jordan, as a seasoned architect, must have played a substantial role in the design. How he came to be involved with Haller is unclear. His architectural projects in the 1930s were in the sober functionalist style that was then popular in Oslo but later criticized by the Nazi press.[46] From the point of view of public relations, the involvement of Jordan and Norwegian firms in the creation of spaces for German soldiers played well strategically, reinforcing Nazi propaganda that Germany was not occupying Norway but rather helping out with her defense. The stories planted by the Labor Front in German and Norwegian newspapers in the spring of 1941 (to which Haller contributed) presented the project explicitly on those terms: as a friendly collaboration between German and Norwegian specialists. They even went so far as to suggest that Norwegian locals would be invited to enjoy cultural performances at the soldiers' homes.[47] Later articles, less concerned with Norwegian sensitivities, notably dropped any mention of Jordan's participation.[48]

Despite Hitler's seal of approval, Speer's protests, coupled with complaints from other quarters, prompted a review of Haller and Jordan's designs.[49] A Strength through Joy official in Berlin urged Haller to employ German architects in the future in order to achieve "more noble architectural forms, particularly in the facade."[50] Luther advised that, at the very least, the homes be so altered as to withstand the test of time, meaning that they would still hold up architecturally and technically a decade later.[51] Speer, for his part, encouraged Terboven to scrap Haller and Jordan's designs altogether and rethink the soldiers' homes on the basis of a modular approach proposed to him by Luther. According to this concept, the soldiers' homes would be composed of three detached modules, each serving a different function (auditorium, restaurant, and recreation rooms), which could be arranged with a view to the townscape and adapted to individual site conditions.[52] Architects employed by the Labor Front headquarters in Berlin and by the Reich Commissariat also proposed some new models.[53] Of the many homes designed by Haller and Jordan that were already under production or construction, however, only minor alterations could be made. The Labor Front was unwilling to take on the "great financial sacrifice" or further add to building delays by making more substantial changes to these assembly-ready units.[54] Speer did win the concession, however, that the urban siting of the soldiers' homes would be carried out thenceforth

according to his guidelines.[55] Jordan, meanwhile, was quietly dropped from further collaboration on the projects.[56]

As these design discussions unfolded behind closed doors, money for the soldiers' homes poured in publicly. The German press kept a tally of the growing donations, which by May 1941 approached eight million Reichsmarks.[57] With this level of support and enthusiasm, the Labor Front initially planned to build fifty soldiers' homes in Norway in 1941 alone, half of the Führer's stated goal. Haller settled on that number in April 1941 in consultation with Dr. Loosch, intendant general of the German armed forces in Norway. A few weeks later, in light of shifting priorities, Loosch reduced it to thirty. Even so, as the summer and peak construction season approached, the prospects looked good for soldiers' homes to begin sprouting across Norway.[58]

Then came a shocking bulletin from Berlin. On June 12, 1941, Hermann Göring, as head of the Four Year Plan Office, charged with mobilizing Germany's economy for war, ordered a halt to construction not classified as essential to the war effort and prioritized as urgent.[59] A few weeks later, the Wehrwirtschaftsstab Norwegen (War Economy Staff for Norway), a unit of the Armed Forces High Command, delivered further bad news: the military was suspending its material support of the project. This was a crushing blow, because as long as the military included the soldiers' homes in its allocations, they were deemed to be urgent. Without this designation or guarantee of support, the soldiers' homes joined a long list of lesser-ranked projects competing for increasingly scarce resources. In the coming months, and especially as it became clear that there would be no swift victory in the Soviet Union, access to raw materials and transport were sharply curtailed as the Norwegian economy was reorganized to serve German war needs. In August, construction was halted on all soldiers' homes in Norway deemed to be less than 75 percent completed, resulting in a stoppage of about 85 percent of the projects.[60] Only four were far enough along to proceed.[61] Soldiers' homes that were already factory-made in Fredrikstad and ready to ship were put into storage.[62]

These setbacks worsened the already-difficult conditions created by the war, resulting in a plague of problems for the homes' construction. Letters from annoyed military clients, frustrated architects, and harried bureaucrats fill the folders of correspondence for the soldiers' homes preserved in the National Archives of Norway. Military commanders expressed displeasure with architects who seemed to work as if there

were no war in progress. The Narvik garrison commander demanded that the supervising architect be removed from his position "since he constantly makes changes that delay the completion of the soldiers' home."[63] On the building site, architects faced immense hurdles, foremost among them difficulty obtaining building materials such as steel and cement, a lack of vehicles (or gas to power them), and an acute shortage of construction workers.[64] Equipment and furnishings needed to be shipped vast distances, requiring good weather and transport licenses.[65] The opening of the soldiers' home in Kristiansand was delayed considerably by a belated delivery of film equipment.[66] Sometimes shipping crates arrived with contents broken or vital pieces missing.[67] Extreme winter weather conditions routinely shut down construction sites, as did bombing raids—in Kirkenes in the summer of 1941, these were a near-daily occurrence.[68] Not surprisingly, the turnover of on-site architects was high. Meanwhile, the bureaucrats charged with procuring the foreign exchange and export permits needed to purchase and deliver orders from Germany were fettered by the red tape of Göring's economic restrictions. On a broader level, poor communication and coordination among the multiple organizations and firms involved in the planning and execution of the homes—the Labor Front and its branches, various Reich Commissariat departments, the armed forces, and Norwegian and German contractors—resulted in confusion, delays, and waste.

The German public heard nothing about this other story of the soldiers' homes in Norway, the saga of struggles and complaints that emerges across hundreds of pages in the archive. Instead, the official narrative of the soldiers' homes remained unremittingly positive: a tale of heroic challenges overcome with ingenuity and courage. Although this feat was largely attributed to the Germans, Norwegians at first received a share of the credit. This "generosity" was evident not only in early newspaper articles but also at the opening of the first soldiers' home, in Åndalsnes (fig. 3.3). The ceremonial handing over of the keys to the armed forces on April 7, 1941, was heralded in German and Norwegian newspapers as the first of what was then expected to be, in short order, many more such openings all over Norway.[69]

In keeping with the message of friendly collaboration put forth in earlier publicity, the Åndalsnes festivities included German armed forces commanders, Reich Commissariat officials, and German troops, as well as German and Norwegian engineers, architects, and

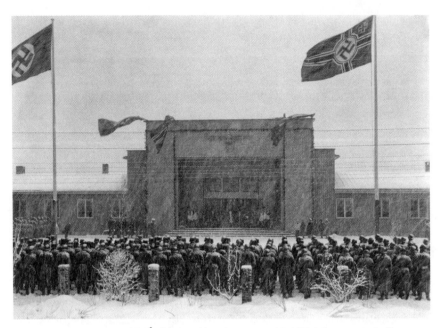

3.3. The snowy inauguration of the Åndalsnes soldiers' home on April 7, 1941. Infantry are in the foreground. "Sisters" in white aprons stand by the main entrance doors.

construction workers. In his speech Haller emphasized the "great difficulties" encountered in the home's construction—difficulties that had been overcome thanks to German-Norwegian collaboration.[70] After the ceremony guests were invited to cake and coffee and an entertainment program organized under the motto "the triumph of gaiety."[71] Despite this welcoming impression, the policy of the soldiers' homes was to admit only armed forces members and German citizens in Norway, thus reserving it as a "meeting place" for Germans.[72] This piece of information was excluded from reports in the German-controlled Norwegian newspapers.

The Åndalsnes soldiers' home exemplifies Jordan and Haller's designs before they were subject to criticism and revision (figs. 3.4–3.7). The Type A building comprised two intersecting volumes: one C-shaped (single-story), and the other rectangular (double-height). The entrance, at the center of the C and decorated with a false front, led into a vestibule, from which the visitor could either proceed forward into the auditorium or turn to enter the arms on either side. Facing the theater, one turned right to enter the large open space of the *Gemeinschaftsraum* (common room), which housed the restaurant-pub. Turning to the left

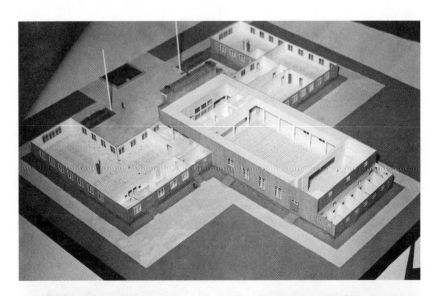

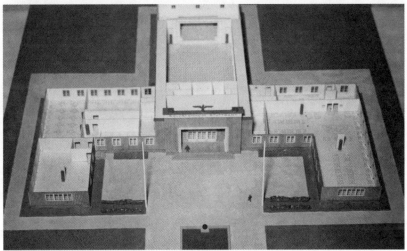

3.4 & 3.5. Fritz Jordan (with Edgar Haller), model of a Type A soldiers' home, plan view from the side-rear (top) and from the front (bottom) with the roof removed, c. spring 1941.

brought one to the activities rooms. From the air, this plan would have had an impressive, and perhaps even menacing, effect, like a giant crustacean crawling across the Norwegian landscape.

Stylistically, on the exterior, the building mixed a grand, proscenium-like entrance, foreshadowing the theater beyond, with mundane and, as Speer later pointed out, barrack-like wings. The original designs for the Narvik soldiers' home (fig. 3.8), which also provoked Speer's ire, further

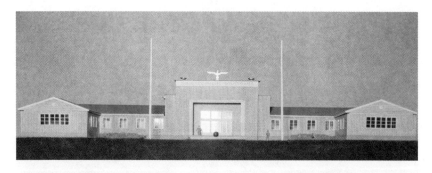

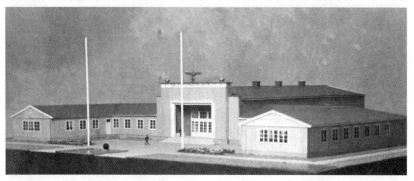

3.6 & 3.7. Fritz Jordan (with Edgar Haller), model of a Type A soldiers' home, front facade view (top) and diagonal front view (bottom), c. spring 1941.

suggest theatrical precedents, the monumental entrance recalling art deco facades such as that of Oslo's Folketeater (People's Theater), the competition for which Jordan, years earlier, had submitted an entry.[73] Narvik was a one-off design, intended only for this location, and its dramatic jagged roofline accentuated the home's unique status. The more common Type A developed by Haller and Jordan at Åndalsnes had a flat roofline for its entrance, a feature that would be replaced with a pitched form—echoing the wings and in keeping with Nazi stylistic preferences—in the revised designs (see fig. 3.9).[74]

The natural settings of the soldiers' homes at Åndalsnes, Narvik, and many other locations in Norway were stunning in their beauty. The buildings, however, were not designed with an eye to bringing the landscape into the interior spaces. This was difficult to achieve with rigid typologies, which, as Speer rightly pointed out, were not easily accommodated to specific landscape features. Additionally, the windows installed in the soldiers' homes were modest in size. Incorporating large expanses of glass, which would have more fully exposed occupants to

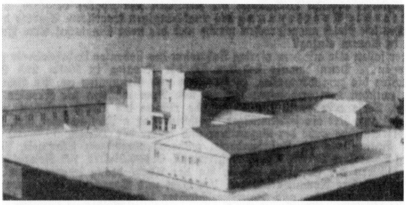

3.8. Fritz Jordan (with Edgar Haller), drawing (top) and model (bottom) for the Narvik soldiers' home, c. 1941. The Narvik home's unique design celebrated the town's special status in Nazi accounts of the Norwegian campaign and the "heroic" stand of German troops in the Battles of Narvik against Allied forces in the summer of 1940.

external vistas, posed logistical difficulties, given that building materials had to be shipped by crate to remote locations. More glass would also have made the buildings harder to heat, a concern in the extreme weather conditions of northern Norway.

But technical limitations ultimately do not explain the strong focus on interiority in the soldiers' homes. As we have seen in the case of the autobahns, Hitler's engineers would go to extreme lengths to visually appropriate particular landscape features. Thus the inward focus of the soldiers' homes must be understood not as a by-product of design but rather as the intention driving the project. Interiority—turning away from the outside world, and from Norway in particular—was precisely what these homes were about.

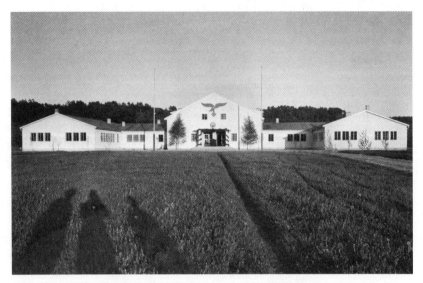

3.9. Soldiers' home in Kjevik (for twelve hundred men), c. 1943. The pitched roofline of the main entrance building and porch represents a modification to Jordan and Haller's original designs. The entrance, including the posts, may have been decorated for the home's inauguration.

In an interview with the Munich newspaper *Die Post* published a few weeks after the opening in Åndalsnes, Haller made that goal abundantly clear. The soldiers' homes served human needs of a "purely psychological nature." In particular, they nurtured and gave expression to the feelings of domesticity that lay at the heart of the German soul. "Wherever Germans may be in the world," the article stated, "they strive to shape their home in their own way." This differed from, say, decorating according to personal taste, and it went much deeper. The phrase "in their own way" meant grounded in German *Wohnkultur*, a culture of dwelling made up of habits, moods, and ways of thinking distinctive to a people.[75]

Transcending personal identity, *Wohnkultur* was not only shared with other Germans but also made manifest in their company. Gathering together in the soldiers' home, the men brought German *Wohnkultur*—and the German soul rooted within it—to life. Thus the interiority of the soldiers' homes was portrayed as an expansive force: the lone individual was drawn into a broader community in the collective experience and creation of German domestic culture. Haller likened the psychological effect of the soldiers' homes and their materialization of *Wohnkultur* to encountering your own soul. And in this

way, "they liberate the German soldier from any feeling of constriction and alienation."[76]

The community united by German domesticity could stretch far beyond a particular location. At its inauguration in May 1943, the soldiers' home in Kjevik (fig. 3.9) was described as "a real link between the homeland and the front." This link was partly concrete: the physical manifestation of the support of the homeland, which had donated funds in order to realize the home. But it was also presented as something psychic—a bond of German homes across space and time. In one of the inaugural speeches, the assembled troops heard how they might feel especially connected to their family members in this new home, which was also a German home and a piece of the homeland. Here, too, they would find new sources of strength in their fight to protect those families from the enemy.[77] This message was reinforced through the artwork in the soldiers' homes, which included depictions of the families left behind by the departing men (see figs. 3.21 and 3.25). In these ways, the domesticity of the soldiers' homes was explicitly militarized in its conception.

Given that German homes were traditionally associated with women in their roles as wives and mothers, the soldiers' homes sought to introduce a certain gender balance. Bruno Roemisch, the journalist, reported that their management "is placed in the hands of German women," thereby rounding out the homes' "German character."[78] These women were "sisters" from the National Socialist People's Welfare organization and the German Red Cross (fig. 3.10). Each soldiers' home had a female administrator, who had attended a soldiers' home management program, as well as female assistants—one for every 150 soldiers.[79] The larger homes, intended to serve 1,200 men at a time, thus had sizable female teams. The women were especially visible in the restaurant-pub, which offered off-duty soldiers inexpensive drinks and meals when they wanted to take a break from military rations. In his interview with the Munich *Post* Haller referred to the hands of German women "preparing special native [German] dishes for the men on duty in the far north." Here, food prepared by German women's hands provided a further domestic link between soldiers' homes in Norway and German homes in the old Reich.

Those hands were also portrayed as explicitly motherly. In a 1943 article published on the second anniversary of the opening of the Colonel General von Falkenhorst Soldiers' Home in Norway (at an unspecified

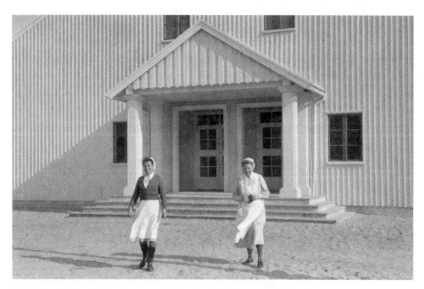
3.10. Sisters in front of the entrance to the Kjevik soldiers' home, c. 1943.

location), W. D. Libbert, a soldier, wrote in glowing terms of the manager, Sister Anni, and her domestic vision. "The soldier," she told him, "should feel here the effect of womanly—well, let's just say—calm, motherly hands (you'll grant me this ability as a mother of three boys), and never have the feeling of sitting anxiously in a waiting room or standing in a pub drinking beer, where, in the jostling crowd, he manages to consume a refreshment only with great difficulty. No, this home belongs to the soldier as a real place of rest and service, a home." Libbert also praised Sister Anni's motherly qualities as a willing and attentive listener, a theme repeated in other articles about the sisters in soldiers' homes.[80] This wholesome image of domesticity in the soldiers' homes no doubt comforted the mothers of German sons, but the armed forces were equally interested in the sobering effect of the sisters' presence. In April 1941, an officer with air forces command in Drammen, which was about to take over a preexisting soldiers' home in the area, requested that Red Cross sisters be sent to replace its "morally somewhat loose" management.[81]

The idealistic vision of the soldiers' homes laid out by Libbert and Sister Anni, with its fireside chats and motherly hands, clearly was not shared by all soldiers. In a directive from July 1943, Arendal territorial division commander Petsch wrote that he was dismayed to observe, on his troop visits, how soldiers treated the homes and the German

women in them: "There are apparently still soldiers who have not yet grasped the meaning of the soldiers' homes. The soldiers' homes are not taverns, but rather are supposed to be, for soldiers living in foreign parts, a piece of the homeland in their spare time. That is also why they are not run by local contractors, but rather by *German* women, and the soldiers are taken care of here by *German* sisters. I must expect the soldier to appreciate this and, through his behavior toward the mostly volunteer sisters, to show his respect before the *German woman*" (emphasis in the original).[82]

Petsch's insistence on the reverential treatment owed to German women in the soldiers' homes was not the only case of military commanders intervening to assure the women's privileged status. Years earlier, in an order issued in March 1941, Colonel General von Falkenhorst, commander in chief of German troops in Norway, banned Norwegian women from soldiers' homes. "A regrettable issue," he wrote "has recently emerged in some garrisons in Norway of German soldiers bringing their Norwegian sweethearts to soldiers' homes run by German women. As a result, German female volunteers were forced to serve female members of the occupied country." In his view this demeaned the commendable voluntary service of German women, given so willingly to soldiers at the front and, by extension, to the nation as a whole. He continued, "It is undignified and shows a lack of a national mind-set when, by taking Norwegian sweethearts along, the German female volunteers are made to serve them as well, and to bring them food and drinks." Falkenhorst thus commanded, "I forbid all members of the army to take female Norwegian citizens into German soldiers' homes or similar establishments in which German female volunteers are engaged in supervision, wait service, or other care of the soldiers." He also ordered that prohibitive signs be posted in the foyer of all soldiers' homes.[83]

The attention to the status of German women in the soldiers' homes should not be seen as a triviality, an instance of officers chivalrously protecting women's delicate pride. Instead, it points to something fundamental in the separation of communities being built by the occupiers in Norway. It is important to remember that the soldiers' homes were, in most instances, located in or near Norwegian towns, including some being redesigned under Speer's supervision. In these towns, Speer strove to engender a feeling of National Socialist community among Norwegians through the creation of new public buildings and spaces.

Meanwhile, a short distance away in the soldiers' homes, an entirely separate National Socialist community was being designed and fostered. Despite initial promises to Norwegians, there are no indications of actual efforts to bring these two communities together through the homes in order to coalesce a broader *Volksgemeinschaft*.

Indeed, there is evidence that the exclusion of Norwegians, far from being incidental, *defined* the soldiers' homes. Sometime after July 1942, official regulations were issued that specified the concept of the soldiers' homes and their management structure and rules. In this document, soldiers' homes were described as recreational institutions whose construction had been (or would be) funded by soldiers' homes donations. In areas that did not yet have such purpose-built structures, recreational facilities established in a requisitioned building could also receive the designation of a "soldiers' home." But in such cases, certain restrictions applied. To begin, places that served a single unit, such as a canteen or fellowship house, did not qualify, since soldiers' homes were open to all armed forces members (across branches and ranks). Furthermore, restaurant-pubs run by the military or other German agencies that primarily served armed forces members but that also *freely admitted Norwegians* (whether male or female) could not be designated soldiers' homes. Clearly, the sense of unity that the soldiers' homes intended to foster across the armed forces depended on the feeling of being *unter uns*, or "just us."[84]

This isolationist stance shares strong continuities with the model of soldiers' homes developed during the First World War. In that conflict, soldiers' homes first made their appearance on the western front, but took on a special protectionist meaning and urgency in the eastern territories occupied by Germany. Military leaders viewed the native inhabitants of these sprawling lands as primitive and uncultured, even dangerous. General Erich Ludendorff believed that soldiers' homes were desperately needed in the east to protect German soldiers' own sense of civilization. Left on their own to combat the isolation and boredom of "the long Russian winter," soldiers risked losing themselves "in the landscape, going native." Soldiers' homes promised to set limits in this limitless land, to create "German domestic order in foreign surroundings." Established in preexisting buildings and staffed by volunteer sisters from Germany, the soldiers' homes offered their users "coffee, reading rooms, piano rooms, evening entertainments, lectures, slide shows, musical evenings, readings of German poets, and

theatrical pieces." The soldiers' encounter with German domesticity and culture, it was hoped, would reinforce a sense of community and identity. The civilizing influence of German women, moreover, would strengthen the men's resolve to stay away from local women. The soldiers' homes were thus part of a moral fight to strengthen German soldiers, who were warned to "Stay German!" The German press reported on the mission of the soldiers' homes and their spread across the east. These stories reassured families on the home front that their sons would remain "unchanged, intact." In short, the soldiers' homes strove to erase distance to the homeland, while erecting barriers to the immediate surroundings. As a ruling class, soldiers had to maintain their distance from the natives who would otherwise absorb and destroy them. Ultimately, the soldiers' homes were "devoted to this apartness of the rulers."[85]

In Norway, the soldiers' homes soon abandoned any pretext of cultural outreach and focused instead on the protective function of Ludendorff's earlier model for the eastern front—keeping German boys German. Having German "mothers" present, cooking German food, was an important aspect of that mission. But the interiors themselves also played an essential role. They were meant to be German cocoons, cloaking the soldiers in imagery of the homeland. A considerable part of the expense of constructing the soldiers' homes lay in their relatively elaborate interiors, which the Labor Front understood as central to their success. When, in July 1942, the Lapland Army High Command— tired of waiting for the keys to the Kirkenes soldiers' home, which was operational but not yet fully decorated—asked whether they might take it over as is, Haller gently refused with the justification of wanting to deliver interiors that would be "as beautiful as possible." Haller, an advertising man by trade, explained that this would have a beneficial psychological effect on the soldiers: "It makes, indeed, a huge difference for the home's visitor whether, on the dark days and long evenings, he sits amid plain, drab wooden walls, or instead in gemütlich, beautifully appointed rooms, which make the difficult hours easier to endure in the long run."[86] From this perspective, then, the homes' protective mission depended on their interior design. As Haller stated plainly in his earlier interview with the Munich *Post*, "We do not want just to build but also to decorate."[87]

In the spring and summer of 1942, the four soldiers' homes on which construction had continued after Göring's shutdown orders—Kirkenes,

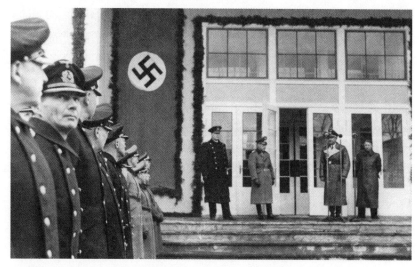

3.11. Inauguration of the soldiers' home in Kristiansand, March 15, 1942.

Kristiansand, Narvik, and Stavern—began opening their doors. The soldiers' home in Kristiansand, near Norway's southern tip, was the second such purpose-built structure to be inaugurated in the country. It was also touted as the largest soldiers' home, not only in Norway but in all of the occupied territories, and was expected to serve around twelve hundred men.[88] On March 15, 1942, almost a year after the ceremonies at Åndalsnes, representatives of the armed forces, the Reich Commissariat, and Nasjonal Samling gathered for the inauguration (fig. 3.11). This time, it seems, no one bothered to suggest that local Norwegians would be welcome to join future events at the home—not even the Norwegian newspapers reporting on the opening.[89]

Reinforcing the financial commitment of the homeland, some of the soldiers' homes were sponsored by National Socialist districts or *Gauen*. In the case of the Kristiansand soldiers' home, the Hessen-Nassau district had pledged to pay for the interiors, including their artistic decoration. From the press accounts of the home's opening day it is clear that these interiors were the star of the show. In a layout similar to that of Åndalsnes, the soldiers' home offered an auditorium for seven hundred with up-to-date film equipment, a common room for three hundred that doubled as a restaurant and pub, rooms for arts and crafts, reading and writing, and games and sports, as well as an officers' room and other facilities (see plate 6). The basement held a bowling alley, baths and showers, and rooms for traveling entertainers

3.12. View of the main hall in the Kristiansand soldiers' home with a Hitler bust, c. March 1942. At the top left is the mural of Frankfurt on the Main River.

(see fig. 3.25).[90] The bathing facilities had been added because, with so many troops stationed in Kristiansand, the sole municipal public bath house, shared by some twenty-five thousand townspeople, had become overcrowded.[91] Later, saunas were added to the soldiers' homes on the orders of Dr. Conti, after he discussed them with Hitler and received his enthusiastic approval.[92]

Beyond this bounty of spaces and facilities, it was the rooms' decoration that, according to a *Deutsche Zeitung in Norwegen* article, best captured Hessen-Nassau district's "special love and care" for the soldiers. Four artists had been sent from Frankfurt to paint murals.[93] Across from the entrance doors, the foyer contained a large panorama of the Main River and the cityscape of Frankfurt, the district capital—the first thing, along with a bust of Hitler, that the visitor saw (fig. 3.12). The ceiling of the theater was decorated at its center with a map of the Hessen-Nassau district, surrounded by its cities' coats of arms (fig. 3.13). The walls of the common room were painted with Hessian buildings and people in native dress (fig. 3.14). In a more fanciful vein, the back wall of the games room, fitted out for table tennis and billiards, was painted with a large mural, *A Soldier Reads Faust*, depicting a foot

3.13. View of the auditorium (facing outward from the stage) at the Kristiansand soldiers' home, c. March 1942.

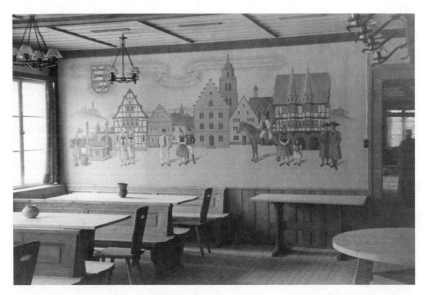

3.14. View of a mural with Hessian motifs in the common room (restaurant-pub) of the Kristiansand soldiers' home, c. March 1942.

soldier reading to a mountain infantry man from Johann Wolfgang von Goethe's play and, to the right, the scene from the witch's kitchen with Faust and Mephistopheles (figs. 3.15 and 3.16). Within the mural, the background behind the soldiers depicts a luminous Norwegian summer night (a rare instance, even if highly idealized, of a northern landscape entering inside the soldiers' homes), grazing horses, and a German sentry.[94] Goethe was, of course, Germany's most celebrated writer and Frankfurt's native son. "Thus," the article concluded, "changing images of home constantly appear before the off-duty soldier's eyes . . . and in the armchair by the fire he can dream of home."[95]

In addition to bringing German muralists to Norway, the homes' architects imported artwork for the soldiers' homes from Germany.[96] Surviving photographs of paintings and sculpture reveal the popularity of themes common to National Socialist art: landscape, family, war, women, and farmers tending their fields (figs. 3.17–3.19, 3.21, and see 3.25). Soldiers, too, contributed art and decorative objects (fig. 3.20). Roemisch, who had reported on the soldiers' homes in early 1941, returned in the fall of 1942 to see how they had developed, and he noted how energetically their users had brought to life the old German proverb "Schmücke dein Heim!" (Adorn your home!). The German soldiers, he wrote, had "sawed, planed, carved, forged and crafted, painted, and

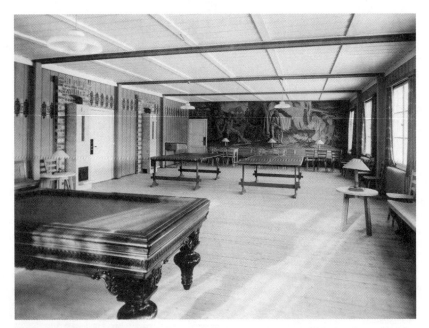

3.15. View of the games room with *A Soldier Reads Faust* mural on the far wall in the Kristiansand soldiers' home, c. March 1942.

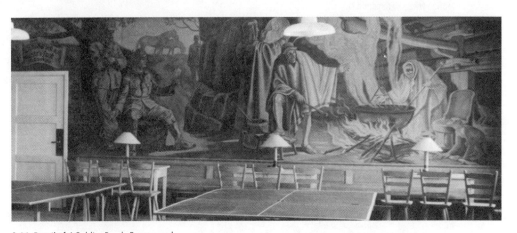

3.16. Detail of *A Soldier Reads Faust* mural.

3.17. Sculpture of a woman in the entrance courtyard of the soldiers' home in Kristiansund (on Norway's west coast—not to be confused with Kristiansand, in the south), c. 1943. The photograph is stamped "Monge Foto, Kristiansund N."

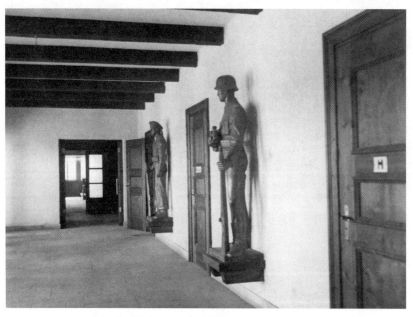

3.18. Sculptures of a sailor (left) and soldier (right) in the entrance of the Kristiansund soldiers' home, c. 1943.

decorated and thus lured the spirit and magic of their far-flung homeland into their own world of the Nordic soldiers' homes."[97]

Although the art in the soldiers' homes was for German eyes alone, a number of exhibitions organized by the German armed forces in Norway, not least at the National Gallery in Oslo, presented the creative off-duty work of German troops to the broader public. These shows included a wide range of fine and decorative art forms, from oil painting to woodworking. Some of the work displayed was created by trained artists, but much was by amateurs. German reporters visiting the exhibitions praised the armed forces for inciting and exposing these talents. Additionally, they applauded the opportunity for Norwegians to see that there was more to a gray military uniform than knowing how to use a gun.[98] Norwegian motifs, particularly landscapes, dominated the representational art in such shows, eliding the violence of the actual occupation with this gentler, visual appropriation. But the most important audience for the shows may have been the troops themselves. Beyond encouraging them to see themselves as a meaningful creative force, the exhibitions also offered them solace, proof that "the love of all things beautiful and lofty has remained alive and alert in the hearts of our soldiers despite all the hardships of war."[99]

The activities wing of the soldiers' homes—which, as mentioned above, Hitler particularly admired—offered resources for the more introspective work of remaining connected to "all things beautiful and lofty." The arts and crafts room was set up with large, studio-like tables where soldiers could work on artistic projects (fig. 3.22). Additionally, this wing housed a reading room stocked with carefully vetted books (fig. 3.23). Some homes had an acoustically isolated music room, and instruments were among the material gifts made by donors. (Terboven, for example, donated a concert piano for the home at Åndalsnes.) Among the inventory requested for Narvik were guitars, violins, an accordion, and a cello.[100] The rooms in the activities wing, although generous in size, sought to convey a more intimate feeling of domestic coziness—the book read by the fireplace—while also offering spaces conducive to the action and reflection that connected the soldier to higher realms of beauty.

By contrast, the common room that housed the restaurant-pub sought to create a feeling of convivial and far-reaching community. Its large open spaces were critically important to this mission: here the soldiers could see each other in a "Germanic" setting that connected their

3.19. Paintings of farmers working their fields in the restaurant-pub of the Kristiansund soldiers' home, c. 1943.

109

3.20. Carved figurines and heraldic symbols decorating the lamps in the restaurant-pub of the Kristiansund soldiers' home, c. 1943. In the background, at bottom right, is a mural of a couple with their children (see 3.21).

small group to a broader national community (figs. 3.24 and 3.25). The latter was amply represented here, with German women serving the men German refreshments, all surrounded by German-themed decorations. Additionally, the common room was painted in light-toned colors to create a feeling of physical expansiveness.[101] As Roemisch described it, these bright wide spaces, where soldiers sang and chatted, dispelled the loneliness and confinement of the northern landscape.[102]

In the theaters of the soldiers' homes, the search for connection to the beautiful and the lofty came together in dramatic fashion with the search for community. The auditoriums of the largest soldiers' homes were impressive spaces. When the soldiers' home opened in Narvik in August 1942, the German press boasted that its theater was the largest room in northern Norway.[103] Traveling Strength through Joy entertainers performed variety shows and plays as well as music and choral concerts for the troops here.[104] The theaters also screened German and Austrian commercial films, such as the immensely popular color film *Die goldene Stadt* (The Golden City, 1942), a melodrama about a naive German country girl who moves to the seductive city of Prague, loses her sense of identity, and is ruined, and *Wen die Götter lieben* (Whom

3.21. Mural of a rural couple with their young children visible through the doorway (itself decorated with a figural carving) to the restaurant-pub at the Kristiansund soldier's home, c. 1943. While clasping his wife's hand, the man helps his child, holding a doll, to walk. Behind him is a rifle, knapsack, and hat, suggesting his imminent departure for war. To the right of the woman, who holds a baby, stands a shovel. The visible text, in the painted ribbon to the left of the man, ends with the exhortation "and get ready" (und mache dich bereit). There is at least one other mural in the room (of two soldiers, one mortally wounded), with words from the ballad *Der gute Kamerad* (The Good Comrade), a traditional lament of the German armed forces. This suggests a larger narrative, including the mural above, about war, sacrifice, and friendship.

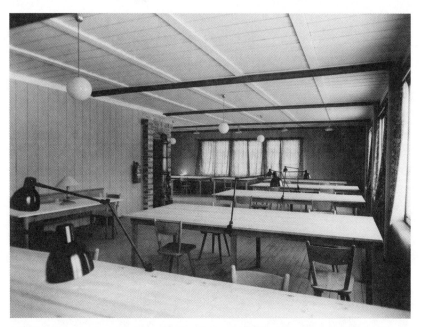

3.22. Arts and crafts room in the Kristiansand (south Norway) soldiers' home, c. March 1942.

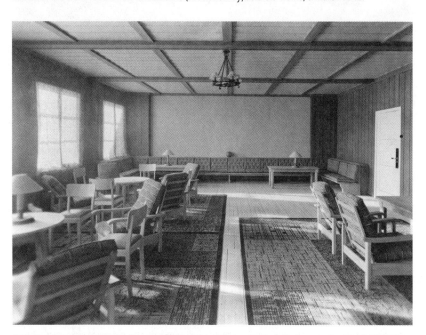

3.23. Reading room in the Kristiansand soldiers' home before it was fully decorated, c. March 1942. The facing blank wall was later covered with a large global map that daily showed the shifting positions of the fronts in Europe, Africa, and elsewhere.

the Gods Love, 1942), a somber historical biography of Mozart that portrayed "artistic genius as a manifestation of racial superiority."[105] Needless to say, Strength through Joy approved the choice and content of such programming.

Inside the auditoriums of the soldiers' homes, a distant German world materialized to entertain but also to reinforce the ties of nationality. As a German audience consuming German music, theater, and film, the soldiers were again reminded of the cultural values that bound them to each other and to a distant homeland while also underscoring their difference from their Norwegian surroundings. Many of the films and performances were comedic in nature, which might, at first glance, seem an obvious choice for raising troop morale. But comedy also translates poorly across cultures, and one can imagine the troops streaming into the pub after a comedic film, laughing about the jokes that "those others" do not get.[106] Nor did the performance end at the auditorium's doors. The soldiers' homes were in themselves a theater, requiring their users to continually perform (and thereby legitimize and reinforce) their German identity, whether by appreciating Beethoven in the music room, playing board games such as Bomben auf England (Bombs on England), or drinking beer and singing German folk songs in the pub.[107]

Considered as a whole, the soldiers' homes were a type of tether, which implies both comfort (a connection) and also insecurity (a floating away). This condition was captured in the terms employed by their users, reporters, and German officials to describe the soldiers' homes. Most frequently, they are described as a piece of the homeland; but they are also referred to as islands, bridges, and oases.[108] They are a utopic displacement. As Sister Anni put it, "For the soldier, a soldiers' home should be an island of his own sociability (Geselligkeit) in a foreign land, that is, a piece of the homeland projected into the distance." Libbert presented it somewhat differently. The homes were a mechanism to forget not only that you are not in Germany but, more precisely, that you are no place at all. In the soldiers' home, he wrote, one forgets that one is, in reality, "in the middle of nowhere."[109]

This language evoking "a space complete unto itself" and yet also "a fragment, a part of some greater whole from which it is in exile" recalls earlier descriptions of Anglo-Indian clubs established in colonial India for military and civil stations—European segregated settlements.[110] The

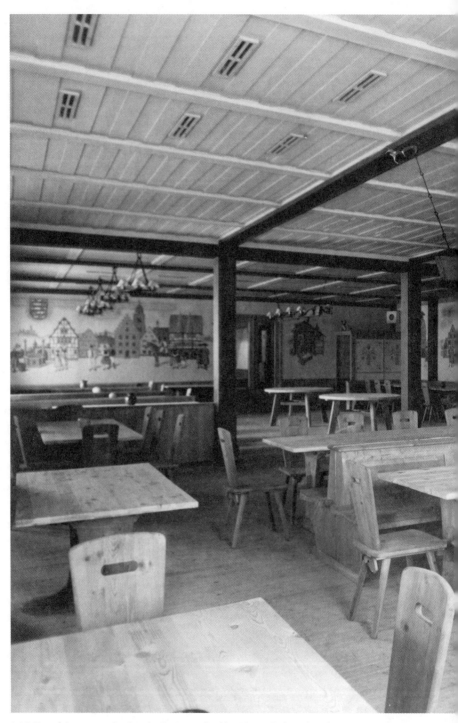

3.24. View of the restaurant-pub in the Kristiansand soldiers' home. To the right is the service counter.

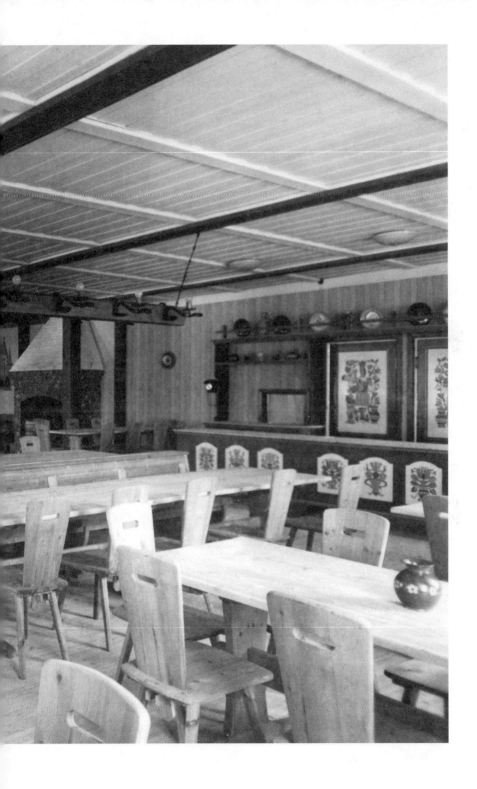

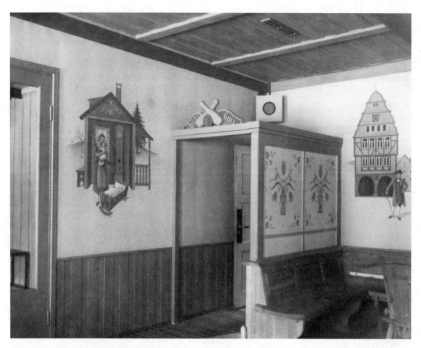

3.25. To the left, a mural representing a mother with a child in the restaurant-pub of the Kristiansand soldiers' home. At the center is the entrance to the bowling alley in the basement.

clubs, access to which was limited to white men and women, were the center of social life in the stations. They were "equipped with a range of facilities including a library, a billiards room, and tennis courts, and the social calendar might include theatricals . . . as well as picnics and sporting events." Literary scholar Ralph Crane analyzes the club in colonial fictions, such as E. M. Forster's *A Passage to India* (1924), where it is "a potent signifier of Empire" and "both territorially and racially other." It "functions as an 'island' microcosm within a larger framework of colonial isolation," sustaining a "community which fears for its survival outside its enclosing border."[111] As historian Elizabeth Collingham writes in *Imperial Bodies*, the club "daily reinforced collective identity" and "was also the place where newcomers were initiated into the social code, or those who had been observed to stray from the narrow Anglo-Indian social path were chastised in a friendly manner for letting standards slip."[112] Thus the clubs were also a place where a not-yet-stable colonial identity could be defined, reinforced, and perfected. By setting itself against the broader Indian context around it, the club, according to Crane, was "the most anglomorphic site in India."[113] In Nor-

way, too, the soldiers' homes defined Germanness by turning inward and away from the country around them. Although the homes did not discriminate *racially* against Norwegians, who were thought to share the occupiers' Aryan genes, they created nationally segregated habitats, bolstering German distinctiveness and superiority. Norwegians, as intruders, would have upset the delicate island ecology of the soldiers' homes and, thereby, their value "as a defensive zone, a last outcropping of resistant consciousness."[114]

How the Germans envisioned the soldiers' homes functioning after an expected Axis victory in Europe remains unclear. Anglo-Indian clubs were never integrated during colonial rule since colonialism depends on an ideology of superiority and exclusion. Germans believed, however, that their brand of colonialism in Norway would somehow transmute over time into a partnership based on shared cultural values and racial bonds, even if Germany would remain dominant. Among the thousands of surviving internal documents about the soldiers' homes, a single reference suggests that Nazi authorities viewed them as a future gathering place for Germans and Norwegians. In April 1941, at the behest of Speer—who, as noted above, was annoyed at not having been consulted about the siting of soldiers' homes, which he felt ignored the broader urban context—Reich Commissariat and Strength through Joy officials agreed, according to a memorandum, that "future soldiers' homes will be centrally integrated into the planning and rebuilding of their respective locations so that the homes, similar to NSDAP *Gemeinschaftshäuser* [community halls] in the Reich, become cultural hubs."[115] In Germany, community halls erected in new National Socialist towns were considered an integral part of the public life of the *Volksgemeinschaft*. Events for the community, such as plays and political assemblies, occurred in these large, centrally located buildings. In the spring of 1941, Speer and Stephan introduced such elements of National Socialist planning into the reconstruction of war-damaged towns in Norway under their supervision. Their demand to incorporate soldiers' homes into those plans reveals that they sought to make them a part of the New Order infrastructure being implemented in the rebuilt towns. But it is also possible that Speer, once he overcame his initial irritation, may have realized that the one hundred soldiers' homes Hitler had ordered could serve as a vehicle to extend these Nazi urban principles to a much larger swath of the country, even to villages and towns that had survived the invasion physically intact.

At the same time, the sentence in the memo is vague, not specifying who the users of these "cultural hubs" would be. Even if we assume an open-door policy, the aim expressed here is in keeping with sentiments representative of the early phase of the soldiers' homes initiative, when the German media also suggested, as we have seen, that these institutions would become cultural meeting points for Germans and Norwegians. The subsequent history of the homes, traced here, clearly demonstrates a different path taken, toward isolation and exclusion. It is hard to imagine how the totalizing German worlds of the soldiers' homes, as they were actually constructed, would have left any space for Norwegian voices or influences in a postwar Greater German Reich. Or perhaps the Nazis expected that these cultural hubs would always remain German soil, onto which Norwegians would someday be invited (when they were subdued and worthy) as admiring visitors rather than as equal partners.

The creation of the soldiers' homes as "utopian" German islands in Norway was tremendously expensive. Beyond the construction costs, a substantial proportion of the furnishings and supplies were imported from Germany, down to ashtrays and kitchen towels.[116] The Kristiansand and Kirkenes soldiers' homes, both Type A, cost 1,150,000 kroner and 1,126,000 kroner, respectively.[117] These figures are perhaps best understood in terms of the construction values of the time. The 1942 Norwegian national budget included a hefty appropriation of 550,000 kroner (the equivalent of salaries for thirty cabinet members) to refurbish the Villa Grande, on the island of Bygdøy outside Oslo, as Vidkun Quisling's residence.[118] Quisling renamed the mansion Gimle, after the Norse dwelling for the gods, a name befitting its palatial size and appearance. At the other end of the scale, a carpentry supervisor on a soldiers' homes construction site who "daily worked past midnight" to complete the building was paid 1.82 kroner an hour.[119]

Unlike Quisling's palace, the soldiers' homes were not meant to be lavish. To the contrary, and in keeping with the aesthetic philosophy of the Schönheit der Arbeit (Beauty of Labor)—a division of the Labor Front devoted to beautifying workers' environments, which also assisted in outfitting the soldiers' homes—the interiors aimed for a simple elegance that arose from well-crafted functional design.[120] The architect in charge of furnishing the Kristiansand soldiers' home, however, was tempted in another direction. The orders he sent to Strength through Joy's headquarters in Berlin prompted the head of its soldiers'

homes department, a Herr Kornowsky, to complain that the architect seemed to be outfitting first-class hotels. When the architect submitted a large textile order, Kornowsky intervened to prevent the homes from filling up with upholstered armchairs and thereby attaining "a completely unnecessary luxurious appearance." Kornowsky worried that to acquiesce to this architect's desires would be to set off a luxury wildfire across the homes, as other architects followed suit.[121] This fear had to do with more than rising costs, which at Kristiansand had spiraled alarmingly, or the shortages of textiles and other materials.[122] As Kornowsky's comments about first-class hotels and splendid surroundings reveal, luxury did not mesh well with the core values fostered by the soldiers' homes. Luxury typically is a marker of privilege that differentiates social classes, while inside the homes the goal was unity.

At the same time, it was not just architects who pushed for a more opulent touch. In Kristiansand, the garrison commander, Lieutenant Commander Luchting, disagreed with Kornowsky's stance on luxury, insisting that "the soldiers' homes are to be decorated more sumptuously, in order to provide the soldiers with rest and relaxation and to give them the feeling of being at home." Luchting wrote a letter to Haller on this issue, and although that document is now lost, it is possible to imagine his reasoning.[123] Although he undoubtedly understood the material shortages and the time pressures of building the soldiers' homes, he must also have felt that his troops had earned their plush armchairs.

In the midst of the first winter of the Russian offensive, in January 1942, German field army command put pressure on Haller to finish "as quickly as possible" the homes in Narvik and Kirkenes, inside the Arctic Circle, so that German troops being pulled back from the fighting in northern Russia could make use of their facilities.[124] Haller was already under considerable political pressure to complete more homes, despite the curtailments. In August 1941, Haller told a colleague, who recorded their conversation, that "the building of soldiers' homes is not a mere construction project, but rather *a political mission*. He [Haller] has received orders again from Berlin to complete as many homes as possible."[125]

Inasmuch as the homes represented a political mission, Haller and the Labor Front had to please two masters. The first was the German people, who, thanks to an overly enthusiastic press, had been led to believe that soldiers' homes were mushrooming across the Norwegian landscape already by the spring of 1941.[126] Stories tracking the sums

accumulated ensured that Germans were well aware of the spectacular success of the fund-raising campaign. The second master was the Führer himself, for whom this project represented not only a vision concerning his soldiers' welfare but also the fulfillment of a Labor Front promise. By early 1942, a year after Goebbels had extended the building of soldiers' homes into a national campaign, it appeared as if the Labor Front might not be able to deliver even on its original pledge of ten homes. As the Labor Front well knew, "the paralysis of the Führer's campaign would signify considerable damage to the reputation of the party agencies entrusted with it."[127]

The Labor Front had been forced to put twenty-six soldiers' homes on hold in 1941 (out of the thirty it had originally planned to erect that year); Haller pushed to have all of them constructed in 1942.[128] An untiring booster of the projects, Haller was clearly unrealistic in his expectations, given the ongoing shortages of cement, steel, wood, and other building materials. In the end construction began (or resumed) on thirteen new, purpose-built soldiers' homes in Norway in 1942.[129] These ranged in size from the large Type A structure used at Kristiansand to the smallest models, meant to accommodate several hundred soldiers in remote locations.

To move these projects forward with any momentum, the Labor Front needed to guarantee its supply of construction materials. Its best hope was to receive an allotment through the armed forces. Because of the tense relationship between these organizations, and the armed forces' previous refusals to dip into their own supplies, the Labor Front appealed to Fritz Todt, as Reich minister for weapons and munitions, to intervene. Todt agreed to personally advocate on the Labor Front's behalf to reach an agreement with the armed forces.[130] On January 16, 1942, Todt wrote to Falkenhorst asking him to support the construction of Norwegian soldiers' homes by ordering the various military branches benefiting from such facilities to provide steel from their own contingents. The amount, he argued, would be negligible in the broader context of the armed forces' massive building projects.[131]

Three weeks after writing the letter, on February 8, 1942, Todt perished in a plane crash and was immediately replaced by Albert Speer. At the time of Todt's death, the critical question of the steel contingent remained unresolved. Speer's priorities were restructuring and centralizing Germany's "total war" economy to boost war production. Under these conditions, and perhaps because of his previous negative

experiences with the soldiers' homes in Norway, he was decidedly less interested in helping out. In March Speer had a subordinate write to Kornowsky with bad news: Falkenhorst had declined to provide building material from the armed forces' allocations, which Speer took to indicate insufficient interest in the soldiers' homes. Speer also took into account the broader war picture in Europe and the sharp reduction of German troops that had taken place in Norway after the attack on the Soviet Union.[132] In Speer's view, "there is currently a far greater need for military accommodations in the east, so we must use any and all available building materials and workers primarily for this purpose and, for the time being, refrain from carrying out the soldiers' homes."[133]

This decision did not quite deliver the death blow to the projects planned for 1942, which plodded along with some help from Terboven's administration; but without the armed forces' support the chance to significantly expand the crop of new soldiers' homes seemed to vanish.[134] Then came yet another upturn in this history of booms and near busts. Having started with the blessing of the Führer, and an outpouring of donations from Germans, only to be, a year later, almost extinguished by economic restrictions and red tape, the soldiers' home program flourished again in the final years of the war. Following a series of British operations in late 1941 and early 1942, Hitler's fears of an Allied invasion in Norway led him to massively reinforce its coastal defenses. At the start of 1942, following troop transfers in the wake of the Soviet Union invasion, the numbers of German soldiers in Norway had fallen to 100,000. By midsummer 1942, that number had returned to 250,000 and would continue to grow until it reached over 400,000 by early 1945.[135] Soldiers' homes once again became an urgent priority.[136] Construction on many of the homes that had been halted in 1941 was revived. The realization of Hitler's dream of soldiers' homes proliferating across the Norwegian landscape again seemed not only possible but imminent.

In an effort to streamline and improve the building process, the Organisation Todt took over construction from Haller and his staff in September 1942.[137] (Haller did not fare well in the transition: he was dismissed on the grounds of "deception, etc."—perhaps on the basis of the OT's review of his account books—and arrested. He managed to flee to Sweden, where he remained until war's end.)[138] The OT's greater discipline and access to material resources, as well as control of a vast pool of POW laborers, speeded the construction of the soldiers' homes.[139] And yet the armed forces' demand for new homes tested even their

capacities; they turned down requests for additional locations in order to keep up with the many projects already under way. In May 1943, the OT's Middle Norway Operation (one of several regional divisions) alone was supervising the construction of five such homes.[140] As the buildings were completed, a new round of openings were celebrated, although with less press fanfare than before. On August 1, 1944, festivities marked the opening of two new homes: in Værnes (near Trondheim) and in Mo i Rana (just south of the Arctic Circle).[141] The last such event was the inauguration in September 2, 1944, of the soldiers' home at Ørlandet, part of the Atlantic Wall fortification in the vicinity of Trondheim (fig. 3.26).[142] The next month, German armed forces began their catastrophic retreat from northern Norway, burning everything—including the soldiers' homes—in their wake.

In total, around two dozen purpose-built soldiers' homes were erected in Norway during the war. Although this represents a quarter of Hitler's original goal, their construction is nonetheless remarkable, given the exceptionally difficult conditions facing any large-scale building project at the time. These new soldiers' homes required a tremendous investment of resources, from the funds collected through a national campaign, and the building materials secured and transported, to the equipment and furnishings purchased and shipped, and the skilled labor of construction workers (forced and paid), engineers, architects, artists, administrators, and volunteer staff.

Tens of thousands of German troops stationed in Norway used the purpose-built soldiers' homes during the occupation. Unfortunately, records of their personal experiences are scarce.[143] In a letter from June 25, 1942, Haller wrote to Reinhold Schön, one of the painters of the murals in the Kristiansand soldiers' home, about the home's opening, which he deemed a great success, and the effect of its artwork on the men. "Every day there are so many visitors that the home often has to be closed because of overcrowding. The paintings in the individual rooms always arouse lively interest among the soldiers. Many stand before the individual pictures and marvel at the works—in particular, the picture *A Soldier Reads Faust* is often the cause for lively discussions."[144]

Haller's letter brings our attention once more to the emphasis on interiority and community as defining experiences of the soldiers' homes, here represented by the contemplation of a mural and the conversation it sparked among comrades. Interiors such as these—spaces of the everyday where one could be among "one's own," performing and solid-

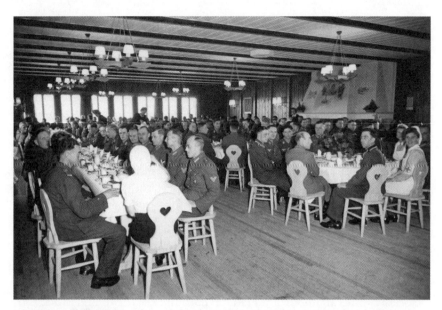

3.26. Photograph by Gäbelein, taken on September 2, 1944, as invited guests enjoyed cake at the inauguration of the Ørlandet soldiers' home.

ifying a shared German identity—are often overlooked in the study of Third Reich architecture. The soldiers' homes are particularly intriguing because they are hybrid spaces, belonging to a state institution, the armed forces, and yet also a place where one could be "off duty." Their constant comparison to German homes reveals that they were meant to be thought of as a domestic realm, in which, however, the occupants belonged first and foremost to the nation. In this sense, they were part of a broader transformation of German homes occurring in this period, in which the lines between family and state were increasingly blurred.

Like the autobahn or polar railway, the soldiers' homes cannot be explained by function alone. The armed forces, after all, had established facilities (fellowship houses) for the troops' recreational hours, and although these may not have been architecturally inspiring, they fulfilled the need to pass time. By contrast, the soldiers' homes were something above and beyond. They were aspirational projects about creating realms of German culture and domestic order in unruly lands. They reveal how the Nazis began to develop new architectural forms in conquered territories to reinforce bonds to the homeland and among Germans spread out across the vast expanse of the Greater German Reich.

The soldiers' homes also raise the question of how relationships would have looked between Germans and Norwegians down the line,

had Hitler's vision of an Aryan-dominated empire taken hold. For all the Nazi propaganda about Germans and Norwegians' shared racial roots and cooperation, celebrated in countless press stories, the soldiers' homes betray a determination to maintain the "apartness of the rulers." The soldiers' homes also cast the *Lebensborn* homes, another new type introduced by the occupiers, in a different light. The Norwegian sweethearts banned from the soldiers' homes by Falkenhorst were the same women welcomed by the *Lebensborn* authorities. But if Norwegian women were valued for their genes, their presence was unwelcome in German spaces; they remained fundamentally unequal in the eyes of their "superior" German partners. Nor did it end here. This diminution and repulsion extended beyond the female population to include all Norwegians, culminating in Hitler's ambitious but unrealized plan for a new German city in Norway, to be designed around German culture and populated by Germans. The construction of soldiers' homes therefore stands as an important material harbinger of the intended Nazi colonial rule to come, which, it seems, would have kept the Norwegian people and their wintry climes at a distance, even as Germans settled in for the long term.

4 The Nazification
of Norway's Towns

Shaping Urban Life and Environments
during Wartime

In May 1942, the German-occupation magazine *Deutsche Monats-hefte in Norwegen* featured the photograph of a burning Norwegian house over which it superimposed the article title "The Reconstruction of Norwegian Cities."[1] What was, from the point of view of the occupied, a symbol of the calamity that had befallen their nation was, from the conqueror's perspective, an opportunity. For Adolf Hitler, a burning house was a beautiful thing, because fire cleansed and prepared the ground for the construction of his Greater German Reich.

About fourteen thousand buildings had been destroyed during the German invasion in the spring of 1940. The cost of their reconstruction was estimated at four hundred million kroner: an immense burden for Norway, equivalent to two-thirds of the national budget for 1939–40.[2] Twenty-three towns had been damaged, and some—Bodø, Kristiansund, Namsos, Narvik, Molde, and Steinkjer—had seen their centers obliterated (fig. 4.1). But none of this, the Germans were quick to point out, was the occupiers' fault. According to Edgar Luther, Reich Commissariat chief architect and author of the article, Norway was fortunate that the Germans had managed to repel the Allies so quickly, thus sparing the country a long war and even worse physical destruction. In addition to blaming the Allies, Luther castigated the former democratic Norwegian government for failing to offer war damage insurance to protect its people and their property in the event of a conflict. The dense timber building in town centers, Luther continued,

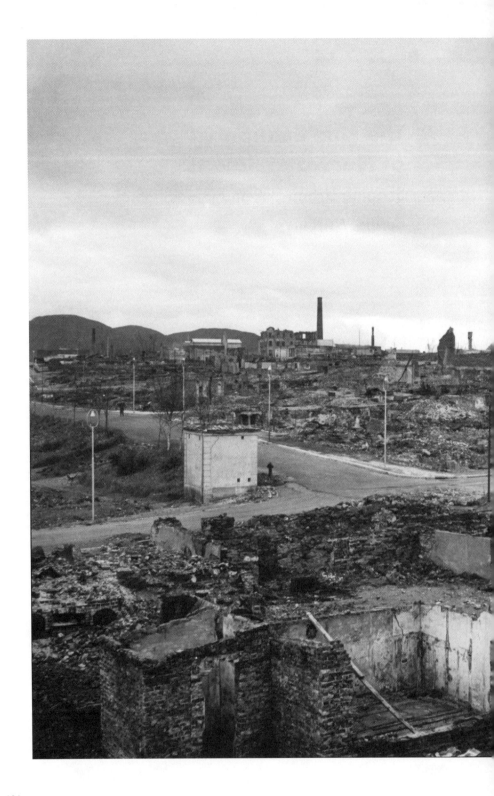

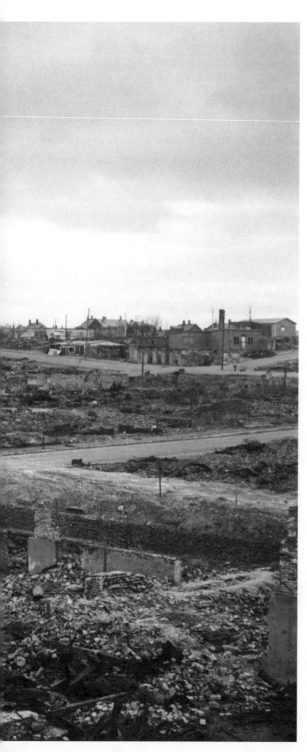

4.1. View of the destruction in Bodø after the German invasion. Hans Stephan included this photograph, which he may have taken himself, in the travel diary he produced documenting his trip to northern Norway in July 1941.

also fueled the fires. As a result, he concluded, the Germans were left with "a lot of catching up to do."[3]

For the occupiers, a major hindrance to this "catching up"—although Luther did not say so in his article—came in the form of the Norwegian architects tasked with reconstruction. Whereas the Norwegians wanted to restore what had been lost, the Germans aimed to build toward their vision of a National Socialist future. In August 1940, Reich Commissar Josef Terboven asked Hitler's favored architect, Albert Speer, to oversee the reconstruction planning. Speer agreed insofar as his role was understood to be advisory, with Terboven remaining responsible and making final decisions. The following month, Speer sent a high-level representative from his office, in his capacity as Berlin's general building inspector (GBI), to assess the situation.[4]

Hitler had appointed Speer to lead Berlin's architectural development in January 1937, on the fourth anniversary of his ascension to power. He granted Speer and his staff enormous—some have argued, nearly dictatorial—powers to transform Berlin into the "world capital" Germania, the future metropolis of the Greater German Reich. Hitler "decreed that Speer's personal staff were neither a government agency nor a branch of municipal government: they were answerable to Speer alone." Speer, in turn, answered directly to Hitler. Speer's design for Germania was organized around two grand axes running north-south and east-west through the city, intersecting at the Brandenburg Gate. The architect Hans Stephan supervised planning for the fifty-kilometer-long east-west axis. Stephan was the second-in-command in Speer's GBI office, the senior department manager responsible for master planning, traffic, industry, and housing.[5] Construction of the east-west axis was well under way when Speer asked Stephan to interrupt his work in Berlin and go to Norway for two weeks, from September 20 to October 5, 1940 (fig. 4.2).

Stephan's assignment was to evaluate, through on-site visits, the reconstruction proposals for damaged towns prepared by the Norwegian architects in relation to the possibilities and limitations of local conditions. Over the two weeks, he traveled to Åndalsnes, Molde, Kristiansund, Steinkjer, Namsos, Elverum, and Trondheim, in addition to meeting with officials and architects in Oslo. Given Stephan's position in the GBI, an office charged with building an imperial capital, it is not surprising to find his appraisal of the Norwegian reconstruction plans influenced by an emerging hub-and-spoke relationship between Berlin

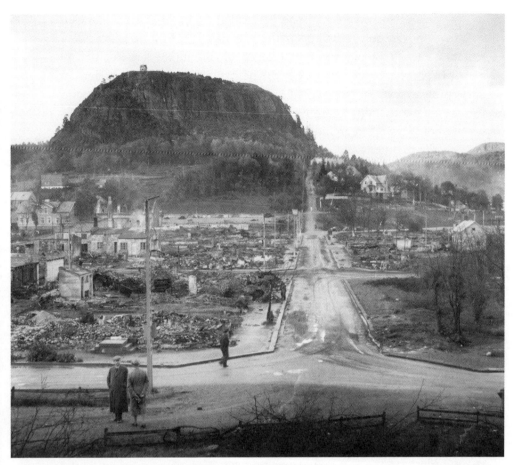

4.2. Sverre Pedersen (facing the camera) standing beside Edgar Luther in Namsos. Hans Stephan toured the war-damaged towns with Pedersen, Luther, and Norwegian architects Claus Hjelte and John Horntvedt in the fall of 1940. This photograph was taken from the site of the destroyed church, looking out at the Bjørumsklumpen, the rocky outcrop at the town's center, and the road toward it that would become the main axis for the Namsos reconstruction plan.

and the peripheries of the Greater German Reich. Moreover, Stephan, whose GBI work focused on designing the center of the center—the core of a world capital—was steeped in thinking about the role that urban centers were to play in the new empire. Through publications and lectures in Germany and abroad, he articulated the ideals of the GBI and of Third Reich architecture more broadly.[6] Stephan's recommendations for the Norwegian reconstruction plans were thus deeply informed by the ideological mission of Speer's office.

The plans under review, by contrast, had been crafted with vastly different intentions. Even as the invasion continued to be fought in

the north, Norway's remaining political and administrative establishment moved quickly to repair the war damage. In June 1940, a new state agency, Burnt Sites Redevelopment (Brente Steders Regulering or BSR), was created to lay out the new town plans. Sverre Pedersen, a professor at the Norwegian Institute of Technology in Trondheim and an internationally renowned urban planner, led the agency and its staff of Norwegian architects. Beyond his team, Pedersen reached out broadly to other architects, institutions, and the affected communities for their input on the plans and to help with the enormous challenges they faced in rebuilding. The BSR was directed to produce new town plans rapidly, allowing for few preparatory studies. In addition to time pressures, financial considerations also limited the designs; particularly, the need to retain surviving buildings and the earlier street layout. Although the agency foresaw some modernization of the damaged areas, it also sought to preserve their small-town qualities.[7] Just months after the destruction, in August and early September, the BSR published its first reconstruction proposals in the Norwegian press.[8]

Stephan was dismayed at the rush to present the public with completed designs, which he suspected was an attempt by Pedersen to push them through as a fait accompli. In the report he submitted to Speer when he returned from Norway, Stephan expressed disappointment with the proposals he had reviewed in Oslo, and with the conservative, parsimonious mind-set of the BSR planners, who focused on modest, targeted repairs rather than taking a broader view of urban design. He directed his most substantial criticism, however, at what he saw as the weakness or formlessness of the town centers. He wrote, "Only a few plans make the attempt at a firmer layout of the town center. The plans cling too closely to the existing conditions. Community consciousness, which also has to be expressed in urban design, is innately foreign to the Norwegian." The right kind of public spaces, Stephan believed, would help lead Norwegians away from the previous era's "emphatic individualism" toward the new communal ideal.[9]

The idea of the *Volksgemeinschaft*, community of the people, was a political cornerstone of National Socialist ideology. Historian Michael Wildt describes the production of the *Volksgemeinschaft* as "a process of social inclusion that was supported by promises of equality, economic prosperity, and symbolic recognition."[10] At the same time, this process exacted a very high price: terror, the loss of political freedom, and

the exclusion and annihilation of those judged to be alien—whether in body, mind, behavior, or belief. For Detlev Peukert, a scholar interested in everyday life in Nazi Germany, the social utopia of the *Volksgemeinschaft* was a performative concept that embraced mass rituals, celebrations, and festivals.[11] The Nuremberg Rally Grounds were the most famous of the spaces designed for this performance, but the *Volksgemeinschaft* was enacted on many lesser communal stages as well, such as on streets and in town squares.

Already in *Mein Kampf*, published in 1925, Hitler had argued for the importance of representing the *Volksgemeinschaft* in architecture. Moreover, he contended that such structures should be publicly owned and take precedence over private concerns. Looking admiringly back at ancient Rome, he noted that temples, public baths, basilicas, stadiums, and other monuments that belonged to the state, and thus to the people as a whole, dominated the center of the imperial capital. Private spaces, including commercial and residential buildings, occupied less prominent locations. The "landmarks" of the *Volksgemeinschaft* were also those designed to last: as Hitler stated, "The few still towering colossi that we admire today amid the ruins and rubble of the ancient world are not the former commercial palaces, but temples and state buildings; that is, works that belonged to all." This dedication to communal monuments, Hitler continued, was upheld in medieval cities, with their great cathedrals. But by the modern era, the industrial city, devoted above all to profit, no longer invested in architectural representations of the people. (Modern public buildings, such as the Reichstag, left Hitler unimpressed.) Rather, he claimed, disproportionate amounts were expended on private buildings: the "Jewish" department store, for example, became the modern counterpart of the Roman temple and the medieval cathedral. To remedy this state of affairs, Hitler believed that "in the future, the Germans would have to build as the Romans had done."[12]

Such beliefs deeply colored urban-planning principles in Nazi Germany and also guided ideas of how to construct the empire abroad. In his report to Speer, Stephan wrote that the built environment had an integral role to play in the development of a new collective consciousness in Norway and would prepare the way for the incorporation of the nation's "emphatic" individuals into the *Volksgemeinschaft* of the Greater German Reich. The occupiers sought to embed this future "utopia" directly into the reconstruction plans—particularly in the urban layout

and building types. The physical environment, shaped with ideological intentionality, would serve as an instrument of transformation, turning the Norwegian people into *Volksgenossen*, racial comrades.

Speer and Stephan were not at all sure that Pedersen was the right architect to put in charge of achieving these goals. Among his other tasks, Stephan's mission to Norway involved an assessment of Pedersen's character and abilities. Stephan reported to Speer that Pedersen had "always been German-friendly," judging from his studies in Germany and his manifold professional connections there. He appeared to be "quite uninterested" in politics, claiming that "an engineer 'has no time for such questions.' " In their conversations, Pedersen also mentioned—pointedly, Stephan felt—"that he never belonged to any party movement nor any freemasonry lodge."[13] Yet remaining apolitical in Nazi-occupied Norway suggests less inclination than determination. Pedersen's insistence that he had "no time for such questions" obscures the consuming difficulties that befell his family after the invasion. One of his sons, Einar, battled the Germans in Norway before fleeing on skis to Sweden, making his way to Canada, and training and fighting as a pilot and navigator with the Allies. A second son, Gunnar, disappeared in the invasion, and Pedersen searched frantically for news of his whereabouts. The eldest son, Ragnar, was arrested in the fall of 1941 as a spy and sentenced to death. Pedersen was able to use his connections to save his life, although Ragnar was transported to a prison in Germany. Thus regardless of his claim to be apolitical, Pedersen had strong reasons to tread lightly in order to avoid alienating those in power. In assessing Pedersen's political reliability, Stephan may have been concerned less with the Norwegian's capacity to be turned into a believer than with his propensity to refrain from interfering with German plans. In his report, significantly, he noted the fact of Pedersen's missing son. Whether Stephan saw this as a threat or as leverage he did not say.[14]

Pedersen's vast experience and stature as a planner, by contrast, were never in any doubt. Nonetheless, Stephan was ambivalent in his assessment of Pedersen's reconstruction proposals. The weaknesses that Stephan saw in some of his plans, particularly their timidity and lack of imagination, he attributed largely to the restrictions imposed on Pedersen by Norwegian bureaucracy, budgets, and property laws. Pedersen himself recognized the weaknesses, and Stephan believed Pedersen could produce better designs if freed of these limitations. "In all

cases," Stephan noted, "we discussed the essential features of a better and more generous solution."[15]

Although Pedersen's stated willingness "to draw up plans that break free of these excessive restrictions and meet our needs" weighed in his favor, Stephan faulted what he saw as the Norwegian's obsequiousness. "He seems to be a little bit lacking in integrity for he often asked, 'Would you like this square, or would you not like it?' 'Would you like gables, or would you like hipped roofs?' 'You could have both, just as you wish.'"[16] These comments, beyond revealing Stephan's blindness to how power distorted his dealings with Pedersen, suggest that Speer and Stephan wanted Norwegian architects to contribute their own ideas to the design process—even while also expecting them to "meet our needs."

Pedersen's age—he was then fifty-eight—also counted against him (fig. 4.3). For Speer, who had been appointed general building inspector for the Reich Capital at the age of thirty-one, empire building was a young man's game. In his Berlin office, Speer surrounded himself with young male colleagues. His three closest architectural associates— Stephan, along with Willi Schelkes and Rudolf Wolters—were still in their thirties at the time of the Norwegian invasion. Joachim Fest, a German journalist who helped Speer compile his memoirs, wrote that Speer had a rule "that no leading colleague should be more than fifty-five years old, and that deputies should at most be forty. In this way he made the staff exceptionally youthful, and soon people were using the expression 'Speer's boys' and speaking of the 'knavish pranks' they permitted themselves." As Speer told Fest: "No one past his mid-fifties who has been successful escapes the proven formula. Everything turns into routine and arrogance."[17]

Given the cult of youth in Speer's office, some young Norwegian architects saw Stephan's visit as an opportunity to challenge Pedersen's proprietary hold on the reconstruction projects. Stephan noted in his report that "among the younger architects, Pedersen has the reputation of not tolerating rivals."[18] While in Oslo, Stephan met with one of Pedersen's most vocal young critics. Fred Minsos, a Canadian-born Norwegian, had studied architecture in Stuttgart under Paul Bonatz. He had come to the attention of Nazi officials when, in August 1940, he had written a letter to Joseph Goebbels, in his capacity as the Reich Chamber of Culture president, criticizing the Norwegians' handling of the reconstruction process, requesting German intervention, and declaring

4.3. Hans Stephan (left, in the light-colored trench coat) and Sverre Pedersen (right) in Kristiansund. Stephan pasted this photograph in his October 1940 report for Speer over the caption "Assessment of Sverre Pedersen (right, in front of the stack of clipfish)."

himself "an adherent of the German worldview."[19] (The letter was for-warded to the Reich Commissariat, and was perhaps a factor in Ter-boven's appeal to Speer.) After meeting them at a pub, Minsos invited Stephan and Luther back to his apartment to show them his drawings. Stephan described the late-night scene in the apartment, including the decor—a picture of Bonatz hanging on the wall beside a clock designed by Heinrich Tessenow, Speer's former teacher and mentor—and Min-sos's "very lively" mother serving up sandwiches. He noted that Min-sos, whom he judged to be about thirty, had been married to a German architect who had recently died in childbirth, and that both "he and his mother have always been very German-friendly."[20]

Minsos told his visitors that there were a number of talented young Norwegian architects, many of whom had studied in Germany, and

especially in Stuttgart. They had, thereby, gained a solid educational foundation, he maintained, even if this had been weakened by the influence of functionalism upon their return to Norway. While admitting Pedersen's superior experience, Minsos criticized him sharply for blocking younger architects. At the same time, he argued that holding open architectural competitions would not solve the problem because young Norwegian architects had too little experience, especially in urban planning, which was handled "completely wrongly" at the Norwegian Institute of Technology (under Pedersen). Indeed, he joked to Stephan that the entire school should be shut down so that Norwegians would be forced to study in Germany. For all these reasons, Minsos felt that the best solution for the reconstruction of Norwegian cities would be to establish a cooperative of younger architects working with Pedersen under close German supervision. Minsos recommended that Speer send a representative to Norway for three months to develop the plans closely with the cooperative. Stephan responded enthusiastically.[21]

The meeting with Stephan further emboldened Minsos, and three weeks later he took the attack on Pedersen public. On October 30, 1940, Minsos published an article on the reconstruction of Norwegian cities in *Fritt Folk*, the newspaper of Norway's fascist party Nasjonal Samling. There was no mistaking his message. "The new era," he wrote, "needs new men with fresh powers." The BSR plans, he claimed, offered nothing forward-thinking or dynamic: "The proposals display in many instances the same deficiencies and weaknesses that the cities already had before. This shows that the proposals' instigator, Professor Sverre Pedersen, does not have the power to break free from this now outdated, calculating, and narrow-minded attitude." According to Minsos, this mind-set resulted in Pedersen's focus on "trifles" and his consequent failure to grasp the "beautiful, healthful, and harmonious" city as a spiritual force for the new age, which would mold future generations. Minsos concluded, "We have enough capable young architects who, if given the chance and necessary employment opportunities, are able to solve these problems."[22]

Despite Minsos's efforts to make the energy of youth a focus (or even requirement) of the reconstruction of Norwegian cities, Pedersen was too important to sideline. In addition to his expertise in urban planning, he had over the decades drafted plans for many Norwegian towns, including the majority of those damaged in the invasion.[23] Because of the destruction of municipal offices and their collections of

town plans and maps, Pedersen's archive contained blueprints and other records indispensable for rebuilding.[24]

But it was not just experience and expediency that Pedersen had to offer. The National Socialists also liked his style. Pedersen's work reveals the influence of several different periods in European town planning. On travels to France and Central Europe, he had studied baroque town plans, with their geometric principles of axiality and symmetry, and their broad, radiating avenues with long, uninterrupted vistas. Norway had its own impressive baroque precedent that deeply influenced Pedersen: Johan Caspar von Cicignon's plan for the reconstruction of Trondheim, created after the city was destroyed by fire in 1681. Ebenezer Howard's English Garden City movement, emerging around the turn of the twentieth century, left its mark in Pedersen's treatment of town and countryside as a harmonious unit, and in his careful attention to landscape design as a means to improve the quality of life for urban residents. Scottish biologist and town planner Patrick Geddes's ideas of holistic urban design informed Pedersen's incorporation of views to the surrounding topography into his urban plans as a means to ground them in place.[25] The impact of interwar functionalism is evident in Pedersen's concern with hygienic housing, particularly the demands for light and air.

Generally speaking, these various elements aligned with the direction of National Socialist town planning in Germany, an affinity that did not escape Stephan's attention. On October 3, 1940, the day after visiting Minsos at home, Stephan met again with the young architect at the National Association of Norwegian Architects' library in Oslo. After noting that the National Socialist art journal *Die Kunst im Deutschen Reich* was nowhere in sight, Stephan proceeded with Minsos to leaf through "a large number of volumes" of *Byggekunst*, the association's official magazine. The two men hoped to evaluate architects who might join the reconstruction effort, but as Stephan wrote in his report to Speer: "The general impression is awful. The crazier, the better. In urban design, almost nothing." Judging the work of Oslo's city-planning department to be even worse, he conceded that "the only urban designs in which one comes across approaches that reflect our own thinking are still those of Pedersen."[26]

After leaving the library, Stephan went to the Storting, the Norwegian parliament building, to report his findings on the BSR's reconstruction plans to Terboven. Also in attendance were other Reich

Commissariat administrators, including Carlo Otte, head of the Economy Department, Heinz Klein, head of the Engineering and Transport Department, and Edgar Luther. Terboven listened attentively, having taken over just days earlier—on September 25—what was left of an independent Norwegian government, with the creation of a Norwegian puppet cabinet accountable directly to him, a political shift that also brought the BSR under German rule. After laying out the problems, Stephan concluded that "in the German sense, the plans and models should be regarded only as preliminary studies." He told his listeners that the creation and actual realization of superior plans necessitated the following preconditions: reform of the legal basis for expropriation and reallocation of property; a ban on all building in the reconstruction zones to prevent individuals from erecting structures that interfered with the plans; and generous reconstruction budgets. Terboven directed his staff to begin immediate action on these matters, although he was firm that Norwegians would have to pay for the reconstruction themselves. If they were too miserly to accede to more generous measures, he added, then the towns would just have to remain there lying in ruins. As he told Stephan, there was no hurry to rebuild—rather, he laid greater emphasis on the quality of the plans. "Norway now belongs to the Greater German territory," he stated, "and the newly reconstructed districts should show later on that under German leadership they were built perfectly."[27]

Thus in a meeting with no Norwegians present, the country's hope of quickly repairing its damaged towns was effectively dashed so that the occupiers could take their time and build in a manner flattering to the Greater German Reich. That some towns were in a state of catastrophic need—more than eight hundred buildings had been lost in Kristiansund alone, a town of fifteen thousand residents—concerned the men at the meeting not at all.[28] With regard to the designs themselves, Terboven was clear that nothing should happen without the involvement and approval of Speer's office. Nonetheless, he said that he wanted the Norwegians to have "the feeling" of directing their own affairs.[29] While Norwegians were thereby encouraged to take charge of the rebuilding of their cities as (ostensible) partners in shaping a new era and empire, Germans intended to keep tight control over the plans' development—a contradiction that underlay the reconstruction efforts throughout the occupation years.

Later that afternoon, Stephan held a meeting for Norwegian ar-

chitects, engineers, and lawyers to deliver his message about the reconstruction. In the small assembly hall in the Storting, Stephan hung photographs and plans for Berlin and other German projects on the walls and placed BSR models and plans around the room. The setting was thus prepared for a lecture on empire and architecture intended to clarify the relationship of metropole to periphery—both of which were represented here, in blueprints and bodies, in one room. Stephan underscored his own position of power by holding this meeting in the Norwegian parliament building, now occupied by the Reich Commissariat. Although he had invited and expected about thirty people to attend, including BSR architects and officials, almost one hundred crowded into the room.[30]

"I tried to make it clear to them," Stephan wrote in his report to Speer, "that the fate that has befallen some Norwegian cities must be used to create something truly flawless as well as relevant for the future." The rebuilding, he told his listeners, was about "a shared European challenge, which cannot be met with the previous methods of an emphatic individualism and with the means of the so-called 'functionalism' still so popular in Norway." Stephan then turned to examples of Speer's designs for Berlin and to other German cities to illustrate "the basic principles of healthy urban planning." Here he emphasized in particular "the importance of the city center as an expression of the urban community."[31]

To the assembled group, Stephan described the BSR plans as "valuable preliminary work" but unacceptable in their current form as the basis for the reconstruction. As a step toward their reworking, he announced that Speer would invite a number of Norwegian architects for a study tour of Germany, "to give them the opportunity to study firsthand our plans and buildings, and to utilize them for their own Norwegian purposes."[32] The idea of the study tour originated with Terboven, who saw it as training necessary for the Norwegian architects to successfully tackle the reconstruction.[33] He asked Speer to organize it, and while in Norway, Stephan, with Minsos's help, vetted Norwegian architects who might be included on the trip.[34]

In early November 1940, seventeen Norwegian architects, including Pedersen and Minsos, embarked on a three-week study trip of Germany and Austria.[35] Their itinerary, with visits to more than sixteen towns and cities, reveals what Speer and his colleagues believed to be the architecture and urban plans most representative of a new era and em-

pire. From busy construction sites transforming Berlin into Germania to tranquil new towns in the distant Alps, the Norwegians absorbed the complex and far-reaching elements of the New Order as well as the monumentality of the mission awaiting them upon their return. They were, in essence, traveling into their own future, as mapped out for them by their occupiers.

The Norwegians began their journey in Berlin with a morning visit on November 4 to Speer's GBI headquarters on Pariser Platz (by the Brandenburg Gate), in the former Prussian Academy of the Arts, which housed the hall displaying Speer's enormous models for the transformation of Berlin into Germania. With the models as visual aids, discussions focused on the organization of traffic, including underground arteries and connections to the autobahn on the city's periphery, as well as on the political buildings, such as the Volkshalle, a mountain-sized assembly hall in which 180,000 people could gather to hear the Führer speak.[36] Speer had designed the Volkshalle on the basis of Hitler's sketches as the centerpiece of the new capital. The Norwegians thus came face-to-face with the heart of a megalomaniacal empire toward which they were expected to orient themselves. This terrifying vision was rapidly becoming reality outside the hall of models. Over the course of the next two days, the group toured some of the places in Speer's plan that were already under construction: the Round Plaza, the grand circular space where the north-south axis intersected with Potsdamer Strasse; and tunnels that were part of an underground transportation network for roads and rail. Fritz Todt, the celebrated father of the autobahn, introduced them to the superhighways leading to the capital.[37]

In Berlin, Munich, and Nuremberg, the Norwegian group visited monumental buildings that embodied the technological, political, and cultural aspirations of Hitler's regime. On the southern outskirts of Berlin, they explored Tempelhof Airport, then the most modern airport in Europe, with its architect, Ernst Sagebiel. Stylistically, Tempelhof Airport blended new and old with its "two faces": a steel-and-glass aesthetic, evoking modern technology, faced the airfield, while stately stone facades greeted the public on the city streets.[38] In the city center, Stephan escorted the group through the vast marbled spaces of the New Reich Chancellery, a monumental edifice by Speer meant to communicate imperial power. Here and elsewhere, the appropriation of classical styles and motifs positioned the regime as the successor of antiquity's great civilizations. On the city's western edge, Werner March showed

off the severe, classically inspired stadium and amphitheater as well as the parade ground that he had designed for the 1936 Olympic Games and for political assemblies. In Munich, the Norwegians encountered the late Paul Troost's austere classicism in his Führerbau (which housed the offices of Hitler and his staff) on the Königsplatz, and in his House of German Art, where they also viewed an exhibition representative of the new German art sanctioned by Hitler, which had been purged of Jewish, modernist, and other "degenerate" influences. In Nuremberg, Walter Brugmann, Speer's associate and senior construction manager for the Nazi Party Rally Grounds, led the Norwegians through the sprawling complex of stadiums and parade grounds laid out by Speer on a colossal scale and evoking the ancient structures of Rome.[39]

What did the Norwegian delegation think of this new national architecture, a variation of which they were expected to develop in their own country? Minsos, at the end of the trip, wrote a laudatory account for the newspaper *Norges Handels og Sjøfartstidende* (Norwegian Commerce and Shipping News). While admiring the different styles of buildings they had encountered and the quality of workmanship each displayed, he was impressed above all by the spirit of progress and idealism that seemed to infuse the projects. This included even the new Nuremberg Zoo, which had opened in 1939 and let the animals roam free in enclosures integrated with panoramic landscapes. At the same time, Minsos downplayed the physical impact of the war in Germany, noting, for example, that the three air raid alarms they had experienced during their travels had not been followed by actual bombings.[40]

Pedersen's response was more ambivalent and cautious. At a luncheon on November 15 hosted by Munich's mayor for the visiting architects, Pedersen gave a brief speech in which he described his impressions of the delegation's first two weeks in Germany. More than once, he mentioned the monumentality of the plans and buildings they had seen, without further elaborating on their qualities. Turning to Munich, Pedersen delivered a short history lecture. He praised the great architects of its past, including Leo von Klenze, who had laid out Munich's Königsplatz in the nineteenth century. He also named the city's famed painters, such as Franz von Lenbach, as well as the Norwegian artists who had spent time in Munich, including Eilif Peterssen and Henrik Ibsen, which served to pay tribute to the city as an artistic mecca (especially in the nineteenth century) while also reminding those present of Norway's own artistic accomplishments. Notably absent from

Pedersen's address were specific references to Munich's National Socialist artists and architects, such as Troost, whom Hitler considered the equal of Klenze. Pedersen closed by nevertheless acknowledging that "the time of great order" had arrived in the city, with its characteristics of "force" and "beauty."[41]

On the previous evening, architect Hermann Giesler had addressed the Norwegian visitors upon their arrival in Munich. Giesler was a devoted National Socialist. In 1938 Hitler had appointed him general building inspector for Munich and entrusted him with the city's redesign in keeping with its official status as the "Capital of the [Nazi] Movement."[42] In his speech to his Norwegian colleagues—glimpsed through Pedersen's notes—Giesler focused on the "driving forces" behind city planning in the new era. Suggesting how Nazi values were reconciled with and presented through the lens of older, more familiar urban ideals, he cited the philosopher Aristotle on the purpose of the Greek *polis*: to make its citizens "secure and happy." This ancient voice was filtered through the writings of the nineteenth-century Austrian architect Camillo Sitte, who had invoked Aristotle to argue that "a city must be so constructed that it makes its citizens at once secure and happy. To realize the latter aim, city building must be not just a technical question but an aesthetic one in the highest sense."[43] For Giesler, the National Socialist planner had to put the *Volksgemeinschaft* at the core of the modern urban expression of those eternal human needs for security, happiness, and beauty. Indeed, the racial community had become the highest value of the new age. Referring to cathedrals that had once formed the heart of medieval towns, he stated that the "new religion" was "the idea of the community." Giesler concluded by insisting that "Norway build Norwegian," and singled out for special mention Trondheim and the traditions of timber architecture. His admiration for the latter is evident in the elaborate wooden interiors he created for his own National Socialist buildings.[44]

Even as the study tour organizers sought to educate and improve the Norwegians in their charge, they spared no effort to make their guests feel valued and welcomed. The most prominent architects and engineers of the Third Reich offered personal tours and presentations. Mayors in various cities held receptions to honor the visitors, who were wined and dined and put up in grand hotels such as the Hotel Weinzinger in Linz, where Hitler himself had stayed after Austria's annexation. In the evenings the architects were treated to theater and

opera performances, although on one occasion—on the seventeenth anniversary of the Beer Hall Putsch on November 8—their German hosts arranged for them to listen to a speech by Hitler, broadcast from Munich. (In it, the Führer stated that he had permitted his armies to strike only at military targets in Norway. One can only imagine what the Norwegian architects, preparing to rebuild the towns Hitler had destroyed, thought of his words.)[45] At the end of the trip, Speer threw the visitors a farewell party at the clubhouse of the Kameradschaft der Deutschen Künstler (Fellowship of German Artists) in Berlin, a National Socialist artists' association.[46] Taken as a whole, this preferential treatment reveals that the tour was not just about studying Third Reich architecture but also about convincing the Norwegian group of the Führer's best intentions and their welcome into his New Order.

Although the Norwegian architects experienced many different architectural forms of this New Order while in Germany and Austria, the most dominant examples, based on their itinerary, were the model housing settlements, often associated with Third Reich military or industrial concerns. In his article about the study trip, Minsos stated that urban planning and German *Siedlungen*, or housing settlements, were a focus of the tour.[47] While in Berlin, they had visited the housing estate of the Heinkel aircraft factory in Oranienburg, which produced fighter planes for the Luftwaffe. Starting in 1936, architect Herbert Rimpl designed the factory and laid out a vast housing settlement, with more than twelve hundred dwellings for some six thousand residents.[48] The ultramodern style of the plant—considered, when it was built, "the best equipped and the most efficiently operated aircraft producing plant in the world"—contrasted with the traditional look of the housing settlement.[49] This stylistic split typifies Third Reich architecture, which favored functionalism for industrial and technical facilities, local and regional vernacular (or *Heimatstil*) for housing, and stripped-down classicism for representative public buildings—a combination of forward- and backward-looking approaches that was in keeping, as architectural historian Ian Boyd Whyte has pointed out, with the regime's modern and reactionary mythologies.[50]

Other housing settlements on the Norwegians' itinerary included Mascherode (the tour of which was led by its principal designer, Julius Schulte-Frohlinde) and Lehndorf, both in Braunschweig; the neighboring Salzgitter, planned as an industrial city in a natural setting (the Nor-

wegian delegation met with its chief architect, Herbert Rimpl—also responsible for Oranienburg); Volkswagen's factory town at Fallersleben, renamed Wolfsburg after the war (where the group met with its lead architect, Peter Koller); and a number of estates under construction in Austria for the Reichswerke Hermann Göring iron and steelworks and ore-mining operations.[51] Although the settlements varied considerably in scale, they shared urban design principles that aimed at the reorganization of public life under National Socialism. It was this vision of a collective political existence grounded in local, everyday spaces that appears to have been the central message intended for the Norwegian visitors.

Among Pedersen's mementos of his German travels are publications on Lehndorf that reveal how National Socialist housing settlements gave form to the *Volksgemeinschaft*, the "new religion" spoken of by Giesler.[52] Most of the houses in the community were single-family homes, but large four-family units lined the main street on either side to give it "a strong framework"—an articulated boulevard ideal for processions (fig. 4.4).[53] On this avenue, and at the urban and ideological center of the settlement, stood the Aufbauhaus, a monumental L-shaped complex, with a tower on one end as well as an adjoining plaza. The name Aufbauhaus is important: *Aufbau* was a term frequently used in National Socialist literature to denote a radical break with the past and the building up of something new and hopeful.[54] In the context of Lehndorf, it can be translated as "Resurrection House."

The Aufbauhaus (fig. 4.5) was a multiuse complex that contained an elementary school, with a gymnasium that could double as a meeting hall for five hundred; the tower accommodated Nazi Party administrative offices, social services, and organizations, including Hitler Youth, as well as the police and local authorities. Attached to the front of the tower was a memorial hall commemorating the fallen in the early struggles of the Nazi movement and in the First World War. This hub of social life at the center of town was thus strongly defined by the National Socialist organizations and mythologies at the core of the *Gemeinschaft* ideal. Murals painted inside the Aufbauhaus depicting themes such as the homesteaders' bonds to blood and soil reinforced such tenets. The connection to place was also visually incorporated into the urban plan, with the main street leading to nearby woods. The residents were themselves expected to be model citizens of the Third Reich. All

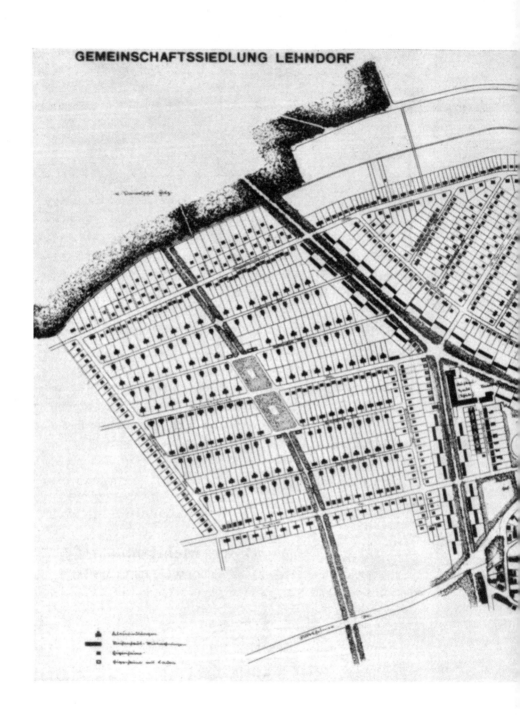

GEMEINSCHAFTSSIEDLUNG LEHNDORF

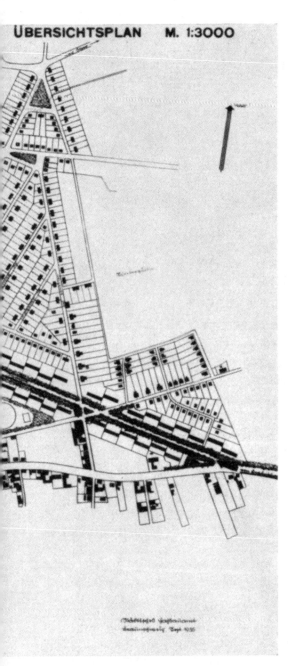

ÜBERSICHTSPLAN M. 1:3000

4.4. Plan (c. 1936) of the Lehndorf settlement in Braunschweig showing the main street (the dark diagonal double lines stretching from top left to bottom right) and the L-shaped Aufbauhaus in the center.

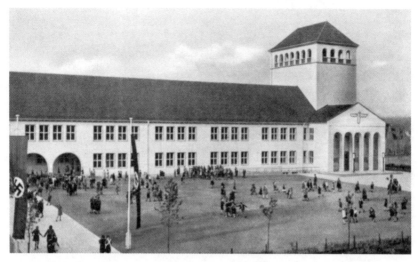

4.5. Partial view of the Aufbauhaus and adjoining square in Lehndorf, c. 1936. To the right is the tower that housed Nazi Party organizations and the police. The memorial hall stands at the bottom. Photograph by Gertrud Hotze.

prospective residents had to undergo a doctor's examination to verify their racial health, as well as an examination of their character and political reliability.[55]

As the Norwegians absorbed this new Germany, their hosts "assisted" them with the application of the study trip lessons to the design of Norwegian urban spaces. At both the beginning and the end of the Norwegians' travels, Stephan met with them in Berlin to assess the BSR reconstruction plans. The first consultation, at the start of the study tour, occurred among Stephan, Luther, and Pedersen. In this meeting Pedersen presented plans that he had reworked on the basis of Stephan's criticisms made the previous month in Oslo. At the end of the trip, just before the Norwegians departed for home, and with the accumulation of experiences still fresh, Stephan and Luther met with the group as a whole to discuss the reconstruction plans.[56]

In her biography of Pedersen, art historian Helga Stave Tvinnereim asserts that he was convinced that Norwegian control of the BSR, and his leadership in particular, were at stake on this trip.[57] These concerns may explain Pedersen's reluctance to speak negatively about the National Socialist design projects that he encountered in Germany and Austria and their ideological foundations—although the belief that a town planner needed to rise above politics was also deeply engrained in

him. Pedersen was not wrong in sensing that he was under evaluation. In Vienna Stephan met with Luther, Minsos, and Wilhelm Essendrop—an architect and chair of the Nasjonal Samling's Committee on Culture, whom Stephan described as a "Quisling man"—to discuss Pedersen's continued role in the BSR. As Stephan told the Norwegians, the Germans' intention was to limit Pedersen to designing just two plans on his own and to leave the other cities in the hands of architectural teams, composed of two younger architects each, supervised by Pedersen. Although Minsos had earlier proposed to Stephan that Pedersen work with a cooperative of young architects, now he and Essendrop protested that it could be "dangerous" to retain Pedersen in a supervisory role, given what they saw as his domineering manner. The younger architects would hardly be able to develop their own ideas under his direction. But Stephan reminded them of what Minsos had himself previously admitted in Oslo—that the younger architects did not have the experience needed for this scale of work. He also expressed the concern that the Germans did not want to be blamed in the future for bad plans undertaken by inexperienced young Norwegians—a comment apparently directed at Minsos, whose work Stephan and Speer considered mediocre at best, despite the fact that they kept him around because of his political usefulness. At the same time, Stephan acknowledged the importance of the younger architects taking "pleasure in their own work." As a result, he proposed that Pedersen not be solely responsible for the supervision of the young architects' teams but instead that the latter be jointly supervised by Pedersen and Essendrop, to which those present at the Vienna meeting heartily agreed.[58]

Despite preferring to work with younger architects, Stephan and Speer did not come to regret their decision to retain Pedersen. In early January 1941, a month after the Norwegians had returned from their study trip, Luther met with Stephan in Berlin to update him on the reconstruction efforts. He brought with him plans that Minsos had prepared for the rebuilding of the town of Elverum in the forested region of inland eastern Norway. Minsos proposed moving the entire town to an island. In a memo to Speer about the meeting, Stephan did not explain Minsos's rationale for such a drastic move, but it may have had to do with wanting to erase the memory of the resistance in Elverum, to which the Norwegian king and government had briefly fled after Oslo fell on April 9, 1940. It was here that the parliament signed the Elverum Mandate, legitimizing the government in exile to act on

Norway's behalf until the Storting could be reconvened.[59] When the king refused to dissolve parliament in favor of a new regime led by Quisling, thereby bolstering the resistance, German bombers reduced the town to rubble. Whatever the reason, Stephan told Speer that the proposal proved "how right it was that we did not do away with a senior role for Pedersen."[60]

Yet Pedersen—even after having been put through his paces in the study tour—was not granted the freedom or responsibilities that he had enjoyed when the BSR was first organized in the summer of 1940.[61] Although he continued to lead the BSR (fig. 4.6), the Germans maintained tight control over the reconstruction design process. In a letter from Speer to Terboven written in early December 1940, just days after the Norwegians had left for home, Speer requested that nothing be built in the damaged cities without the prior approval of Terboven's office. For any significant design issue that might arise, Speer recommended that Luther pass along the relevant materials to Stephan. When the plans had reached a more mature stage, Speer considered it appropriate that Luther, Pedersen, and Essendrop present them to him in Berlin, where he could personally evaluate them.[62]

In a surprising response, sent the following spring, Terboven asked that Norwegian architects not be compelled to present their work in Berlin. The tyrannical Terboven, who rode roughshod over Norwegians' rights, was uncharacteristically concerned with letting the Norwegian architects maintain the illusion of control.[63] This caution may have been prompted by the departure in early 1941 of a number of Norwegian architects from the BSR in protest over German leadership.[64] Terboven understood how it would look to their peers if Pedersen and Essendrop had to go to Berlin, plans in hand, to ask for Speer's approval. Instead, Terboven asked that Stephan return for a longer period to Norway to assess the plans in consultation with BSR architects and through on-site visits, as he had done the previous fall. Stephan began to travel more regularly to Norway, and in July 1941 spent several weeks there. Speer had planned to join him on that trip, but had to cancel at the last minute when Hitler, fearing that his first architect would be exposing himself to danger, told him not to go.[65]

How, then, did German influence play out at the level of design in the BSR's plans? Pedersen's proposals for Molde provide a valuable case study because they illuminate how German, Nordic, and broader European influences shaped the designs—and why, for this very reason,

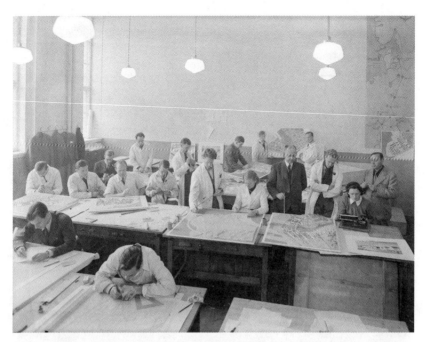

4.6. Sverre Pedersen (in the dark suit, holding a pointer) and Jacob Hanssen (far right) with assistants working on BSR projects in Oslo, 1942.

they became a source of contention after the war, when it was possible to interpret them in a variety of ways. Stephan and Speer deemed some aspects of Pedersen's early proposals for Molde—created in the summer of 1940 before the assertion of German influence over the BSR—to be correct from the perspective of National Socialist town planning. They nonetheless insisted on revisions, in some cases significant, which left their own discernable imprint on the final plan.

Heavy German air raids during the invasion had devastated Molde, a town of four thousand people on Norway's west coast. Over two hundred buildings were lost in the bombings and fires, with the heaviest destruction at the city's center, the core of its commercial life.[66] Before the catastrophe, businesses had clustered around the harbor on narrow streets (fig. 4.7). Buildings were typically two- to three-story wooden structures, which mixed residential and commercial functions. The scale of the town center was intimate, with streets and buildings closely interwoven. A modest square by the water with two piers formed a focal point, but it was not a completely open space, as a building occupied the middle. The church and city hall lay outside this center.

4.7. Aerial view of Molde's center before the April 1940 German invasion.

The curving main street, Storgata, unfolded like a ribbon through the town, running parallel to the shoreline. Its width was inconsistent and at its narrowest point measured just five meters—a bottleneck the locals called "the dangerous corner."[67] Buildings along Storgata did not neatly line up, some being set back from the road. This somewhat disorderly but romantic townscape, combined with stunning mountain scenery and a mild climate, made Molde, known as the city of roses, a popular tourist destination before the war.

The town's largely unplanned development, while picturesque in its results, created difficulties with the advent of modern forms of transportation, particularly automobiles and buses. In the mid-1930s, Molde authorities commissioned Pedersen to devise a rationalized town plan. The proposal he created in 1936 (fig. 4.8), in collaboration with Molde's city engineer Ingar Findahl, gathered the buildings into blocks or rows (thus creating more space between them), and enlarged the square on the waterfront, which would have integrated views of the islands in the fjord and the lofty peaks of the Romsdal mountains across the water—a panorama that Pedersen considered one of the most beautiful in Europe—into the townscape. Pedersen would have liked to modernize the main street by straightening and widening it but was unable to do so because this would have necessitated knocking down buildings that stood in the way.[68] He did, however, propose a beltway around the town to divert traffic from the center and a road beside the waterfront to serve the businesses near the shore. The plan had yet to be fully approved when German bombers arrived and obliterated much of the town.

The designs for Molde that Pedersen created during the summer of 1940 drew significantly on this earlier plan. The central square was symmetrically framed with commercial buildings on three sides, including a large-U-shaped building—just north of the square and set back from the street—facing the fjord (figs. 4.9 and 4.10). The arrangement of these three buildings gave the town plan a central north-south axis, projecting out toward the water, and framed views of the fjord. The main thoroughfare was straightened as it passed in front of the U-shaped building, with an artery joining it from the west to form a kind of east-west axis (more apparent in the plan than would have been the case in the hilly landscape). On the northern side of this east-west trajectory, three-story apartment buildings were arranged in tidy rows on either side of the U-shaped building, with their short ends along the main road. Pedersen

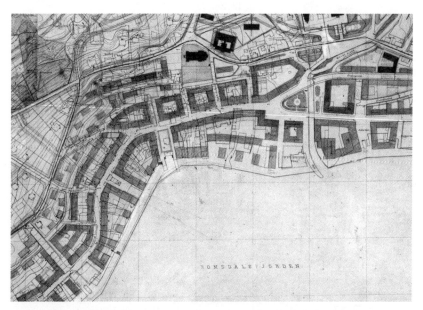

4.8. Sverre Pedersen, detail of the city center in the rationalized plan for Molde, fall 1936. The gray-shaded blocks indicate proposed new structures. The faint lines mark already-existing buildings, revealing the jumbled nature of the town center (also visible in 4.7) and the physical intrusions into the main street.

renamed this stretch of the thoroughfare Rosegaten, or Rose Street. In keeping with the new name, rose gardens were planned for the open spaces in between these apartment buildings.[69] The church, destroyed in the bombings, was to be brought closer to the center than it had been previously. A person standing in the square looking to the northeast would have had a dramatic view of the church, framed in a long diagonal vista (fig. 4.11). An article on the reconstruction plans for Molde published on September 9, 1940, in the Oslo daily *Aftenposten* (Evening Post) included a drawing by architect Jacob Hanssen with a caption that emphasized the new prominence of the church.[70]

The strong symmetry of this scheme reflects Pedersen's preference for the classical tradition, which had been revived in the Renaissance and baroque periods, and still exerted influence in Europe (including in Norway and Germany) in the early twentieth century, when Pedersen had studied architecture.[71] The design's pronounced axiality and sweeping vistas were in keeping with baroque precedents in cities such as Rome and Trondheim that Pedersen admired; similar features also appeared in his interwar plans for other Norwegian cities. The concept

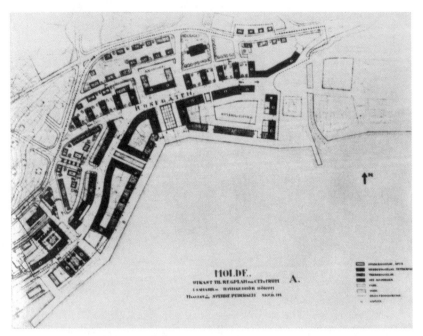

4.9. Sverre Pedersen, BSR plan for Molde, August 1940, as it appears in the October 1940 report Stephan submitted to Speer.

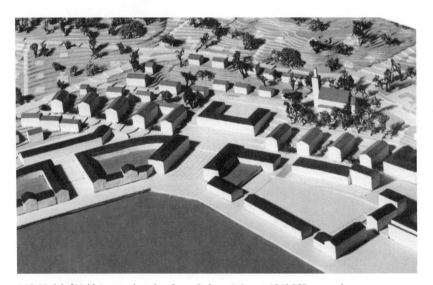

4.10. Model of Molde's center based on Sverre Pedersen's August 1940 BSR proposal.

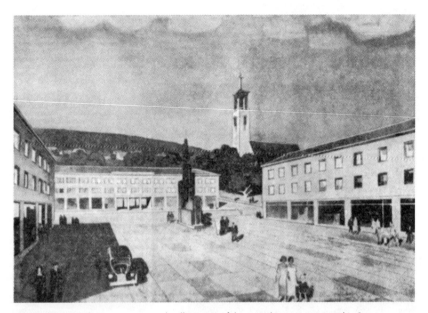

4.11. Architect Jacob Hanssen's watercolor illustration of the central square envisioned in Sverre Pedersen's BSR proposal for Molde from August 1940. The buildings around the square were intended for commercial purposes, with glass storefronts. The square's dimensions were considered too small by Hans Stephan, who also disliked the church's visual prominence.

of a deep and narrow square laid out longitudinally toward a dominant building and giving the impression of a room or enclosed space reveals Sitte's influence. His 1889 book, *Der Städtebau nach seinen künstlerischen Grundsätzen* (City Planning according to Artistic Principles), rejected the hygienic and technical concerns of nineteenth-century urban planning to argue instead for the aesthetic and creative experience of the city.[72] Pedersen's design also bears the mark of German architect and planner Karl Henrici, a contemporary and follower of Sitte, who emphasized the visual delights that unfold along a curved street. When Pedersen, in the summer of 1940, drew up new plans for Molde, he would have been impeded in the creation of a new straight thoroughfare by the high costs associated with building a new road and by the legal restrictions related to existing property lines. But his decision to retain Storgata's curve also speaks to his aesthetic appreciation for the lively, picturesque drama of a street's arc.

Other influences emerge in the treatment of natural elements, such as greenery and light. Pedersen's intermixture of rose gardens and apartment buildings drew on the English Garden City movement

and the ideas of Ebenezer Howard. In his book *Garden Cities of Tomorrow*, first published in 1898 (under a different title), Howard combined rural and urban elements in his vision of beautiful, healthy towns in the countryside, freed from the pollution and overcrowding of industrial cities. In Scandinavia, Howard's ideas influenced the development of settlements outside city centers with generous outdoor spaces that gave urban dwellers some of the advantages of a traditional farmstead, such as the ability to grow food.[73] The design of healthy urban environments also concerned functionalist planners in the interwar years, who embraced science and technology and renounced Sitte's picturesque approach to the modern city. Functionalist planners, such as Le Corbusier, geared their designs to meeting human physiological needs for sunlight, air, greenery, and open space. Their urban schemes arranged the city into separate zones based on functions (dwelling, work, recreation, and transport), with urban populations housed in high-rise apartment blocks situated at widely spaced intervals. Pedersen adopted many aspects of functionalist planning, as seen, for example, in the row of apartment buildings he designed along Rosegaten, which were positioned for maximum direct light. He veered away, however, from functionalist-style architecture, preferring instead to maintain regional building traditions.

Pedersen's proposals for Molde were thus shaped by many different intellectual and design influences, absorbed and refined over decades of work. While grounded in the Scandinavian context, his work was also tuned in to broader European movements. Indeed, Pedersen was a leader within the international culture of planning in the interwar years, in which ideas were shared through publications, exhibitions, and conferences. Young Nazi architects, who had trained under Pedersen's contemporaries, shared many of the planning approaches discernable in the Molde proposals. At the same time, their mission had changed. Under National Socialism, a once-familiar language of planning was made to serve new ideological aims, leaving the forms seemingly intact while radically shifting their meanings.

During his fall 1940 visit to Norway, Stephan evaluated the plan for Molde that Pedersen had completed in August, and approved of its basic features, although he also had some criticisms. As he noted in his report to Speer, "everything [is] too cramped and too small." There was no consideration for Molde's anticipated growth, he complained, and the dimensions of the beltway were too narrow: at 12.5 meters, its width

was about half of what Stephan considered ideal. The main square, measuring forty meters wide by sixty meters long, was also too small (see fig. 4.11). To Stephan, these flaws betrayed the limitations of a parsimonious mind-set. He was particularly irked by the inclusion of "even half-destroyed houses" in the plan and pasted into his report a photograph of a bombed "ruin" that Pedersen intended to thriftily include in the reconstruction.[74]

Stephan's concerns may seem, at first glance, innocuous—objections that any planner might raise. During the interwar years, Europe's population increased by 16.3 percent, and even in Norway, where growth was slower (10.8 percent), urban areas confronted internal migration as people moved to the towns from rural districts.[75] Increased motor vehicle traffic in European cities prompted the creation of new roads and highways.[76] Molde was hardly unique in grappling with such challenges, and Stephan's critiques, seen from this perspective, do not appear overtly radical. But in the context of National Socialist ideology and long-range development policies for occupied lands, ideas that appear to emerge out of a shared European planning discourse take on a different cast. A fundamental premise of the Nazi regime was the necessary increase of Aryan peoples (alongside the disappearance of "lesser" races), and its pronatalist policies fostered births among racially "valuable" populations, leading to the implementation of the *Lebensborn* program for German-fathered children in Norway. The regime also expected that the exploitation of Norway's natural resources would lead to an economic boom that would end a long history of Norwegian emigration to North America and thereby keep the nation's racially valuable stock in place. Thus Norway's population increase, from the perspective of the occupiers, was not a demographic possibility but rather a policy certainty—one that required accommodation in any town plan.

Similarly, the size of the bypass would need to transcend local traffic needs. Stephan's work in Berlin involved developing new traffic systems that would link the capital to the empire through broader transportation networks. From that perspective, the metropole radiated outward. In Norway, Stephan confronted the view from the other side, with tributaries feeding a complex system that led back to the center. Norway's towns were to be integrated into pan-national and pan-European transportation networks of superhighways that would serve to gather a widely dispersed population and to strengthen Norwegians'

connection to the Greater German Reich. From the start of reconstruction, Pedersen had also been concerned with enlarging and improving roads—in some cases, more so than his Norwegian colleagues—but his focus remained primarily local. By contrast, Stephan's requirement of a minimum width of twenty-four meters for Molde's beltway seems difficult to reconcile with local conditions, given that—as Stephan himself admitted—the town's out-of-the-way location made heavy traffic unlikely. His insistence on these dimensions appears to have been determined rather by the Germans' vision of a much larger interconnected system. Notably, the standard overall width of the autobahn in Germany was also twenty-four meters, suggesting the basis for a new standard across the Reich.[77]

Finally, Stephan's annoyance at the frugality and "smallness" of Pedersen's proposal came from a position of great power. As a senior member of the GBI, the most powerful architectural and planning office in Nazi Germany, Stephan was accustomed to working in an environment largely unobstructed by budgets or laws. The GBI expelled tens of thousands of Berlin Jews from their homes to clear the way for constructing Germania, forced concentration camp inmates to supply building materials, and enjoyed a nearly limitless budget to advance its projects.[78] Charged by Speer with helping to lay down an empire in Norway, Stephan had little patience for what he saw as narrow thinking on Pedersen's part, which he also considered, in accordance with Nazi views, a Norwegian trait. From Stephan's perspective, Molde's reconstruction was not about saving a krone here or there but about building a new society.

The ideological dimensions of Stephan's criticisms are nowhere clearer than in his reaction to Pedersen's proposal for Molde's center. Stephan was particularly concerned that BSR reconstruction plans combat what he saw as the Norwegians' exaggerated individualism, and foster instead a sense of community through a strong town center, which was to function as the kernel of National Socialist society. After reviewing Pedersen's Molde plan, Stephan recommended substantially expanding the modest central square into two plazas, with the lower one, closer to the waterfront, serving as a marketplace, and the upper one representing the community. Importantly, he also advised making the focus of this upper square a new, large city hall.[79] This would replace the old one, outside the center, that had survived the bombing.

When Pedersen arrived in Berlin in November 1940 to begin the

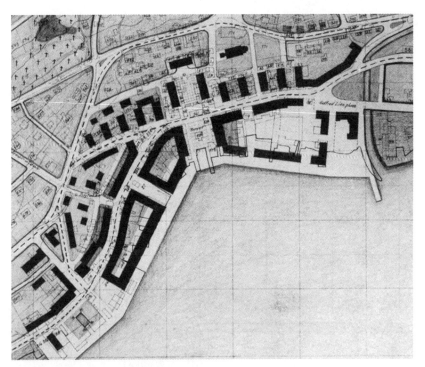

4.12. Sverre Pedersen, detail of a revised BSR plan for Molde, October 1940. The plan includes previous structures and property lines (marked in faint lines) and shows how much more space the new double square occupied in comparison to the original central wharf. The dotted lines show the main thoroughfares, including the new beltway around the town.

study tour with the other Norwegian architects, he brought with him a proposal for Molde revised according to Stephan's suggestions (fig. 4.12). The changes mark an important shift toward a National Socialist vision of the ideal town. The original square had become two, facing each other across Storgata. To create the second square, Pedersen had turned the U-shaped building around and broken off the wings to create three separate buildings that defined the space of the upper plaza. The two squares together combined into a much larger enclosed public space, with the new city hall building, facing the fjord and with its back pushed against the hill, forming the northernmost extreme of the longitudinal rectangle. The length of the central north-south axis grew accordingly, creating a more dramatic, powerful vista out toward the water and, significantly, from the water back toward city hall. The church remained prominently visible from the lower, commercial square in a diagonal perspective (fig. 4.13), but the tripartite

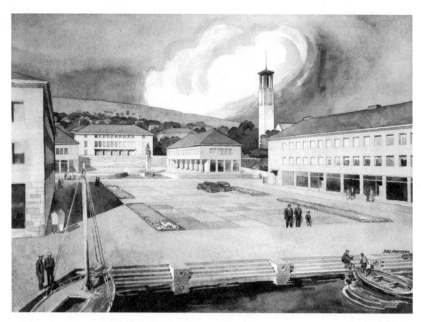

4.13. Jacob Hanssen's watercolor illustration of the central square in Sverre Pedersen's BSR proposal for Molde from October 1940.

arrangement of the buildings in the upper square left few unobstructed views of the church for anyone standing in the upper, civic plaza.

The scale of the new center, with its doubled squares, made it a far more dominant element in the overall town plan. The once-intimate, jumbled feel of the small square that had originally stood near the water now transformed into a statement about monumentality, order, and power. Yet it was not only the scale but also the function of this central area that changed notably in the revised plan. While the commercial dimension remained, it was subordinated to the civic presence, which occupied the place of honor visually and spatially. Architecturally, the new layout made clear the new public focus of life for the town's residents. In short, these changes represent not minor adjustments to an established scheme but rather a significant shift in emphasis and meaning.

A further change in the new plan exposes another underlying National Socialist intention to reshape Molde's communal life. The diminished visibility of the church from the upper square was not incidental. In a report Stephan wrote for Speer on November 28, 1940, in which he commented on the new Molde proposal, it is clear that he had objected to the more dominant view of the church in Pedersen's earlier,

single-square design. That visual emphasis recognized the traditional role of the church as a focus of town life in Molde. Although in Pedersen's new proposal the church was still visible from the lower, commercial square, this view did not carry the same symbolic power now that the lower plaza had been demoted in importance. In the upper square, the space dedicated to representing the new National Socialist community, the church, in Nazi eyes, had no place.[80]

Because Speer considered the status of churches—and, more specifically, their position or hierarchy in the reconstructed townscapes—a political question, Speer took up the matter with Terboven in May 1941, asking the Reich commissar to make the final decision. Speer noted that in some of the BSR proposals, the church occupied the most prominent visual and spatial location in the new urban plans. Even in those proposals where the church had been moved to a subsidiary position, it still constituted a significant presence in the urban landscape. Essendrop had told Stephan, when the latter had been in Oslo earlier that month to look at a new batch of proposals, that Nasjonal Samling authorities had "no interest" in church buildings being granted preferential placement in the plans. The local communities, however, very strongly desired the opposite.[81]

The problem of how to handle churches in the BSR reconstruction plans reflected broader developments in Germany and Norway as their respective National Socialist regimes sought to bring religious life into line with a New Order. Although Hitler publicly aligned National Socialism with Christianity before coming to power, his regime repeatedly clashed with Protestant and Catholic churches in Germany after 1933. Hitler encouraged the unification of Germany's twenty-eight regional Protestant churches, to which most Germans belonged, into a national Reich Church that—with a pro-Nazi bishop installed as its leader—could be more easily controlled by the state. This Nazification process weakened church control over communities through the co-optation or dissolution of church services and institutions, such as the merger of church youth groups into Hitler Youth and the prohibition on new church building.[82]

The ban on church construction meant that some new housing settlements in Germany had no churches at all. Among those sites visited by the Norwegian architects, Salzgitter, Fallersleben, and Mascherode lacked such buildings. In some cases, however, where the construction of new churches and investment in their decoration were seen as

a means to reduce unemployment, authorities permitted new church building. This was the case in Lehndorf, also visited by the Norwegians. Here, the traditional visual prominence accorded to churches in German towns was replaced by a diminished, even humble, position in the urban landscape. The new Lutheran church designed by Munich architect Gustav Gsaenger "was integrated into the street front with only a small turret on the roof to identify it as a church. The building shows the clear influence of the return to *Heimatstil*: its entrance even looks rather like a stable door."[83] Significantly, the church was located across the street from and behind the Aufbauhaus—a position that was still central in terms of the town's layout but also clearly subordinate.

After the invasion of Norway, and under the leadership of the bishop of Oslo, Eivind Berggrav, the Church of Norway, the state church, strongly resisted the German occupation and attempts to Nazify its leadership and message. Berggrav also fiercely opposed Nasjonal Samling leader Vidkun Quisling, who considered himself the prophet of what he called Universism, a new worldview that would absorb some Christian values, while sweeping away Christianity itself. In February 1941, a few months before Speer wrote to Terboven about church sites, Berggrav led the Church of Norway bishops in issuing a pastoral letter highly critical of the New Order. Pastors read the letter to their congregations on February 9, which garnered the attention of the international press and massive support from the broader Christian community. Terboven and Gestapo chief Heinrich Himmler personally confronted and threatened Berggrav over the letter.[84] Speer's request to Terboven for clarification thus came at a time of heightened feelings in Norway about the church as a force of resistance to Nazi rule. It was a politically sensitive—but also timely—moment to decide the symbolic placement of churches in the reconstructed Norwegian towns.

In June 1941, a month after Speer's request for guidance, Terboven responded that "Mr. Quisling and the Norwegian government agree with me in stipulating that [church buildings] . . . should not be erected on a dominant or central location."[85] Following this decision, Stephan instructed Luther to immediately request new proposals from Pedersen for two towns where the church still featured too prominently in the urban layout and to move it to a remote location.[86] Even in Molde, where the church was already set somewhat apart, the subsequent evolution of Pedersen's proposals suggests a further downgrading of its status. In a 1942 plan (see fig. 4.21), the addition of an L-shaped building

to the east of the upper plaza would have blocked views of the church from the commercial plaza near the water. Thus no unobstructed views would have remained of the church building from the town's two central squares. Slowly but surely, it seems, the church was being pushed out of the urban picture.

In the May 1941 letter in which Speer had asked Terboven to clarify the position of churches, he also stated that Essendrop had added "a final requirement" for the reconstructed cities: a *Parteihaus* (Nazi Party house) with marching square, the two conceived as a unit. As Speer explained, while Stephan had been in Oslo for three days of meetings on the reconstruction plans, Stephan and Essendrop had discussed appropriate locations for a *Parteihaus* and marching square in each town and had made sketches.[87] This decision was announced to Pedersen and other BSR architects on May 16, the last day of meetings. The Norwegian architects listened but did not have much to say on this development.[88]

Speer's letter to Terboven subtly alluded to the interrelation of the church's demotion and the *Parteihaus*'s elevation but did not spell out the connection. Even so, it is clear that these choices hinged on fundamentally different visions of public life: namely, whether the party or God would be at the center of the new communities. When, following Terboven's decision, Stephan told Luther to ask Pedersen for new proposals that diminished the presence of the church, he was clear about what would rise in its place: in those cases where the church occupied the most dominant location in the town plan, it should be replaced by the *Parteihaus*.[89]

Stephan returned to Norway in July 1941 to review yet another new crop of plans. He reported to Speer that in the case of three cities (Bodø, Molde, and Narvik), his meetings in May had resulted in securing the "commanding position" in the urban landscape for the *Parteihaus*, but that this remained to be accomplished in other towns. This comment, contained in an August memorandum, suggests that by the summer of 1941, the Nazis had begun to imagine the dominant building in Molde's new center—at the head of the large public space overlooking the fjord—as the *Parteihaus* rather than the city hall. Stephan described the plaza in front as a marching square and recommended holding a competition to design "the city hall, or rather the *Parteihaus*."[90] In keeping with developments in Germany, it appears it was not just the church that was destined for a loss of status in the reorganization of Norwegian towns, but also local government.

Even if Speer presented the *Parteihaus* as Essendrop's idea, the concept derived from Nazi town planning in Germany. In his 1939 book *Die Neue Stadt* (The New City), Gottfried Feder, an early Nazi Party member, ideologue, and civil engineer, identified the *Parteihaus* as one of "the most important institutions of the future town." The *Parteihaus* would house administrative offices as well as the National Socialist People's Welfare and youth organizations, and should be located in the inner part of the city where it would be "equally easily reached from all districts." Ideally, it should be an independent building located on a square, where it could stand "dignified" apart from other structures. Its significance should be "emphasized outwardly" by a "garland" of green or open spaces surrounding it. Feder insisted that, commensurate with its political and spiritual importance as the heart of the community, the *Parteihaus* occupy the most dominant location in newly planned towns.[91] The role of the *Parteihaus* in Nazi town-planning theory reflected the shift from democratic politics "to party direction (*Lenkung*) that characterized the organization of life in the Third Reich."[92] Although given a different name, the Aufbauhaus in Lehndorf exemplifies how Feder envisioned the *Parteihaus* serving as a hub of public life in the new settlements in Germany.

In addition to the *Parteihaus*, Feder identified the *Gemeinschaftshaus*, or community hall, as an important institution of the new National Socialist town. The *Gemeinschaftshaus* replaced the traditional parish hall and, because it would serve community events, must contain ample gathering space. Lectures, plays, and assemblies would take place here, and Feder recommended that it be situated near the town's marching square and youth organizations.[93] Mascherode, which was planned without a church and which the Norwegians visited on their study tour, had a large and central *Geimeinschaftshaus*.[94] In other new German towns, such as Lehndorf, the function of the *Gemeinschaftshaus* was incorporated into other structures. In Norway, community halls were part of the cluster of National Socialist buildings planned for the main town squares, which Pedersen, as revealed in his correspondence with Stephan, not only acknowledged but also seemed to accept.[95]

Because Norway formed part of the Greater German Reich, a new type of National Socialist building was developed for its reconstructed town centers. In addition to the *Parteihaus*, for local Nazi Party administration and services, and the *Gemeinschaftshaus*, for community assemblies, a *Reichshaus* or *Rikshus* (state house) appears in some of the plans.

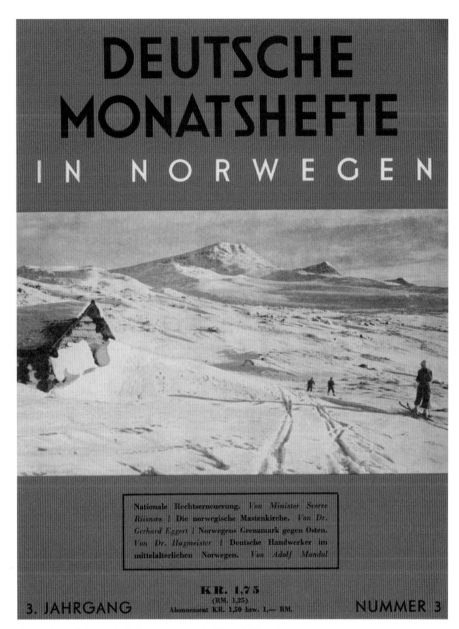

DEUTSCHE MONATSHEFTE IN NORWEGEN

Nationale Rechtserneuerung. *Von Minister Sverre Riisnæs* | Die norwegische Mastenkirche. *Von Dr. Gerhard Eggert* | Norwegens Grenzmark gegen Osten. *Von Dr. Hagmeister* | Deutsche Handwerker im mittelalterlichen Norwegen. *Von Adolf Mandal*

KR. 1.75
(RM. 1,25)
Abonnement KR. 1,50 bzw. 1,— RM.

3. JAHRGANG NUMMER 3

Plate 1. Cover of the March 1942 issue of *Deutsche Monatshefte in Norwegen*.

Plate 2. Ianthe Ruthven, photograph of a double-torpedo bunker on the Bøkfjord overlooking the Barents Sea, near the Russian border, 2014.

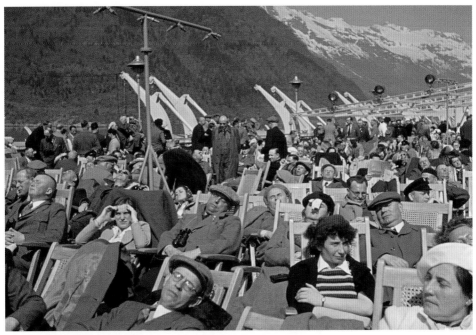

Plate 3. Hugo Jaeger photographed German passengers enjoying the sunshine and scenery on the deck of the Strength through Joy cruise ship *Robert Ley* during a voyage to Norway in May 1939.

Plate 4. Poster by Robert Zinner promoting tourism and scenic views on the autobahn in Germany, produced by the German Railroads Information Office, which encouraged tourist travel to Germany, c. 1936.

Plate 5. Photograph of a baby and nurse in a *Lebensborn* home from Rediess's 1943 booklet *Sword and Cradle*.

BÜHNE

LESE·UND·SCHREIBZ.

SPIELZIMMER

VORRAUM.

ZUSCHAUERRAUM. 216 PL.

VESTIBÜL·GARDEROBE.

VORRAUM.

WERKRAUM.

2.
SOLDATENHEIM.

KRISTIANSAND. ³/₁₀·41.

A

Plate 6. Plan of the Kristiansand soldiers' home, dated August 3, 1941.

Plate 7. Poster for the 1942 *Norges Nyreising* exhibition held at the National Gallery in Oslo.

Plate 8. Erik Birkeland, aerial view of Molde in 2016.

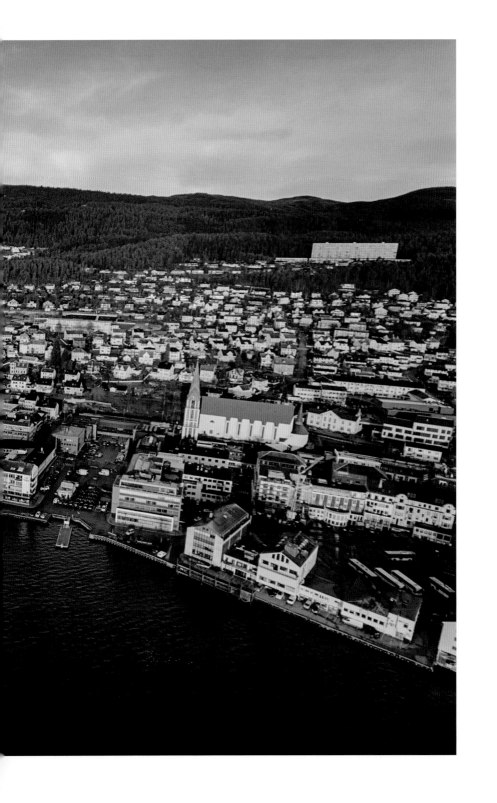

Plate 9. Map from October 1940 showing the area (within the yellow outline) of the Trondheim Fjord to be reproduced as a topographical model by the Munich-based Karl Wenschow firm.

Plate 10. Detail of a map in Albert Speer's files showing the proposed area of habitation (outlined in dark-green pencil) to the west of the peninsula chosen by Hitler as the site for his new German city. The city of Trondheim (Trondhjem) is located at the top right of the map. The Øysand peninsula (marked with faint red lines) is to the south (bottom of the map), adjacent to the Gulosen Fjord.

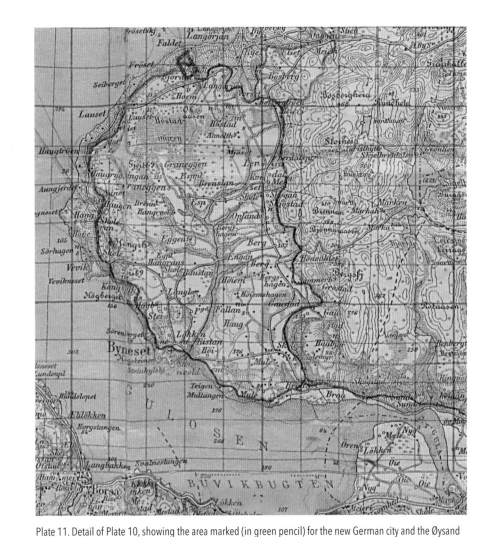

Plate 11. Detail of Plate 10, showing the area marked (in green pencil) for the new German city and the Øysand peninsula (the location of the naval base) at the bottom right.

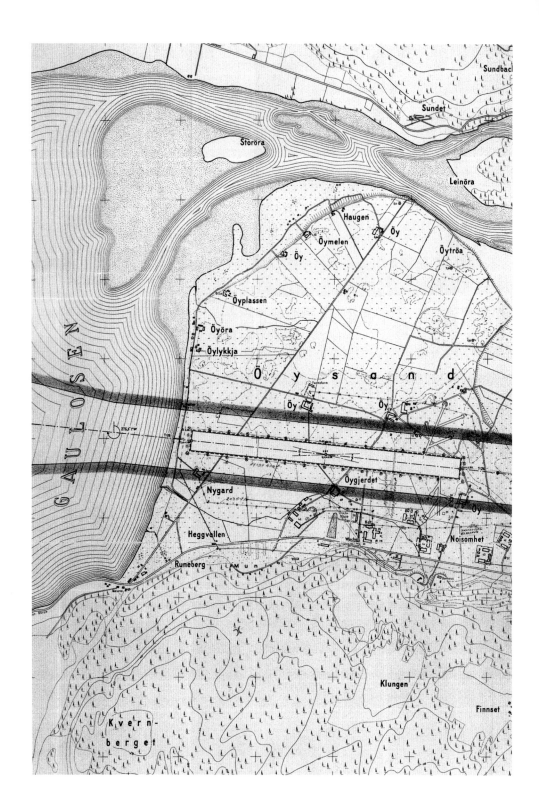

Plate 12. Map of the Øysand peninsula, from December 1944, illustrating the camps (situated along the southern end of the peninsula) for Luftwaffe and Organisation Todt personnel as well as for prisoners of war, and the Luftwaffe airstrip (rectangle, center) with the flight path marked in heavy dark lines.

Plate 12. (detail)

Plate 13. 1942 geological map of the Øysand peninsula showing borehole locations and, in the bottom left-hand side (see arrow), the placement of the large dry dock, excavated inland from the shoreline and resting in part on the bedrock (green) at the base of the cliffs.

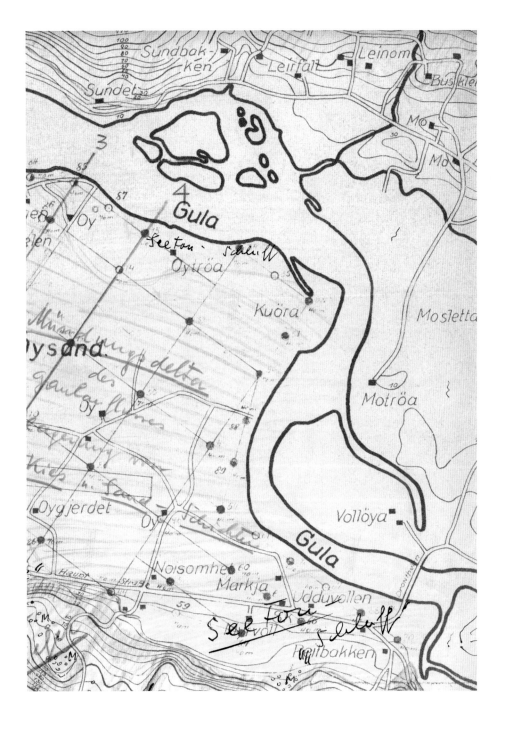

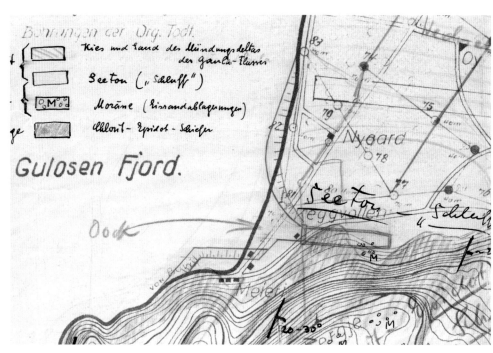

Plate 13. (detail)

Rather than being a German import, however, the inspiration for the *Reichshaus* may have been local. The earliest mention of a *Reichshaus* in Stephan's correspondence appears in a report to Speer from May 1941, where he made a passing reference to the *Reichshaus* in the Narvik proposal.[96] At the time Nazi victories had brought much of Europe under German control, and Hitler was planning to launch Operation Barbarossa to extend his empire farther eastward. This territorial expansion heightened the need not only for greater administrative control but also for its physical manifestation. As the name reveals, the *Reichshaus* would have housed government offices representing the local arm of the Greater German Reich.[97]

Sverre Pedersen, writing about the reconstruction efforts in the Nasjonal Samling journal *Det Nye Norge* (The New Norway), noted that a "state house" for Narvik had already been planned before the war to house the post and telegraph offices.[98] This reassuring comment insinuated a continuity with democratic precedents. But in Hitler's Germany, post and telegraph offices had become instruments for spying on the nation's citizens—thousands were sent to concentration camps for criticizing the government in letters opened by the Gestapo.[99] The inclusion of communications in the *Reichshaus* would have augmented the concentration of surveillance functions in the reconstructed urban cores. The prominent size and location of the *Reichshaus* type as developed during the occupation also indicates that the Germans foresaw a weightier role. Namely, these imposing edifices had the potential to knit together town and empire by introducing the presence and power of global National Socialist authority directly into the fabric of local spaces. By 1942, Luther, writing in *Deutsche Monatshefte in Norwegen*, identified the *Reichshaus* as among the standard and most important building types for the main public squares planned for the reconstructed cities.[100] The *Reichshaus* would have added a new, imperial layer onto the complex political landscape being created for Norwegian towns. It also suggests how Hitler and his planners envisioned a permanent, embedded presence for German authority—as masters of the National Socialist realm—at the very center of everyday life in the new territories.

Narvik provides a clear example of the intended hierarchy of new and old political building types in the reconstructed townscapes. The reconstruction plan, intended to create a new focal point for the town, was developed by architect August Nielsen on the basis of earlier plans by Pedersen and with contributions by architect Nicolai Holger Bratlie.

4.14. Jacob Hanssen's watercolor illustration of Narvik's reconstructed center according to the 1943 BSR plan.

4.15. Jacob Hanssen's watercolor illustration of the *Parteihaus* (identified by Pedersen as Narvik's city hall) from the 1944 BSR proposal.

As seen in their 1943–44 proposals, the architects developed a strongly articulated public center in the Oscarsborg district, reached by a bridge (fig. 4.14). The *Reichshaus* occupied the most prominent and authoritative position in the ensemble: a large building, it sat on elevated ground and formed the visual focal point of the wedge-shaped layout, with buildings framing it on either side. Immediately below the *Reichshaus* and integrated into the rising landscape was an underground marketplace with a long horizontal, window-filled facade. Viewed head-on, the marketplace facade resembled a podium for the *Reichshaus* above, augmenting its gravitas. The roof of the marketplace created a large terrace in front of the *Reichshaus*, which further enhanced the importance of the building.[101]

The *Parteihaus* occupied the second-most prominent position in the plan (fig. 4.15). Originally the designers intended to locate it elsewhere in the city, but Stephan and Speer decided against a dispersed approach. It was thus moved to the bottom of the outward flowing plaza, on the site originally envisioned for the city hall. The displaced city hall was to be moved to one of the buildings adjacent to the *Reichshaus*. This relocation gave the *Parteihaus* its own distinctive space and took advantage of the magnificent views toward the fjord.[102] Although lower in the elevation and at a distance from the *Reichshaus*, the *Parteihaus* was nonetheless highly visible because of its tall tower, which drew the eye to the building. This tower reached the same height as the roofline of the *Reichshaus*, making them the two tallest structures in the public center and visually forging a symbolic connection between them.[103] In an undated model, two obelisks framed the space of the marching square in front of the *Parteihaus*, giving it a dignified, ceremonial air (fig. 4.16). Overall, it was a powerful design meant to convey both the magnetism of a new public life focused on this center—the layout seeming to funnel people into its space—and the supremacy of the New Order, which occupied the most visually striking spaces in the plan. The placement of the *Reichshaus*, in particular, gives the impression of an emperor on his throne, the plaza below intended for his adoring subjects.

From Stephan's reports to Speer regarding his meetings with BSR architects, there can be no doubt that the Norwegians understood the encroachment of National Socialist values and institutions onto the reconstruction plans. The demand to banish church buildings to the peripheries and instead make the *Parteihaus* the urban focal point was hardly ambiguous in its intentions. That is not to say, however, that BSR

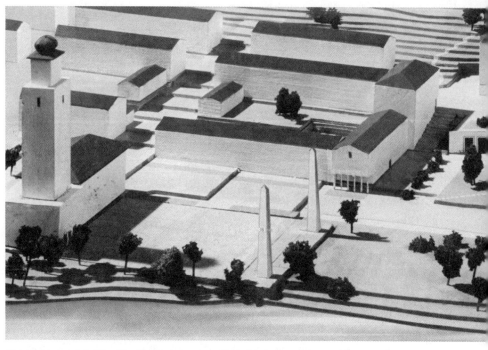

4.16. Undated model of Narvik's reconstructed center, with obelisks in front of the marching square by the *Parteihaus* (bottom left). This model was published in the June 1942 issue of *Baukunst*, dedicated to Norwegian reconstruction.

architects never raised objections. In a report to Luther written in October 1941, explaining a crop of newly revised plans, Pedersen resisted the demand to move the churches, saying that, in most cases, they had been located where they had existed before, "based on tradition." In an attempt to placate the Germans, he further noted that "otherwise, the squares are surrounded by *Parteihäuser*, city halls, community halls, state houses, and other public buildings."[104]

Similarly, when Stephan met with a small group of architects and engineers in Narvik in July 1941 to discuss its reconstruction, they expressed concerns about locating the *Parteihaus* on the site originally planned for the city hall. Specifically, they doubted that the project could be made profitable if it was set off on its own. They preferred to locate the *Parteihaus* in another part of town, where it could be more fully integrated into the urban fabric and associated with surrounding businesses. The Norwegian architects' solicitousness about the financial well-being of the *Parteihaus* seems suspect. More likely, they did not want the *Parteihaus* in such a visible location for political reasons

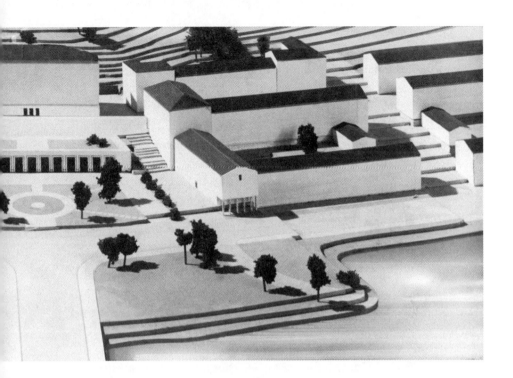

but chose to communicate their objections to Stephan in less fraught, economic terms. In any case, they failed to sway him. Stephan told the group not to worry, and that a cinema and assembly hall could be located in the *Parteihaus* to make it profitable.[105]

In her Pedersen biography, Tvinnereim has argued that the functions of the new public buildings planned for the reconstructed towns remained fluid, and it is certainly possible that Pedersen and his BSR colleagues hoped to ride out the occupation, letting the Germans think of a particular edifice as a *Parteihaus* or a plaza as a marching square, but anticipating a change in function when the occupiers left.[106] In 1941, however, that would have been a risky game to play—signs pointed to the Germans winning the war and staying in Norway for a long time. Moreover, as Pedersen's placating comment to Luther, above, suggests, the urban context was changing dramatically under pressure from the Germans. Even if church buildings remained in prominent locations, they would now be surrounded by a heavy National Socialist apparatus.

On a broader level, the BSR architects inarguably understood—and, it seems, acquiesced to—the ideological motives driving the focus on the form of the new town centers, a message that had been reinforced during the study tour and in Stephan's lectures to and meetings with the Norwegian architects. In his October 1941 report to Luther, in which he resisted the relocation of churches, Pedersen made clear his commitment to the general idea shaping the town centers. Speaking of the revised plans he had submitted, he wrote, "On the whole, there is an attempt to give the new centers a design that is in harmony with the new town-planning ideas and that aims to see each town as an expression of the idea of *Gemeinschaft*." In closing, he thanked Luther and Stephan for their "collegial" guidance, which had improved the plans and professionally "enriched" him and his colleagues.[107]

If they felt that they could (mostly) control the BSR designers, Terboven, Speer, and Stephan knew that local communities and authorities would be far less accommodating to overt ideological intrusions in the reconstruction plans. Correspondence among the three men reveals numerous instances of them warning each other about the importance of withholding information and thus minimizing interference from local communities, which were defined as "oppositional" in nature.[108] For example, when Terboven conveyed to Speer the decision to demote church buildings in the townscapes, he remarked that it would be "necessary to ensure that the centralized creation of the plans as well as the centralized oversight of their implementation is protected from subjective or unacceptable objections from the communities." Although Pedersen himself later acknowledged that the Germans' controlling approach to reconstruction freed him and other BSR designers from such local restrictions, it also broke with a long tradition of democratic town-planning practice in Norway.[109] Speer had pioneered this autocratic approach first in Berlin, where he had systematically blocked the efforts of Berlin's municipal authorities to interfere with his urban redevelopment plans.[110]

Germans did intend to educate Norwegian men and women about the ideological dimensions of urban reconstruction, but in a carefully selective manner. A December 1940 article in *Fritt Folk*, for example, explored the cultural and political significance of the BSR plans from a Nazi perspective. The author began by placing architecture in the context of the emergence of "a new, great European order" and the "impersonal, intellectual materialism" that new order had vanquished.

According to the article, the "soulless" international functionalism of 1930s Norwegian architecture had treated people like machines. Oslo's chaotic appearance stemmed from overvaluing the singular to the detriment of the whole, with architects attempting to create buildings that would stand out aesthetically from the cityscape rather than blend in.[111]

By contrast, the architecture of the New Order would rely on three fundamental factors: "*Heimat*, the community of the people, and the great order of our time." With regard to urban planning, *Heimat* (home or homeland) was expressed through a connection to place and the natural landscape. Community and the New Order were interconnected: "the *Volksgemeinschaft* requires the incorporation of racial-political perspectives into the new building." This meant that the interests of the individual should not come before those of the community, and that private buildings should be subordinate to public ones. Additionally, urban centers should clearly express the community through their representational form. As germs of urban life, these centers would radiate their order outward, into the broader urban layout of the town. The New Order would be expressed in the harmonious integration of individual buildings into the cityscape and in the visible unification of the whole. In such broad strokes, the article laid out the relationship between the new political order and its urban architectural expression. It hailed the "great responsibility" that had befallen Norwegian architects in the "unique opportunity" afforded by reconstruction.[112]

Norwegians had the opportunity to study BSR models, drawings, and plans in person in the fall of 1942, when the National Gallery in Oslo hosted a large-scale propaganda exhibition, *Norges Nyreising* (Norway's Resurrection) (see plate 7). The show explored Norway's history from a racial perspective, beginning with what it portrayed as a strong past of Vikings and farmers, followed by a period of "Jewish-Communist" degeneracy in the modern age, and ending with the nation's restoration under the occupation to its healthy racial roots and destiny.[113] In the show's final section, dedicated to the cultural and economic progress made in Norway under German rule, a separate room was dedicated to the "Resurrection of Norwegian Cities." A photograph shows an abundance of visual and physical documentation of the reconstruction plans (fig. 4.17). In the absence of a catalog, however, it is unclear how closely those materials were interpreted for viewers, beyond the broader narrative of national and racial renewal adopted by the exhibition.

4.17. Displays of BSR architectural models, photographs, and drawings in the room dedicated to the "Resurrection of Norwegian Cities" in the 1942 *Norges Nyreising* exhibition at the National Gallery in Oslo.

Pedersen's writings in *Byggekunst* represented another source of information, in this case directed at Norwegian architects and planners. His several lengthy articles published in 1943 and 1944 explained the BSR's mission and plans, but they also withheld information as well as made misrepresentations. A 1944 article on Narvik, for example, identified the *Reichshaus* as a public building but did not specify its functions, regardless of its obvious symbolic weight in the design. The *Parteihaus* was misidentified as the city hall, even though it had not been that for several years. In fact, the text remained silent on the *Parteihaus* altogether, despite the fact that Essendrop and Stephan had mandated the building type for all reconstructed cities. In a 1943 article on Molde, Pedersen did refer to "a party building," but he gave the impression that it would be located in a less prominent part of town, away from the center—even as Stephan, in this same period, was making public statements about the location of Molde's *Parteihaus* on the main

square.[114] Whether Pedersen intended thereby to hoodwink his Norwegian readers or to resist his German overseers is unclear. Perhaps he meant to do both. In any case, his more attentive readers would have noticed what was left unsaid. In discussing the public buildings on Molde's main square, for instance, Pedersen stated that, in addition to a community hall, they would house the county administration, police station, courts, and prison, without addressing the concentration of authoritarian functions.[115]

Indeed, nowhere in the BSR articles did Pedersen confront the Germans' underlying ideological mission: to use urban reconstruction to overcome Norwegians' individualism and reshape a new political collectivity. Instead, in the case of Molde, he described how the natural setting and tradition inspired his plan, including how his design of the square incorporated views of the fjord and reflected the *allmenning*, an open space found in other Norwegian coastal towns that had originally been common land.[116] Admittedly, much of the plan's shape and features predated the German invasion, and Pedersen's work was deeply embedded in the Norwegian context. These explanations are, therefore, by no means groundless—but they are partial. The effect of stripping from the narrative the ideologically driven evolution of the plan under the Germans undoubtedly had the effect of leaving the Norwegian reader reassured rather than alarmed. Pedersen may not have been a politically engaged person, but he certainly understood what would upset his colleagues.

By contrast, Nazi propagandists targeting German audiences tended to explicitly frame the reconstruction efforts as part of a broader European mission. In June 1942, *Die Baukunst*, the architecture supplement of *Die Kunst im Deutschen Reich*, dedicated a special issue to Norway. Terboven, who contributed the foreword, described the reconstruction of war-damaged cities under his supervision as "a heartfelt need, rooted in the conviction that there is only one common destiny of the European peoples from now on." With Norway freed from the destructive influence of English culture, Terboven claimed, the reconstruction of the damaged cities was an opportunity to once again infuse Norwegian cityscapes with "the spirit of European tradition and contemporary society." In a similar vein, and in the same issue, Stephan wrote that Norwegian reconstruction was "a European duty of our time" requiring new social and architectural methods to overcome the damaging

effects of the excessive individualism and functionalist styles typical of urban development in the prewar era. Presenting Germany as a benevolent older brother, Stephan described the Germans' sense of obligation to put their experience—achieved through the "vibrant construction activity and multifaceted city planning" happening in their own country—at the service of "the Norwegian people, with whom we are related by blood."[117]

On January 7, 1943, Stephan delivered a public lecture on Norwegian architecture at the Meistersaal, a concert hall in Berlin. He told his audience that it was hard to imagine just how alienated Norway had become from European attitudes and culture before the Germans had arrived in 1940. Although Stephan blamed in part the "corrosive" effect of communism, he identified the primary cause as the "strong Americanization of Norwegian youth." This was the result, he claimed, of a century of looking across the Atlantic for a better life, which had prompted wave after wave of young Norwegians to leave. Norway thus had to be brought back from the brink of its unhealthy American and individualistic mind-set to an embrace of the "collective thought and collective feeling" that would lay the foundation across Europe for a bright political, economic, and spiritual future.[118]

As Stephan explained, the rebuilt townscapes of Norway had the power to foster a new European collective identity among Norway's wayward people. For this reason, any structure erected within them must be representative of and contribute to "a comprehensive European culture." Employing glass slides, Stephan led his audience through the reconstruction plans, pointing out features that he found particularly important or attractive, such as strong centers, natural views embedded into the townscapes, and improved roads, among others.[119] As the audience listening to Stephan that evening well knew, he and Speer were in charge of the massive construction upheavals then under way in Berlin, and it would not have been difficult for listeners to understand what was happening in Norway as part of a much broader restructuring of society and cities happening across the Greater German Reich, a process that united metropole and periphery.

In his visual tour of Norway's reconstructed cities, Stephan failed to mention one vitally important fact: not much of anything had actually been built. The reconstruction process had slowed after being taken over by German authorities when the goals of the rebuilding efforts

changed from more pragmatic solutions to get Norwegians housed and their businesses running to grand ideological schemes of creating urban environments that would bring Norwegians back into the European fold. Whereas the Norwegians had originally intended to preserve and rebuild quickly, the Germans wanted to transform and build slowly. As Terboven had instructed Stephan in October 1940, there was no rush to reconstruct. Attitudes such as Luther's, expressed in his 1942 *Deutsche Monatshefte in Norwegen* article, which vaunted a slow pace for its ability to nurture the growth of an indigenous form of stone architecture, privileged aesthetics and ideology.[120] The sheer magnitude of the task the occupiers set for themselves—made even more complicated by the international vetting process Terboven had initiated by bringing Speer on board—meant that the Norwegian towns imagined by the Nazis were still only on paper in the summer of 1942 when the need to divert resources, including building materials, to the war effort ended most civilian construction in Norway.[121]

Work on the plans continued nonetheless, with a focus on the design of individual buildings. Changes introduced in this period indicate the level of detail informing the design of the urban environments intended to foster a European collective identity, down to the style of windows. Interior ministry regulations issued on March 24, 1942, carefully laid out the architectural style for the reconstructed town centers. Stylistic elements associated with the functionalism the Nazis despised were banned: specifically, flat roofs, ribbon windows, and corner windows.[122] For Pedersen the regulations had little effect, since his proposals already drew on the Nordic classicism that had characterized Norwegian architecture in the 1920s, a style that also closely aligned with the preferences of Speer and Stephan. Younger architects, however, may have found them more restrictive. The regulations would also have made clear the new architectural direction expected for future design competitions that the Germans intended to hold for important buildings in the reconstructed town centers.

The drawings for Narvik and Molde (fig. 4.18; and see figs. 4.14 and 4.15) reveal that buildings in the new town centers were to be characterized by a pared-down classicism recalling 1920s Nordic classicism but also influenced, in their simple volumes and forms, by 1930s functionalism.[123] Thus continuities with earlier Norwegian architectural developments would be filtered through and reshaped by National Socialist

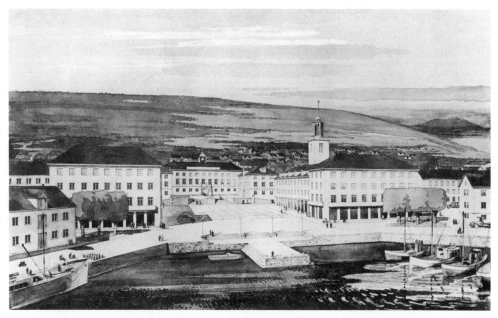

4.18. Watercolor by Jacob Hanssen of Molde's reconstructed center according to a 1942 BSR proposal by Sverre Pedersen.

ideals. Durable materials, including stone and brick, were intended for the construction of public and monumental buildings, in keeping with Hitler's preferences for Germany. The timber typical of Norwegian vernacular traditions was to be limited to the symbolically less important residential areas. This material distinction would accentuate the public parts of town.[124] Additionally, the stylistic split between public classicism and residential *Heimat* followed the pattern established in new German settlements. Despite Giesler having encouraged his Norwegian colleagues visiting Munich in 1940 to "build Norwegian"—a message repeated by Terboven and Stephan in subsequent publications about the BSR's plans—Norwegian architects had to work within stylistic boundaries determined by Nazi rulers seeking to create pan-European urban environments.

In addition to restrictions on styles and materials, national standards governed the colors, heights, and roof angles (thirty degrees) that could be used for buildings located in the reconstructed urban centers.[125] These various specifications would have further homogenized the appearance of new town centers, reinforcing National Socialist ideals of "collective thinking" and "collective feeling." It is important to note

that the intention was not to create identical towns.[126] The desire expressed by Norwegian and German architects to take into account natural scenery and topography indicates their interest in the specificity of place. Rather, these measures would have banished what was seen as the disorderly individualism of older Norwegian town centers, which was believed to fray social bonds. Molde could look different from Narvik, but within each town the careful regulation of architectural details would have promoted a sense of an overarching shared identity.

These regulations ensured that the differences among the various rebuilt town centers in Norway would have been balanced by a common architectural language. A resident of Molde would have felt a certain familiarity standing in Narvik's new Oscarsborg center. This suggests that the centrally determined specifications for the BSR towns had another important function: to brand the new public spaces as specifically National Socialist spaces. A similar type of branding effort through form, material, and color also characterized the architectural projects of Paul and Gerdy Troost in Germany, Hitler's first architectural collaborators, whose approach exerted a strong influence on later National Socialist architecture, including that of Speer.[127] Through this type of architectural branding, National Socialist space could accommodate the particular while remaining tied to and promoting the ideas and values of a broader entity.

Beyond such branding effects, the regulations on architectural specifications produced a more consolidated, uniform backdrop for the performance of *Volksgemeinschaft* in the city centers. As architect Peter Butenschøn writes, Hitler and Speer's vision for Germania was less about a well-functioning metropolis than about creating an "impressive political scenography" that would induce among the masses a sense of belonging and faith in National Socialism.[128] The evolution of Pedersen's BSR designs for Molde reveals a similar scenography coming into tighter focus. In Pedersen's August 1940 proposal, for example, the height of the rooflines around the central square and along Storgata varied, creating a hybrid effect (see fig. 4.10). In his 1943 proposal, these same rooftops carefully line up to create the impression of solid, unbroken blocks (figs. 4.19 and 4.20). Pedersen also extended the width of Storgata in this later plan from twelve to eighteen meters to create a wide avenue ideal for parades and marches. Along its northern section (Rosegaten), he changed the orientation of buildings to align the long

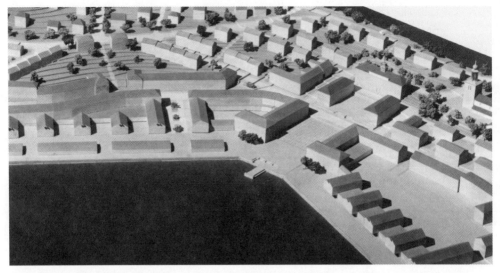

4.19. Model based on a 1942 plan of Molde by Sverre Pedersen.

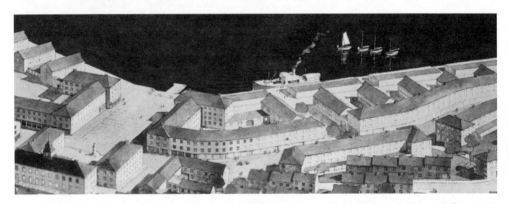

4.20. Watercolor of Molde (detail) showing uniformity of buildings along Storgata leading to the central square (left), c. 1942.

side walls with the street, thus using the walls to frame the street in a manner recalling Lehndorf's main avenue (fig. 4.21, and see figs. 4.4, 4.10, 4.19–20).[129] Enclosing street space in this manner was "indispensable to the imposing effect of the city if the buildings themselves did not have a strongly monumental character," and closely followed strategies employed by Speer and Stephan in their transformation of Berlin.[130] In Molde, the uninterrupted wall of buildings along Storgata would have cut off views of the fjord and diverted attention away from the monumentality of nature to the theater of the street.[131] Admittedly, not every design decision in the BSR plans was ideologically driven; nevertheless,

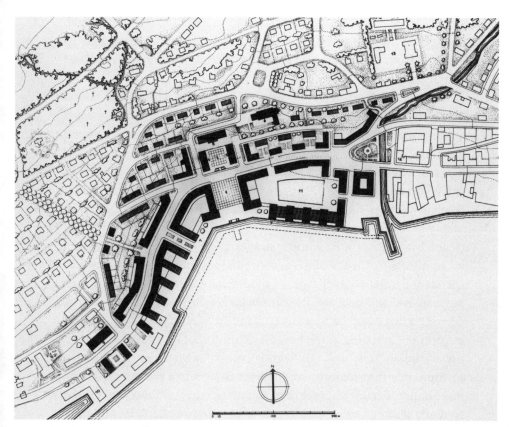

4.21. A 1942 BSR plan of Molde by Sverre Pedersen.

the general trajectory of the design changes introduced after the BSR came under German supervision demonstrates a clear and progressive transformation of urban environments into political stage sets.

It is debatable how much Stephan truly understood the Norwegian towns he reviewed with Pedersen and other BSR architects over the years. On the one hand, the BSR reconstruction program represented a level of contact and collaboration between occupying and occupied architects that was unprecedented in the Second World War.[132] When Stephan toured devastated Norwegian cities in 1940 and again in 1941, Pedersen went out of his way to introduce him to a broader Norwegian context.[133] The study trip to Germany provided another extended period of contact and dialogue between Norwegian architects and their occupiers. Stephan also had many other opportunities, during his meetings with Norwegian architects and officials, to learn about the people

and places he was charged with transforming. On the other hand, evidence from his own travel journal suggests that Stephan remained disengaged from the people and places he visited, viewing them instead through the lens of authority and privilege.

"Reise nach Norwegen" (Journey to Norway) is a typed and bound manuscript, 180 pages in length, with captioned photographs inserted as illustrations. Written in the style of a diary, the text offers a firsthand account of Stephan's Norwegian travels from July 1 to July 19, 1941.[134] The trip was undertaken at Terboven's request to assess reworked BSR proposals and to visit BSR war-damaged locations in the far north that Stephan had been unable to see on his 1940 tour. Despite a certain informality in tone, the presentation as a book suggests that Stephan hoped to publish it in a limited edition, similar to other travel books written by architects in Speer's office and circulated among a select group of friends and influential officials—a small but powerful audience. In 1941, Stephan had self-published *Niederländisches Tagebuch* (Dutch Diary), documenting a trip he took to Holland in May 1940 to present slide lectures on "building in the new Germany and the redesign of the imperial capital." The first talk was delivered on May 9 at the Colonial Institute in Amsterdam to an audience of between two hundred and three hundred, mostly Dutch. The following day, the Nazis invaded the Netherlands and unleashed a Blitzkrieg, ending Stephan's lecture tour. The diary chronicled the attack from the perspective of a German in Holland, trapped in the midst of the invasion.[135]

Although Stephan's experience of the Battle of the Netherlands was equally marked by privilege—locked down in a hotel with bombs exploding outside, he grumbles about the spotty meal service—it gave him a firsthand glimpse of the impact of war on civilians. Even so, he chose to believe that the Dutch were really on the Germans' side, and that the invasion had barely ruffled their brotherly feelings. After hostilities ended, he described German and Dutch soldiers palling around. Not a single hateful word had been directed at him, he wrote, not even in the midst of the fighting.[136] In Norway, too, Stephan claimed not to have observed any anti-German sentiment, even though his diary tells us otherwise: an encounter in a rural store in the far north, where the Norwegians refuse to speak to him; a young Norwegian bus driver who emphatically tells Stephan he will not join the Norwegian Legion (Norwegian SS volunteers who fought for the Germans) and wants nothing to do with the war; a passing glimpse of the burnt-out ruins of Frost-

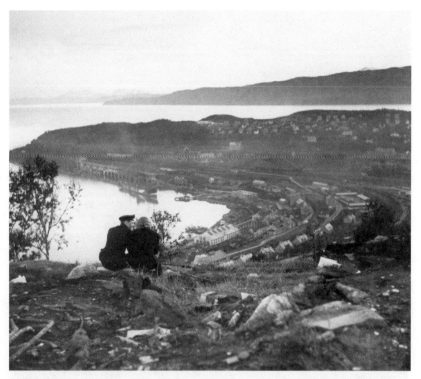

4.22. A German sailor and Norwegian woman above war-damaged Narvik, 1941. Stephan ended his 1941 Norwegian travel diary as well as his Berlin lecture with this image. The caption in his travelogue reads, "The hope of the future lies with Europe's youth. Midnight in Narvik."

filet, a German-seized fish-processing factory in Bodø that Stephan notes had been destroyed by saboteurs; a visit to a prison camp near Tromsø with a rapidly expanding population of political prisoners; matches broken into V-symbols and left on tables in hotels, the V referring to the hoped-for Allied victory over the Germans. While making note of them, Stephan did not take these signs of resistance seriously; as he wrote, "Every [German] soldier and every sailor has, after all, his [Norwegian] girl" (fig. 4.22).[137]

Stephan's denial of the reality on the ground is not surprising for what amounts to a Nazi armchair travel guide to Norway. *Niederländisches Tagebuch* had been dedicated to Speer, and Stephan almost certainly imagined Speer as the primary reader for his Norwegian diary. When he submitted his official report on the trip to Speer in early August 1941, he let him know that "a detailed account of the journey (of a more personal nature) will follow shortly"—presumably, the diary.[138] As mentioned earlier, Speer had intended to accompany Stephan on

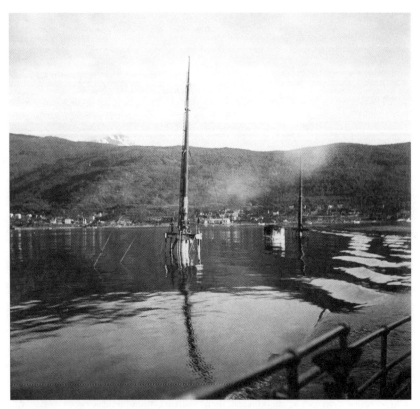

4.23. The masts of a sunken ore carrier rising above the water in Narvik's harbor, 1941.

this trip to Norway but was forced by Hitler to cancel his plans. Stephan may have written the diary to give back to Speer some sense of the experience lost to him—especially a sense of the vastness of the country. The trip, encompassing travel by airplane, train, ship, and automobile, took Stephan from Berlin to Oslo, Oslo to Trondheim, Trondheim to Hemnesberget, Fauske, Bodø, Narvik, Bjerkvik, Tromsø, and on to Helligskogen near the Finnish border, back to Trondheim, from there to Oslo and Bergen, and back to Oslo before departing for Berlin. In total, Stephan calculated that he had traveled some four thousand kilometers in Norway alone.[139]

Outside of the towns, Stephan described the landscapes he encountered as mostly empty but also as marked by the war and occupation. He attentively looked for and noted German traces: a gigantic white swastika painted by German soldiers on a cliff above the village of Rognan; the grave of a German soldier marked with a birch cross and

4.24. Edgar Luther (left) taking a photograph of a Sámi woman near the village of Kvesmenes in the Lyngen Fjord, in northern Norway, 1941. Stephan may have taken the photograph, which he included in his Norway travelogue.

hanging steel helmet glimpsed on the way to the village of Felling-fors; sunken German boats, their masts rising above the waterline, in Narvik's harbor (fig. 4.23); and endless barracks and fortifications. At a stonemasonry company in Fauske, he unexpectedly recognized, by the size and shape of large marble and travertine blocks, a supplier for "our Berlin and Nuremberg buildings," which further cast for him Germany's presence over the land. Norwegian quarries did, indeed, supply Speer's monumental buildings in Berlin and Nuremberg, and in August 1940 Speer had himself planned to travel to Norway on account of his "granite issues."[140]

Enraptured by Norway's landscapes, Stephan, by contrast, seems to have barely noticed the inhabitants, who rarely appear in the book. Although this obscuration of a country's inhabitants is not unusual for travel guides, not all people are hidden in Stephan's diary. Germans in Norway are far more present and vivid in his account; they seem to be the people he encounters most frequently (or finds worthy of attention). He also demonstrates a particular interest in the Sámi, whom he encounters in the far north and whose names and ages he records, as if collecting specimens (fig. 4.24). The most substantial encounter Stephan has with a Norwegian occurs near the end of the diary, when in Bergen he dines with that city's chief building inspector and BSR architect Sverre Madsen. A member of Nasjonal Samling who was married to a German and had practiced architecture for many years in Hamburg, Madsen admitted to being thoroughly alienated from his neighbors and other Norwegians. Their conversation is as close as we come in the diary to a frank discussion about the occupation, even if skewed through the eyes of two National Socialist believers.[141]

Pedersen makes a brief but revealing appearance in Stephan's diary. Pedersen intended to accompany Stephan from Trondheim to Narvik; Stephan wrote that he liked to have Pedersen along as a travel companion because he told amusing local-color stories about the places they passed by. As they set out in the open car, Stephan poked fun at how Pedersen, windblown and cold in the backseat, pulled a woolen cap down over his ears and tied a long red woolen scarf around his head and neck, making himself, Stephan claimed, into a spectacle. Later that day, near Grong, Pedersen suddenly became carsick: "He jumps out of the car and spews like a garden hose." Dwelling on the scene, Stephan described Pedersen as being "at the mercy of this elemental force." The Norwegian decided to abandon the trip, insisting instead on taking the train through Sweden to rejoin Stephan in Oslo. Pedersen's refusal to fly, which Stephan also noted, further marked him, in the context of Speer's technology-obsessed office, as a man left behind by the modern age. When Stephan saw him in Oslo, Pedersen again made a "sad impression," having had to spend a sleepless night on his return journey in a hotel room located under a busy set of stairs. Thus the diary presents Pedersen, not as the highly accomplished and internationally known architect that he was, but as a man who is part entertainer and part punch line.[142]

Stephan's July 1941 trip may have been his last to Norway: there are no indications in the surviving records of a return journey, although he and Speer remained involved in the reconstruction projects. The BSR continued to send plans and models to Berlin for approval.[143] In the official report he submitted to Speer about his July visit, Stephan expressed his satisfaction with almost all the revised BSR proposals he had seen in Norway.[144] Given that progress, he may have felt that subsequent reviews and approvals could be carried out remotely. But there may have been another reason for Stephan to lower his profile. The Germans planned to hold a number of architectural competitions to allow a broad array of Norwegian architects to participate in the reconstruction process, and to ensure a high caliber of design for the most representational buildings or parts of towns. The competitions also bolstered the message that the shaping of Norwegian towns remained a Norwegian affair. At the same time, the Germans were concerned with how to maintain control over the outcome. Speer suggested that German architects be allowed to compete "so that the Norwegians are brought even more strongly into line with and spurred toward our direction." The possibility of including Germans on the prize juries was also discussed. In the end the competitions were limited to Norwegian architects and jurors, although the latter were selected with German input. Even so, Terboven's approval was required before prizewinners could be announced—thus the prize jurors' decision was not binding. An early competition for the bombed Nordnes residential district in Bergen roused strong resentment at German interference when Terboven made the jurors' decision dependent on Stephan's review—it was for this reason (to review the fifty-nine competition entries) that Stephan had traveled to Bergen in July 1941. After that experience, Terboven, in a letter to Speer, outlined a less antagonizing, behind-the-scenes approach to controlling future competitions.[145]

When Norway was liberated in May 1945, the places that had been damaged in the invasion five years earlier were still largely empty. The rubble had long been cleared away and the terrain prepared for rebuilding, including expropriations and redistribution of plots, creation of roads, and the laying down of other infrastructure. Very few buildings, however, had actually been erected. On the outskirts of the towns, emergency housing had been constructed to help accommodate the many thousands made homeless by the invasion. Speer had

4.25. Swedish Red Cross housing at Namsos, c. 1941.

insisted that such housing be confined to urban peripheries because
he did not want any structures interfering with his plans for the town
centers (fig. 4.25).[146] As a result, these centers remained a landscape of
vacant lots.

As Norwegians turned their attention to rebuilding their war-
devastated country, they confronted the problem of what to do with
the BSR's preparatory work under the Germans: move ahead with the
plans, which had taken years to develop, or start over from scratch? In
June 1945, Pedersen, disgraced by his cooperation with the Germans,
resigned from the BSR and returned to teaching at the Norwegian Insti-
tute of Technology. He was replaced by architect Erik Rolfsen, a cham-
pion of functionalist approaches who had worked closely with Pedersen
at the BSR (and participated on the 1940 study trip to Germany), but
who, dismayed by the caliber of their work, had left the group in 1943
and gone into exile.[147] Harald Hals, chief planner in Oslo and president
of the National Association of Norwegian Architects, lobbied the gov-
ernment to review and possibly revise the BSR plans. To further his

cause, he dedicated the first postwar issue of *Byggekunst* to an appraisal by Scandinavian architects of the urban designs. Hals believed that the public should have a chance to voice their desires and openly discuss the merits of the BSR's work, which had not been possible under the occupation.[148]

Contributors to the special *Byggekunst* issue were harshly critical (fig. 4.26). Hals decried the "German mentality" pervading the BSR plans, the autocratic methods of planning employed, and the irrelevance of the resulting designs to the needs of modern democratic nations. Edvard Heiberg, a Norwegian-Danish architect who evaluated Pedersen's plan for Molde, argued that its German origin was palpable in its absolutist and abstracted ideals. The proposal struck him more as a surreal vision than as an actual plan for the city's development: it had the character of "a materialized dream of the future." The town was laid out with a "brutal" axiality. The center was a "German Forum Romanum, meant to instill respect and obedience and to impress a gaping, passive and hailing crowd. . . . The buildings arranged around this public square were uniform building blocks, which were intended less to serve human needs than to stand at attention at military parades." He also condemned the surveillance-like nature of the city center, where administrative and policing functions prevailed: "Could one wish for a clearer symbolization of 'the state' as described by Engels?" Even Pedersen's former colleagues distanced themselves from their joint work. John Horntvedt, an architect who had worked closely with Pedersen at the BSR (and had also been a study-trip participant), worried that the plans they had produced were too ambitious, assuming a postwar growth that might never happen. He further decried the emphasis on the city center to the detriment of the development of the town as a whole, and the "forlorn monumentality" hostile to the expression of social democracy.[149]

In fact, the voices raised against Pedersen's work with the Germans went far beyond the pages of *Byggekunst*. At the Norwegian Institute of Technology, students boycotted his classes in the fall of 1945, leading him to take a prolonged leave of absence. Pedersen was also censured and symbolically banished by his colleagues in the National Association of Norwegian Architects, which rescinded his membership until 1949.[150] These immediate postwar years marked the nadir of Pedersen's reputation, which would not recover for decades, until after his death in 1971.

Fig. 1.

Fig. 2.

Fig. 3.

38

4.26. Illustration accompanying an article, "Three Cities," by architect Per Pihl (later chief planner in Drammen) that appeared in the 1945 *Byggekunst* issue evaluating BSR plans. Based on the BSR's plan for Namsos, Pihl imagined three scenarios: the militaristic conformity of a Nazi-approved BSR plan in 1; the anarchic result of too little central control in 2; and an ideal mixture of central planning, private initiative, and mixed-use spaces (domestic, commercial, and light industrial) in 3.

Despite vociferous criticisms, the BSR plans developed under Nazi supervision were, with minor modifications, constructed after the war.[151] The fact that the streets had already been laid out contributed significantly to this outcome. More broadly, the costs and delays involved to begin anew were simply too great, especially at a time of desperate need. Hitler's scorched-earth campaign in northern Norway meant that, in addition to the war damage that still needed to be addressed from the 1940 invasion, whole swaths of northern Norway also needed to be rebuilt, necessitating an enormous expenditure of resources and architectural expertise. Many BSR architects therefore went north, to restore the towns that had been burned and razed in the winter of 1944–45 by Hitler's retreating troops.[152]

The most substantial changes to the BSR plans occurred perforce, with the destruction of the Greater German Reich and its ideological apparatus: buildings intended as linchpins in the creation of ideal National Socialist communities, such as the *Parteihaus* and *Reichshaus*, were reassigned democratic or commercial functions. On the level of design, attempts to modulate the authoritarian sensibilities denounced by the *Byggekunst* critics focused largely on aesthetic interventions.[153] In Molde, for example, architects again embraced modernist styles and materials; on Storgata, they pulled some buildings back from the street and varied their rooflines to relax the impression of uniform building blocks standing at attention. Molde historian Olav Arild Abrahamsen has called this process a washing off of the town's "German cosmetics." The fundamental elements of Pedersen's vision remained and even enjoyed local support. Molde authorities who had worked with Pedersen in the mid-1930s and appreciated the similarities to that earlier proposal were far more positive than the *Byggekunst* critics about his BSR plan.[154]

In 1980, the editors of *Byggekunst* reevaluated the BSR reconstruction plans. They placed many of the elements that had been condemned as National Socialist, such as the axiality and symmetry of the plans, in the context of broader Norwegian and European traditions. They also drew attention to continuities with Pedersen's prewar ideals. The editors acknowledged that the Germans' preference for Pedersen's style did not make it fascist; indeed, they concluded that the BSR designs were "Norwegian until the Germans blessed them." Architect Unnleiv Bergsgard, writing in *Byggekunst* on the 1982 centennial of Pedersen's birth, admitted that functionalist architects of his generation had welcomed Edvard Heiberg's strong criticisms as a reaction against

Pedersen's hegemonic position in Norwegian town planning. Heiberg's disgust also resonated with their antipathy to Pedersen's architectural values, which Bergsgard and his peers had rejected after the war. In the 1980s, when the tide of criticism turned against postwar functionalism, Pedersen's work did not seem so bad. In Molde, meanwhile, the population had increased beyond all expectations, refuting concerns that Pedersen's plan had been outsized. The pressures of growth threatened, in fact, to overwhelm his design, leading to calls to protect and preserve it (see plate 8).[155]

Today, assessments of Pedersen's work for the BSR remain mixed, with some believing he capitulated to the New Order in occupied Norway, and others arguing that he resisted German influence.[156] Tvinnereim's biography brings needed attention to the ambiguities of the wartime picture, in terms of both Pedersen's motivations (to the degree that these can be known) and efforts by local communities to intervene where they could in shaping their towns. The view from the German archives presented in this chapter adds further layers of complexity, including the complicated and ambivalent relationship that Stephan and Speer developed with Pedersen in their search for the "right" partners in Norway. Most importantly, however, these archival materials reveal just how intently Germans strove to bring the BSR plans into ideological alignment with National Socialist town planning in Germany.

In their mission to create a Greater German Reich, the Nazis established a framework for a vast social experiment in Norway, an attempt to use urban form to transform Norwegians into racial comrades. After the war, those urban frameworks lost their original ideological input, but the physical forms remained largely intact. Although the BSR designs demonstrate many continuities with broader urban-planning traditions, in light of this new evidence it seems irrefutable that Speer, Stephan, Luther, and other National Socialist architects also left their mark. Planning the hoped-for National Socialist *Gemeinschaft* represented a deep, structural project that reorganized urban form. Aesthetics were an important part of that transformation, but they were not the entire picture. The occupiers' mark, in short, could not be washed off like cosmetics.

This raises the question of what, if any, impact National Socialist interventions in Norwegian reconstructed towns have had since the war's end. Did the more monumental scale of the designs and their emphasis

on urban centers transform in any way social habits and activities? In a new political era, could the formal design emphasis on community participation have strengthened democratic values, in direct opposition to Nazi intentions? Left, by and large, with an urban built environment designed to encourage political performance by the inhabitants, what became of the play?

5 A German City in the Fjords
Hitler's Plans for New Trondheim

In October 1939, with England and France having declared war
in the wake of Germany's invasion of Poland, and confronting
the possibility of a protracted war, Grand Admiral Erich Raeder, com-
mander in chief of the German navy, focused his attention on the ac-
quisition of new naval bases. German naval strategy was fundamentally
disadvantaged by the fact that the nation's bases lay within England's
blockade lines, a situation that could become critical with the intensifi-
cation of sea warfare. During World War I, the Allied naval blockade,
which had cut off the maritime supply of goods to Germany for the
war's duration, contributed to civilian famine and to Germany's even-
tual defeat. Having then served as Admiral Franz von Hipper's chief
of staff, Raeder was well aware of criticism within the navy, already
voiced during the First World War, about the need to adopt a strate-
gically offensive position, which required free access to the Atlantic
and German bases on the Norwegian coast.[1] With Germany and En-
gland again at war, Raeder considered ways to obtain a base that would
strengthen his country's sea power and protect supply routes from a
potentially escalating blockade.

One option the grand admiral considered would have a friendly
power provide access to a base on its own soil. Preparations were al-
ready under way to develop a base on the Murman Coast in north-
west Russia, which would secure a supply route. But this option had
the disadvantage of being a great distance from Germany and would
also require constructing new facilities. In Raeder's view, Trondheim
in Norway offered multiple advantages as the site for a German base,
the most obvious being its relative proximity and preexisting harbor

facilities. Deepwater channels leading to the harbor could also be counted on to deter the English from laying naval mines, and its inland location would provide additional protection from sea threats. Supplies from Trondheim could be delivered to Germany by rail (via Oslo and Stockholm) and ship. But there were also drawbacks to a base in Norway. Among them, if political pressure (possibly exerted in tandem with Russia) could not convince the Norwegian government to offer access peacefully, the use of force would be necessary. Once established, the overland portion of the supply line would also be vulnerable to attack. Raeder thus concluded that while negotiations with the Soviets progressed, plans for Trondheim should be developed as well, in case the Murman Coast base fell through or proved insufficient for German needs.[2]

Raeder stated his position clearly in a memorandum dated October 20, 1939, written after a meeting with Hitler on October 10, during which the grand admiral had raised the idea of using Trondheim as a naval base. Hitler had said he would consider the matter, but did not act.[3] By December, however, concerns about England's war moves had made him more receptive. In a December 12 conference with the Führer, Raeder reported on his meeting with Norwegian Nasjonal Samling leader Vidkun Quisling, then visiting Berlin, who had warned of the mounting threat of a British landing in Norway. When Hitler, at Raeder's suggestion, met personally with Quisling, the latter bolstered rumors of a British intervention in Norway, then circulating in the international press, by claiming secret knowledge of a British-Norwegian conspiracy.[4] Hitler, alarmed, ordered Raeder to draw up preliminary plans for a military attack, which would lead, over the next few months, to Operation Weserübung and the invasion of Norway on April 9, 1940.[5]

Following the capitulation of fighting forces in Norway on June 10, 1940, Raeder moved swiftly to implement his plans. On June 20, he made the case to Hitler that Trondheim needed to be developed as a military base on a grand scale. Raeder also took this opportunity to complain about the Luftwaffe's poor defense of his fleet in Trondheim's harbor, following repeated British air attacks on German battleships stationed there in mid-June, as further justification for upgrading facilities.[6]

Raeder's argument fell on enthusiastic ears. Already two months earlier, at his birthday luncheon in April, Hitler had told his guests that "Trondheim will have to be developed and expanded to such an extent that Singapore is mere child's play by comparison."[7] What Hitler was

referring to—and what he planned to put to shame—was the vast new British naval base in Singapore: completed in 1938 at enormous cost, the technologically modern base offered "more than twenty square miles of deep water anchorage, more than enough to accommodate the entire British Fleet," as well as the largest dry dock in the world.[8] In early July 1940, Admiral Hermann Boehm, commander of German naval forces in Norway, received orders "to submit proposals for the construction of a high-performance shipyard, primarily for war operations, in the area of Trondheim."[9]

In the following weeks, Hitler's ambitions for the naval installation solidified. By early August, he ordered that Trondheim should be developed into a first-class base (Stützpunkt 1) on par with Kiel on the Baltic and Wilhelmshaven on the North Sea, Germany's main naval bases. Although the new shipyard had initially been conceived as serving wartime purposes, Hitler decided to expand its role to that of a major shipyard for peacetime building and maintenance. Furthermore, he made clear that the base would unfold on a monumental scale, and that its designers should, from the outset, adopt an approach that would allow for large-scale development, which meant no scrimping on space. Other stipulations included not concentrating the ships' berths in one place or surrounding them by mountains, which could heighten the danger of air attacks.[10]

But this was not all that Hitler had in mind. On July 11, 1940, when Raeder reported to him that planning for the naval base was under way, he learned that Hitler's intentions were twofold. First, Hitler wanted to build a base near Trondheim, protected by land and sea, suitable for the construction of very large ships. But, second, he wanted to create "a most beautiful German city" on the fjord near the shipyard.[11] This was not to be a suburb or satellite of Trondheim, but rather, as Speer later described it, "a completely new German city."[12] Joseph Goebbels, who had spoken with Hitler about what he envisioned on July 9, two days before the meeting with Raeder, noted in his diary that the city would be "fabulously built."[13] Just weeks after the invasion had ended, Hitler no longer saw the base as sufficient for his plans in Norway: instead, he pushed forward with a more audacious project—the foundation of a magnificent new German center in the North.

The expansion of the project from a naval base, already a substantial undertaking, to a base plus a city—each with its unique spatial demands —complicated the search for a suitable location. Adding to this difficulty

was the scale at which Hitler preferred to work. The new city's intended population was set at 300,000, which would have made it the largest settlement anywhere in Norway, surpassing even Oslo, with its 275,000 inhabitants. It would have dwarfed Trondheim's population (66,000) by comparison.[14] Hitler's plan, in short, was to construct not only a new city in Norway, but also the biggest one in the country—and, moreover, to erect that city from scratch.

To determine the locations of the city and base, much more information was needed about the geography of the Trondheim Fjord. As a first step in that process, in July 1940, Luftwaffe General Karl Kitzinger, at the request of the Reich Commissariat, ordered photographs taken of a sixty-by-sixty-kilometer area of the Trondheim Fjord at a scale of 1:10,000, which made natural features easily discernable.[15] The images were to be delivered to Hitler and also sent to the Norsk Modellerings Kompani in Oslo. The model-making company used them to create a raised-relief map of the area, also at a scale of 1:10,000. The finished model, which measured five by ten meters, was shipped in pieces and in eighteen crates to Berlin, where it arrived in early September 1940.[16] Additionally, the Reich Commissariat commissioned the Karl Wenschow firm in Munich to produce two copies of a topographical model of the area at a more distant scale of 1:25,000 (fig. 5.1 and see plate 9). The company, already inundated with orders from the Armed Forces High Command, dispatched the models only in February 1941. One was placed in the Hall of Models, a large room located in the upper story of the new Reich Chancellery in Berlin. The other was displayed in the Storting in Oslo, before being shipped, in July 1941, to the Stiftsgården, the royal residence in Trondheim, where Reich Commissar Terboven made his residence while visiting (fig. 5.1).[17]

While the Trondheim Fjord was being photographed and mapped during the summer of 1940, the Naval High Command Norway and the Reich Commissariat held meetings to discuss the new naval base and city and how to organize their collaboration. On August 2, 1940, Admiral Boehm met with Terboven in Oslo to explain the navy's vision and needs, and to let the Reich commissar know that they had been looking at an area east of Trondheim for a suitable location. Terboven responded that he had envisioned establishing the new city southwest of Trondheim on the north side of the Gulosen Fjord (a branch of the Trondheim Fjord).[18] For the navy, a location east of Trondheim would have provided easy access to the existing harbor. Terboven, by con-

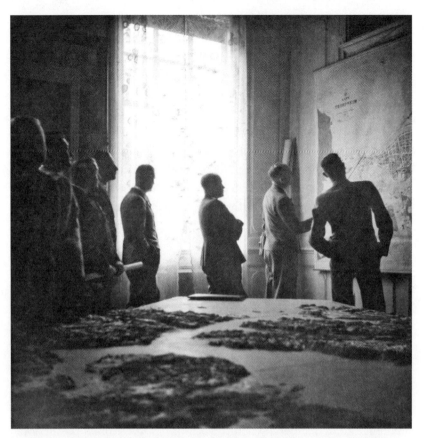

5.1. Terboven and Nazi officials in the Stiftsgården in Trondheim during the Reich Commissar's July 1942 visit. In the foreground is the topographical model of the Trondheim Fjord completed in early 1941 by the Karl Wenschow firm. A copy of the same model was also placed in the Hall of Models in the Reich Chancellery in Berlin.

trast, may have been drawn to the southwestern location because the sparsely populated region aroused feelings of exploring a terra incognita and of creating something truly new (rather than an extension of Trondheim). Terboven was captivated by the idea of finding a location for Hitler's imagined German city, and he undertook numerous flights in a Fieseler Storch, a small airplane, to survey the landscape.[19]

A few days after the meeting took place, on August 5, Vice Admiral Eduard Eichel, senior director of the Naval Shipyard Trondheim, and Heinz Klein, head of the Reich Commissariat's Engineering and Transport Department, met in Oslo to continue the discussions Boehm and Terboven had begun. They agreed that the navy would formulate a

proposal regarding its needs for manpower and facilities, on the basis of which a projection of building requirements would be drawn up. The base was to be constructed primarily by the navy, while the city itself was to be planned and built by Klein's department. Locations under consideration for the base included areas east and south of Trondheim but also on the bay near Steinkjer. Once the navy had submitted its initial scheme, Klein stated, his department would begin the geological and other studies needed to determine the site. Klein was particularly concerned that the navy submit its proposal in a timely manner, since a project of this scale would require greatly expanding his division's architectural staff, a process that would take considerable time.[20]

Given this understanding with Eichel, Klein was shocked and distressed to learn, the following year, that Hitler had given the commission for the new city to Albert Speer. Klein confronted Hans Stephan, Speer's Berlin colleague and representative in Norway, over his department's ouster at a meeting in Oslo on July 1, 1941. As Stephan's report to Speer on the meeting reveals, Klein began by laying out the preparatory work that had been done to plan the new city. Klein insisted that it would be very unfortunate, given this effort and experience, if the Reich Commissariat were not involved in the project moving forward. Indeed, he expressed his resentment in the strongest terms: "Those of us who, up to now, have done the donkeywork in Norway would very much like to be included when the best is being creamed off the top." Stephan, seeking to mollify Klein while also putting him in his place, countered that "the Führer must see this project as extraordinarily important to have entrusted it to his first architect, Herr Speer." Nor could he say whether there would be any room for collaboration. Klein's subordinate, Reich Commissariat chief architect Edgar Luther, also present at the meeting, pleaded with Stephan to intercede with Speer on his group's behalf.[21]

Stephan was in Norway that summer to work closely with Luther on the reconstruction of Norwegian cities damaged during the German invasion, a large-scale undertaking being overseen by Speer. Yet despite this previous partnership between Speer's and Klein's offices, neither Speer nor Stephan, it seems, had any desire to share the bounty of their new commission from Hitler with their Reich Commissariat colleagues. As Speer had politely but firmly explained to Terboven in a letter of April 24, 1941, Hitler had given him full powers over the creation of the new city in Trondheim, on par with the enormous

powers he enjoyed in Berlin as the city's general building inspector. Accordingly, Speer continued, Hitler preferred that Speer use his own Berlin-based staff for the project's on-site development. Speer thus drew a clear boundary meant to repel incursions from the Reich Commissariat's own people.[22] (Terboven failed, however, to report any of this to his staff, leading to Klein's later unpleasant discovery.)[23] In short, the creation of a German city on the Trondheim Fjord was a prestige project, even if it was located on the outer fringes of the empire, and those in the most powerful positions in Berlin defended their claim over territorial officials such as Klein and Luther, who believed that their proximity and grunt work entitled them to a place at the architectural feast.

The circumstances under which Speer received the commission for the new city undoubtedly also played into his determination to keep it to himself. In a January 17, 1941, meeting with Hitler, Speer told his patron that he could no longer continue to carry out the volume of general assignments entrusted to him, which was harming his artistic work, and that he would, therefore, have to choose between the two.[24] This act of defiance resulted less from overwork, as Speer claimed, than from professional jealousy: Hitler increasingly favored Hermann Giesler, Speer's architectural rival, whom he had named general building inspector for Munich in December 1938. In an effort to secure his supremacy, Speer, in November 1940, had submitted to Hitler (via Martin Bormann) a proposal to have himself named "The Führer's Commissioner for Architecture and City Planning of the NSDAP." This position would have given Speer enormous control over the shaping of the Reich's buildings and cities, transportation systems, and construction economy, as well as the employment of its architects. Speer argued that he had effectively already taken on these responsibilities for the party, but without any official recognition or support. Giesler and Bormann blocked this power grab, and Hitler turned down Speer's request. Dismayed, Speer wrote to Bormann on January 20, 1941, telling him about his meeting with Hitler a few days earlier, and about the understanding and support the latter had expressed for Speer's stated desire to focus thenceforth on his own oeuvre and legacy. Speer ended the letter with a request to be passed along to the Führer: namely, to give him a new city to design. Freed from the many thankless and unsatisfying tasks that he had previously accepted for the party, he reasoned that he would now have more time to dedicate to his own artistic endeavors. As he wrote to Bormann, "You will admit that with the construction of a new city,

such as Trondheim, I will give the Führer greater joy and leave posterity a visible sign of my work."[25]

Hitler understood that Speer was hurt by his decision not to name him the party's building commissioner. He also understood how to best make amends. A few days after their January 17 meeting, Hitler granted Speer's request, commissioning him to design an entire new city in Norway.[26] Thus although Speer did not receive the title he had sought, he did come out of the conflict with Giesler with a considerable consolation prize, one made sweeter by the fact that Speer had long had his eye on Trondheim, even before he had approached Hitler about it. When, in August 1940, Terboven and his staff began moving forward with planning the new city, Speer wrote to the Reich commissar to warn him that Hitler had other ideas: "In the planning of Trondheim," he wrote, "I had until now the impression from the Führer's many discussions that he would like to get involved in a special way with *his* architects" (emphasis in the original).[27] For Speer, this commission represented his first opportunity to design an entire city, from the first to the last brick. The April 24, 1941, letter he subsequently wrote to Terboven, in which he made clear that his office alone would be in charge of the project, reveals that Speer wanted every decision to be his own, without meddlesome influence. Where the new city on the fjord was concerned, his authority reigned supreme.

In early April 1941, Speer asked Stephan to determine the area required for a nonindustrial city of 300,000 residents. In his report to Speer, Stephan drew comparisons to similarly sized cities in Germany, particularly Hanover and Essen. Assuming that building would be limited in the new city to three stories and that there would be abundant green spaces, Stephan concluded that between 70 to 100 square kilometers would be ideal.[28] This allowed for a density of roughly 3,000 to 4,300 residents per square kilometer, comparable to Helsinki (3,000 inhabitants per square kilometer) and Washington, DC (4,300 people per square kilometer) today. Between 70 and 100 square kilometers for a midsized city seems a rather large area. It is bigger, for example, than Manhattan, which covers 59.1 square kilometers of land and currently holds 1.64 million residents (with a resulting population density approaching 28,000 per square kilometer, far higher than Hitler or Speer wanted for their new city).[29] Indeed, when Stephan submitted his estimates, Speer was initially skeptical, believing that the space requirements were excessive. Stephan reran the figures using a comparison to

Hermann-Göring-Stadt (today Salzgitter), a planned National Socialist industrial city near Braunschweig, which yielded similar results. Figures in hand, Speer met with Hitler at his headquarters in mid-April 1941 to present two possible locations for the new city. The first lay northeast of Trondheim, while the second lay to the west, where the fjord bent southward (this was the area that Terboven had also recommended to Boehm). Speer's criteria included southern exposure for the residential areas and a large flat terrain with good water access for the shipyards.[30] The two areas he selected presumably offered both.

However closely Speer and Hitler may have studied photographs, charts, and models of the Trondheim Fjord seeking the home of Germany's new northern city and base, a site's viability could not be predicted visually; it could be determined only through in situ testing of soil conditions. Understanding subsurface conditions, including soil strength and density, is critically important for any large-scale construction since soil characteristics affect the ability to build and the intensity of land use. Further complicating development in the Trondheim region was the instability of its slopes. The Trondheim Fjord was prone to onshore and offshore landslides, which had caused major damage in the past. In 1888, an underwater landslide in the bay of Trondheim generated a tsunami wave up to seven meters in height that killed one person and devastated Trondheim's main railway station, washing large sections of track into the fjord.[31] In the spring of 1941, the navy drilled fifty boreholes to test the soil along the coast of Øysand on the Gulosen Fjord.[32]

At Raeder's request, Speer and Stephan met in Berlin on May 2 with Rear Admiral Werner Fuchs, chief of naval construction, and his staff to discuss the projects in the Trondheim Fjord. Fuchs presented an overview of the locations under consideration by the navy, enumerating their advantages and disadvantages. He further disclosed that the navy was considering two shipyards: a small one in the immediate vicinity of Trondheim and a large one, possibly at the mouth of the Gula River, each requiring residences for their workers. Speer's response to Fuchs's presentation is revealing: he stated flatly that the particular arrangement of the shipyard did not interest him. (Indeed, he admitted that he had never seen a large shipyard, and asked Fuchs to name the biggest in Germany, so that he might visit one.) He needed only to know the fundamentals: the shipyard's location and spatial dimensions. Further distinguishing Speer's endeavors from those of Fuchs, the two left the

meeting in agreement that the schedule for designing and constructing the shipyard would not be bound to that of the new city.[33]

Speer's distancing himself from the particulars of the navy's shipyard plans is not entirely surprising, given that Eichel and Klein had already decided that the navy would be primarily responsible for its construction. But with Klein's effective removal from the project, Speer, it seems, needed to reassert those boundaries and make clear that he was not working *for* the navy. This issue arose more urgently after the Naval High Command sent Speer a letter, dated June 24, 1941, concerning its needs within the new city plan. Over several pages the letter described the facilities required and the approximate space they would occupy. Thirty facilities common to a naval base were listed, including a naval hospital, military court building, officers' club, and naval observatory. The land needed for these various facilities was projected to be over seven square kilometers, a not insubstantial part of the city. Beyond these naval facilities, the letter also estimated the residences needed: fifty-five thousand dwellings for members of the navy; officials, civilian employees, and service personnel attached to the fleet; and shipyard and arsenal personnel, as well as another twenty-eight thousand dwellings for those working in the retail trade and in small businesses. At the end of the list came more general community facilities, such as schools, daycares, sports arenas, Hitler Youth homes, police stations, and movie theaters. The letter asked Speer to keep in close contact with the Naval High Command regarding the details of their space requirements, particularly concerning the location of their buildings within the city.[34]

Speer's initial response to the letter was silence: for nearly two months he ignored it. When, on August 15, he finally responded, he did not engage in any meaningful way with the Naval High Command's requests, saying it was premature to have such detailed discussions when soil tests on the site were only just beginning. Moreover, without knowing whether the site would be acceptable, Speer could not say whether the requested space could be granted. Speer then clearly and firmly asserted his authority over the project. He would begin planning the city, he wrote, on the basis of his previous experience with large-scale urban design projects (in other words, and without directly saying so, not on the basis of the navy's wish list). He did reassure the Naval High Command that he would check in with them about the location

of their buildings in due time. And he concluded—again in a tone that managed to both reassure and assert control—that he would make the individual pieces fit since the comprehensive powers that Hitler had granted him ensured that he had the oversight and authority needed to create an integrated whole.[35]

If the city's physical form remained undetermined when Speer wrote his letter to the Naval High Command, the nature of the naval base itself and the population it would bring to the city were begin ning to take definite shape. A classified document in Raeder's files from June 1941 reveals that the new naval facilities being planned for Trondheim were foreseen to be of such a scope that the Plan Z fleet, originally intended for Kiel, could be stationed there instead.[36] Plan Z was an ambitious naval construction program initiated by Hitler prior to the war and strongly supported by Raeder in his efforts to challenge Britain and the United States for global naval domination. Under this scheme, and in violation of the restrictions on the German fleet imposed by the Versailles Treaty after World War I, the German navy would have been vastly expanded with the construction of super-battleships (H-class), small battleships, aircraft carriers, light cruisers, destroyers, torpedo boats, and U-boats.[37]

The classified document in Raeder's files further estimated for the Trondheim base a presence of 48,500 naval and civilian personnel (1,900 officers, 11,800 noncommissioned officers and civilian personnel, and 34,800 enlisted men). Many of the personnel would be married, and their families also needed to be taken into account. Moreover, there would be thousands of workers engaged in support services and industries, such as laundries and bakeries. Then there was the massive workforce envisioned for the shipyard. As detailed in another classified document in Raeder's files, the shipyard was expected to construct one new H-class battleship per year, as well as undertake repairs and maintenance on two battleships, six Spähkreuzer (reconnaissance cruisers), and twenty-four U-boats, which would require 26,000 workers and about 5,000 officials and staff members. (Compare this to two private German shipyards employed by the navy: 12,450 workers at Deutsche Werke Kiel and 7,500 workers at Deutsche Werke Gotenhafen, the seaport in Poland taken over by the Germans in 1939 in the city formerly called Gdynia.) Finally, the navy's arsenal would employ about 9,000 workers, with an additional 4,500 officials and staff members. Based on

the new city's intended size of 300,000, these figures suggest that around a third of the population would have worked directly or indirectly for the base.[38]

The shipyard itself was ambitiously planned: it would house three large building slipways, four smaller building slipways, three large docks, three medium docks, and ten small docks. At 2,500,000 square meters, the estimated area these would cover was over four times that of Deutsche Werke Kiel, one of the largest shipyards in Germany. The total quay length (6,000 meters) would be twice that of Kiel. The arsenal, furthermore, would have added considerably to the overall area (1,700,000 square meters) and quay length (5,000–6,000 meters).[39] The total area was thus projected to be 4,200,000 square meters, with a total quay length of up to 12,000 meters. Hitler agreed with the navy's request to hire private firms to help plan and build the shipyard. Initially, in September 1940, negotiations were undertaken with Hamburg shipbuilder Blohm and Voss. The following year, in the summer of 1941, contracts were signed with both Deutsche Werke Kiel and the Krupp firm of Essen, an arms and battleship manufacturer.[40]

Thus not much more than a year after Hitler had boasted that his plans for Trondheim would make Singapore look like child's play, his vision was on its way to being realized. The home port of Raeder's superfleet in the Norwegian fjord would have been among Germany's chief naval bases in Europe, from which the German navy planned to dominate the world's oceans. The city, teeming with the activity of the navy and the massive shipyard, would have played a substantial economic role in German-occupied Europe. In terms of its German population, it would have far surpassed the total number of Germans (about 23,500 in 1913) who had lived in German colonies in Africa, China, and the Pacific during the imperial period.[41]

In the spring of 1941, as the Trondheim project advanced, Speer prepared to travel to Norway to scout possible locations for the city. While there, he also intended to visit some of the war-damaged Norwegian cities being reconstructed under his supervision and to take a holiday, notably without his family. The monthlong trip, planned for mid-June to mid-July 1941, would have taken Speer, among other places, to the Sogne Fjord, the Jotunheimen mountains (the highest mountain range in Scandinavia), and northern Norway as far as Narvik. It would also have given him several days in Trondheim for his investigations. For Speer this personal experience of the site of the future

city was indispensable—but not only for himself. As he wrote to Terboven on April 24, 1941, "I assume that the location can be conclusively determined only through a personal visit by the Führer." Just when Hitler's on-site visit might occur, which would have brought him to Norway for the first time since his cruise of April 1934, Speer did not say. In the end, neither of these visits happened. In a letter to Terboven dated June 9, 1941, Speer explained that he was compelled to cancel his trip only days before his planned departure. Unfettered by modesty, he wrote that Hitler did not want him to undertake the tour for the time being because "travel conditions in Norway appear to him to not yet be safe enough, and I am irreplaceable for him." Norwegian saboteurs had been particularly active in the weeks leading up to Speer's planned trip, perhaps prompting Hitler's reluctance to let him go.[42]

Although Speer expressed the hope to Terboven that he would be able to travel to Norway "in the foreseeable future," the decision on the site for the new city and base could not wait any longer. On June 18, Speer met with Raeder to discuss the projects. Then, on June 21, Speer and Raeder met at the Reich Chancellery with Hitler, Major General Alfred Jodl (chief of operations, Armed Forces High Command), and Captain Karl-Jesco von Puttkamer (Hitler's naval adjutant) to choose the locations: the large peninsula west of Trondheim for "the new German city," and the Gulosen Fjord for the base. (Three days later, the Naval High Command sent Speer their wish list for the city, which so irked him.) After the meeting, one of the first people whom Speer informed about the location of the new city was Fritz Todt, inspector general of German roadways, who had been waiting for this determination in order to move forward with planning the autobahn that was to stretch from Oslo to Trondheim. As Speer explained to Todt, the chosen location would not change unless ongoing investigations turned up "insurmountable difficulties for the building project."[43]

Because Speer could not immediately visit the location of the city he was meant to design, in July 1941 he sent his employee Hans Stephan in his place. On a trip that also involved meetings and on-site visits for the reconstruction of Norwegian towns, Stephan spent three days in Trondheim to explore the large western peninsula that Hitler had identified as the site for the new city—the primary purpose of his travels.[44] Much of the peninsula was mountainous, leaving only limited areas for habitation. A map from the naval construction office indicates the area, outlined in green pencil, that Hitler chose for the actual building of the

city: a large area of farms along the peninsula's far western coast (see plates 10 and 11).[45] Stephan expressed some concern to Speer that, given the area needed for a city of three hundred thousand people, the entire town might not fit there, but he also reasoned that they could annex the southeasterly lands around the mouth of the Gula River, if need be.[46] The various features of the peninsula as a whole seemed to appeal to the Germans as a larger ecology for the planned city. In Terboven's view the forested mountains would provide the city a green lung as well as protection from harsh northern winds.[47]

On the rainy afternoon of July 4, 1941, Stephan set out to look at the site for the first time, accompanied by a German photographer. As he described it to Speer, the peninsula could be divided into four zones from east to west (see plate 10). The section farthest to the east bordered on the river Nid, and its gentle slopes had already been partly settled around Trondheim. In its southernmost portion was Ringvål, a modernist sanatorium constructed in the 1930s. Westward, the next zone was taken up by mountains with an elevation of up to 565 meters, moors, and a "very pretty spruce forest." This segment encompassed Bymarka, a wooded area popular among Trondheim residents for skiing, hiking, and other recreational activities. In the next tract, farther to the west, lay a broad, nearly flat plateau of fertile soil, occupied by farmsteads and a few small villages, such as Byneset and Spongdal—this was the area outlined on the map (see plate 11). Finally, on the far western edge, a number of small wooded elevations ringed the plateau, before descending steeply to the fjord that surrounded the peninsula.[48]

The next morning, Stephan returned with a group of Germans to continue scouting the area. They hiked up Gråkallen, which has an elevation of 552 meters, for a grand panoramic view of the peninsula. On the mountain, Stephan identified the stone he saw as greenstone and quartz and described the flora: a small orchid, northern violet, cloudberry, and other alpine species. Stephan also caught sight of the mountain lakes that supplied Trondheim's water, although he noted that better water could be obtained from somewhat farther away. After a blueberry pancake lunch at Skistua, Bymarka's ski lodge, the group boarded a motorboat to tour the coast of the peninsula. The cold, wet weather made the four-hour ride unpleasant. But during this time, they were able to photograph the landscape from all angles; the professional photographer they had brought along also took panoramic images. A week later, on July 13, Stephan returned for a final visit to the area, this

5.2. Photograph taken on July 13, 1941, from the summit of Storheia, showing the plateau to the west (surrounded by the fjord) that was envisioned as the site of the new German city to be designed by Speer. This image was included in Hans Stephan's unpublished diary, "Reise nach Norwegen" (Journey to Norway), an account he probably wrote for Speer.

time to climb the highest peak in Bymarka, Storheia at 565 meters (fig. 5.2). The goal that day was to map notable features of the site, but given the size of the area to be covered and the continuing unpredictable weather, the work would need to be completed by another member of Speer's staff over the following weeks.[49]

When Stephan returned to Berlin, he sent Speer a large quantity of material: a map marked with elevations and natural features, a geological survey map of Norway, an extensive report on geological conditions, a map tracing the planned autobahn from Oslo to Trondheim, and many photographs, including panoramic and aerial views.[50] In

September, Speer ordered a more detailed topographical model of the site, at a scale of 1:4,000 and measuring five by five meters, which was constructed in plaster.[51] It was on the basis of these materials that Speer designed the "most beautiful German city" on the Trondheim Fjord, which Hitler had envisioned for Norway. For decades historians have chased after these designs, but to no avail. Traces remain maddeningly elusive. Although archival collections contain references to Speer's designs, they have not yet yielded drawings, photographs, or any other visual material. In large measure this is due to the Germans' intense secrecy about their Trondheim plans: both the shipyard and the city were classified projects. The Nazis understood that Norwegians opposed to the occupation of their country would take badly to the discovery that the Germans were planning to create a permanent city and naval base on their shores. As a result, knowledge of and information about both projects was highly restricted.

Some clues nonetheless survive regarding Speer's design approach. On September 20, 1941, at the Führer's headquarters, Fritz Todt and Hitler had a conversation over lunch about Trondheim. Todt spoke about his last trip to Trondheim and the start of construction on a new transport corridor between Hamburg and Copenhagen. Hitler insisted that an autobahn "must be built" to Trondheim. Hitler also discussed "his plan to rebuild anew the city of Trondheim in a terraced location, so that every house would have sunshine all day long."[52] The concept of a terraced city would almost certainly have been something that he also discussed with Speer, or that Todt would have passed along to him after his conversation with Hitler. Speer may have adopted Hitler's idea, using the site's topography to create a natural terracing effect. Local historian Gabriel Brovold, who in the 1990s wrote about the Nazis' Øysand projects, recalled seeing photographs of a large, detailed model of Speer's design, with the city's residential quarter laid out on a southern-facing slope.[53] Importantly, Speer had no experience designing cities in the mountainous terrain typical of Norway. Berlin—the intended site of the new world capital, Germania, the planning for which Hitler had entrusted to him—is notoriously flat. These brief references to a terraced or sloping city raise the possibility that Speer's design was influenced by the study of Norwegian towns, the reconstruction of which he was then in the process of overseeing. By mid-1941, Speer and Stephan had spent many hours in discussion with Norwegian architects, which may have shaped Speer's thinking on his own northern

city. Until supporting visual evidence is found, however, any such influence must remain conjectural.

In shaping his German city on the fjord, Hitler planned to leave his mark above all in its cultural brilliance. As Speer reported to Terboven in August 1940, in the early stages of the project, Hitler told him that what he had in mind was "the creation of the northernmost cultural center of the Greater German Reich." Nothing would be lacking. "According to [Hitler], the new city should have everything necessary for a city of cultural importance, such as an opera, theater, library building, and grand picture gallery, but also a stadium, swimming pools, and so forth."[54] The lavishness of Hitler's vision would certainly have played a role in Speer's determination to build the city, not to mention the Führer's obvious enthusiasm for the project. In a late-night monologue on January 15, 1942, at his Wolf's Lair headquarters in East Prussia, Hitler stated that he wanted to act as the new city's patron, referring, it seems, to a special role as cultural benefactor.[55]

Although we have few details about the cultural institutions Hitler planned for the new city, the national focus is clear enough. On February 19, 1942, in another late-night talk at his headquarters, Hitler announced that the grand picture gallery—the collections for which he himself would assemble—would be dedicated "solely to German masters." Hitler believed that art not only expressed but also served to realize a nation's cultural and political greatness. It is no coincidence that the first monumental building he commissioned after coming to power was the House of German Art in Munich, an art gallery devoted solely to contemporary German artists and to defining a new artistic vision and standard for the Third Reich. Hitler's proposal to open a German art gallery in the northern reaches of the empire was thus a significant gesture, suggesting how he envisioned reinforcing the cultural identity and strength of Germans living outside the nation's traditional borders. At the same time, he also saw such projects as his greatest legacy. Referring to his Trondheim plans, he stated, "Wars come and go; only the works of human culture remain."[56]

This emphasis on the new city as an artistic and cultural beacon as well as Hitler's desire to act as its patron strongly suggests that he imagined it as a *Führerstadt*, or "Führer city," in the North. Before the war Hitler had designated five such cities—Berlin, Hamburg, Nuremberg, Munich, and Linz—which were to be transformed into the architectural and cultural jewels of the Third Reich.[57] Plans for their

reconstruction entailed the massive reorganization of their urban centers to accommodate monumental new structures and cultural institutions. Hitler intended to endow his hometown of Linz, for example, with an immense art gallery displaying the very best collections of European art (much of it confiscated from other countries), which he himself would curate.[58] The new city planned for the Trondheim Fjord, if designated a Führer city, would have been the first such urban "jewel" outside the boundaries of the Greater German Reich as they had existed before 1939. Moreover, it would have been the first one to be created whole cloth, unconfined by previous urban settlement.

Hitler's proposed art gallery for the new city on the Trondheim Fjord would have joined another major cultural project that similarly would have proclaimed the new settlement's German roots: a monumental war cemetery and memorial (fig. 5.3). This idea originated with the Army High Command Norway, which in early 1941 proposed war cemeteries for four Norwegian towns: Bergen, Narvik, Oslo, and Trondheim. Together, they were to hold thirty-one hundred German soldiers' graves. Three of these locations were associated with casualties and fighting that occurred during the invasion: the sinking of the *Blücher*, in the Oslo Fjord, and of the *Königsberg*, in Bergen, which had resulted in significant German losses, and the dogged resistance of General Eduard Dietl's mountain troops in Narvik, which had elevated the town to heroic status. The lure of Trondheim, by contrast, seems to have been its future importance as a naval base.[59]

Wilhelm Kreis served as the architect of these projects, which were part of a larger mission to honor Germany's fallen soldiers in the newly occupied war zones throughout Europe. In March 1941, and at Speer's suggestion, Hitler named Kreis general architect for the design of German war cemeteries.[60] Kreis's career underwent a remarkable reversal during the Third Reich. When the Nazis came to power in 1933, he had been dismissed as president of the Association of German Architects. Speer's patronage revived his career with high-profile commissions, such as a monumental Soldiers' Hall in Berlin—a National Socialist appropriation of the Norse Valhalla, a majestic hall ruled by the god Odin and inhabited by worthy dead warriors. Speer considered Kreis, who was nearly twice his age, a close friend and had previously traveled with him to Italy.[61] Speer invited him along on his 1941 trip to Norway; when this was canceled, Kreis traveled by himself, in August 1942, to scout locations for his war cemeteries.

In Trondheim, Kreis's attention focused on Høvringberget, a 230-meter-high mountain in Bymarka overlooking the fjord, on the peninsula Hitler had chosen for the new settlement.[62] In this location, the stone monument he designed, with its large, embossed swastika, would have been highly visible from the sea, announcing the new German colony to approaching visitors (fig. 5.4). Like his other cemetery designs, which were inspired by the Castel del Monte in Italy and the Athenian Acropolis in Greece, it was intended for an elevated location. The memorial would have made a dramatic destination for German residents out for a nature walk, a place from which they could survey their new lands from the vantage of the German soldiers who had died to acquire them. It would have powerfully connected the new city's residents to a "heroic" point of German origin, reinforcing a deep bond to blood and nation. The design was widely published, including in *Das Reich*, a successful weekly newspaper with a European focus launched in 1940 by Goebbels, and in *Die Baukunst*, the National Socialist architecture journal edited by Speer.[63]

The cults of art and death were integral, intertwined elements in the National Socialist *Weltanschauung*.[64] In anthems, theater performances, art exhibitions, memorials, ceremonies, and processions, the fallen comrade was symbolically and collectively lamented and exalted. When the Nazis expanded their empire, they exported their myths and rituals to their new territorial possessions. But they did not elevate them to the same degree of visibility everywhere. The prestige projects envisioned for the new German city on the fjord suggest that Trondheim had a special status for the Nazis, which led Hitler to see it as a worthy place to build the northern cultural capital of his Greater German Reich.

National Socialist writings about Trondheim make clear its many positive associations for German propagandists. Foremost among them were Trondheim's Viking origins, recorded in the Icelandic sagas, and its status as the capital of powerful kings who, in the late Viking period and early Middle Ages, unified a vast northern empire. The monumental stone architecture of the Nidaros Cathedral, the medieval church in which Norwegian kings were crowned, also impressed. German writers similarly admired Trondheim's traditional wooden architecture as well as the generous public spaces of its baroque urban plan, laid out by Johan Caspar von Cicignon after the catastrophic fire of 1681. Finally, German propagandists sought out traces of German influence in

Trondheim, from wealthy merchants and bankers to architects, who (they claimed) had indelibly shaped the town's development.[65]

Trondheim's positive features were often contrasted in National Socialist propaganda with Oslo's purported flaws. Where Trondheim was ancient and haunted by the ghosts of warrior kings, Oslo was considered modern and soulless. Despite its German traces, Trondheim was

5.3. Wilhelm Kreis, "Trondheim-Hövringberg," soldiers' cemetery and memorial, pen-and-ink drawing, 1941. Note the figure sketching on the rocks in the foreground.

5.4. Detail of 5.3, Kreis's Trondheim-Hövringberg soldiers' cemetery and memorial, showing the embossed swastika on the monument facing the fjord.

lauded as the most Norwegian city in the country, rooted to the people and the soil; Oslo, on the other hand, was "American-unauthentic." Trondheim's architectural beauty and open urban spaces put Oslo's functionalist buildings and crowded, working-class neighborhoods to shame. Although Oslo had emerged in modern times as Norway's political capital thanks to its geographical location, Trondheim had the feel of an imperial capital based on its role through the ages as a spiritual and cultural center.[66]

These accolades penned by National Socialist writers raise questions as to why the German occupiers did not choose to rebuild the existing town of Trondheim as their own settlement. The reasons are both practical and symbolic. The scale of the planned naval base was ill-suited to Trondheim Bay, which was limited by size and geological instabilities. From a symbolic perspective, Trondheim's strong sense of Norwegianness would have impeded the superimposition of a new German identity. Indeed, such an attempt would have risked the reverse: the Norwegification of the German settlers, a form of cultural "degeneration" that—as seen with regard to soldiers' homes—worried the occupiers. Significantly, there is no evidence that the Nazis saw the establishment of a new city as an opportunity to develop shared ground, as a people, with the Norwegians. To the contrary, the settlement was envisioned as a place apart, a German enclave that remained separate from the surrounding native Norwegian population. Positive

associations with Trondheim were to be assimilated into a carefully defended web of German culture, on German terms.[67]

Even the name of the new city suggests the desire to appropriate while remaining distinct. On July 9, 1940, Goebbels noted in his diary, following a conversation with Hitler, that it would "probably" be called Nordstern.[68] This name, meaning North Star (Polaris), would have positioned the new city in terms of its geographical location and evoked a beacon guiding Germans north, but it was also rather trite. Over the centuries, the North Star had acquired many associations, including some—with the doomed 1871 *Polaris* expedition to the North Pole—that would have been decidedly unappealing to the Nazis. Whatever Hitler may have told Goebbels, there is no evidence that "Nordstern" was ever used to refer to the new settlement. Instead, for the first year or so, internal documents referred to the new German city on the fjord as "the new city near Trondheim" or "the new city of Trondheim."[69] Often it was simply called "Trondheim," with the context indicating whether the reference was to the existing Norwegian town or to its imagined German successor. Beginning in the fall of 1941, the new city appeared as New Trondheim (Neu-Trondheim), while Trondheim itself emerged as Old Trondheim (Alt-Trondheim).[70] By thinking of the planned city as a reconstructed Trondheim, the occupiers reinforced its connection to the original Trondheim, while also signaling its departure from the past. The name "New Trondheim" implied that the once-exalted capital of Vikings and kings, now a sleepy town, would arise again under the Nazi empire.

But even as the Nazis set the new city apart as its own entity, they nonetheless understood that the two neighboring towns—New and Old Trondheim—would need to function together as a larger metropolitan area. As Willi Henne—leader of the Organisation Todt Viking Taskforce and general plenipotentiary for construction works in Norway—acknowledged in April 1942, Old Trondheim would experience a strong increase in population, traffic, and economic activity with the creation of New Trondheim. In order to relieve the resulting pressures and to allow for "organic development," he insisted that Old Trondheim needed to merge with smaller surrounding municipalities.[71] This expanded entity was referred to in German documents as Gross-Trondheim or Greater Trondheim.

The Germans' ambitious plans for the region hinged on this broader coordination. They needed a framework for economic and infrastruc-

ture development that would break down the barriers then existing among the various municipalities and agencies, particularly in order to coordinate an efficient regional transportation system. In the summer of 1942, Sverre Pedersen drew up a general plan for the incorporation of Strinda into Trondheim. In devising his plan, he worked with representatives from Trondheim and Strinda municipalities, from Norwegian rail, road, and port authorities, as well as from the Norwegian Ministry of the Interior, the Reich Commissariat, and the Organisation Todt. The materials he submitted to the Reich Commissariat in early November 1942 included proposals for new railway lines, new railway stations, new main roads, a port expansion, and zoning for industrial areas and green spaces. Some of these projects had been long anticipated by Norwegian authorities (Pedersen had been working on a general plan for Strinda already in 1936), but the occupiers accelerated the time frame, while also hijacking the agenda to serve their own military and economic goals.[72]

As part of this integrated transportation network, the Germans planned to connect New Trondheim and the nearby shipyard to Old Trondheim via rapid transit rail and autobahn.[73] This infrastructure would ensure that the new settlement, despite its relative proximity to Old Trondheim, would not be geographically isolated. It would also help to transform these sleepy rural areas into the vibrant hub that Hitler imagined as his Singapore of the North. Farms then occupied the Øysand peninsula, the site chosen for the naval base of super-warships. The flat peninsula was located south of Trondheim and bounded on the east by the Gula River, on the west by the Gulosen Fjord, and to the north by the river's mouth (see plates 10 and 11). In the summer of 1940, the Luftwaffe built an airstrip in the middle of the farmers' fields (see plate 12). Luftwaffe personnel were later joined by Organisation Todt employees and, in 1942, by prisoners of war. The barrack camps and facilities expanded, necessitating improvements to the electrical, water supply, and sewage systems. Additionally, the Germans began to build a new railroad bridge over the Gula River to service a dockyard construction site.[74]

Until the new shipyard was constructed, Trondheim's harbor had to bear the brunt of serving as both a commercial port and a naval base. Built to serve the peacetime needs of a small city, the port struggled to meet the demands inflicted on it by the occupying forces.[75] Since 1941 the east end of the port had been a construction site for monumental

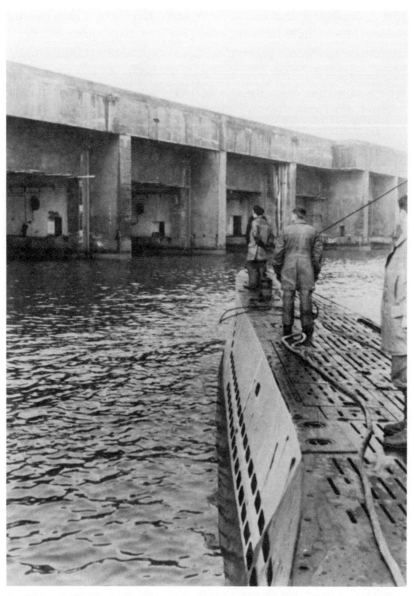

5.5. Photograph of a German U-boat returning to the Dora I submarine bunker in the port of Trondheim, undated.

U-boat bunkers, intended to shelter and repair submarines (fig. 5.5).[76] But the port's other docks and basins were also being monopolized by the military. This heavy, round-the-clock usage, coupled with the military's refusal to pay harbor fees, caused havoc with shipping schedules and speeded the dangerous deterioration of the mostly wooden structures.[77] Various minor improvements were implemented in the short term to help relieve the pressure. A grandiose plan to expand the existing port into "a world trade center of the first order for the entire North" met with skepticism in light of space limitations. Vice Admiral Eichel advised Reich Commissariat officials to search the Trondheim Fjord for a suitable location for the creation of a new port. He reasoned that the population surge expected and the new demands it would impose on existing facilities would keep Trondheim's port from becoming superfluous, even if a new port were built nearby.[78]

German plans to extend Trondheim's transportation infrastructure and its municipal boundaries may have been a response to more than the immediate pressures created by the occupation or the growth anticipated with the founding of New Trondheim. An article about (old) Trondheim published in the *Deutsche Zeitung in Norwegen*, a German occupation newspaper, hints at an even greater transformation envisioned for the region. An admiring portrait of the city through time, the essay concludes with this striking observation directed toward the area's future: "According to the opinion of a resettlement expert, there is room for eight hundred thousand more people in the Trøndelag and its northern border regions."[79] Brief but loaded, this comment must be read in the broader context of Nazi programs to Germanize new territories. Particularly in German-occupied Eastern Europe "resettlement experts" were overseeing the massive emigration of ethnic Germans into conquered lands alongside the deportation of unwanted Slavic and Jewish populations. The man at the heart of these programs was Heinrich Himmler, who, having taken a special interest in Norway, traveled there twice in the spring of 1941. On one of these visits, he inspected a "country farm near Trondheim typical of the central Norwegian landscape."[80] From this perspective, the article's concluding comment about population expansion suggests that New Trondheim may have been only the first step in a much broader process of middle Norway's Germanization, a plan perhaps under exploration at this time.

As National Socialist building projects for the Trondheim area proliferated on paper, engineers and technicians were busy in the field,

undertaking research to prepare for construction. These tests were extensive and laborious, but also critical to building safely for the long term. Although Hitler had selected the sites for the new city and shipyard in June 1941, he did so on the basis of preliminary surveys, before knowing whether these locations would actually be viable. Much more testing was needed before that choice could be definitively confirmed or ruled out. In addition to the peninsula west of Trondheim and Øysand to the south, Hitler's preferred sites, engineers also explored areas east and north of Trondheim, including the island of Tautra, the Frosta peninsula, Stjørdal (next to the Luftwaffe's air base in Værnes, east of Trondheim), and Verdalsøra (along the Trondheim Fjord at the mouth of the Verdal River). These tests, supervised by the Organisation Todt, were conducted over the fall and winter of 1941 and continued into the spring of 1942.[81]

The German firms subcontracted by the Organisation Todt to undertake the ground surveys transported engineers and massive equipment from Germany to often rural and isolated locations in Norway. The arrival of the drilling machinery and crews disrupted the tranquility of the residents, who were compelled to give up or share their houses.[82] The peaceful seclusion of the island of Tautra, in the middle of the Trondheim Fjord, had attracted a Cistercian monastery in 1207, the monumental stone ruins of which stood out from the surrounding landscape of farms and bird-filled wetlands. In November 1941, a Tautra farmer whose land was used for borehole investigations received the considerable compensation of five hundred kroner for the harvest he lost of gull eggs and eiderdown.[83]

Workers conducting the laborious geotechnical tests faced harsh weather and rough living conditions on-site. On Frosta, demoralized drillers were kept on the job with bribes of rum.[84] German-built compounds on Øysand that housed members of the Luftwaffe as well as Organisation Todt employees and subcontractors had few frills. A German engineer in Øysand to conduct boring tests wrote to the Organisation Todt's Trondheim office to ask for improvements to his barrack accommodations, including a cozy chair and the ability to prepare himself a warm drink after working outside all day in all types of weather.[85]

Such creature comforts were certainly not offered to the prisoners of war held in Øysand. The first POWs arrived here in 1942 and were placed in internment camps encircled with barbed wire.[86] By the end of the war, thousands had passed through the camps on their way to

northern Norway, the majority from the Soviet Union and Yugoslavia.[87] Some of the prisoners were "loaned" to firms carrying out the preparations for Hitler's new naval base. In a November 7, 1942, report, surveyor Lindenmayer, employed by the Organisation Todt's drilling division in Øysand, complained that "the entire work on Øysand is very difficult and proceeding slowly" because the forty prisoners who had been assigned to the Berlin firm and OT subcontractor Daedlow and Pollems were usually reduced to just twenty-eight. As Lindenmayer noted, "The Pollems firm was thus unable to carry out its work at the desired pace. The allocation of prisoners is still not adequate." Without additional manpower, he warned, they would continue to lose time. Lindenmayer pointed out that the work of another company (Butzer) digging test pits was similarly delayed because it did not have enough prisoners.[88] A map created by Lindenmayer around this time, indicating the location of boreholes then being sunk by German firms for the naval base on Øysand, lists forty-eight "helpers," almost all Russian, working on the drilling sites.[89]

Having reinforced the need to increase the prisoner workforce on the boring crews, Lindenmayer then added a further concern to his report, this time about "the provisions in Camp 2" in Øysand. Specifically, "the people are complaining that they do not get enough to eat."[90] His use of the term "people" instead of "prisoners" reveals that those complaining were the paid employees. "People" was not a term that the occupiers applied to prisoners. And indeed, Camp 2 housed German, Norwegian, and Dutch laborers.[91] If they suffered from hunger, one can only imagine how much worse it was for the internees in Øysand's camps. Prisoners of war forced to labor on German construction sites confronted starvation on rations that were far smaller than those allotted to paid workers.[92] The caloric intake of their diets was nowhere near equal to the energy expended through their physical labor or needed to battle the cold.

When Hitler decided on the location of his naval base in June 1941, the slaves who would build it had not yet arrived on Øysand. Despite a shortage of available construction workers, the Führer's projects received priority, and Hitler was clearly anxious for development to begin. His first priority for the naval base was a large dry dock, and he ordered construction to start immediately. The mouth of the Gula River, to the northeast of the Øysand peninsula (see plate 13), had been provisionally selected as the site for the shipyard. The navy was considering diverting

the path of the Gula River past the mountains to the south in order to reclaim more land to the east of the peninsula.[93] Because the shipyard was still in the early planning stages when Hitler ordered the dry dock built, the latter's location had to be considered carefully in order not to interfere with the future construction of the other installations.

In the summer and fall of 1941, extensive geotechnical testing was conducted to determine the dry dock's location. The laying out of the general plan of the shipyard and arsenal on the Øysand peninsula followed. In the spring of 1942, the navy, working together with the Organisation Todt, began the foundations of the dry dock "across the mouth of the Gula," at a site where it would not interfere with future shipyard planning. However, on May 13, 1942, Hitler decided to relocate the dry dock to the south of the peninsula, to a site on the Gulosen Fjord, even though this move added nearly a year to the anticipated construction time. This change in plans came on the same day that Hitler ordered that the construction of Norway's defenses be made a top priority, reflecting his growing fears of an Allied invasion from the north.[94] Despite this sense of urgency, the decision to transplant the dock critically delayed the project. In retrospect, it saved the Øysand peninsula from greater damage to its landscape through construction of the base.

The impetus for the relocation appears to have been Hitler's desire, expressed in the spring of 1942, to construct the "large dock inside a rock hangar"—presumably to protect it from aerial attack.[95] In this scheme, the dock would have been placed inside an enormous rock cavern that would be blasted out of a waterfront precipice.[96] Because there were no such rock walls in the vicinity of the Gula River mouth, other locations had to be considered. When the creation of a rock cavern proved to be impossible in the area around Trondheim, the search began for a location where the dock could at least be built on rock foundations. As a result, new drilling tests were ordered for Stjørdal and Øysand to determine which of the two locations was most suitable. In May 1942, the cliffs to the south of the Øysand peninsula were determined to be the better site, at which point Hitler ordered the change of location to be made. The dimensions of the dock grew bigger at this point, and the location was moved farther inland than had been previously planned.[97] The dock was now positioned at the base of the cliffs at the southwestern corner of the Øysand peninsula (see plate 12). Extensive boring tests to determine the exact position of the dock and geological conditions took place that summer and fall. By the end of

1942, construction equipment had been brought to the building site, and blasting and excavations began. Preparatory work to sink the piers for the railroad bridge over the Gula River, which would have brought a railway line from Melhus to the dock construction site, was also under way at this time. Meanwhile, the numbers of workers in Øysand kept growing, creating a shortage of beds.[98]

That winter, the war took a disastrous turn for Germany, ending in the destruction of the German Sixth Army at Stalingrad.[99] On February 18, 1943, in the Berlin Sportpalast, Goebbels delivered his famous speech calling on the nation to commit itself to "total war" to defend itself against Bolshevism and Jews.[100] The subsequent impact of the complete mobilization of labor and resources was felt throughout occupied Europe, including in Norway. Despite the tremendous amount of planning, work, and resources invested since the summer of 1940, the creation of a new northern city and naval base became unsustainable projects in a time of total war. In early 1943, Hitler ordered that construction of the Øysand dry dock be postponed until further notice. In March 1943, Speer, by then armaments minister, designated the shipyard a peacetime project and halted all planning—presumably to resume when Germany had won the war.[101]

When peace did return to Øysand, the peninsula reverted to the quiet place it had once been. Prisoners of war still in the work camps began to be repatriated in 1945. The hastily dug graves of Russian and Serbian prisoners who had not survived internment were moved to other locations in Norway; today, a small stone memorial at the former grave site on Øysand recalls their suffering. Buildings from some of the Nazi compounds were converted to other functions, and some remain in use today. The Luftwaffe's airstrip, plowed under long ago, lingers as a ghostly outline visible in the farmers' fields. Although the foundations for the new naval base were mostly dismantled in the 1950s, remnants persist. Rebar jutting from the water and excavations into the rock cliffs are visible from the highway between Øysand and the village of Buvika.[102] A camping ground and beach now occupy the site on the Gulosen Fjord planned for the dry dock. Littered among the sand and stones, building materials, their edges worn from decades in the water, testify to a terrifying past that seems almost unimaginable amid the stillness.

There are no markers on the beach or signs on buildings to indicate the wartime transformation of Øysand. Yet the evidence that survives in the Norwegian landscape and in the archives speaks nonetheless to

the postwar empire that the Nazis had begun to build for themselves on these shores. New Trondheim was planned as the lodestar of the New Order in Norway, intertwining military strength and cultural achievement as defined by Hitler's vision of German greatness. Regional planning and new transportation infrastructures would bind this northern hub to the German homeland, shrinking distance and integrating economies. The site's attractions for future residents were considered at all levels, from the design of monuments to the variety of wildflowers. The high level of secrecy surrounding the new naval base and city reveals the Germans' awareness of the depth and danger of Norwegian resistance as well as their own determination to forge ahead anyway, cultivating the glories of their empire as soon as new territories came under their control.

This secrecy also points to another profound disconnect between the occupiers and the occupied. Even with the extensive planning to coordinate the development of Old Trondheim with New Trondheim, the two were conceived as fundamentally distinct. While the Reich Commissariat architects fought with Speer and Stephan over who would be at the table when "the best is being creamed off the top," Norwegians were left out of the room altogether. Edgar Luther, having pled his own case for involvement, intervened to prevent Pedersen from being included in the planning of the new naval base and city on the basis that these projects were "purely a German affair."[103] Given the glowing propaganda about Nordic brotherhood, the extensive efforts to merge German and Norwegian genes in the production of Aryan babies, and the careful attention to politically reorienting Norwegians through the urban reconstruction of their own cities, we might wonder why the Germans felt the need to build strongholds for themselves, either in the soldiers' homes scattered across the country or in this "most beautiful German city" on the fjord. Presumably, the danger from the resistance would eventually fade away as Norwegians became faithful members of the *Volksgemeinschaft*. The creation of New Trondheim as a peacetime project makes clear the Germans' determination to remain separate from their northern brethren over the long term. In the eyes of the occupiers, it seems, the Norwegians, even with their superior Aryan blood, were not quite good enough.

Conclusion
Ghosts in the Landscape

For Norwegians, the summer of 1945 marked the beginning of recovery after the long and bitter occupation by German forces. King Haakon VII returned home on June 7, exactly five years after leaving Tromsø for England. In a speech he gave at the end of the month to fifteen hundred American, British, and Russian soldiers in Oslo's Palace Square, he thanked them for their part in Norway's liberation and pledged close cooperation with the Allies "to lay the foundations of a new and better world."[1]

With transportation systems in Europe overwhelmed and Germany itself in chaos, the evacuation of four hundred thousand German troops from Norway to Germany proceeded at the slow rate of about twenty-five thousand a week, beginning in July.[2] Their dominant presence in many parts of the country, as well as their visible leisure, irritated Norwegians struggling to put their country back together. With ample supplies in their camps, laid in before the war's end, these "well-fed, sun-bathing Germans" were seen "boating, bathing and fishing, building bathing floats and reclining chairs at lake-front camps." Tom Twitty, war correspondent for the *New York Herald Tribune*, reported that the Germans seemed to be "making the most of their holiday," transforming Norway into "a vast picnic ground." Anticipating tougher days ahead when they began the journey home, the soldiers were "indulging in an orgy of eating and drinking and smoking on the theory that the good thing they had would not last." But the mood was neither joyous nor carefree. "Despite their lavish living," Twitty noted, "many of the Germans were depressed at the future and a wave of suicides was sweeping the camps." He compared this to the camps holding former

Soviet prisoners of war, where many were recovering from diseases such as scurvy. Here, too, there was excess, but for different reasons. In one Russian camp, the men, not having been able to satisfy their hunger for a long time, consumed thirty days' worth of rations in five days.[3]

Although elated by Nazi Germany's defeat and the return of democracy to their country, Norwegians continued to suffer physical and emotional hardships from the occupation. The extent of Gestapo torture and murder was fully revealed after liberation, and the discovery of secret burial grounds confirmed fears that many of Norway's missing would not be found alive.[4] At the trial of the Nazi puppet leader Vidkun Quisling in August 1945, a survivor testified that most of the Jews deported from Norway had been gassed immediately upon arrival at death camps in Poland.[5] The situation in Finnmark and North Troms, burned to the ground by retreating German troops, was dire. Evacuees were crammed into barracks that had once housed German soldiers, while others returned to their devastated villages and towns against the orders of the Norwegian government, living in tents and shacks as they began to rebuild.[6]

Norwegians worried about what would happen to the nation's young after the war. What effect would the years of resistance have on children who had kept their families' secrets and borne the psychological strain of the ever-present danger of their parents' capture by the Gestapo? How would the children of parents dishonored as traitors survive in the schools alongside the children of patriots? Would the babies fathered by German soldiers be sent away? Then there was the question of fascist youth programs and how to undo their ideological training. More broadly, an educational routine had to be reestablished for Norwegian students, who had spent extensive periods out of school. Many school buildings had been commandeered by German forces, and education had been further disrupted by strikes, closings, and expulsions. What would normal life look like now for Norway's young?[7]

In many cases, it was not possible to simply reopen schools when peace returned. The Nazis had destroyed books, maps, globes, and other educational materials and left the schools they had occupied in derelict condition. This was true of buildings used by Germans across Norway, indicating that they "adopted a deliberate policy of destruction through carelessness, neglect, and vandalism during the occupation's waning months." Following liberation, Norwegians spent weeks "sweeping, scrubbing, and painting" to make German quarters livable

again. In Trondheim, the once-elegant Hotel Britannia was described by a *Christian Science Monitor* correspondent as a "pigsty" in July 1945. He reported that "even the glass dome and the tops of the high walls were splotched with filth. Trondheim citizens recall occasions when German officers rode their horses through the corridors and dining rooms and even up the broad staircases into bedrooms." In Oslo, "the debris-littered filth-encrusted Gestapo prison and torture chambers at Victoria Terrasse" spoke to the inhuman crimes that had been perpetrated there.[8]

Even in those areas that had survived the invasion and occupation relatively intact, the massive cleanup necessary at war's end went well beyond scrubbing and minor repairs. In Oslo, Task Force A of the US Army under the command of Brigadier General Owen Summers began to return to Norwegians the buildings and other property that had been seized by the German occupiers. Again in July 1945, the *Christian Science Monitor* reported that the discovery of "tremendous amounts of German munitions" created a problem that was "solved by the dumping of a daily average of 300 tons in mines and other dangerous explosives into the sea." The process was necessarily slow: "Because the operation is cumbersome as well as dangerous, it is estimated that it will take three months before Norway will be cleared of these explosives."[9] (Today, war mines in the Oslo Fjord, unexploded and leaking, have become a serious environmental and safety hazard.)[10]

In this context of postwar salvage and restoration, press stories about "constructive" remnants of the German occupation in Norway were understandably rare. But as a new global economy began to emerge in the wake of the war, some journalists looked to German-built infrastructure in Norway as a kind of bridge between past and future. In particular, they considered some twenty-five airports built by the Luftwaffe as "not unwelcome relics" of the occupation, given the growing markets for domestic and international commercial aviation.[11]

As early as July 1945, a writer for the *Scotsman* described "the immense Gardermoen aerodrome, some 30 miles from Oslo" as "a gift to Norway." The Luftwaffe had seized Gardermoen, originally an army camp and flight station for the Norwegian military, during the invasion and subsequently cleared thousands of trees from the surrounding forest for new facilities. The airport, with concrete runways seven thousand feet long and three hundred feet wide and "air-conditioned hangars," was built with the labor of German workers and Soviet

prisoners of war. The colonel who drove the reporter around the 2.5-square-mile airport shared his belief that the Luftwaffe intended "this huge enterprise" as a base to bomb America. Now this "gift" to Norway might serve a more constructive purpose: "The aerodrome is the largest in Northern Europe and should play an important part in the future of air transport."[12]

A year later, Albert Hughes, aviation editor for the *Christian Science Monitor*, reported that the two largest German-built airports in Norway—Gardermoen and Sola, a few miles from Stavanger on Norway's west coast—were now hubs for international flights. Sola, which opened in 1937, was similarly captured by the Luftwaffe in the invasion and considerably expanded. In the vein of the earlier *Scotsman* article, Hughes wrote about this German-built infrastructure from the perspective of both future potential and deliverance from what might have been: "Britons and North Americans, for that matter, should feel reasonably glad that Sola never was used for the purposes for which it was built. The field quite obviously could have been the jumping-off point for air raids on England, and possibly for rocket raids on North America. Rocket developments by the Germans uncovered at the end of the war could reasonably have been launched at Sola and landed in North America."[13]

Norwegians themselves widely shared a sense of relief at having escaped this alternative future. The sentiment is poignantly and succinctly captured in a front-page article published in the July 14, 1945, issue of *Verdens Gang* (World Affairs), an Oslo newspaper. Above the fold, a large black-and-white photograph stretches across the page (figs. c.1–c.2). It depicts a monumental stone building positioned at the top of a broad flight of stairs bordered with bold geometrical greenery. The building's striped facade alternates between attenuated pillars and dark space. Near the bottom, a simple but heavy lintel marks the entrance. There is no other ornamentation except for a thin cornice and a stone eagle grasping a sun cross, the emblem of Quisling's Nasjonal Samling Party. In the foreground are waiting buses. Men and women stroll as if on their way to work or to shop in the city center. In the background to the right are recognizable buildings and features of the Oslo landscape. The place pictured on the front page thus seems familiar and real, but is, at the same time, terribly wrong.[14]

The short text accompanying the photograph began with a pun, of sorts: "The Nazis had big building plans." As it went on to explain,

c.1. Front page of *Verdens Gang* on July 14, 1945, with the headline story "The House That Was Never Built."

c.2. Unrealized design for a new Nasjonal Samling headquarters in Oslo, published in *Verdens Gang* at the end of the occupation.

this strange scene represented a design for a new Nasjonal Samling headquarters, on the site where Skansen Restaurant, designed by Norwegian architect Lars Backer, then stood (fig. c.3). The image had been discovered in the former Nasjonal Samling offices at Rådhusgata 17 in Oslo. The design—and all that it symbolized—could now safely enter the category of "unrealized plans." As the headline above the photograph declared, it was "the house that was never built."[15]

Skansen Restaurant, sadly demolished in the 1970s, was Norway's first functionalist building, completed in 1927. Created at a time of political and economic change as well as extensive modernization in Norway, Backer's radical design spoke to the dreams of a new era.[16] The rounded design, with sweepingly dynamic curves on the interior and tall windows overlooking the Oslo Fjord, captured the light and energy of a new modernity—one that was to be filled with sociability and leisure for all. Adjacent open-air terraces connected diners to nature in the summer months.

The Nasjonal Samling building meant to erase all of that. Its architecture and meaning are the inversion of Skansen Restaurant: rigidly rectilinear against Skansen's curves, heavy against its lightness, lofty against its human scale, traditional against its innovation. The design recalls Italian fascist precedents: in particular, the style echoes Marcello Piacentini's Rectory (Rettorato) for the University of Rome, and the siting and shape bring to mind the Palace of Italian Civilization (Palazzo della Civiltà Italiana) in Rome by Giovanni Guerrini, Ernesto Bruno La

c.3. Lars Backer, Skansen Restaurant in Oslo, 1927. This was the intended site of the new Nasjonal Samling headquarters. Photograph by Mittet & Co., c. 1930.

Padula, and Mario Romano, but without its aesthetic qualities. The site for the proposed Nasjonal Samling headquarters lies between Akershus Fortress and the new city hall that the Nazis detested, and it is possible to see this design as an appropriation of the power of the former to "correct" the perceived weakness of the latter. In any case, the values the design sought to convey are unmistakable: unbending authority and discipline, a bulwark of the New Order.

Like the discovery of the buried bodies, the revelation about this planned construction occurred only after the Nazis' defeat made it possible to dig through their files. But the full extent of this history has taken decades to emerge, in part because the occupiers intentionally left behind a mess not just in the buildings they occupied but also in the records they abandoned. Archivists have spent decades painstakingly reconstructing the evidence that the Germans hoped to hide. For as it turns out, stories of Germans doing nothing but sunbathing in Norway after their defeat were not entirely correct. Some former occupiers, including administrators, continued to function in their roles out of necessity, because they could not be immediately replaced or deported. Organisation Todt employees took advantage of this time to destroy things they did not want others to find. In the National Archives of Norway in Oslo, there is an Organisation Todt folder of general

correspondence for the soldiers' homes with a message for prying eyes. On the cover, a German hand has scrawled in large letters: "Everything of interest removed. April 8, 1946"—a pointed stick in the eye to future historians trying to understand the full breadth of Nazi plans.[17]

But the stick misses its mark, and a combing through of the now-available materials in Norwegian and German archives makes clear those intentions. The Nazis expected that postwar Norway, like the rest of Europe, would orbit around Berlin's sun, and the development of vast infrastructure systems would move resources and people between them. Norway itself would become pockmarked with spaces of German identity and seclusion, including an entirely new German city, which would allow the rulers to remain distinct and apart. German art and culture would blossom in the North, and Norway's wild landscapes would be shaped according to German ideals of beauty and order and for German consumption. Norwegian cities would be redesigned to break the troublesome independent spirit of their residents and thus bring them into the fold of the *Volksgemeinschaft*, the National Socialist community. Similarly, Nordic babies destined for export to Germany would be weaned of their "selfish" impulses by SS *Lebensborn* institutions in order to prepare them for their future roles as mothers or soldiers. In sum, the North would bend to Hitler's will, and many more Germans would follow in the footsteps of his legions. The German press reassured those future emigrants that it would be a homecoming—a return to a place that had always been theirs. We could hardly be surprised if *Verdens Gang* readers, pondering the house that was never built, breathed a sigh of relief.

Yet can we say that the sense of escape from the "never built" proffered by the paper was fully justified? Hitler's fantasies of a northern utopia based on an Aryan brotherhood did not leave Norway unchanged. The superhighway between Trondheim and Berlin may not have gotten off the drawing board, but many new roads were built, especially in northern Norway and coastal areas. The polar railway, similarly, never reached its final destination, but railway lines throughout Norway had been extended by the war's end and continue to be used today. The modernization of Norway to align it with the "tempo" of the Greater German Reich resulted in many other infrastructural upgrades, including modern telecommunications systems and power plants that could produce 30 percent more energy by the war's end. In the past few years, historians have begun to more thoroughly investi-

gate the role that German investment in infrastructure—on a scale that set Norway apart from other occupied countries—has played in the nation's swift postwar economic recovery.[18]

Many other questions remain about the postwar legacy of the occupiers' plans, such as the long-term impact of Nazi ideals of *Volksgemeinschaft* and of strong urban centers on the redevelopment of Norwegian cities, or the postwar reuses of buildings and spaces that the occupiers created for themselves, including the surviving soldiers' homes, which were infused with German identity. Recent efforts to remember and make visible the lives damaged by the racial building blocks of New Order Norway—the *Lebensborn* mothers and children who were punished and shunned after the war, the Soviet and Eastern European prisoners of war who sickened and died to realize the Nazis' vast construction projects, and the deported Norwegian Jews who never returned—underscore the undeniable stamp of Nazi visions on this northern land. Slowly, a different landscape is coming into view, not just of the house that Hitler never built but also of the one he left behind.

That it has taken so many decades for Norwegians to fully confront that legacy reflects not only the pain and labor of digging up the bodies, literally and figuratively, in a war-torn country. Ideological changes have also played a role. As the days of liberation wore on, new political forces began to reshape the narratives told about the occupation, which obscured less palpable accounts. These shifts are exemplified in the postwar crisis that developed over how to manage the dead prisoners of war buried across Norway. When the war ended, eighty-four thousand Soviet prisoners and forced laborers remained in Norway, many badly in need of medical attention. Approximately fourteen thousand had perished on Norwegian soil, often buried on the spot where they had died or in unpopulated woods and marshes. This treatment reinforced their low status and distinguished them from dead German soldiers, who merited proper burials and heroic war memorials.[19]

The summer following Germany's surrender, Norwegians and Soviets collaborated to find and rebury the bodies in local cemeteries. This search for and caretaking of the dead was also a process of rehumanizing the people the Nazis had mistreated as cheap construction labor. In July 1945, a mass grave was discovered at Trondenes in Harstad holding eighteen hundred bodies. Over six hundred had been shot, but most had starved to death.[20] Ex-internees waiting to be repatriated to

c.4. Norwegian women identified as traitors and "tyskertøser" (or German tarts, women accused of having had relationships with German soldiers) being punished in 1945 by being forced to excavate a mass grave in the woods at Trandum, northeast of Oslo. The forested area was used by the Gestapo to execute mostly Norwegian political prisoners, but also captured Soviet and British soldiers. A contemporary Norwegian description of the women digging stated, "Tyskertøser claimed that the report of the death forest was only propaganda. They were brought to the scene."

the Soviet Union participated in creating monuments to their fallen friends and comrades. Graves were marked in both Norwegian and Russian, with plaques relating the story of the prisoners' suffering and resilience in language that hailed them as Soviet heroes resisting fascism. In certain instances, the reburials also became a vehicle to punish the perpetrators (fig. c.4): "Norwegian locals and freed Soviet POWs in some places forced arrested personnel of the German Gestapo, German soldiers and Norwegian quislings to do the dirty work of excavating and identifying the dead Soviets from the unmarked graves." This approach to memory as a common cause that united Norwegians and Soviets, as expressed through joint ceremonies and memorials, also fostered the creation of Norwegian-Soviet friendship associations in many towns in northern Norway.[21]

But with the rise of the Cold War, Norway's alliances shifted away from the Soviet Union and toward the United States, and a fundamen-

c.5. Undated aerial photograph of the Tjøtta War Cemetery.

tal change in the Norwegian policy of remembrance took place. Norwegian politicians became concerned about the increasing number of visits by Soviets to the war graves, which by virtue of being spread out across northern Norway made it easier for Soviet representatives to travel around the countryside. Officials in the Norwegian Ministry of Foreign Affairs feared that Soviet spies were using grave visits for espionage, particularly to travel around sensitive military areas in order to gain information on Norway's strategic defense facilities.[22]

In the summer of 1951, the Norwegian government quietly and hurriedly began moving ninety-five Soviet war cemeteries in the northern counties of Nordland, Troms, and Finnmark. Operation Asphalt (named after the asphalt-and-paper sacks used as body bags) relocated the remains of POWs to a central burial ground on the remote island of Tjøtta on Norway's Helgeland coast—away from the spaces of everyday life (fig. c.5). Most of the bodies were buried in a common grave, without headstones. The associated costs of the operation were high, as measured not only in financial terms but also in psychological ones for the Norwegians carrying out the gruesome work of excavating and

transporting the eight thousand decaying corpses. Memory, too, paid a price. In the relocation process, many newly erected monuments to the dead were intentionally smashed or blown up. The reasons given for the destruction varied: the monuments impeded authorities from removing the corpses, blocked farmers from cultivating their fields, and disturbed the views for tourists traveling along the main roads—all of which have been discounted by historians. A coolness also made its way into the language commemorating the dead. Standardized inscriptions on new government-authorized monuments replaced the heroic Soviet rhetoric of the old graves and memorials with unemotional words that remember the "Soviet soldiers who lost their lives in Norway in 1941–1945, and who are buried here."[23]

Operation Asphalt caused a significant diplomatic rift with the Soviet government, which called the action an "insult to the memory of Soviet soldiers."[24] Vehement protests were also lodged by Norwegians who lived near the original burials, and who remembered with empathy the Russians whose suffering they had personally witnessed. To some, the hasty removal of the graves and markers, done without public consultation or notice, was tantamount to desecration. In the town of Mo i Rana, the start of Hitler's polar railway, some eight hundred people protested in the local graveyard to prevent the removal of the Soviet dead.[25]

This Cold War attempt to rewrite historical narratives by removing graves and effacing memorials has been challenged in recent years by various initiatives—academic, institutional, and local—to collectively recover and make visible the traces of the Soviet POWs that once dotted the northern Norwegian landscape. Historian Steinar Aas writes, "One could say that the memory of Operation Asphalt, as well as the memory of the dead Soviet POWs, has been part of a Hegelian dialectical struggle between two extreme groups: those interested in preserving the memory, and those eager to forget."[26]

The battle to recognize these hidden histories and injustices continues today in Norway. In 2018, the Norwegian women who had been arrested, interned, and even stripped of their citizenship after the war because of their relationships with German soldiers received a formal apology from the Norwegian government for their mistreatment. On the occasion of the seventieth anniversary of the United Nations Universal Declaration of Human Rights, Norwegian prime minister Erna Solberg offered on behalf of the nation an apology for their suffering.

Unfortunately, few of the women were still alive to hear it. Norway's thousands of "war children," fathered by German soldiers, continue their fight for recognition and compensation from the Norwegian government, testifying about the systematic discrimination and sometimes horrific physical and mental abuse they suffered growing up in a country that treated them as "human garbage." In 2007, a group of Norwegian war children took their case for compensation to the European Court of Human Rights but were denied a hearing because of the amount of time that had passed since the offenses had been committed.[27]

Exploring the physical legacies that Hitler left behind and that remain unseen in the Norwegian landscape requires a shift in attention and focus. In many cases, such constructions have become a familiar part of everyday life and are easily overlooked. Today, one can book a room in the former soldiers' home in Stavern, which served for decades after the war as a municipal cinema and was converted more recently into a budget hotel. Online customer reviews note that its spaciousness makes it an ideal place to hold a wedding or other large gatherings. In the towns reconstructed after the war on the basis of BSR plans, grappling with embedded legacies necessitates a willingness to consider the ideological uses of everyday space, and how these can be resisted or channeled in new directions. In 1961, the year of the Berlin crisis and the building of the Berlin Wall, Molde established an international jazz festival, one of the oldest in Europe. Such festivals soon flourished throughout Europe with the encouragement of the US State Department, which turned jazz, touted as the music of democracy and freedom, into an ideological weapon to fight communism.[28] In Molde, the music and spectacle of the jazz festival intertwined with the public spaces of the city, newly constructed after the war. Every July, thousands of jazz lovers descend on the city. Crowds gather for free concerts in the large square by the city hall, with views of the fjord and mountains. And every day of the festival a jazz parade takes place through the town. Musicians play their instruments and march along Storgata, the broad main avenue, while onlookers cheer and dance.

Notes

Introduction: Hitler in the Fjords

1. Frohwein (German Foreign Office) to German Embassy in Oslo, telegram, 7 April 1934; and Reichswehrminister to Auswärtiges Amt, 7 April 1934; both in Besuch deutscher Kriegsschiffe im Auslande, July 1933–April 1935, R 33434, Political Archive, Federal Foreign Office, Berlin, Germany.

2. Frohwein (German Foreign Office) to German Embassy in Oslo, telegram, 11 April 1934; Büro II Abrüstung, note about telephone report from Hofrat Schulz, Chiffrierbüro, April 12, 1934; Frohwein to Min. Dir. Meyer, memo, April 12, 1934; all in Besuch deutscher Kriegsschiffe im Auslande, July 1933–April 1935, R 33434, Political Archive, Federal Foreign Office, Berlin, Germany.

3. "Hitler stod på broen og var begeistret over de norske fjorde," *Tidens Tegn*, April 17, 1934.

4. "Auslandsfahrt des Kanzlers," *Berliner Lokal-Anzeiger*, April 15, 1934; "Die Fahrt des Führers in die norwegischen Gewässer," *Völkischer Beobachter* (Berlin), April 18, 1934; "Hitler war in norwegischen Fjorden," *Deutsche Allgemeine Zeitung*, April 18, 1934; clippings in Kriegsschiffsbewegung Norwegen, July 1930–July 1935, R 81097, Political Archive, Federal Foreign Office, Berlin, Germany.

5. "Har Hitlers Norgesreise politisk bakgrunn?" *Tidens Tegn*, April 17, 1934. The publication of this article irritated the German ambassador in Oslo, Heinrich Rohland, who saw no "logical connection" between the cruise and disagreements among Nazi Party leaders. See Heinrich Rohland to the Foreign Office in Berlin, 18 April 1934, in Besuch deutscher Kriegsschiffe im Auslande, July 1933–April 1935, R 33434, Political Archive, Federal Foreign Office, Berlin, Germany.

6. Richard J. Evans, *The Third Reich in Power, 1933–1939* (New York: Penguin, 2015), 29.

7. "Hitler stod på broen og var begeistret over de norske fjorde."

8. John C. G. Röhl, *Wilhelm II: Into the Abyss of War and Exile, 1900–1941*, trans. Sheila de Bellaigue and Roy Bridge (Cambridge: Cambridge University Press, 2014), 1029–1945.

9. "Hitler på besøk i Norge," *Bergens Tidende*, April 14, 1934, clipping in Besuch deutscher Kriegsschiffe im Auslande, July 1933–April 1935, R 33434, Political Archive, Federal Foreign Office, Berlin, Germany.

10. Peter Fjågesund, *The Dream of the North: A Cultural History to 1920* (Amsterdam: Rodopi, 2014), 477–78.

11. "Rikskansler Hitler på besøk i Vestlandsfjordene med *Deutschland*," *Bergens Aftenblad*, April 16, 1934.

12. "Hitler på besøk i Norge," *Bergens Tidende*, April 14, 1934.

13. Prints made by Heinrich Hoffmann's Berlin Office, c. 1933–44, 242-HLB 270 thru 319, vol. 5, pp. B288–B301, Heinrich Hoffmann Collection, US National Archives at College Park, Maryland.

14. Kriegsschiffbesuche in Norwegen 1934, list of visits by German warships to Norway in 1934; Heinrich Rohland to the Foreign Office in Berlin, 11 July 1934; Heinrich Rohland, secret report, July 27, 1934; Secretary of State to Reich Minister, note, 1 August 1934; all in Kriegsschiffsbewegung Norwegen, July 1930–July 1935, R 81097, Political Archive, Federal Foreign Office, Berlin, Germany.

15. On Quisling, see Oddvar K. Hoidal, *Quisling: A Study in Treason* (Oslo: Norwegian University Press, 1989); and Hans Fredrik Dahl, *Quisling: A Study in Treachery*, trans. Anne-Marie Stanton-Ife (Cambridge: Cambridge University Press, 1999). Dahl's book has been criticized for its sympathetic portrayal of Quisling and for underplaying his antisemitism.

16. Winston Churchill, *The Hinge of Fate*, vol. 4 of *The Second World War* (Boston: Houghton Mifflin, 1950), 112.

17. Gustav Schenk, "Narvik in Ausbau," *Frankfurter Zeitung*, January 17, 1941.

18. Neuengamme Concentration Camp Memorial, *Norway under German Occupation*, brochure for the exhibition *Traces of History: Neuengamme Concentration Camp 1938–1945 and Its Post-War History* (Hamburg: KZ Gedenkstätte Neuengamme, 2010), 13. Accessed June 22, 2019: http://media.offenes-archiv.de /ha2_2_9_2_thm_2370_engl.pdf.

19. In *Hitler at Home* (New Haven, CT: Yale University Press, 2015), I explore the ideological power of intimate, smaller-scale Third Reich architecture through the design of Hitler's domestic spaces.

20. Hermann Boehm, "Die politische Entwicklung in Norwegen in der Zeit seit der Besetzung 1940 bis zum Frühjahr 1943," undated position paper, Handmaterial Ob.d.M., Denkschrift Gen. Adm. Boehm (Norwegen 1940–1943), RM 6/89, Bundesarchiv-Militärarchiv Freiburg, Germany.

21. There is a vast literature on the Second World War in Norway, most of it in Norwegian. For histories published in English, see François Kersaudy, *Norway 1940* (London: Collins, 1990); Adam R. A. Claasen, *Hitler's Northern War: The Luftwaffe's Ill-Fated Campaign, 1940–1945* (Lawrence: University Press of Kansas, 2001); Chris Mann and Christer Jörgensen, *Hitler's Arctic War: The German Campaigns in Norway, Finland and the USSR 1940–1945* (New York: Thomas Dunne Books, St. Martin's, 2003); Geirr H. Haarr, *The Battle for Norway: April–June 1940* (Annapolis, MD: Naval Institute, 2010); Kjersti Ericsson, ed., *Women in War: Examples from Norway and Beyond* (Farnham, Surrey: Ashgate, 2015); and Neal Bascomb, *The Winter Fortress: The Epic Mission to Sabotage Hitler's Atomic Bomb* (Boston: Houghton Mifflin Harcourt, 2016). A significant shift in Norwegian-language scholarship has occurred in recent years as Norwegian historians and journalists have begun to challenge the black-and-white narrative that dominated postwar accounts, and that pitted a majority of "good Norwegians" against Vidkun Quisling and his small band of Nasjonal Samling traitors. In particular, these writers are concerned with a broader and murkier history of complicity involving the deportation of Norwegian Jews, Norwegian volunteers of the Waffen-SS, the use of slave labor in Norway, and the collaboration of Norwegian industrialists with the occupiers. See, for example, Anne Eriksen, *Det var noe annet under krigen: 2. verdenskrig i norsk kollektivtradisjon* (Oslo: Pax, 1995); Bjarte Bruland, *Det norske Holocaust: Forsøket på å tilintetgjøre de norske jødene* (Oslo: HL-Senteret, Senter for Studier av Holocaust og Livssynsminoriteter, 2008); Bjørn

Westlie, *Fars krig* (Oslo: Aschehoug, 2008); Marianne Neerland Soleim, *Sovjetiske krigsfanger i Norge 1941–1945: Antall, organisering og repatriering* (Oslo: Spartacus, 2009); Anette Storeide, *Norske krigsprofitører: Nazi-Tysklands velvillige medløpere* (Oslo: Gyldendal, 2014); and Marte Michelet, *Den største forbrytelsen ofre og gjerningsmenn i det norske Holocaust* (Oslo: Gyldendal, 2015).

Chapter One: Romanticizing the North

1. Bruno Roemisch, "Vier Monate Nachdenken in Oslo: Schrittweise Befriedung des öffentlichen Lebens: Das Nationaltheater als Beispiel," *Krakauer Zeitung*, September 19, 1940.

2. Ibid.

3. The National Archives of Norway holds the vast press clippings collection of the Reich Commissariat's Department of Public Enlightenment and Propaganda. The collection contains articles on Norway published after April 1940 in German-language newspapers and journals from across Germany and occupied Europe. See Reichskommissariat, Hauptabteilung Volksaufklärung und Propaganda, Abteilung Presse, RA/RAFA-2174/E/Ed, Riksarkivet, Oslo.

4. Heinz-Werner Eckhardt, *Die Frontzeitungen des deutschen Heeres 1939–1945* (Vienna: Braumüller, 1975), 37ff.; Oron J. Hale, *The Captive Press in the Third Reich* (Princeton, NJ: Princeton University Press, 1973), 280.

5. Nikolaus von Falkenhorst, "Die Wacht im Norden," *Straubinger Tagblatt*, April 9, 1941.

6. Anita Unterholzner, *Straubinger Juden, jüdische Straubinger* (Straubing: Attenkofer, 1995), 11–12, 105ff.

7. Falkenhorst, "Wacht im Norden."

8. Adolf Hitler, *Hitler, Mein Kampf: Eine kritische Edition*, ed. Christian Hartmann, Thomas Vordermayer, Othmar Plöckinger, and Roman Töppel (Munich: Institut für Zeitgeschichte, 2016), 1:753; Richard McMahon, *The Races of Europe:*

Construction of National Identities in the Social Sciences, 1839–1939 (London: Palgrave Macmillan, 2016), 171ff.; Johann Chapoutot, *Greeks, Romans, Germans: How the Nazis Usurped Europe's Classical Past*, trans. Richard R. Nybakken (Berkeley: University of California Press, 2016), 23ff.

9. Terje Emberland, "Pure-Blooded Vikings and Peasants: Norwegians in the Racial Ideology of the SS," in *Racial Science in Hitler's New Europe, 1938–1945*, ed. Anton Weiss-Wendt and Rory Yeomans (Lincoln: University of Nebraska Press, 2013), 110.

10. Hans Günther, *Rassenkunde des deutschen Volkes* (Munich: Lehmanns, 1922), 128ff.

11. Emberland, "Pure-Blooded Vikings and Peasants," 110.

12. Hans F. K. Günther, *Der Nordische Gedanke unter den Deutschen*, 2nd ed. (Munich: Lehmanns, 1927), 49ff.

13. Emberland, "Pure-Blooded Vikings and Peasants," 110.

14. Amos Morris-Reich, *Race and Photography: Racial Photography as Scientific Evidence, 1876–1980* (Chicago: University of Chicago Press, 2016), 117.

15. Günther, *Rassenkunde des deutschen Volkes*, 31ff.

16. Erna Lendvai-Dircksen, *Das germanische Volksgesicht: Norwegen* (Bayreuth: Gauverlag Bayreuth, 1942); Claudia Schmölders, "Das Gesicht von 'Blut und Boden': Erna Lendvai-Dircksens Kunstgeografie," in *Körper im Nationalsozialismus: Bilder und Praxen*, ed. Paula Diehl (Munich: Fink; Paderborn: Schöningh, 2006), 51–78; Robert Heynen, *Degeneration and Revolution: Radical Cultural Politics and the Body in Weimar Germany* (Leiden: Brill, 2015), 403.

17. The sun cross was also appropriated as the symbol of Nasjonal Samling.

18. Lendvai-Dircksen, "Norwegen," foreword to *Das germanische Volksgesicht*, n.p. On earlier romantic portrayals of Norwegians as "primitive" people living

in harmony with nature and uncorrupted by civilization, see Peter Fjågesund and Ruth A. Symes, *The Northern Utopia: British Perceptions of Norway in the Nineteenth Century* (Amsterdam: Rodopi, 2003), 160ff.

19. Heinrich Meyer, "Norwegens Volk vor dem Aussterben?" *Deutsche Monatshefte in Norwegen* 2, no. 11 (1941): 11; Christine Charlotte Makowski, *Eugenik, Sterilisationspolitik, "Euthanasie" und Bevölkerungspolitik in der nationalsozialistischen Parteipresse* (Husum: Matthiesen, 1996), 181; Ida Blom, "Voluntary Motherhood 1900–1930: Theories and Politics of a Norwegian Feminist in an International Perspective," in *Maternity and Gender Policies: Women and the Rise of the European Welfare States, 1880s–1950s*, ed. Gisela Bock and Pat Thane (London: Routledge, 1991), 30ff.

20. Atina Grossmann, *Reforming Sex: The German Movement for Birth Control and Abortion Reform, 1920–1950* (New York: Oxford University Press, 1995), 136ff.

21. Meyer, "Norwegens Volk," 11.

22. See, for example, Martin Gläser, "Besinnung in Norwegen: Das norwegische Kunstschaffen und die politische Neuordnung," *Pariser Zeitung*, May 21, 1942.

23. Mario-Andreas von Lüttichau, "*Entartete Kunst*, Munich 1937: A Reconstruction," in *"Degenerate Art": Fate of the Avant-Garde in Nazi Germany*, ed. Stephanie Barron (Los Angeles: Los Angeles County Museum of Art; New York: Abrams, 1991), 64.

24. Anita Kongssund, "Art and Non-Art: A Modern Iconoclasm," in *Art in Battle*, ed. Frode Sandvik and Erik Tonning (Bergen: KODE Art Museums of Bergen, 2015), 76–97.

25. Walter Passarge, "Ein Maler aus nordischem Geist: Edvard Munch zum 80. Geburtstag," *Deutsche Zeitung in Norwegen*, December 11, 1943; Hans-Jürgen Buderer, *Entartete Kunst: Beschlagnahmeaktionen in der Städtischen*

Kunsthalle Mannheim 1937, 2nd ed. (Mannheim: Städtische Kunsthalle Mannheim, 1990), 59, 77.

26. sol, "Kann Oslo schöner werden?" *Deutsche Zeitung in Norwegen*, May 13, 1942. On Oslo's industrial development and housing crisis, see Synnøve Veinan Hellerud and Jan Messel, *Oslo: A Thousand-Year History*, trans. J. Basil Cowlishaw (Oslo: Aschehoug, 2000), 205ff.

27. Wilhelm Brepohl, "Die Hauptstadt als Schmelztiegel: Ist Oslo Norwegen?" *Deutsche Monatshefte in Norwegen* 3, no. 6 (1942): 13–14.

28. Ibid., 16.

29. "Oslos Zukunft: Generalbebauungsplan für Gross-Oslo," *Deutsche Zeitung in Norwegen*, January 28, 1942.

30. August Hoppe, "Norwegens Auge in der Welt: Oslo—Emporkömmling unter Weltstädten," *Wacht im Norden*, August 1, 1942. See also G. Privat, "Winterfahrt nach Norwegen," *Donau-Zeitung*, January 27, 1942.

31. H. Kramm, "Wo finden wir das Nordische im Norden? Das Bekenntnis der norwegischen Bauten—Erbe aus germanischer Zeit," *Wacht im Norden*, July 11, 1942; ol., "Das nordische Holzhaus: Betrachtung über seine Geschichte und Bauweise," *Deutsche Zeitung in Norwegen*, September 4, 1942; Eugen Kusch, "Norwegens mittelalterliche Kunst," *Revaler Zeitung*, March 9, 1943.

32. Gläser, "Besinnung in Norwegen."

33. Kramm, "Wo finden wir das Nordische im Norden?"

34. Hermann Phleps, "Stabbur in Norwegen—Stadel in den Alpen: Gleiche ländliche Bauweise im Norden und im Süden," *Deutsche Monatshefte in Norwegen* 2, no. 4 (1941): 10–13.

35. On the long history of the idea of a shared identity among German and Scandinavian peoples, and its racialization under National Socialism, see Barbara Miller Lane, *National Romanticism and Modern Architecture in Germany and the Scandinavian Countries* (Cambridge:

Cambridge University Press, 2000), 21ff., 306ff.

36. Arnved Nedkvitne, *The German Hansa and Bergen: 1100–1600* (Cologne: Böhlau, 2014), 335; Antjekathrin Graßmann, "Das Hansekontor zu Bergen: Kirche und Wohltätigkeit," in *Das Hansische Kontor zu Bergen und die Lübecker Bergenfahrer: International Workshop Lübeck 2003, ed.* Antjekathrin Graßmann (Lübeck: Archiv der Hansestadt Lübeck, 2005), 78.

37. Bruno Roemisch, "Deutsche Baukunst in Norwegen," *Deutsche Monatshefte in Norwegen* 2, no. 12 (1941): 6–7.

38. *The Medieval Cathedral of Trondheim: Architectural and Ritual Constructions in Their European Context*, ed. Margrete Syrstad Andås, Øystein Ekroll, Andreas Haug, and Nils Holger Petersen (Turnhout, Belgium: Brepols, 2007), 13, 18.

39. Per Storemyr, "The Stones of Nidaros: An Applied Weathering Study of Europe's Northernmost Medieval Cathedral" (PhD diss., Norwegian University of Science and Technology, 1997), 72–75, 267; Dag Nilsen, "The Cathedral of Nidaros: Building a Historic Monument," *Future Anterior* 7, no. 2 (2010): xiv–17.

40. A. L. Berg, "Jahrhunderte bauten an einem Dom: Ein deutscher Baumeister half das Werk vollenden," *Deutsche Zeitung in Norwegen*, June 25, 1942.

41. A. L. Berg, "Deutsche Baumeister in Norwegen," *Deutsche Zeitung in Norwegen*, July 2, 1942; Mari Hvattum, *Heinrich Ernst Schirmer: Kosmopolittenes arkitekt* (Oslo: Pax, 2014).

42. P. Brinkmann, "Bergen: Stadt der Hanse," *Deutsche Zeitung in Norwegen*, November 27, 1941.

43. "Deutsche gründeten Tromsö," *Deutsche Zeitung in Norwegen*, undated clipping in Abteilung Presse, Avisutklipp. E. Chronik und Lokales, 1940–1943, Reichskommissariat, RA/RAFA-2174/E/ Ed/L0046, Riksarkivet, Oslo. By contrast, a nineteenth-century German

traveler to Tromsø described the town as "unheimlich," or uncanny, in part because of the large presence of indigenous Sámi. See Ulrike Spring, "Arctic and European In-Betweens: The Production of Tourist Spaces in Late Nineteenth-Century Northern Norway," in *Britain and the Narration of Travel in the Nineteenth Century: Texts, Images, Objects*, ed. Kate Hill (Milton Park, Abingdon, Oxon: Routledge, 2016), 19.

44. Kala, "Warum manche Norweger nicht verstehen," *Wacht im Norden*, August 16, 1941.

45. The initial order to confiscate radios applied to Norwegians living in coastal areas. The order was later extended to apply to the whole country. Kathleen Stokker, *Folklore Fights the Nazis: Humor in Occupied Norway, 1940–1945* (Madison: University of Wisconsin Press, 1997), 80; Maynard M. Cohen, *A Stand against Tyranny: Norway's Physicians and the Nazis* (Detroit: Wayne State University Press, 1997), 122, 158; Tor Myklebost, *They Came as Friends*, trans. Trygve M. Ager (New York: Doubleday, 1943), 37–38, 183–84, 228.

46. Kala, "Warum manche Norweger nicht verstehen."

47. "Deutsch-norwegische Zusammenarbeit 1941," *Deutsche Zeitung in Norwegen*, January 1, 1942.

48. Heinz Klassen, "Landjugendaustausch: Norwegische Jungbäuerinnen besuchen deutsche Höfe," *Deutsche Zeitung in Norwegen*, August 3, 1942. To further cement those bonds, Germany also sent youth groups to Norway, including German women who visited Norwegian farms to learn their "ancient culture," and who returned to Germany with gifts of Prime Minister Vidkun Quisling's book on the Soviet Union, his photograph, and a book of Norwegian folk songs. See "Deutsche Bauernmädel in Norwegen," *Deutsche Allgemeine Zeitung*, October 8, 1942.

49. Hans Otto Frøland, Gunnar

Damhagen Hatlehol, and Mats Ingulstad, "Regimenting Labour in Norway during Nazi Germany's Occupation," 11; Working Paper Series A, No. 12, ed. Elizabeth Harvey and Kim Christian Priemel, Working Papers of the Independent Commission of Historians Investigating the History of the Reich Ministry of Labour (*Reichsarbeitsministerium*) in the National Socialist Period (2017). Accessed June 22, 2019: https://www.historikerkommission-reichsarbeitsministerium.de/sites/default/files/inline-files/Working%20Paper%20UHK%20A12_Fr%C3%B8land%2B Hatlehol%2BIngulstad_0.pdf.

50. Joachim Schieferdecker, "Besuch beim norwegischen Arbeitsdienst," *Völkischer Beobachter* (Norddeutsche Ausgabe), August 5, 1942; Mats Ingulstad, "The Shovel Is Our Weapon: The Norwegian Labour Service and the Paradox of Nationalist Internationalism," *Scandinavian Journal of History* 43, no. 4 (2018): 13.

51. Carl W. Gilfert, "Ghetto Juden und Ungeziefer gehören zusammen," *Donauzeitung* (Belgrade), November 22, 1941, cited in Raul Hilberg, *The Destruction of the European Jews*, 3rd ed. (New Haven, CT: Yale University Press, 2003), 1:262n291.

52. Carl W. Gilfert, "Betrachtungen zwischen weissen Nächten: Nationaler Arbeitsdienst als tragende Säule eines neuen Europa," *Deutsche Zeitung im Ostland*, August 11, 1942.

53. Guri Hjeltnes, "Supplies under Pressure: Survival in a Fully Rationed Society; Experiences, Cases, and Innovation in Rural and Urban Regions in Occupied Norway," in *Coping with Hunger and Shortage under German Occupation in World War II*, ed. Tatjana Tönsmeyer, Peter Haslinger, and Agnes Laba (Cham, Switzerland: Palgrave Macmillan, 2018), 62–63.

54. Amanda Johnson, *Norway, Her Invasion and Occupation* (Decatur, GA: Bowen, 1948), 123.

55. Richard J. Evans, *The Third Reich at War* (New York: Penguin, 2009), 341; Johnson, *Norway*, 211; Stokker, *Folklore Fights the Nazis*, 142–43; Hjeltnes, "Supplies under Pressure," 74.

56. "Norwegen im Gestaltwandel: Das Erwachen des germanischen Gemeinschaftsgefühls," *Thüringer Allgemeine Zeitung*, January 5, 1943; Martin Gläser, "Norwegens neues Gesicht: Wandlung zum neuen Europa," *Deutsche Ukraine-Zeitung*, February 17, 1942; "Norwegen zwischen gestern und morgen: Loslösung von westlichen Ideen," *Hildesheimer Beobachter*, September 23, 1942.

57. Alan S. Milward, *The Fascist Economy in Norway* (Oxford: Clarendon Press, 1972), 280.

58. Gläser, "Norwegens neues Gesicht"; Johnson, *Norway*, 212.

59. "Norwegen im Gestaltwandel."

60. Ibid.; ow, "Wie orientiert sich Nordeuropa: Die nordischen Länder und die Neuordnung," *N.S.Z. Westmark*, March 5, 1942.

61. a, "Norwegen zieht eine neue Bahn: Sprödes Land im Norden im Schmelztiegel der neuen Zeit," *Westfälische Neueste Nachrichten*, October 17/18, 1942; Hans Zielinski, "Norwegens innerer Aufbau: Nach dem Grundsatz der autoritären Verantwortlichkeit," *Berliner Börsen-Zeitung*, April 9, 1942; ow, "Wie orientiert sich Nordeuropa."

62. Dahl, *Quisling*, 287.

63. "Norwegen: Eckstein des neuen Europa," *Thorner Freiheit*, February 16, 1942; Dahl, *Quisling*, 250–53. See also gl, "Norwegens Wendung zum Kontinent," *Westfälische Landeszeitung—Rote Erde*, February 17, 1942; "Wendepunkt in Norwegen," *Frankfurter Zeitung*, February 3, 1942; and Hans Zielinski, "Norwegens Wirtschaft besinnt sich," *Deutsche Allgemeine Zeitung*, February 17, 1942.

64. gl, "Norwegens Wendung zum Kontinent."

Chapter Two: Norway in the New Order

1. Vitalis Pantenburg, "Zum Dach Europas: Eine Reise in Europas arktische Zonen," *Kölnische Zeitung* (Reichsausgabe), printed in seven parts on January 5, 1941; January 12, 1941; January 19, 1941; January 26, 1941; February 2, 1941; February 9, 1941; February 16, 1941.

2. Ibid.

3. Kurt Singer, *Spies and Traitors of World War II* (New York: Prentice Hall, 1945), 44. Singer called Pantenburg "one of the best Nazi spies in Europe." Kurt Singer, *Duel for the Northland: The War of Enemy Agents in Scandinavia* (New York: McBride, 1943), 162.

4. Diagram of OT Set-Up in Norway with Location of Building Sites (Baustellen), map in a report by Lt. Colonel A. Roscher Lund, "Organization Todt in Norway: Set-Up and Main Activities," High Command, Royal Norwegian Forces, II Department, January 10, 1944, in Organisation Todt Collection, Organisation Todt in Norway—Set-Up and Main Activities (No. 94), 1944, OT-materiale avlevert fra Norges hjemmefrontmuseum (NHM) i 1990, RA/RAFA-2188/2/H/Hh/0020, Riksarkivet, Oslo.

5. Ketil Gjølme Andersen, *Grossraum: Organisation Todt and Forced Labour in Norway 1940–45* (Oslo: Norwegian Museum of Science and Technology, 2017), 51.

6. George Forty, Leo Marriott, and Simon Forty, *Hitler's Atlantic Wall: From Southern France to Northern Norway, Yesterday and Today* (Havertown, PA: Casemate, 2016), 6, 10, 26, 40; J. E. Kaufmann and H. W. Kaufmann, *Fortress Third Reich: German Fortifications and Defense Systems in World War II* (Cambridge, MA: Da Capo, 2007), 196, 219.

7. In his memoirs, Albert Speer claimed that he convinced Hitler of "ruin value": constructing important state buildings of the Third Reich in such a

way that hundreds or thousands of years after being abandoned, they would make for beautiful ruins, providing inspiration for future architects, much as the Roman ruins that Hitler admired had done in the past. Albert Speer, *Inside the Third Reich*, trans. Richard and Clara Winston (New York: Macmillan, 1970), 56.

8. Roscher, "Organization Todt in Norway," 1; Andersen, *Grossraum*, 7.

9. Forty, Marriott, and Forty, *Hitler's Atlantic Wall*, 26ff. The poor treatment and high mortality of Soviet POWs was true beyond the Organisation Todt. See Johann Custodis, "Employing the Enemy: The Economic Exploitation of POW and Foreign Labor from Occupied Territories by Nazi Germany," in *Paying for Hitler's War: The Consequences of Nazi Hegemony for Europe*, ed. Jonas Scherner and Eugene N. White (New York: Cambridge University Press, 2016), 71.

10. *Handbook of the Organisation Todt (OT)* [Nr. 95], MIRS-London, March 1945, Organisation Todt Collection, OT-materiale avlevert fra Norges hjemmefrontmuseum (NHM) i 1990, RA/RAFA-2188/2/H/Hh/0021, Riksarkivet, Oslo.

11. Roscher, "Organization Todt in Norway," 1.

12. Thomas Zeller, *Driving Germany: The Landscape of the German Autobahn, 1930–1970*, trans. Thomas Dunlap (New York: Berghahn, 2007), 66; Franz W. Seidler, *Fritz Todt: Baumeister des Dritten Reiches* (Schnellbach: Bublies, 2000), 57ff., 71ff.

13. Dr. Leschke, "Jetzt fährt man zu Land nach dem Norden," *Deutsche Monatshefte in Norwegen* 1, no. 1 (1940): 23.

14. Ibid.

15. Marian Aguiar, *Tracking Modernity: India's Railway and the Culture of Mobility* (Minneapolis: University of Minnesota Press, 2011), xiv–xv.

16. Pantenburg, "Zum Dach Europas," January 5, 1941.

17. Karl Scharping, "Neuordnung

zwischen Jütland und Nordkap: Norwegen lernt ein neues Tempo," *Warschauer Zeitung*, September 29–30, 1940.

18. Bernhard Rieger, *The People's Car: A Global History of the Volkswagen Beetle* (Cambridge, MA: Harvard University Press, 2013), 56.

19. Leschke, "Jetzt fährt man zu Land nach dem Norden," 23–24. See also Josef K. F. Naumann, "Ausbau des Norwegischen Verkehrsnetzes in Deutsch-Norwegischer Zusammenarbeit," in *Die Betonstrasse* 16, no. 3 (1941): 38–42.

20. Leschke, "Jetzt fährt man zu Land nach dem Norden," 24–25. See also Frank Kleinkorst, "Oslo-Kirkenes: Die Geschichte einer Strasse," *Deutsche Zeitung*, October 27, 1940; and "Nördliche Strasse vor der Vollendung: Zum erstenmal unter hervorragender deutscher Hilfe eine Landverbindung zu Europas hohem Norden," *Der Danziger Vorposten*, September 18, 1940.

21. Strassenbau in Norwegen 1940, undated report (c. 1940); and Straßen und Brücken in Norwegen von Baurat Hesse und Regierungsbaumeister Neyer, typescript, December 19, 1940; both in Organisation Todt Collection, Einsatzgruppe Wiking, Abt. Strassenbau, B. I. Allgemeines, Oslo—Kirkenes, 1940, RA/RAFA-2188/1/E/E2/E2b/L0005/0003, Riksarkivet, Oslo.

22. "Nördliche Strasse vor der Vollendung." See also Naumann, "Ausbau des Norwegischen Verkehrsnetzes," 40–41. On the history of Riksvei 50 (now European route E6), see John Douglas, *Norway's Arctic Highway: Mo i Rana to Kirkenes* (Hindhead, Surrey: Trailblazer, 2003), 46ff. Despite the fact that the roadwork was often requested by and in the interest of the Wehrmacht, their requisitioning (indeed, theft—these appropriations sometimes occurring secretly in the night) of equipment and materials belonging to the Norwegian Roads Administration resulted in frustrations and delays. See Hesse

to Armee-Oberkommando Norwegen Oberquartiermeister, 1 May 1941, in Organisation Todt, Abt. Strassenbau, B. Strassenbauten, I Allgemeines, 1941–1942, RA/RAFA-2188/1/E/E2/E2b/L0004, Riksarkivet, Oslo.

23. "Was der Verhkehr bringt," *Deutsche Zeitung in Norwegen*, July 4, 1942.

24. Claudia Schneider, "Kraft durch Freude: Begegnungen auf Distanz," in *Hundert Jahre deutsch-norwegische Begegnungen: Nicht nur Lachs und Würstchen*, ed. Bernd Henningsen (Berlin: Berliner Wissenschafts-Verlag, 2005), 227–29; Shelley Baranowski, *Strength through Joy: Consumerism and Mass Tourism in the Third Reich* (New York: Cambridge University Press, 2004), 122; Rasso Knoller, *Norwegen: Ein Länderporträt* (Berlin: Ch. Links, 2013), 69.

25. G. B., "Norwegen gefragtes Reiseland," *Deutsche Zeitung in Norwegen*, March 29, 1942.

26. hg, "Norwegen: Alle Räder rollen für den Sieg," *Deutsche Zeitung in Norwegen*, April 15, 1943.

27. After considerable effort and inconvenience, Stephan succeeded in procuring a car for some, but not all, legs of his trip. Hans Stephan to Josef Terboven, 18 July 1941, Generalbauinspektor für die Reichshauptstadt, Trondheim—Stadtplanung, 1941–1942, R 4606/4007, Bundesarchiv Berlin. On Stephan's work on urban reconstruction in Norway, see chapter 4.

28. G. B., "Norwegen gefragtes Reiseland."

29. See, for example, "Frühling und Feldgrau in Westnorwegen," *Völkischer Beobachter* (Berlin), May 17, 1941.

30. "'Zum Dach Europas': Lichtbildervortrag über die Strassenbauvorhaben in Norwegen," *Kärtner Grenzruf* (Klagenfurt), November 20, 1940.

31. Hartmut Berghoff, "Enticement and Deprivation: The Regulation of Consumption in Pre-War Nazi Germany," in *The Politics of Consumption: Material*

Culture and Citizenship in Europe and America, ed. Martin Daunton and Matthew Hilton (New York: Berg, 2001), 175.

32. Rieger, *People's Car*, 42ff.

33. Dr.-Ing. Walther Heide, Technischer Bericht über die Planungsarbeiten für die Reichsautobahn Trondheim—Oslo—Halden, report dated March 1941, Reichskommissar für die besetzten norwegischen Gebiete Abteilung Technik und Verkehr, Gruppe Reichsautobahnen, in Skriv vedrørende Autobahn Trondheim-Oslo og Halden, flere tegninger av Autobahn i Tyskland og "Teknisk ukeblad" fra November 1940, Organisation Todt Collection, Oberbauleitungen, OBL-Drontheim/Mittelnorwegen: Korrespondanse og regninger, RA/RAFA-2188/2/F/Fa/Fae/L0042, Riksarkivet, Oslo.

34. Heide, Technischer Bericht über die Planungsarbeiten für die Reichsautobahn; and Dipl.-Ing. [Helmut] Beyrer, Die Planung und vorbereitenden Arbeiten für die Reichsautobahnlinie Trondheim—Oslo: Bericht für die norwegische Wegebaudirektion, report dated October 26, 1940; both in Skriv vedrørende Autobahn Trondheim-Oslo og Halden, flere tegninger av Autobahn i Tyskland og "Teknisk ukeblad" fra November 1940, Organisation Todt Collection, Oberbauleitungen, OBL-Drontheim/Mittelnorwegen: Korrespondanse og regninger, RA/RAFA-2188/2/F/Fa/Fae/L0042, Riksarkivet, Oslo. On the Norwegian engineers' trip to Germany, see Todt to Terboven, 15 May 1941; and memo for Oberst von Sannow, February 28, 1941; both in Generalinspektor für das deutsche Straßenwesen, Autobahnen im Ausland, Norwegen, R 4601/1109, Bundesarchiv Berlin. Of the thirty engineers invited to participate, it appears that twenty actually undertook the training program: "Norwegische Ingenieure auf deutschen Reichsautobahnen," *Rundschau Deutscher Technik*, January 23, 1941.

35. Heide, Technischer Bericht über die Planungsarbeiten für die Reichsautobahn.

36. Ibid.

37. Erhard Schütz and Eckhard Gruber, *Mythos Reichsautobahn: Bau und Inszenierung der "Straßen des Führers" 1933–1941* (Berlin: Links, 1996), 94; Seidler, *Fritz Todt*, 112ff.

38. Zeller, *Driving Germany*, 138–42, 149–51; Richard Vahrenkamp, "Automobile Tourism and Nazi Propaganda: Constructing the Munich-Salzburg *Autobahn*, 1933–1939," *Journal of Transport History* 27, no. 2 (2006): 30.

39. William H. Rollins, "Whose Landscape? Technology, Fascism, and Environmentalism on the National Socialist *Autobahn*," *Annals of the Association of American Geographers* 85, no. 3 (1995): 498, 510; Zeller, *Driving Germany*, 152.

40. Todt quoted in Zeller, *Driving Germany*, 136.

41. "Norwegens Strassenbau, Energiewirtschaft und Autobahnen-Planung," *Rheinisch-Westfälische Zeitung*, May 5, 1942.

42. Heide, Technischer Bericht über die Planungsarbeiten für die Reichsautobahn.

43. Ibid.; Schütz and Gruber, *Mythos Reichsautobahn*, 88ff. When the German defense ministry expressed similar concerns about the autobahn in Germany, Todt explicitly asserted the peacetime function of the autobahn. See Seidler, *Fritz Todt*, 137.

44. Adam Tooze, *The Wages of Destruction: The Making and Breaking of the Nazi Economy* (New York: Viking, 2006), 47.

45. Schütz and Gruber, *Mythos Reichsautobahn*, 68ff.; Zeller, *Driving Germany*, 60–61.

46. These figures exclude motorbikes. Zeller, *Driving Germany*, 52. See also Tooze, *Wages of Destruction*, 149ff. The situation was only marginally better in Norway. In 1935, Norway had twenty-two vehicles per one thousand people. C. L. Paus, *Report on Economic and Commercial*

Conditions in Norway, no. 657, prepared for the Department of Overseas Trade (London: H.M. Stationary Office, 1936), vi, 73. The Nazis expected an increase in motorization, particularly in western and northern Norway, through "German influence" and the improvement of road networks. See "Organisation der norwegischen Kraftfahrzeugwirtschaft," *Deutsche Bergwerkszeitung*, August 15, 1943.

47. Vahrenkamp, "Automobile Tourism," 25–26, 32.

48. Zeller, *Driving Germany*, 128–29, 132–33; Rudy Koshar, "On the Road in Germany between the World Wars," in *Unravelling Civilisation: European Travel and Travel Writing*, ed. Hagen Schultz-Forberg (Brussels: Peter Lang, 2005), 295.

49. Schütz and Gruber, *Mythos Reichsautobahn*, 43–44, 104ff.; Zeller, *Driving Germany*, 62ff.

50. "Autostrada Trondheim-Svartehavet," *Fritt Folk*, October 28, 1940; Harald Espeli, "Incentive Structures and State Regulations of the Norwegian Economy," in *Industrial Collaboration in Nazi-Occupied Europe: Norway in Context*, ed. Hans Otto Frøland, Mats Ingulstad, and Jonas Scherner (London: Palgrave Macmillan, 2016), 261.

51. Otto Kahrs, "Bilstamveien Halden-Oslo-Trondheim," *Teknisk Ukeblad* 87, no. 45 (1940): 465–69.

52. "Autobahn nach Norwegen und Schweden? Neue Verkehrswege erschliessen das zukünftige Europe," *Gelsenkirchener Zeitung*, September 29, 1940. See also Schütz and Gruber, *Mythos Reichsautobahn*, 87ff.

53. Ben Wheatley, *British Intelligence and Hitler's Empire in the Soviet Union, 1941–1945* (London: Bloomsbury Academic, 2017), 135; Czesław Madajczyk, ed., *Vom Generalplan Ost zum Generalsiedlungsplan* (Munich: Saur, 1994), 23–24. On Nazi plans for new cities in Eastern Europe, see Werner Durth and Niels Gutschow, *Träume in Trümmern:*

Stadtplanung 1940–1950 (Munich: Deutscher Taschenbuch, 1993), 75–112.

54. Werner Koeppens, entry for Saturday, September 20, 1941, in *Herbst 1941 im "Führerhauptquartier." Berichte Werner Koeppens an seinen Minister Alfred Rosenberg*, ed. Martin Vogt (Koblenz: Bundesarchiv, 2002), 28–29.

55. Frank Schipper, *Driving Europe: Building Europe on Roads in the Twentieth Century* (Amsterdam: Aksant, 2008), 103ff.; Schütz and Gruber, *Mythos Reichsautobahn*, 89.

56. See chapter 5.

57. Entry for Saturday, September 20, 1941, in *Herbst 1941 im "Führerhauptquartier,"* 28. A month prior to this meeting, the representative (Hermann) of the director of the autobahn group (Neyer) of the Reich Commissariat wrote to the office of the General Inspector of Roads in Berlin to complain that after initially offering its full support, the Reich Commissariat was withholding resources needed to further plan the autobahn. Other projects, particularly the expansion of the aluminum industry, were now of greater priority for the Reich Commissariat. Hermann asked for his group to be taken out of the Reich Commissariat and placed under the authority of the OT in Oslo. Two weeks later, Todt intervened with Terboven to obtain more resources for the autobahn group, with Terboven promising to substantially increase the budget and other resources at the group's disposal. The goal was not construction at that point, which Todt acknowledged was beyond the resources then available, but rather to advance the technical planning and design of the highway beyond a preliminary stage. Hermann to Ilsemann, 18 August 1941; Todt to Terboven, 1 September 1941; Terboven to Todt, 16 September 1941; all in Generalinspektor für das deutsche Straßenwesen, Autobahnen im Ausland, Norwegen, R 4601/1109, Bundesarchiv Berlin.

58. Heide, Technischer Bericht über die Planungsarbeiten für die Reichsautobahn.

59. The autobahn from Oslo to Trondheim never got off the drawing board. Despite Terboven promising Todt, in February 1941, to supply workers to begin construction the following May, other projects—such as the development of the aluminum industry and submarine bunkers in Norway—took precedence. Nevertheless, a team of fifteen employees, consisting of five Germans and ten Norwegians, continued the planning of the autobahn until the spring of 1942. At that point, the project was shut down and its technical personnel transferred to more urgent road-building projects in northern Norway. Teboven to Todt, 26 February 1941; Hermann to Ilsemann, 18 August 1941; Neyer to the Reich Commissar (via the Central Economic Department), 21 August 1941; all in Generalinspektor für das deutsche Straßenwesen, Autobahnen im Ausland, Norwegen, R 4601/1109, Bundesarchiv Berlin. Neyer to the Norwegische Wegebaudirektion, 11 April 1942, in Organisation Todt, Abt. Strassenbau, B. Strassenbauten, I Allgemeines, 1942–1943, RA/RAFA-2188/1/E/E2/E2b/L0004, Riksarkivet, Oslo.

60. Andersen, Grossraum, 37; Milward, Fascist Economy in Norway, 116, 273, 277.

61. Robert Bohn, Reichskommissariat Norwegen: "Nationalsozialistische Neuordnung" und Kriegswirtschaft (Munich: Oldenbourg, 2000), 365–66; Milward, Fascist Economy in Norway, 277. See also Bjørn Westlie, Fangene som forsvant: NSB og slavearbeiderne på Nordlandsbanen (Oslo: Spartacus, 2016), 56ff.

62. Bohn, Reichskommissariat Norwegen, 363; Westlie, Fangene som forsvant, 44–46, 49.

63. Westlie, Fangene som forsvant, 70, 76; Milward, Fascist Economy in Norway, 115, 164ff.

64. Bohn, Reichskommissariat Norwegen, 365–66.

65. Milward, Fascist Economy in Norway, 165, 273–76. Despite the lives and resources expended in support of Hitler's monomania, the railroad only reached Dunderland by war's end. In the early 1960s, the NSB extended the Nordland Line to Bodø, which remains its northern terminus today. The construction of an extensive network of short-haul airports in northern Norway in the 1970s largely undermined the need for a railway farther north, although plans for a high-speed rail were explored, and then rejected, in the 1990s. When European Route 6 was extended northward from Fauske during the 1960s, the highway followed part of the route planned for the polar railway, using a number of tunnels excavated as well as the land seized for the train. In the surrounding landscape, scattered amid woods and meadows, are abandoned relics of railway bridges, tunnels, and embankments. See Ursula Bartelsheim, "Die Nordlandbahn," in Unterwegs zum Polarkreis: Eisenbahnabenteuer in Skandinavien, ed. Deutsche Bahn Nürnberg (Nuremberg: DB Museum, 2008), 16–17.

66. Milward, Fascist Economy in Norway, 272–73.

67. Andersen, Grossraum, 37. For a more extensive analysis of the polar railway project, see Ketil Gjølme Andersen, "Teknisk æresoppdrag av høyeste orden: Organisation Todt og byggingen av Hitlers polarjernbane," Historisk tidsskrift 97, no. 3 (2018): 206–23. Dr. Andersen is the project leader of the exhibition Grossraum: Organisation Todt and Forced Labour in Norway 1940–45, which opened at the Norwegian Museum of Science and Technology in Oslo in 2017. The exhibition is part of a larger research project undertaken by the Norwegian Museum of Science and Technology in collaboration with historians at the Norwegian University of Science and Technology in Trondheim focused on the Organisation Todt and forced labor in Norway during

the Second World War. I am grateful to Dr. Andersen for our conversations and for sharing the following article draft: Ketil Gjølme Andersen, "The Politics of Space: German Large-Scale Construction Projects in Norway 1940–1945" (2015).

68. Andersen, *Grossraum*, 5, 37, 45, 49–50. See also Marianne N. Soleim, "Soviet Prisoners of War in Norway 1941–1945: Destiny, Treatment and Forgotten Memories," *Modern History of Russia* [Novejsaâ Istoriâ Rossii], no. 1 (2016): 22–32.

69. John Connelly, "Nazis and Slavs: From Racial Theory to Racist Practice," *Central European History* 32, no. 1 (1999): 2, 13.

70. Dr. Klein, memo, December 1, 1941, in Organisation Todt, Abt. Strassenbau, B. Strassenbauten, I Allgemeines, 1941–1942, RA/RAFA-2188/1/E/E2/E2b/L0004, Riksarkivet, Oslo.

71. Hesse, Beschäftigung russischer Kriegsgefangener im Strassenbau (nach roher Schätzung), undated table of figures of Russian POWs working on Norwegian roads, in ibid.

72. Soleim, "Soviet Prisoners of War in Norway," 26; Vincent Hunt, *Fire and Ice: The Nazis' Scorched Earth Campaign in Norway* (Stroud, Gloucestershire: History Press, 2014), 82; Andersen, *Grossraum*, 34.

73. Dr. Bauer, Auszug aus dem Bericht des SS-Stubaf. Dr. Bauer vom 17.8.42 über die vom 28.7 bis 13.8.1942 durchgeführte Inspektionsreise, in Organisation Todt, Abt. Strassenbau, B. Strassenbauten, I Allgemeines, 1942–1943, RA/RAFA-2188/1/E/E2/E2b/L0004, Riksarkivet, Oslo.

74. Gorana Ognjenović, "The *Blood Road* Reassessed," in *Revolutionary Totalitarianism, Pragmatic Socialism, Transition*, vol. 1, ed. Gorana Ognjenović and Jasna Jozelić (New York: Palgrave Macmillan, 2016), 205.

75. Odd Storteig, *Krigsfangenes historie: Blodveien i Saltdal* (Bodø: Saltdal kommune, 1997), 16.

76. Georg Lilienthal, *Der "Lebensborn e.V.": Ein Instrument nationalsozialistischer Rassenpolitik* (Stuttgart: Gustav Fischer, 1985), 38; Kåre Olsen, "Under the Care of Lebensborn: Norwegian War Children and Their Mothers," in *Children of World War II: The Hidden Enemy Legacy*, ed. Kjersti Ericsson and Eva Simonsen (Oxford: Berg, 2005), 16–17; Lynn H. Nicholas, *Cruel World: The Children of Europe in the Nazi Web* (New York: Knopf, 2005), 61–62.

77. Olsen, "Under the Care of Lebensborn," 16; Tara Zahra, *The Lost Children: Reconstructing Europe's Families after World War II* (Cambridge, MA: Harvard University Press, 2011), 126–27. For autobiographical accounts of *Lebensborn*, see Ingrid von Oelhafen and Tim Tate, *Hitler's Forgotten Children* (New York: Berkley Caliber, 2016); and Dorothee Schmitz-Köster and Tristan Vankann, *Lebenslang Lebensborn: Die Wunschkinder der SS und was aus ihnen wurde* (Munich: Piper, 2012).

78. SS-Gruppenführer Rediess to Heinrich Himmler, 5 December 1940, Sonstige zentrale Dienststellen und Einrichtungen der SS, Lebensborn e.V., vol. 1, 1937–1941, NS 48/29, Bundesarchiv Berlin.

79. Kåre Olsen, *Vater: Deutscher; Das Schicksal der norwegischen Lebensbornkinder und ihrer Mütter von 1940 bis heute*, trans. Ebba D. Drolshagen (Frankfurt: Campus, 2002), 19–21, 31, 50; Emberland, "Pure-Blooded Vikings and Peasants," 110, 117.

80. Wilhelm Rediess, *Schwert und Wiege* (Oslo: Aas and Wahls, 1943), 22.

81. Kjersti Ericsson and Eva Simonsen, "Shame and Silence: The Experience of German-Norwegian War Children," in *Women in War: Examples from Norway and Beyond*, ed. Kjersti Ericsson (Farnham, Surrey: Ashgate, 2015), 201–3; Olsen, "Under the Care of Lebensborn," 20.

82. Olsen, *Vater: Deutscher*, 49–51, 62–62. In two homes—Godthaab and

Geilo—it appears that Norwegian doctors were also involved. See "Heime," an undated list of Lebensborn homes in Norway, Sonstige zentrale Dienststellen und Einrichtungen der SS, Lebensborn e.V., vol. 1, 1937–1941, NS 48/29, Bundesarchiv Berlin.

83. Ericsson and Simonsen, "Shame and Silence," 202; Olsen, *Vater: Deutscher*, 189; Dorothee Schmitz-Köster, *"Deutsche Mutter, bist du bereit…": Der Lebensborn und seine Kinder* (Berlin: Aufbau, 2010), 292–93.

84. Olsen, *Vater: Deutscher*, 55, 58, 64–65; Oelhafen and Tate, *Hitler's Forgotten Children*, 145; Schmitz-Köster and Vankann, *Lebenslang Lebensborn*, 13.

85. Olsen, "Under the Care of Lebensborn," 20–21; Olsen, *Vater: Deutscher*, 41; Oelhafen and Tate, *Hitler's Forgotten Children*, 146.

86. Rediess, *Schwert und Wiege*, 7ff., 17, 26.

87. Thomas Cook Ltd., *Cook's Handbook to Norway and Denmark*, 8th ed. (London: Thos. Cook, 1911), 95; Stefan Gammelien, "Die Nordlandfahrten Wilhelms II," in *Hundert Jahre deutsch-norwegische Begegnungen: Nicht nur Lachs und Würstchen*, ed. Bernd Henningsen (Berlin: Berliner Wissenschafts-Verlag, 2005), 224–26; Fjågesund, *Dream of the North*, 477ff. On the emperor's role as a patron of Norwegian architecture, see Lane, *National Romanticism*, 73ff.

88. *Bennett's Handbook for Travellers in Norway*, 29th ed. (Christiania: Thos. Bennet and Sons, 1902), 118.

89. Rediess, *Schwert und Wiege*, facing 46, 47.

90. Olsen, *Vater: Deutscher*, 183.

91. Rediess, *Schwert und Wiege*, 43, 44–45, 47.

92. Ibid., 55, 83.

93. Ibid., 55–58; Olsen, *Vater: Deutscher*, 88–89.

94. Rediess, *Schwert und Wiege*, 41; Olsen, *Vater: Deutscher*, 56–57, 59, 87.

95. [Edgar] Luther, Nachweisung

Nr. 2, Bauten der Sondergruppe "Lebensborn—Mütterhilfe," accounting report from the architecture group of the Reich Commissariat dated August 4, 1942, in Organisation Todt Collection, Einsatzgruppe Wiking, OT Hochbau, Oversikt over byggearbeider, 1942, RA/RAFA-2188/2/H/Hf/Hfc/0078, Riksarkivet, Oslo.

96. [Edgar] Luther, memo, Aufnahme von RK-Bauten in die Dringlichkeitsliste 1942, March 26, 1942, Organisation Todt Collection, Einsatzgruppe Wiking, OT Hochbau, Mütterheim Hurdals verk der Gruppe Lebensborn mappe 2, 1942, RA/RAFA-2188/2/H/Hf/Hfc/0068, Riksarkivet, Oslo.

97. See invoices and reports in A/Hoch/12—Mütterheim Godthåb der Gruppe Lebensborn mappe 1, 1942, RA/RAFA-2188/2/H/Hf/Hfc/0065; Mütterheim Hurdals verk der Gruppe Lebensborn mappe 2, 1942, RA/RAFA-2188/2/H/Hf/Hfc/0068; Mütterheim Stalheim der Gruppe Lebensborn mappe 3, 1942, RA/RAFA-2188/2/H/Hf/Hfc/0069; Mütterheim Godthaab der Gruppe Lebensborn mappe 4, 1942, RA/RAFA-2188/2/H/Hf/Hfc/0070; Mütterheim Klekken der Gruppe Lebensborn, mappe 5, 1942, RA/RAFA-2188/2/H/Hf/Hfc/0071; all in Organisation Todt Collection, Einsatzgruppe Wiking, OT Hochbau, Riksarkivet, Oslo.

98. Olsen, "Under the Care of Lebensborn," 24.

99. Kjersti Ericsson, "Love and War: Norwegian Women in Consensual Sexual Relationships with German Soldiers," in *Women in War*, 154–55; Olsen, "Under the Care of Lebensborn," 26–27; Richard Bessel, *Germany 1945: From War to Peace* (London: Pocket, 2008), 352ff.

100. Olsen, "Under the Care of Lebensborn," 24; Lars Borgersrud, "Meant to Be Deported," in *Children of World War II*, 74; Kjersti Ericsson and Dag Ellingsen, "Life Stories of Norwegian War Children," in *Children of World War II*, 94.

101. Olsen, "Under the Care of Lebensborn," 28.

102. Ibid., 30.

103. Henrik O. Lunde, *Finland's War of Choice: The Troubled German-Finnish Coalition in World War II* (Philadelphia: Casemate, 2011), 369.

Chapter Three: Islands of Germanness

1. "Norwegen erhält Soldatenheime: Der Führer stiftet eine Million Reichsmark," *Deutsche Zeitung in Norwegen*, February 4, 1941. It is not clear whether Goebbels himself spoke on the radio or whether his appeal was read by an announcer. For the full text of the appeal, see "Soldatenheime in Norwegen: Ein Spendenaufruf von Reichsminister Dr. Goebbels," *Frankfurter Zeitung*, February 4, 1941.

2. Hans-Jörg Koch, *Wunschkonzert: Unterhaltungsmusik und Propaganda im Rundfunk des Dritten Reichs* (Graz: Ares, 2006), 109ff.; Peter Fritzsche, *Life and Death in the Third Reich* (Cambridge, MA: Harvard University Press, 2008), 70–71.

3. Hans Otto Frøland, Mats Ingulstad, and Jonas Scherner, "Perfecting the Art of Stealing: Nazi Exploitation and Industrial Collaboration in Occupied Western Europe," in *Industrial Collaboration in Nazi-Occupied Europe: Norway in Context*, ed. Hans Otto Frøland, Mats Ingulstad, and Jonas Scherner (London: Palgrave Macmillan, 2016), 24; Hans Otto Frøland, "Nazi Germany's Financial Exploitation of Norway during the Occupation, 1940–45," in *Economies under Occupation: The Hegemony of Nazi Germany and Imperial Japan in World War II*, ed. Marcel Boldorf and Tetsuji Okazaki (Abingdon, Oxon: Routledge, 2015), 131.

4. Einar Richter Hansen, *From War to Peace: The Second World War at Nordkapp* (Honningsvåg: Nordkapplitteratur, 1994), 5.

5. Hunt, *Fire and Ice*, 141–42.

6. See, for example, Hlg., "Soldatenheime in Norwegen," *Die Post* (Munich),

May 5, 1941; and Bruno Roemisch, "Truppenbetreuung in Norwegen," *National Zeitung* [Essen], October 16, 1942. See also Ebba D. Drolshagen, *Der freundliche Feind: Wehrmachtssoldaten im besetzten Europa* (Munich: Droemer, 2009), 88ff.

7. Leora N. Rosen, Kathryn H. Knudson, and Peggy Fancher, "Prevalence of Seasonal Affective Disorder among U.S. Army Soldiers in Alaska," *Military Medicine* 167, no. 7 (2002): 581–84.

8. Hansen, *From War to Peace*, 5; "German Suicides Continue," *News of Norway* 1, no. 34 (1941): 4; "German Morale Reported Collapsing in Northern Norway," *News of Norway* 3, no. 36 (1943): 141–42.

9. Heinrich Rodemer, "Kleines Haus in Hammerfest: Im nördlischsten Soldatenheim der Welt," *Deutsche Zeitung in Norwegen*, November 28, 1942. The soldiers' home in Hammerfest was not among those purposely built, but was established in an existing house.

10. Th. Hesselberg and B. J. Birkeland, "The Continuation of the Secular Variations of the Climate of Norway 1940–1950," *Geofysiske Publikasjoner* 15, no. 5 (1956): 14.

11. Dorothee Schmitz-Köster, *Der Krieg meines Vaters: Als deutscher Soldat in Norwegen* (Berlin: Aufbau, 2004), 146.

12. Knobel to Dr. Klein, file memo, February 1, 1943, Organisation Todt Collection, Oberbauleitungen, OBL-Drontheim/Mittelnorwegen, Korrespondanse og regninger, Abteilung Hochbau folder, RA/RAFA-2188/2/F/Fa/Faa/L0138/0002, Riksarkivet, Oslo.

13. Dr. Lingg to Georg Amend, 14 May 1943; and Olbricht, copy of an order from the Oberkommando des Heeres, June 21, 1940; both in Arbeitsgemeinschaft für Soldatenheime folder, Hauptamt IX—Versicherungs- und Sozialamt, NS 1/390, Bundesarchiv Berlin.

14. Dr. Lingg to Georg Amend, 14 May 1943, Arbeitsgemeinschaft für Soldatenheime folder, Hauptamt

IX—Versicherungs- und Sozialamt, NS 1/390, Bundesarchiv Berlin.

15. Olbricht to the Befehlshaber der Deutschen Truppen in Dänemark, 21 June 1940, RW 38/73, Bundesarchiv-Militärarchiv Freiburg.

16. Dr. Lingg to Georg Amend, 14 May 1943; and Olbricht, copy of an order from the Oberkommando des Heeres, June 21, 1940; both in Arbeitsgemeinschaft für Soldatenheime folder, Hauptamt IX—Versicherungs- und Sozialamt, NS 1/390, Bundesarchiv Berlin; and "Soldatenheime in den besetzten Gebieten," draft, copy dated September 27, 1941, Organisation Todt Collection, Hochbau—Soldatenheimbau, Korrespondanse, notater og tegninger, mappe 1/3, 1940–1943, RA/RAFA-2188/2/H/Hf/Hfd/0062, Riksarkivet, Oslo.

17. Baranowski, *Strength through Joy*, 203ff.

18. Edgar Haller (b. 11 September 1901), Parteistatistische Erhebung 1939, July 6, 1939, R 9361/I/1109, Bundesarchiv Berlin. Haller's role in the soldiers' home program needs further investigation. In a 1942 letter to Terboven, Haller identified himself as the initiator of the "Soldatenheimaktion," but did not specify further. (See Haller to Reichskommissar, 27 July 1942, Organisation Todt Collection, Hochbau—Soldatenheimbau, mappe 2/18, RA/RAFA-2188/2/H/Hf/Hfd/0023, Riksarkivet, Oslo.) In 1965, Haller wrote an account of the genesis of soldiers' homes in Norway that elevated his role and recast it as one of "positive resistance" to the regime, while downplaying the early involvement of Nazi leaders, a narrative contradicted by contemporary records. See the following folder of correspondence (which also contains drawings, photographs, and other materials pertaining to the soldiers' homes): Schriftwechsel mit Herrn Edgardus Haller, 2085 Quickborn, über Briefstempel der früheren Wehrmacht, RH 20/20 310, Bundesarchiv-Militärarchiv Freiburg.

19. Fritz Jordan to Mewes, 10 November 1941, Organisation Todt Collection, Hochbau—Soldatenheimbau, Kontrakter, regninger etc. norske firmaer, mappe 2/2, 1941–1945, RA/RAFA-2188/2/H/Hf/Hfd/0066, Riksarkivet, Oslo. For an example of an early contract, see the contract for the Banak soldiers' home, Organisation Todt Collection, Hochbau—Soldatenheimbau, Korrespondanse, mappe 2/9, 1941–1944, RA/RAFA-2188/2/H/Hf/Hfd/0005, Riksarkivet, Oslo.

20. The homes were for Kirkenes (two homes: Kirkenes I and Kirkenes II), Narvik, Banak, Åndalsnes, Vadsø, and Nesseby. See Edgar Luther, Soldatenheim memo, December 4, 1940, Organisation Todt Collection, Hochbau—Soldatenheimbau, Intern korrespondanse, mappe 2/9, 1941–1944, RA/RAFA-2188/2/H/Hf/Hfd/0014, Riksarkivet, Oslo.

21. Edgar Haller to the Reichskommissariat, Department of Public Enlightenment and Propaganda, 16 February 1942, appendix, Organisation Todt Collection, Hochbau—Soldatenheimbau, Korrespondanse, notater og tegninger, mappe 1/3, 1940–1943, RA/RAFA-2188/2/H/Hf/Hfd/0062, Riksarkivet, Oslo.

22. Henne, memo to Albert Speer, Bau der Soldatenheime, March 19, 1942, Organisation Todt Collection, Hochbau—Soldatenheimbau, Korrespondanse—mye personalsaker, RA/RAFA-2188/2/H/Hf/Hfd/0060, Riksarkivet, Oslo. Henne's memo describes the Labor Front's pledge as a birthday gift to Hitler, but does not specify the date it was made. However, it makes clear that it preceded Hitler's own donation of one million Reichsmarks.

23. Bruno Roemisch, "Größtes Bauvorhaben in Norwegens Geschichte: Die Schaffung der deutschen Soldatenheime," *Krakauer Zeitung*, February 11, 1941.

24. According to surviving

Organisation Todt documents, purpose-built soldiers' homes were erected in Åndalsnes, Banak, Bogenbukt (Bogen in Ofotfjord), Husøen, Hysnes, Kirkenes I, Kirkenes II, Kjevik, Kristiansand, Kristiansund, Lista, Lofjord (Åsen), Løkhaug, Mo i Rana, Ørlandet, Narvik, Nesseby, Stavern, Vadsø, and Værnes. A map of Norway pinpointing the location of soldiers' homes, in Haller's possession in 1965, indicates twenty-six such sites (see Edgardus Haller to Bundesminister der Verteidigung in Bonn, 29 April 1965, in Schriftwechsel mit Herrn Edgardus Haller, 2085 Quickborn, über Briefstempel der früheren Wehrmacht, RH 20/20 310, Bundesarchiv-Militärarchiv Freiburg). Further research is needed to confirm the exact number and locations of purpose-built soldiers' homes. For (incomplete) lists of soldiers' homes in Norway, both refitted and purpose-built, see Organisation Todt Collection, Hochbau—Soldatenheimbau, Fire løse ark—oversikt over "Soldatenheimen," mappe 1/18, RA/RAFA-2188/2/H/Hf/Hfd/0022, Riksarkivet, Oslo.

25. Dr. Lingg to Georg Amend, 14 May 1943, Arbeitsgemeinschaft für Soldatenheime folder, Hauptamt IX—Versicherungs- und Sozialamt, NS 1/390, Bundesarchiv Berlin; Grebe (Abteilung Propaganda) to die Hauptabteilung Verwaltung, 13 March 1942, Organisation Todt Collection, Hochbau—Soldatenheimbau, Intern korrespondanse, folder 2/9, 1941–1944, RA/RAFA-2188/2/H/Hf/Hfd/0014, Riksarkivet, Oslo.

26. Der Oberfehlshaber des Heeres, Der Chef der Militärverwaltung in Frankreich, memo about soldiers' homes in France, September 29, 1940, RM 45/IV 863, Bundesarchiv-Militärarchiv Freiburg.

27. F. M., "Häuser der Kameradschaft: Vorbildliche Soldatenheime als Geschenk der Heimat," *Deutsche Zeitung in Norwegen*, February 4, 1941.

28. Concerns about control of the homes (in both their creation and their management) are clearly expressed in a series of complaints filed against Haller by the Wehrmacht's Chefintendant. See Edgar Haller to the Reichskommissariat, Department of Public Enlightenment and Propaganda, 16 February 1942, Organisation Todt Collection, Hochbau—Soldatenheimbau, Korrespondanse, notater og tegninger, mappe 1/3, 1940–1943, RA/RAFA-2188/2/H/Hf/Hfd/0062, Riksarkivet, Oslo.

29. Klein to Terboven, memo, Bau von Soldatenheimen, December 13, 1940, Organisation Todt Collection, Abteilung Technik und Verkehr, Dr. Klein, mappe 5, 1940–1941, RA/RAFA-2188/2/H/He/0021, Riksarkivet, Oslo.

30. Otte to Hauptabteilung Presse und Propaganda, 16 December 1940, Organisation Todt Collection, Hochbau—Soldatenheimbau, Korrespondanse, notater og tegninger, mappe 1/3, RA/RAFA-2188/2/H/Hf/Hfd/0062, Riksarkivet, Oslo.

31. Dr. Conti to Staatssekretär Gutterer, 30 July 1941, NS 18/1018, Bundesarchiv Berlin.

32. "Permanent Centers for Nazis in Norway," *Christian Science Monitor*, February 3, 1941. My emphasis.

33. Mewes to Haller, memo, Zusammenstellung für einen Lagebericht der Soldatenheim-Bauarbeiten vom 1. Oktober 1941, October 8, 1941, Organisation Todt Collection, Hochbau—Soldatenheimbau, Korrespondanse, mappe 4/9, 1941–1944, RA/RAFA-2188/2/H/Hf/Hfd/0007, Riksarkivet, Oslo.

34. Hlg., "Soldatenheime in Norwegen"; F. M., "Häuser der Kameradschaft"; Roemisch, "Größtes Bauvorhaben in Norwegens Geschichte"; Mewes to Architect Stephanowitz, memo, Baubeschreibung und Typenbezeichnungen, June 11, 1941, Organisation Todt Collection, Hochbau—Soldatenheimbau, Korrespondanse, mappe 6/9, 1941–1944,

RA/RAFA-2188/2/H/Hf/Hfd/0009, Riksarkivet, Oslo; Edgar Haller to the Reichskommissariat, Department of Public Enlightenment and Propaganda, 16 February 1942, appendix, Organisation Todt Collection, Hochbau—Soldatenheimbau, Korrespondanse, notater og tegninger, mappe 1/3, 1940–1943, RA/RAFA-2188/2/H/Hf/Hfd/0062, Riksarkivet, Oslo.

35. Roemisch, "Größtes Bauvorhaben in Norwegens Geschichte."

36. F. M., "Häuser der Kameradschaft."

37. Ibid.

38. Albert Speer to Josef Terboven, 17 April 1941, R 4606/469, Bundesarchiv Berlin. Even before writing to Terboven, Speer had ordered the Arbeitsgebiet "Soldatenheime" to consult with Edgar Luther, as his "representative" in the Reichskommissariat Technik und Verkehr office, on the location and design of the soldiers' homes. See Mewes to Edgar Luther, 3 April 1941, Organisation Todt Collection, Hochbau—Soldatenheimbau, Intern korrespondanse, mappe 2/9, 1941–1944, RA/RAFA-2188/2/H/Hf/Hfd/0014, Riksarkivet, Oslo.

39. Contract for Narvik soldiers' home, no date (c. fall 1940), Organisation Todt Collection, Der Generalbevollmächtigte für die Regelung der Bauwirtschaft: Baustoffbewirtschaftung in Norw., Arbeitsgemeinschaft für Soldatenheime folder, RA/RAFA-2188/2/H/Ha/Haa/L0021, Riksarkivet, Oslo; Mewes, Neue Standortliste der Soldatenheime nach Mitteilung des Chefintendanten b. Oberbefehlshaber vom 29.5.1941, May 29, 1941, Organisation Todt Collection, Hochbau—Soldatenheimbau, Intern korrespondanse, mappe 2/9, 1941–1944, RA/RAFA-2188/2/H/Hf/Hfd/0014, Riksarkivet, Oslo.

40. Hans Stephan, memo, Wiederaufbau Norwegens: Besprechung mit Luther, Speer, Stephan, April 15, 1941, Generalbauinspektor für die Reichshauptstadt,

Trondheim—Stadtplanung, 1941–1942, R 4606/4007, p. 90, Bundesarchiv Berlin.

41. See chapter 4.

42. Ibid.

43. Fritz Jordan to Mewes, 10 November 1941, Organisation Todt Collection, Hochbau—Soldatenheimbau, Kontrakter, regninger etc. norske firmaer, mappe 2/2, 1941–1945, RA/RAFA-2188/2/H/Hf/Hfd/0066, Riksarkivet, Oslo.

44. See, for example, the October 3, 1940, contract for the Åndalsnes soldiers' home in the Organisation Todt Collection, Der Generalbevollmächtigte für die Regelung der Bauwirtschaft: Baustoffbewirtschaftung in Norw., Arbeitsgemeinschaft für Soldatenheime folder, RA/RAFA-2188/2/H/Ha/Haa/L0021, Riksarkivet, Oslo. Haller was later asked by the Labor Front to remove his name from such references for legal reasons, since he was not a licensed architect. Kornowsky to Mewes, 26 May 1941, Organisation Todt Collection, Hochbau—Soldatenheimbau, Korrespondanse, mappe 2/9, RA/RAFA-2188/2/H/Hf/Hfd/0005, Riksarkivet, Oslo.

45. Fritz Jordan to Mewes, 10 November 1941, Organisation Todt Collection, Hochbau—Soldatenheimbau, Kontrakter, regninger etc. norske firmaer, mappe 2/2, 1941–1945, RA/RAFA-2188/2/H/Hf/Hfd/0066, Riksarkivet, Oslo.

46. Jens Christian Eldal, "Fritz Jordan," Norsk kunstnerleksikon, vol. 2 (Oslo: Universitetsforlaget, 1983), 432.

47. F. M., "Häuser der Kameradschaft"; Roemisch, "Größtes Bauvorhaben in Norwegens Geschichte."

48. See, for example, "Soldatenheimbau geht weiter," Deutsche Zeitung in Norwegen, March 27, 1942.

49. Mewes to Haller, memo, Soldatenheime nach Entwürfen von Architekt Jordan, July 27, 1941, Organisation Todt Collection, Hochbau—Soldatenheimbau, Korrespondanse—mye personalsaker, 1941–1942, RA/RAFA-2188/2/H/Hf/Hfd/0057, Riksarkivet, Oslo.

50. Moessel to Haller, 5 June 1941 (copy 26 September 1941), Organisation Todt Collection, Hochbau—Soldatenheimbau, Korrespondanse, mappe 1/9, 1941–1944, RA/RAFA-2188/2/H/Hf/Hfd/0004, Riksarkivet, Oslo.

51. Mewes to Mössel, 2 April 1941, Organisation Todt Collection, Hochbau—Soldatenheimbau, Korrespondanse, mappe 1/9, 1941–1944, RA/RAFA-2188/2/H/Hf/Hfd/0004, Riksarkivet, Oslo.

52. Luther presented sketches for modular soldiers' homes to Speer at their April 15, 1941, meeting, after which Speer wrote to Terboven strongly advocating for this new concept (Albert Speer to Josef Terboven, 17 April 1941, R 4606/469, Bundesarchiv Berlin). The authorship of these sketches is unclear. Site plans for the Namsos (undated) and Mosjøen (August 3, 1941) soldiers' homes by the architects H. Leonhardt and R. Deimling-Ostrinsky (Hamburg) appear to be based on this modular conception: see Soldatenheim Namsos Lageplan and Soldatenheim Mosjoen Lageplan, both Organisation Todt Collection, Hochbau—Soldatenheimbau, Diverse kart, tegninger og foto, RA/RAFA-2188/2/H/Hf/Hfd/0081, Riksarkivet, Oslo.

53. Mewes to Kornowsky, 25 November 1941, Organisation Todt Collection, Hochbau—Soldatenheimbau, Intern korrespondanse, mappe 1/9, 1941–1944, RA/RAFA-2188/2/H/Hf/Hfd/0013, Riksarkivet, Oslo. For an overview of the soldiers' homes' early construction history, see Mewes's memo to Haller cited in note 33.

54. Mewes to Haller, memo, Soldatenheime nach Entwürfen von Architekt Jordan, July 27, 1941, Organisation Todt Collection, Hochbau—Soldatenheimbau, Korrespondanse—mye personalsaker, 1941–1942, RA/RAFA-2188/2/H/Hf/Hfd/0057, Riksarkivet, Oslo.

55. Steinwarz, Zusammenarbeit Dienststelle des Leiters des Arbeitsgebietes für Soldatenheime und Abteilung Technik und Verkehr beim Reichskommissar, April 29, 1941, Organisation Todt Collection, Hochbau—Soldatenheimbau, Intern korrespondanse, mappe 2/9, 1941–1944, RA/RAFA-2188/2/H/Hf/Hfd/0014, Riksarkivet, Oslo.

56. When Jordan applied for a position as an architect with the Soldiers' Homes Area of Operation in the Labor Front, which succeeded the Working Group for Soldiers' Homes originally established by Haller, he was turned down. Mewes to Jordan, 27 November 1941, Organisation Todt Collection, Hochbau—Soldatenheimbau, Kontrakter, regninger etc. norske firmaer, mappe 2/2, 1941–1945, RA/RAFA-2188/2/H/Hf/Hfd/0066, Riksarkivet, Oslo.

57. Hlg., "Soldatenheime in Norwegen." The accuracy of that figure is supported by a letter from Dr. Conti dated July 1941, in which he implied that the total amount raised was over 8 million Reichsmarks, including 1.5 million Reichsmarks from the Labor Front. Conti to Staatssekretär Gutterer, 30 July 1941, NS 18/1018, Bundesarchiv Berlin.

58. Mewes, draft, Allgemeiner Lagebericht über die Soldatenheimbauten in Norwegen vom 22. Juli 1941, July 22, 1941, Organisation Todt Collection, Hochbau—Soldatenheimbau, Intern korrespondanse, mappe 2/9, 1941–1944, RA/RAFA-2188/2/H/Hf/Hfd/0014, Riksarkivet, Oslo. This document includes a list of soldiers' homes built, under construction, or planned as of May 29, 1941.

59. Neyer to Admiral Norwegen, 5 August 1941, Organisation Todt Collection, Einsatz Mittelnorwegen/OBL Drontheim, Soldatenheim Lofjord, RA/RAFA-2188/1/G/G3/G3c/L0006/0004, Riksarkivet, Oslo; Rud. Kasper to Stemmer, 14 August 1941, Organisation Todt Collection, Hochbau—Soldatenheimbau,

Korrespondanse, mappe 1/9, 1941–1944, RA/RAFA-2188/2/H/Hf/Hfd/0004, Riksarkivet, Oslo.

60. Mewes, draft, Allgemeiner Lagebericht über die Soldatenheimbauten in Norwegen vom 22. Juli 1941, July 22, 1941, Organisation Todt Collection, Hochbau—Soldatenheimbau, Intern korrespondanse, mappe 2/9, 1941–1944, RA/RAFA-2188/2/H/Hf/Hfd/0014; Mewes to Haller, memo, Zusammenstellung für einen Lagebericht der Soldatenheim-Bauarbeiten vom 1. Oktober 1941, October 8, 1941, Organisation Todt Collection, Hochbau—Soldatenheimbau, Korrespondanse, mappe 4/9, 1941–1944, RA/RAFA-2188/2/H/Hf/Hfd/0007; and Mewes, report, Bericht über den Stand der Bauarbeiten für die Soldatenheime in Norwegen vom 20. August 1941, August 20, 1941, Organisation Todt Collection, Oberbauleitungen, OBL-Drontheim/Mittelnorwegen: Korrespondanse og regninger, Korrespondanse angående soldatheim, folder 1941–1943, RA/RAFA-2188/2/F/Fa/Fac/L0033/0002; all in Riksarkivet, Oslo.

61. These were Kirkenes I, Kristiansand, Narvik, and Stavern. Edgar Luther to Pauk, 4 September 1941, Organisation Todt Collection, Hochbau—Soldatenheimbau, Intern korrespondanse, mappe 2/9, 1941–1944, RA/RAFA-2188/2/H/Hf/Hfd/0014, Riksarkivet, Oslo.

62. Mewes, report, Bericht über den Stand der Bauarbeiten für die Soldatenheime in Norwegen vom 20. August 1941, August 20, 1941, Organisation Todt Collection, Oberbauleitungen, OBL-Drontheim/Mittelnorwegen: Korrespondanse og regninger, Korrespondanse angående soldatheim, folder 1941–1943, RA/RAFA-2188/2/F/Fa/Fac/L0033/0002, Riksarkivet, Oslo.

63. Mewes to Spehr, 29 September 1941, Organisation Todt Collection, Hochbau—Soldatenheimbau, Korrespondanse, mappe 6/9, 1941–1944, RA/

RAFA-2188/2/H/Hf/Hfd/0009, Riksarkivet, Oslo.

64. Hilse and Voss to Leiter des Arbeitsgebietes Soldatenheime, Abtlg. Baudurchführung [Mewes], 23 July 1941, Organisation Todt Collection, Hochbau—Soldatenheimbau, Korrespondanse, mappe 4/9, 1941–1944, RA/RAFA-2188/2/H/Hf/Hfd/0007, Riksarkivet, Oslo; Mewes to Kornowsky, 7 October 1941, Organisation Todt Collection, Hochbau—Soldatenheimbau, Intern korrespondanse, mappe 1/9, 1941–1944, RA/RAFA-2188/2/H/Hf/Hfd/0013, Riksarkivet, Oslo; Mewes, memorandum draft, Entwurf: Niederschrift über die am 14. Juni 1941 stattgefundene Besprechung zwischen Vertretern der Abteilungen "Arbeit und Sozialwesen" und "Technik" des Reichskommissars für die besetzten norwegischen Gebiete zur Regelung der Soldatenheimbauten in Norwegen, June 19, 1941, Organisation Todt Collection, Hochbau—Soldatenheimbau, Intern korrespondanse, mappe 2/9, 1941–1944, RA/RAFA-2188/2/H/Hf/Hfd/0014, Riksarkivet, Oslo.

65. Edgar Luther to Reichskommissar, memo, April 24, 1942, Organisation Todt Collection, Hochbau—Soldatenheimbau, Korrespondanse—mye personalsaker, 1941–1942, RA/RAFA-2188/2/H/Hf/Hfd/0057, Riksarkivet, Oslo; Mewes to Paul Spehr, 8 December 1941, Organisation Todt Collection, Hochbau—Soldatenheimbau, Korrespondanse, mappe 4/9, 1941–1944, RA/RAFA-2188/2/H/Hf/Hfd/0007, Riksarkivet, Oslo.

66. Chefintendant für den Wehrmachtbefehlshaber to Reichkommissar für die besetzten norwegischen Gebiete, Hauptabteilung Volkswirtschaft, Abteilung Technik, Abteilung Propaganda, 13 January 1942, Organisation Todt Collection, Hochbau—Soldatenheimbau, Intern korrespondanse, mappe 1/9, 1941–1944, RA/RAFA-2188/2/H/Hf/

Hfd/0013, Riksarkivet, Oslo. For Edgar Haller's response to this charge, see Edgar Haller to the Reichskommissariat, Department of Public Enlightenment and Propaganda, 16 February 1942, appendix, Organisation Todt Collection, Hochbau—Soldatenheimbau, Korrespondanse, notater og tegninger, mappe 1/3, 1940–1943, RA/RAFA-2188/2/H/Hf/Hfd/0062, Riksarkivet, Oslo.

67. Paul Spehr to Molkenthin, 23 February 1942, Organisation Todt Collection, Hochbau—Soldatenheimbau, Korrespondanse, mappe 4/9, 1941–1944, RA/RAFA-2188/2/H/Hf/Hfd/0007, Riksarkivet, Oslo.

68. Speith, Abschrift aus dem Bautagebuch "Abschnittsbauleitung Kirkenes" vom 26.7–1.8.41, August 1, 1941, Organisation Todt Collection, Hochbau—Soldatenheimbau, Intern korrespondanse, mappe 2/9, 1941–1944, RA/RAFA-2188/2/H/Hf/Hfd/0014, Riksarkivet, Oslo.

69. "Det første tyske soldathjem," *Dagbladet*, April 7, 1941; "Das erste Soldatenheim in Norwegen: Ein Treffpunkt für die Reichsdeutschen," *Frankfurter Zeitung*, April 15, 1941.

70. "Deutsches Soldatenheim in Andalsnes," *Gothaisches Tageblatt*, April 8, 1941.

71. "Første tyske soldathjem."

72. "Das erste Soldatenheim in Norwegen." In more remote locations, the homes were expected to become centers for German socializing. See Hlg., "Soldatenheime in Norwegen."

73. Eldal, "Fritz Jordan." A drawing and model for the Narvik's soldiers' home were published in Hlg., "Soldatenheime in Norwegen." See fig. 3.8.

74. Mewes to Haller, memo, Soldatenheime nach Entwürfen von Architekt Jordan, July 27, 1941, Organisation Todt Collection, Hochbau—Soldatenheimbau, Korrespondanse—mye personalsaker, 1941–1942, RA/RAFA-2188/2/H/Hf/Hfd/0057, Riksarkivet, Oslo. On the

ideological implications of the flat roof, see Richard Pommer, "The Flat Roof: A Modernist Controversy in Germany," *Art Journal* 43, no. 2 (1983): 158–69.

75. Hlg., "Soldatenheime in Norwegen." See also the similar text in Roemisch, "Größtes Bauvorhaben in Norwegens Geschichte." On the relationship of German nationalism and domesticity, see Nancy R. Reagin, *Sweeping the German Nation: Domesticity and National Identity in Germany, 1870–1945* (New York: Cambridge University Press, 2007).

76. Hlg., "Soldatenheime in Norwegen."

77. "Bindeglied zwischen Heimat und Front," *Deutsche Zeitung in Norwegen*, May 25, 1943.

78. Roemisch, "Größtes Bauvorhaben in Norwegens Geschichte." On the women's presence as an element in the soldiers' home creation of "a piece of homeland," see also "Soldatenheimbau geht weiter."

79. "Bestimmungen über Soldaten-Heime," undated (after July 1, 1942), Soldatenheim Porsgrunn, Heer: Ortskommandantur, 1942–1945, RA/RAFA-5826/G/L0015/0001, Riksarkivet, Oslo; Erna Linhardt-Röpke, Rundschreiben FW 88/41, August 7, 1941, NS 44/37, Bundesarchiv Berlin. Norwegian women were sometimes hired for certain jobs in the soldiers' homes, such as in the kitchen. See "Ein Zuhause in der Ferne: Leben in einem Soldatenheime in Norwegen," *Arbeitertum* (Berlin), July 2, 1942.

80. W. D. Libbert, "Eine Insel der Heimat im fremden Land: Zwei Jahre Soldatenheim der Generaloberst-von-Falkenhorst-Kaserne," *Deutsche Zeitung in Norwegen*, July 31, 1943; Rodemer, "Kleines Haus in Hammerfest."

81. Mewes, file memo for Haller, April 30, 1941, Organisation Todt Collection, Hochbau—Soldatenheimbau, Korrespondanse, mappe 4/9, 1941–1944, RA/RAFA-2188/2/H/Hf/Hfd/0007, Riksarkivet, Oslo. Concerns about morality

also appear to underlie restrictions placed on the use of soldiers' homes by German women serving in Norway in the armed forces auxiliaries. For a period of time, women auxiliaries were limited to using the soldiers' homes only during specific hours. Even after this restriction was lifted in September 1943, they were expected to eat in a separate small room beside the restaurant pub, which soldiers were forbidden to enter. Women auxiliaries also had to receive permission from the female administrator of the home before using the recreation and activities rooms. Kriegsmarinearsenal Drontheim, Arsenalbefehl Nr. 40, September 14, 1943, Werftbefehle folder for 1943, Kriegsmarine Norwegen, Kriegsmarinewerft/Kriegsmarinearsenal Drontheim, RA/RAFA-5074/D/Db/L0001, Riksarkivet, Oslo.

82. Petsch (Territorialabschnittsbefehlshaber Arendal), memo, Bewirtung in Soldatenheimen, July 30, 1943, Soldatenheim Porsgrunn, Heer: Ortskommandantur, 1942–1945, RA/RAFA-5826/G/L0015/0001, Riksarkivet, Oslo.

83. Generaloberst von Falkenhorst, order issued March 7, 1941, reissued by Territorialabschnittsbefehlshaber Arendal on August 23, 1943, Soldatenheim Porsgrunn, Heer: Ortskommandantur, 1942–1945, RA/RAFA-5826/G/L0015/0001, Riksarkivet, Oslo. The fact that Petsch reiterated the order suggests that Norwegian women were again being invited by soldiers to the soldiers' homes.

84. "Bestimmungen über Soldaten-Heime," undated (after July 1, 1942), Soldatenheim Porsgrunn, Heer: Ortskommandantur, 1942–1945, RA/RAFA-5826/G/L0015/0001, Riksarkivet, Oslo. On the Nazi cultivation of an "unter uns" sensibility among German radio audiences, see Fritzsche, Life and Death in the Third Reich, 65ff.

85. Vejas Gabriel Liulevicius, War Land on the Eastern Front: Culture, National Identity and German Occupation in World War I (Cambridge: Cambridge University Press, 2000), 133–36.

86. In delaying the handing over of the home until it was decoration-ready, Haller also evoked the desires of the patron, Alfred Meyer, the Gauleiter of Westfalen-Nord. The Gau Westfalen-Nord financially sponsored the Kirkenes I soldiers' home. Haller to Armeeoberkommando Lappland, 8 July 1942; Haller to Chefintendanten beim Wehrmachtbefehlshaber in Norwegen, 8 July 1942, both in Organisation Todt Collection, Hochbau—Soldatenheimbau, Intern korrespondanse, mappe 2/9, 1941–1944, RA/RAFA-2188/2/H/Hf/Hfd/0014, Riksarkivet, Oslo.

87. Hlg., "Soldatenheime in Norwegen."

88. "Das größte Soldatenheim in Norwegen," National-Zeitung (Essen), March 24, 1942. The article states that the number of intended users was "about 1,300," but Organisation Todt records consistently put the number at 1,200.

89. kn, "Et stykke Tyskland i Norge," Fritt Folk, March 16, 1942; "Innvielse av det tyske soldaterhjem i Kristiansand," Aftenposten, March 16, 1942.

90. "Neues deutsches Soldatenheim in Kristiansand," Deutsche Zeitung in Norwegen, March 17, 1942; S—el., "Soldatenheim Kristiansand," Deutsche Zeitung in Norwegen, March 17, 1942; "Das größte Soldatenheim in Norwegen"; H. S., "Ein Stück Heimat: Das Neue Soldatenheim in Kristiansand," Wacht im Norden, March 21, 1942. On the rationale for the bowling alley, see Der Standortälteste Kristiansand-Süd to Admiral Norwegen, letter no. 1062, 12 July 1941, Organisation Todt Collection, Hochbau—Soldatenheimbau, Korrespondanse, mappe 6/9, 1941–1944, RA/RAFA-2188/2/H/Hf/Hfd/0009, Riksarkivet, Oslo.

91. Der Standortälteste Kristiansand-Süd to Admiral Norwegen, letter no. 1063, 12 July 1941, Organisation Todt

Collection, Hochbau—Soldatenheimbau, Korrespondanse, mappe 6/9, 1941–1944, RA/RAFA-2188/2/H/Hf/Hfd/0009, Riksarkivet, Oslo.

92. Haller to Mewes, memo, December 8, 1941; and Mewes to Haller, memo, December 10, 1941; both in Organisation Todt Collection, Hochbau—Soldatenheimbau, mappe 2/2, 1941–1943, RA/RAFA-2188/2/H/Hf/Hfd/0059; and Edgar Haller to Edgar Luther, 7 March 1942, Organisation Todt Collection, Hochbau—Soldatenheimbau, Korrespondanse, mappe 3/9, 1941–1944, RA/RAFA-2188/2/H/Hf/Hfd/0006; all in Riksarkivet, Oslo.

93. S—el, "Soldatenheim Kristiansand." The article mentions three artists, but it was actually four, one of whom was Reinhold Schön. See Arbeitsgebiet Soldatenheimbau to Reinhold Schön, 25 June 1942, Organisation Todt Collection, Hochbau—Soldatenheimbau, mappe 2/2, 1941–1943, RA/RAFA-2188/2/H/Hf/Hfd/0059, Riksarkivet, Oslo.

94. For details on the artwork, see Erich Martin to Leiter des Arbeitsgebietes Abt. "Soldatenheime," Baudurchführung, 14 January 1942; and Reinhold Schön, 15 January 1942, both in Organisation Todt Collection, Hochbau—Soldatenheimbau, Intern korrespondanse, 1941–1944, mappe 9/9, RA/RAFA-2188/2/H/Hf/Hfd/0048, Riksarkivet, Oslo.

95. S—el., Soldatenheim Kristiansand."

96. "Für die Soldatenheime in Norwegen," General-Anzeiger für Bonn und Umgebung, June 16, 1941.

97. Roemisch, "Truppenbetreuung in Norwegen."

98. sol, "Sinnvolle Freizeitgestalung," Deutsche Zeitung in Norwegen, April 24, 1942.

99. Fw. L. Winners, "Soldat und Kunst," Deutsche Zeitung in Norwegen, November 23, 1942.

100. Libbert, "Insel der Heimat im fremden Land"; F. M., "Häuser der Kameradschaft"; Roemisch, "Truppenbetreuung in Norwegen"; and "Deutsches Soldatenheim in Andalsnes." On Narvik, see Luther to Kornowsky, telegram, 19 April 1943; and Fiebelkorn to Fickert, 25 February 1944; both in Organisation Todt Collection, Hochbau—Soldatenheimbau, Korrespondanse, mappe 5/9, 1941–1944, RA/RAFA-2188/2/H/Hf/Hfd/0008, Riksarkivet, Oslo.

101. Hlg., "Soldatenheime in Norwegen."

102. Roemisch, "Größtes Bauvorhaben in Norwegens Geschichte."

103. "Neues Soldatenheim in Narvik," Deutsche Zeitung in Norwegen, August 29, 1942. On the opening of the Narvik soldiers' home, see also Heinrich Rodemer, "Das neue Soldatenheim in Narvik," Wacht im Norden, September 1, 1942.

104. In early 1941, Paula Stuck von Reznicek, a tennis star turned journalist and writer, accompanied her husband, race-car driver Hans Stuck, on a speaking tour for German troops stationed in middle and northern Norway. Her unpublished travel journal, with photographs and hand-drawn illustrations, is preserved in the Bundesarchiv-Militärarchiv Freiburg: Paula Stuck v. Reznicek, Wehrbetreuung: Reise- und Erlebnisberichte, Band 3: Norwegen, N 979/4, Bd. 3: 9. Jan. 1941–9. Februar 1941, Bundesarchiv-Militärarchiv Freiburg.

105. Libbert, "Insel der Heimat im fremden Land"; Sabine Hake, Popular Cinema of the Third Reich (Austin: University of Texas Press, 2001), 157; Antje Ascheid, Culture and the Moving Image: Hitler's Heroines: Stardom and Womanhood in Nazi Cinema (Philadelphia: Temple University Press, 2010), 69–78.

106. Libbert, sitting in the pub, noted how it filled up with soldiers when the film let out, although he did not

eavesdrop on their conversations. Libbert, "Insel der Heimat im fremden Land."

107. Liste über Waren im Lager in Möllergt. 48, Intern korrespondanse, folder 8/9, 1941–1944, Hochbau—Soldatenheimbau, RA/RAFA-2188/2/H/Hf/Hfd/0047, Riksarkivet, Oslo.

108. "Soldatenheime in Norwegen: Ein Spendenaufruf von Reichsminister Dr. Goebbels"; Libbert, "Insel der Heimat im fremden Land"; A. H. Rother, "Soldatenheime in Norwegen," *Deutsche Monatshefte in Norwegen* 3, no. 3 (1942): 23.

109. Libbert, "Insel der Heimat im fremden Land."

110. Chris Bongie quoted in Ralph Crane, "Reading the Club as Colonial Island in E. M. Forster's *A Passage to India* and George Orwell's *Burmese Days*," *Island Studies Journal* 6, no.1 (2011): 19.

111. Crane, "Reading the Club as Colonial Island," 18–19.

112. Collingham quoted in ibid., 18.

113. Crane, "Reading the Club as Colonial Island," 19.

114. Gillian Beer quoted in ibid., 21.

115. Mewes to Mössel, 2 April 1941, Organisation Todt Collection, Hochbau—Soldatenheimbau, Korrespondanse, mappe 1/9, 1941–1944, RA/RAFA-2188/2/H/Hf/Hfd/0004; and Mewes to Luther, 3 April 1941, Organisation Todt Collection, Hochbau—Soldatenheimbau, Intern korrespondanse, mappe 2/9, 1941–1944, RA/RAFA-2188/2/H/Hf/Hfd/0014; both in Riksarkivet, Oslo.

116. Materialbeschaffung in Deutschland, undated, Organisation Todt Collection, Hochbau—Soldatenheimbau, Korrespondanse, mappe 4/9, 1941–1944, RA/RAFA-2188/2/H/Hf/Hfd/0007, Riksarkivet, Oslo.

117. Bisherige Kosten für die Soldatenheime, Stand per 1.11.42, undated list (c. November 1942), Organisation Todt Collection, Hochbau—Soldatenheimbau, Intern korrespondanse, mappe 1/9, 1941–1944, RA/RAFA-2188/2/H/Hf/

Hfd/0013; and Übernahme der bisher entstandenen Baukosten auf das Konto der OT, February 15, 1944, Organisation Todt Collection, Hochbau—Soldatenheimbau, Intern korrespondanse, mappe 2/9, RA/RAFA-2188/2/H/Hf/Hfd/0014; both Riksarkivet, Oslo.

118. "The Quislings Also Adopt a Budget," *News of Norway* 2, no. 10 (March 28, 1942): 2.

119. Hptm. u. Ortskdt. to Dirichs, 19 July 1943, Organisation Todt Collection, Bauleitung Kristiansund (N), Allgemeines, mappe 7/18, 1943, RA/RAFA-2188/H/Hf/Hfd/0028, Riksarkivet, Oslo.

120. Moessel to Steinwarz, 14 May 1941 (copy), Organisation Todt Collection, Hochbau—Soldatenheimbau, Korrespondanse, mappe 1/9, 1941–1944, RA/RAFA-2188/2/H/Hf/Hfd/0004, Riksarkivet, Oslo. On the Beauty of Labor's programs for work and domestic spaces, see Baranowski, *Strength through Joy*, 75–117.

121. Kornowsky to Mewes, 24 September 1941; and Kornowsky to Mewes, 1 October 1941; both in Organisation Todt Collection, Hochbau—Soldatenheimbau, Korrespondanse, mappe 5/9, 1941–1944, RA/RAFA-2188/2/H/Hf/Hfd/0008, Riksarkivet, Oslo.

122. Mewes to Westenacher, 13 October 1941, Organisation Todt Collection, Hochbau—Soldatenheimbau, Korrespondanse, mappe 6/9, 1941–1944, RA/RAFA-2188/2/H/Hf/Hfd/0009, Riksarkivet, Oslo.

123. Mewes to Kornowsky, 27 October 1941, Organisation Todt Collection, Hochbau—Soldatenheimbau, Korrespondanse, mappe 6/9, 1941–1944, RA/RAFA-2188/2/H/Hf/Hfd/0009, Riksarkivet, Oslo.

124. Haller to Mewes, memo, January 8, 1942. On the anticipated troop arrivals from Russia, see also Gabriel to Mewes, memo, October 16, 1941. Both documents in Organisation Todt Collection, Hochbau—Soldatenheimbau,

Korrespondanse, mappe 4/9, 1941–1944, RA/RAFA-2188/2/H/Hf/Hfd/0007, Riksarkivet, Oslo.

125. "AL" to Mewes, memo about a conversation with Haller on August 23, 1941, August 26, 1941, Organisation Todt Collection, Hochbau—Soldatenheimbau, Korrespondanse, mappe 4/9, 1941–1944, RA/RAFA-2188/2/H/Hf/Hfd/0007, Riksarkivet, Oslo. My emphasis.

126. Mewes, draft, Allgemeiner Lagebericht über die Soldatenheimbauten in Norwegen vom 22. Juli 1941, July 22, 1941, Organisation Todt Collection, Hochbau—Soldatenheimbau, Intern korrespondanse, mappe 2/9, 1941–1944, RA/RAFA-2188/2/H/Hf/Hfd/0014, Riksarkivet, Oslo.

127. Kornowsky to Mewes, 15 January 1942, Organisation Todt Collection, Hochbau—Soldatenheimbau, Korrespondanse, mappe 5/9, 1941–1944, RA/RAFA-2188/2/H/Hf/Hfd/0008, Riksarkivet, Oslo.

128. Mewes to Klein, 26 November 1941, Organisation Todt Collection, Hochbau—Soldatenheimbau, Intern korrespondanse, mappe 1/9, 1941–1944, RA/RAFA-2188/2/H/Hf/Hfd/0013, Riksarkivet, Oslo. This document mentions twenty-five homes put on hold, but since only four were given the green light to proceed at the end of 1941, I have adjusted the figure here.

129. Todt to Falkenhorst, 16 January 1942; Bisherige Kosten für die Soldatenheime, November 1, 1942; both in Hochbau—Soldatenheimbau, Intern korrespondanse, folder 1/9, 1941–1944, RA/RAFA-2188/2/H/Hf/Hfd/0013, Riksarkivet, Oslo. In 1942, the following locations were added to the list of new, purpose-built (that is, not renovated) soldiers' homes under active construction: Banak, Husøen, Hysnes, Kirkenes II, Kjevik, Kristiansund, Lista, Lofjord, Løkhaug, Mo i Rana, Nesseby, Vadsø, and Værnes. Many of these had already begun construction in 1941, but

had been halted in the fall. See Mewes, report, Bericht über den Stand der Bauarbeiten für die Soldatenheime in Norwegen vom 20. August 1941, August 20, 1941, Organisation Todt Collection, Oberbauleitungen, OBL-Drontheim/Mittelnorwegen: Korrespondanse og regninger, Korrespondanse angående soldatheim, folder 1941–1943, RA/RAFA-2188/2/F/Fa/Fac/L0033/0002, Riksarkivet, Oslo. In addition to these new or reactivated homes, construction continued in 1942 on Kirkenes I, Kristiansand, Narvik, and Stavern.

130. Kornowsky to Mewes, 15 January 1942, Organisation Todt Collection, Hochbau—Soldatenheimbau, Korrespondanse, mappe 5/9, 1941–1944, RA/RAFA-2188/2/H/Hf/Hfd/0008, Riksarkivet, Oslo.

131. Todt to Falkenhorst, 16 January 1942, Organisation Todt Collection, Hochbau—Soldatenheimbau, Intern korrespondanse, mappe 1/9, 1941–1944, RA/RAFA-2188/2/H/Hf/Hfd/0013, Riksarkivet, Oslo.

132. Frøland, Ingulstad, and Scherner, "Perfecting the Art of Stealing," 24.

133. Steffens [for Speer] to Arbeitsgemeinschaft Soldatenheime Berlin-Dahlem [Kornowsky], 5 March 1942, Organisation Todt Collection, Hochbau—Soldatenheimbau, Intern korrespondanse, mappe 2/9, 1941–1944, RA/RAFA-2188/2/H/Hf/Hfd/0014, Riksarkivet, Oslo.

134. Haller to Hauptabteilung Technik (Reichskommissar), 15 April 1942, Organisation Todt Collection, Hochbau—Soldatenheimbau, Intern korrespondanse, mappe 2/9, 1941–1944, RA/RAFA-2188/2/H/Hf/Hfd/0014, Riksarkivet, Oslo.

135. Frøland, Ingulstad, and Scherner, "Perfecting the Art of Stealing," 24.

136. Terboven to General Harmjanz, 14 December 1943, Organisation Todt Collection, Hochbau—Soldatenheimbau, Intern korrespondanse, mappe 4/9,

1941–1944, RA/RAFA-2188/2/H/Hf/Hfd/0043; and Wehrmachtbefehlshaber in Norwegen: Der Chefintendent to Arbeitsgebiet Soldatenheime and Hauptabteilung Technik (Reichskommissar), 12 November 1942, Organisation Todt Collection, Hochbau—Soldatenheimbau, Korrespondanse, mappe 8/9, 1941–1944, RA/RAFA-2188/2/H//Hf/Hfd/0011; both Riksarkivet, Oslo.

137. In a previous attempt to improve efficiency and communication in the building of soldiers' homes, Haller and his team had been absorbed into Terboven's Reich Commissariat administration at the end of 1941. The merger, however, was not considered a success. Neyer, file memo, Eingliederung des Arbeitsgebietes Soldatenheime in die Abteilung Technik, December 11, 1941; and Koch, file memo, April 27, 1942; both in Organisation Todt Collection, Hochbau—Soldatenheimbau, Korrespondanse, notater og tegninger, mappe 1/3, 1940–1943, RA/RAFA-2188/2/H/Hf/Hfd/0062, Riksarkivet, Oslo. See also Hauptabteilung für Volksaufklärung und Propaganda, Abteilung Propaganda to Henne, 13 June 1942; and Luther, memo about a conversation between Henne and Haller, August 3, 1942; both in Organisation Todt Collection, Hochbau—Soldatenheimbau, Intern korrespondanse, mappe 6/9, 1941–1944, RA/RAFA-2188/2/H/Hf/Hfd/0018, Riksarkivet, Oslo.

138. Fiebelkorn, memo, October 27, 1944, Organisation Todt Collection, Hochbau—Soldatenheimbau, Kontrakter, regninger etc. norske firmaer, mappe 2/2, 1941–1945, RA/RAFA-2188/2/H/Hf/Hfd/0066, Riksarkivet, Oslo; Edgardus Haller to Bundesminister der Verteidigung in Bonn, 29 April 1965, in Schriftwechsel mit Herrn Edgardus Haller, 2085 Quickborn, über Briefstempel der früheren Wehrmacht, RH 20/20 310, Bundesarchiv-Militärarchiv Freiburg.

139. On the use of POW labor for construction of the soldiers' homes, see Mewes to Haller, memo, September 19, 1941, Organisation Todt Collection, Hochbau—Soldatenheimbau, Korrespondanse, mappe 4/9, 1941–1944, RA/RAFA-2188/2/H/Hf/Hfd/0007; and Schindelbeck to Baurat Schneider, memo, March 17, 1944, Organisation Todt Collection, Oberbauleitungen, OBL-Drontheim/Mittelnorwegen: Korrespondanse og regninger, Schriftwechsel Soldatenheim Ørlandet, folder 1943–1944, RA/RAFA-2188/2/F/Fa/Fac/L0033/0002; both in Riksarkivet, Oslo.

140. Altinger to Lutter, 25 Mai 1943, Organisation Todt Collection, Hochbau—Soldatenheimbau, Bauleitung Kristiansund—Allgemeines, mappe 7/18, 1943, RA/RAFA-2188/2/H/Hf/Hfd/0028, Riksarkivet, Oslo.

141. For a photographic album documenting the Værnes dedication, see Fotoalbum über zwei neue Soldatenheime in Norwegen, 1944–1945, MSG 2/7511, Bundesarchiv-Militärarchiv Freiburg. Unlike the home in Værnes, the one in Mo i Rana was not fully completed at its official opening on August 1, 1944.

142. Schröter, memo for E, Einweihung—Soldatenheim Ørlandet, September 1, 1944, Organisation Todt Collection, Oberbauleitungen, OBL-Drontheim/Mittelnorwegen, Korrespondanse og regninger, Schriftwechsel Soldatenheim Ørlandet, 1943–1944, RA/RAFA-2188/2/F/Fa/Fac/L0033/0002; and Reichskommissariat Bildarchiv, Soldatenheim Ørlandet folder, RA/RAFA-3309/U/L0045b/0008; both in Riksarkivet, Oslo.

143. For interviews with soldiers posted in the Vanager region of Finnmark, see Ruth Weih Sindt, "Alltag für Soldaten? Kriegserinnerungen und soldatischer Alltag in der Varangerregion 1940–44" (PhD diss., University of Kiel, 2005).

144. H(aller) to Reinhold Schön, 25 June 1942, Organisation Todt Collection,

Hochbau—Soldatenheimbau, mappe 2/2, 1941–1943, RA/RAFA-2188/2/H/Hf/Hfd/0059, Riksarkivet, Oslo.

Chapter Four: The Nazification of Norway's Towns

1. Edgar Luther, "Wiederaufbau norwegischer Städte," *Deutsche Monatshefte in Norwegen* 3, no. 5 (1942): 2–8.

2. Ibid., 2; Otto Zausmer, "War Losses: Material Damage Heavy," *Christian Science Monitor*, August 30, 1941; "Norway," in *The Statesman's Year-Book 1942* (London: Macmillan, 1942), 1151.

3. Luther, "Wiederaufbau norwegischer Städte," 2. For an overview of town planning in Norway, see Erik Lorange and Jan Eivind Myhre, "Urban Planning in Norway," in *Planning and Urban Growth in Nordic Countries*, ed. Thomas Hall (London: Chapman and Hall, 1991), 116–66.

4. Hans Stephan, "Die Wiederaufbau norwegischer Städte," *Die Baukunst: Die Kunst im Deutschen Reich* (June 1942): 119; Hans Stephan, "Besprechung bei Reichskommissar Terboven in Oslo, im Storting, am 3.10.1940, 12.30 Uhr," in Wiederaufbau der norwegischen Städte, unpublished report (c. October 1940) for Albert Speer, pp. 37–39, Lars Olof Larsson Collection, Kiel; Albert Speer to Josef Terboven, 21 November 1940, Generalbauinspektor für die Reichshauptstadt, NSDAP-Gauleitungen, 1937–1943, R 4606/469, Bundesarchiv Berlin.

5. Martin Kitchen, *Speer: Hitler's Architect* (New Haven, CT: Yale University Press, 2015): 57; Lars Olof Larsson, *Die Neugestaltung der Reichshauptstadt: Albert Speers Generalbebauungsplan für Berlin* (Stockholm: Almqvist and Wiksell, 1978), 55–64; Thomas Friedrich, *Hitler's Berlin: Abused City*, trans. Stewart Spencer (New Haven, CT: Yale University Press, 2012), 360–72; Lars Olof Larsson, Sabine Larsson, and Ingolf Lamprecht, *"Fröhliche Neugestaltung" oder die Gigantoplanie von Berlin 1937–1943: Albert Speers Generalbebauungsplan im Spiegel satirischer Zeichnungen von Hans Stephan* (Kiel: Ludwig, 2008), 19ff.

6. Larsson, Larsson, and Lamprecht, *"Fröhliche Neugestaltung" oder die Gigantoplanie von Berlin 1937–1943*, 16.

7. Helga Stave Tvinnereim, *Sverre Pedersen: Pioner i Norsk Byplanlegging* (Oslo: Kolofon, 2015), 272–75; Olav Arild Abrahamsen, "The Reconstruction of the Town of Molde: German Impact on Town-Planning during the Occupation," in *Der deutsche Historikerstreit: Stadtgeschichte und Stadtplanung: Bericht über das 3. deutsch-norwegische Historikertreffen in Trondheim, June 1988* (Essen: Stifterverband für deutsche Wissenschaft, 1988), 153.

8. A collection of articles about the BSR reconstruction plans published in the Norwegian press in August and September 1940 is available in Reichskommissariat, Hauptabteilung Volksaufklärung und Propaganda, Abteilung Presse, Avisutklipp. B. Innenpolitik, 1940–1943, 10 B II 1c Norwegen im neuen Europa, RA/RAFA-2174/E/Ed/L0016/0002, Riksarkivet, Oslo.

9. Hans Stephan, "Ergebnis der Prüfung der bisherigen Pläne an Ort und Stelle," and "Besprechung mit norwegischen Architekten, Ingenieuren und Juristen am 3.10.1940, um 15.45 Uhr, im kleinen Sitzungssaal des Storting in Oslo," in Wiederaufbau der norwegischen Städte, unpublished report (c. October 1940) for Albert Speer, pp. 4, 42, Lars Olof Larsson Collection, Kiel.

10. Michael Wildt, *Hitler's Volksgemeinschaft and the Dynamics of Racial Exclusion*, trans. Bernard Heise (New York: Berghahn, 2012), 3.

11. Detlev J. K. Peukert, *Inside Nazi Germany: Conformity, Opposition, and Racism in Everyday Life*, trans. Richard Deveson (New Haven, CT: Yale University Press, 1987), 188.

12. *Hitler, Mein Kampf: Eine kritische Edition*, 1:693–95; Robert R. Taylor, *The Word*

in *Stone: The Role of Architecture in the National Socialist Ideology* (Berkeley: University of California Press, 1974), 40.

13. Hans Stephan, "Beurteilung des norwegischen Architekten Sverre Pedersen," Wiederaufbau der norwegischen Städte, unpublished report (c. October 1940) for Albert Speer, p. 30, Lars Olof Larsson Collection, Kiel. In her biography of Pedersen, Tvinnereim affirms that he was never a politically engaged person. At the same time, she argues that Pedersen's apolitical stance was also a strategy to keep the BSR in Norwegian hands. See Tvinnereim, *Sverre Pedersen*, 259, 284–85.

14. Tvinnereim, *Sverre Pedersen*, 264–65, 292ff., 355–56, 434ff.; Hans Stephan, "Beurteilung des norwegischen Architekten Sverre Pedersen," in Wiederaufbau der norwegischen Städte, unpublished report (c. October 1940) for Albert Speer, p. 30, Lars Olof Larsson Collection, Kiel.

15. Hans Stephan, "Beurteilung des norwegischen Architekten Sverre Pedersen," in Wiederaufbau der norwegischen Städte, unpublished report (c. October 1940) for Albert Speer, p. 31, Lars Olof Larsson Collection, Kiel.

16. Ibid.

17. Speer quoted by Joachim Fest, *Albert Speer: Conversations with Hitler's Architect*, trans. Patrick Camiller (Cambridge: Polity Press, 2007), 76. See also Larsson, Larsson, and Lamprecht, *"Fröhliche Neugestaltung" oder die Gigantoplanie von Berlin, 1937–1943*, 13ff.

18. Hans Stephan, "Beurteilung des norwegischen Architekten Sverre Pedersen," in Wiederaufbau der norwegischen Städte, unpublished report (c. October 1940) for Albert Speer, p. 31, Lars Olof Larsson Collection, Kiel.

19. Specifically, Minsos asked that Heinz Wetzel, an architect and urban design professor at the Technische Hochschule Stuttgart, where Minsos had studied, be named the judge of the architectural competitions for the reconstruction. Fred Minsos to Präsident der Reichskulturkammer, 19 August 1940, Organisation Todt Collection, OT Hochbau, mappe 3—gjenoppbygging av norske byer, 1940–41, RA/RAFA-2188/2/H/Hf/Hfc/0128, Riksarkivet, Oslo.

20. Hans Stephan, "Zusammentreffen mit Architekten Minsos, am Mittwoch dem 2.10.1940, abends," in Wiederaufbau der norwegischen Städte, unpublished report (c. October 1940) for Albert Speer, p. 34, Lars Olof Larsson Collection, Kiel.

21. Ibid., pp. 34–35. In contradiction to Minsos's claim, Pedersen had made an effort to reach out to younger architects in his early work for the BSR. See Tvinnereim, *Sverre Pedersen*, 274.

22. Fred Minsos, "Vurdering av gjenreisningsproblemet," *Fritt Folk*, October 30, 1940.

23. See Tvinnereim, *Sverre Pedersen*, 93ff.

24. Abrahamsen, "Reconstruction of the Town of Molde," 153.

25. Tvinnereim, *Sverre Pedersen*, 36–38, 55–58, 84–88, 134–36. On the role of scenic vistas, see also Sverre Pedersen, "Reguleringen av de krigsskadede steder," *Det nye Norge*, no. 24 (1944?): 74–76, in Sverre Pedersen Private Archive, Ms SP-585A, Special Collections, NTNU University Library, Trondheim.

26. Hans Stephan, "Zusammentreffen mit Architekten Minsos, am Mittwoch dem 2.10.1940, abends," in Wiederaufbau der norwegischen Städte, unpublished report (c. October 1940) for Albert Speer, pp. 35–36, Lars Olof Larsson Collection, Kiel.

27. Hans Stephan, "Besprechung bei Reichskommissar Terboven in Oslo, im Storting, am 3.10.1940, 12.30 Uhr," in Wiederaufbau der norwegischen Städte, unpublished report (c. October 1940) for Albert Speer, pp. 37–39, Lars Olof Larsson Collection, Kiel.

28. Hans Fredrik Dahl, *A History of the*

Norwegian Press, 1660–2015 (Houndmills, Basingstoke, Hampshire: Palgrave Macmillan, 2016), 129.

29. Hans Stephan, "Besprechung bei Reichskommissar Terboven in Oslo, im Storting, am 3.10.1940, 12.30 Uhr," in Wiederaufbau der norwegischen Städte, unpublished report (c. October 1940) for Albert Speer, pp. 38–39, Lars Olof Larsson Collection, Kiel.

30. Hans Stephan, "Besprechung mit norwegischen Architekten, Ingenieuren und Juristen am 3.10.1940, um 15.45 Uhr, im kleinen Sitzungssaal des Storting in Oslo," in Wiederaufbau der norwegischen Städte, unpublished report (c. October 1940) for Albert Speer, p. 42, Lars Olof Larsson Collection, Kiel.

31. Ibid., pp. 42–43. Stephan published many of the ideas expressed in this report in Stephan, "Wiederaufbau norwegischer Städte," 119–26. Pedersen presented this meeting and Stephan's message in a decidedly less political light to Norwegian audiences. See Sverre Pedersen, "Brente Steders Regulering B.S.R.: Noen meddelelser om reguleringsarbeidet i de krigsherjede byer og steder," *Byggekunst* 25, no. 1 (1943): 6.

32. Hans Stephan, "Besprechung mit norwegischen Architekten, Ingenieuren und Juristen am 3.10.1940, um 15.45 Uhr, im kleinen Sitzungssaal des Storting in Oslo," in Wiederaufbau der norwegischen Städte, unpublished report (c. October 1940) for Albert Speer, p. 43, Lars Olof Larsson Collection, Kiel.

33. Hans Stephan, "Besprechung bei Reichskommissar Terboven in Oslo, im Storting, am 3.10.1940, 12.30 Uhr," in Wiederaufbau der norwegischen Städte, unpublished report (c. October 1940) for Albert Speer, p. 39, Lars Olof Larsson Collection, Kiel.

34. Hans Stephan, "Norwegische Architekten, welche für die Schulung in Deutschland in Frage kommen," in Wiederaufbau der norwegischen Städte, unpublished report (c. October 1940) for Albert Speer, pp. 46–48, Lars Olof Larsson Collection, Kiel.

35. The Sverre Pedersen collection at the Norwegian University of Science and Technology contains a folder (labeled "Reisen Tyskland, Novbr 1940, Sverre Pedersen") of materials saved from the German trip, including itineraries. Sverre Pedersen Private Archive, Ms SP-472, Special Collections, NTNU University Library, Trondheim. On the invitees, see Tvinnereim, *Sverre Pedersen*, 282.

36. Kitchen, *Speer*, 69; Fred Minsos, "Sett og hørt i Tyskland. Inntrykk fra de norske arkitekters studiereise," *Norges Handels og Sjøfartstidende*, February 22, 1941, newspaper clipping in Reichskommissariat, Hauptabteilung Volksaufklärung und Propaganda, Abteilung Presse, Avisutklipp. D. Kultur 1940–1943, 33 D VI Bildende Kunst. 1 mappe, RA/RAFA-2174/E/Ed/L0043/0001, Riksarkivet, Oslo.

37. It is not clear from the itinerary whether Todt met with the architects to discuss the autobahn or actually took them on a tour. Betreuung der norwegischen Architekten, carbon copy of the itinerary dated October 25, 1940, Sverre Pedersen Private Archive, Ms SP-472, Special Collections, NTNU University Library, Trondheim.

38. Matthias Donath, *Architecture in Berlin, 1933–1945: A Guide through Nazi Berlin* (Berlin: Lukas, 2006), 13.

39. Betreuung der norwegischen Architekten, carbon copy of the itinerary dated October 25, 1940; Tagesfolge: 14. November 1940 bis 17. November 1940: Zum Besuch Norwegischer Architekten in Deutschland, printed Munich itinerary; Ergänzungsteil zum Offiziellen Ausstellungskatalog der Großen Deutschen Kunstausstellung 1940 im Haus der Deutschen Kunst zu München; all in Sverre Pedersen Private Archive, Ms SP-472, Special Collections, NTNU University Library, Trondheim.

40. Minsos, "Sett og hørt i Tyskland."

41. Sverre Pedersen, Sehr geehrter Herr Oberbürgermeister, handwritten, undated text; and Tagesfolge: 14. November 1940 bis 17. November 1940: Zum Besuch Norwegischer Architekten in Deutschland, printed Munich itinerary; both in Sverre Pedersen Private Archive, Ms SP-472, Special Collections, NTNU University Library, Trondheim.

42. Tagesfolge: 14. November 1940 bis 17. November 1940: Zum Besuch Norwegischer Architekten in Deutschland, printed Munich itinerary in Sverre Pedersen Private Archive, Ms SP-472, Special Collections, NTNU University Library, Trondheim; Jonathan Petropoulos, *Artists under Hitler: Collaboration and Survival in Nazi Germany* (New Haven, CT: Yale University Press, 2014), 296–97.

43. Camillo Sitte quoted in Carl E. Schorske, *Fin-de-Siècle Vienna: Politics and Culture* (New York: Vintage, 1981), 63.

44. Sverre Pedersen, Generalbaurat Prof. Giesler, Program der neuen Stadt klar dargestellt, handwritten notes, Sverre Pedersen Private Archive, Ms SP-472, Special Collections, NTNU University Library, Trondheim; Michael Früchtel, *Der Architekt Hermann Giesler, Leben und Werk (1898–1987)* (Tübingen: Altavilla, 2008), 53ff.

45. Max Domarus, *Hitler: Speeches and Proclamations, 1932–1945* (Wauconda, IL: Bolchazy-Carducci, 1990), 3:2118.

46. Invitation card from Der Generalbauinspektor für die Reichshauptstadt to Professor Sverre Pedersen, Sverre Pedersen Private Archive, Ms SP-472, Special Collections, NTNU University Library, Trondheim.

47. Minsos, "Sett og hørt i Tyskland."

48. Norbert Rohde, *Das Heinkel-Flugzeugwerk Oranienburg: Legende und Wirklichkeit* (Velten: Velten Verlag, 2006), 140ff. In 1940, when the Norwegians visited, the factory's labor force was German. Two years later, it relied heavily on slave laborers housed behind barbed wire at the nearby Sachsenhausen

concentration camp. See Daniel Uziel, *Arming the Luftwaffe: The German Aviation Industry in World War II* (Jefferson, NC: McFarland, 2012), 167–68.

49. S. Paul Johnston, "Box Score: An Appraisal of European Air Power," *Aviation* 38 (January 1939): 23; Hermann Mäckler, "Die Heinkel-Werke Oranienburg: Architekt Herbert Rimpl," *Die Baukunst: Die Kunst im Deutschen Reich* (February 1940): 21–31.

50. Ian Boyd White, "National Socialism and Modernism," in *Art and Power: Europe under the Dictators, 1930–45*, ed. Dawn Ades, Tim Benton, David Elliot, and Ian Boyd White (London: Thames and Hudson, 1995), 258–69. See also Jeffrey Herf, *Reactionary Modernism: Technology, Culture, and Politics in Weimar and the Third Reich* (Cambridge: Cambridge University Press, 1984).

51. On Salzgitter, see Robert H. Kargon and Arthur P. Molella, *Invented Edens: Techno-Cities of the Twentieth Century* (Cambridge, MA: MIT Press, 2008), 37–45.

52. Dr. Piepenschneider, "Die Gemeinschafts-Siedlung Braunschweig-Lehndorf," *Bauamt und Gemeindebau* 18, no. 16 (1936): 186–89; and Dr. Piepenschneider, "Das 'Aufbauhaus' der Gemeinschaftssiedlung Braunschweig-Lehndorf," *Bauamt und Gemeindebau* 21, no. 2 (1939): 18–19. Both publications are in Sverre Pedersen Private Archive, Ms SP-472, Special Collections, NTNU University Library, Trondheim.

53. Piepenschneider, "Gemeinschafts-Siedlung Braunschweig-Lehndorf," 187.

54. Peter Galison, "The Cultural Meaning of *Aufbau*," in *Scientific Philosophy: Origins and Development*, ed. Friedrich Stadler (Dordrecht: Kluwer, 1993), 75.

55. Piepenschneider, "Gemeinschafts-Siedlung Braunschweig-Lehndorf," 187–88; Piepenschneider, "Das 'Aufbauhaus' der Gemeinschaftssiedlung Braunschweig-Lehndorf," 18–19.

56. Albert Speer to Josef Terboven, 21 November 1940, Generalbauinspektor für die Reichshauptstadt, NSDAP-Gauleitungen, 1937–1943, R 4606/469, Bundesarchiv Berlin.

57. Tvinnereim, *Sverre Pedersen*, 283ff.

58. Hans Stephan, memo, Wiederaufbau der norwegischen Städte, November 28, 1940, Generalbauinspektor für die Reichshauptstadt, NSDAP-Gauleitungen, 1937–1943, R 4606/469, Bundesarchiv Berlin.

59. Arne Hassing, *Church Resistance to Nazism in Norway, 1940–1945* (Seattle: University of Washington Press, 2014), 41.

60. Hans Stephan, memo on the meeting between Edgar Luther and Hans Stephan in Berlin, January 6, 1941, Hauptabteilungsleiter Hans Stephan, Planungsstelle, Bd. 2: 1940–1941, R 4606/711, Bundesarchiv Berlin.

61. On Pedersen's earlier role in the BSR, see Tvinnereim, *Sverre Pedersen*, 272ff.

62. Albert Speer to Josef Terboven, 2 December 1940, Generalbauinspektor für die Reichshauptstadt, NSDAP-Gauleitungen, 1937–1943, R 4606/469, Bundesarchiv Berlin.

63. Josef Terboven to Albert Speer, 15 March 1941, Generalbauinspektor für die Reichshauptstadt, Norwegen—Neugestaltung und Bebauungspläne für den Wiederaufbau norwegischer Städte, 1940–1942, R 4606/3429, Bundesarchiv Berlin.

64. Tvinnereim, *Sverre Pedersen*, 290; Peter Butenschøn, *Byen: en bruksanvisning* (Oslo: Aschehoug, 2009), 69.

65. Anlage zum Schreiben an Brt. Luther vom 24. Mai 1941, itinerary for Albert Speer's Norwegian trip, May 24, 1941; Albert Speer to Josef Terboven, 9 June 1941; both in Generalbauinspektor für die Reichshauptstadt, NSDAP-Gauleitungen, 1937–1943, R 4606/469, Bundesarchiv Berlin.

66. Tvinnereim, *Sverre Pedersen*, 311; Abrahamsen, "Reconstruction of the Town of Molde," 159.

67. Tvinnereim, *Sverre Pedersen*, 245.

68. Ibid., 312.

69. Sverre Pedersen, "Regulering av det Brendte Sentrum i Molde," *Byggekunst* 25, no. 1 (1943): 21.

70. "Fremtidens Molde blir også 'Rosenes by,'" *Aftenposten*, September 9, 1940.

71. On Pedersen's architectural studies in Norway and Germany, see Tvinnereim, *Sverre Pedersen*, 26ff.

72. Camillo Sitte, *City Planning according to Artistic Principles*, trans. George R. Collins and Christiane Crasemann Collins (New York: Random House, 1965).

73. Ebenezer Howard, *Garden Cities of Tomorrow* (Eastbourne, East Sussex: Attic Books, 1985); Thomas Hall, *Stockholm: The Making of a Metropolis* (Abingdon, Oxfordshire: Routledge, 2009), 283; Charlotte Ashby, *Modernism in Scandinavia: Art, Architecture, and Design* (London: Bloomsbury, 2017), 120.

74. Hans Stephan, "Molde," Wiederaufbau der norwegischen Städte, unpublished report (c. October 1940) for Albert Speer, pp. 8, 10, Lars Olof Larsson Collection, Kiel.

75. Dudley Kirk, *Europe's Population in the Interwar Years* (New York: Gordon and Breach, 1946), 24, 133–34.

76. Schipper, *Driving Europe*.

77. Sverre Pedersen, Die neuen Pläne der Kriegsgeschädigten Städte Norwegens, text included with report to Edgar Luther, October 18, 1941, p. 3, Brente steders regulering, Kartmapper, Professor Dr. Sverre Pedersen, NTH, RA/S-1540/D/Da/L0047/0007, Riksarkivet, Oslo; Hans Stephan, "Molde," and "Kristiansund," both in Wiederaufbau der norwegischen Städte, unpublished report (c. October 1940) for Albert Speer, pp. 8 and 12, Lars Olof Larsson Collection, Kiel; Hans Stephan, memo, Wiederaufbau der norwegischen Städte, November 28, 1940, Generalbauinspektor für die Reichshauptstadt, NSDAP-Gauleitungen, 1937–1943, R 4606/469, Bundesarchiv Berlin; Stephan, "Wiederaufbau

Norwegischer Städte," 123; Schütz and Gruber, *Mythos Reichsautobahn*, 82; Tvinnereim, *Sverre Pedersen*, 278–79.

78. Kitchen, *Speer*, 39, 58, 82ff.

79. Hans Stephan, "Molde," in Wiederaufbau der norwegischen Städte, unpublished report (c. October 1940) for Albert Speer, p. 8, Lars Olof Larsson Collection, Kiel.

80. Hans Stephan, memo, Wiederaufbau der norwegischen Städte, November 28, 1940, Generalbauinspektor für die Reichshauptstadt, NSDAP-Gauleitungen, 1937–1943, R 4606/469, Bundesarchiv Berlin.

81. Albert Speer to Josef Terboven, 19 May 1941, Generalbauinspektor für die Reichshauptstadt, Norwegen—Neugestaltung und Bebauungspläne für den Wiederaufbau norwegischer Städte, 1940–1942, R 4606/3429, Bundesarchiv Berlin.

82. Friedrich Weber and Charlotte Methuen, "The Architecture of Faith under National Socialism: Lutheran Church Building(s) in Braunschweig, 1933–1945," *Journal of Ecclesiastical History* 66, no. 2 (2015): 347.

83. Ibid., 347–48, 361. See also Gunnhild Ruben, *"Bitte mich als Untermieter bei ihnen anzumelden!" Hitler und Braunschweig 1932–1935* (Norderstedt: Books on Demand, 2004), 109–17.

84. Hassing, *Church Resistance to Nazism in Norway*, 40, 75–77; Dahl, *Quisling*, 8–10.

85. Josef Terboven to Albert Speer, 7 June 1941, Generalbauinspektor für die Reichshauptstadt, Norwegen—Neugestaltung und Bebauungspläne für den Wiederaufbau norwegischer Städte, 1940–1942, R 4606/3429, Bundesarchiv Berlin.

86. The towns in question were Kristiansund and Namsos. Hans Stephan to Edgar Luther, 5 August 1941, Generalbauinspektor für die Reichshauptstadt, Norwegen—Neugestaltung und Bebauungspläne für den Wiederaufbau norwegischer Städte,

1940–1942, R 4606/3429, Bundesarchiv Berlin.

87. Albert Speer to Josef Terboven, 19 May 1941; Hans Stephan, Wiederaufbau der norwegischen Städte. Besprechung vom 14.-16. Mai 1941 in Oslo, May 17, 1941, report; both in Generalbauinspektor für die Reichshauptstadt, Norwegen—Neugestaltung und Bebauungspläne für den Wiederaufbau norwegischer Städte, 1940–1942, R 4606/3429, Bundesarchiv Berlin.

88. Tvinnereim, *Sverre Pedersen*, 345.

89. Hans Stephan to Edgar Luther, 5 August 1941, Generalbauinspektor für die Reichshauptstadt, Norwegen—Neugestaltung und Bebauungspläne für den Wiederaufbau norwegischer Städte, 1940–1942, R 4606/3429, Bundesarchiv Berlin.

90. Hans Stephan, Vermerk über das Ergebnis der Besprechungen in Oslo am 18.7.1941 über die Wiederaufbaupläne der zerstörten norwegischen Städte in "brente steders regulering"-Büro, report submitted to Albert Speer, August 4, 1941, Generalbauinspektor für die Reichshauptstadt, Trondheim—Stadtplanung, 1941–1942, R 4606/4007, Bundesarchiv Berlin.

91. Gottfried Feder, *Die Neue Stadt: Versuch der Begründung einer neuen Stadtplanungskunst aus der sozialen Struktur der Bevölkerung* (Berlin: Springer, 1939), 110–11.

92. Anthony McElligott, *The German Urban Experience 1900–1945: Modernity and Crisis* (London: Routledge, 2001), 48–49.

93. Feder, *Neue Stadt*, 113. On the role of the Nazi Party's community halls, see also "Gemeinschaftshäuser der NSDAP," in the Gesetzte, Verordnungen und Erlasse section, *Die Baukunst: Die Kunst im Deutschen Reich* (July 1941).

94. Weber and Methuen, "Architecture of Faith under National Socialism," 347.

95. Sverre Pedersen, Die neuen Pläne der Kriegsgeschädigten Städte Norwegens, text included with report to Edgar Luther, October 18, 1941, p. 5, Brente

steders regulering, Kartmapper, Professor Dr. Sverre Pedersen, NTH, RA/S-1540/D/Da/L0047/0007, Riksarkivet, Oslo.

96. Hans Stephan, Wiederaufbau der norwegischen Städte. Besprechung vom 14.–16. Mai 1941 in Oslo, May 17, 1941, report, in Generalbauinspektor für die Reichshauptstadt, Norwegen—Neugestaltung und Bebauungspläne für den Wiederaufbau norwegischer Städte, 1940–1942, R 4606/3429, Bundesarchiv Berlin.

97. The idea of the *Reichshaus* and its imposing architecture recalls Otto Kohtz's 1920–21 unbuilt design for a *Reichshaus* in Berlin, a monumental ziggurat-like structure that would have housed state offices. Kohtz continued to publish variations of this type into the 1930s, and later served as a significant architect of government Third Reich buildings. See Werner Hegemann and Harold Hammer-Schenk, *Otto Kohtz* (Berlin: Gebr. Mann, 1996), ix–x.

98. Pedersen, "Reguleringen av de krigsskadede steder," 78.

99. "Germany Abusing Postal Rights; Seen as Threat against Privacy," *Jewish Daily Bulletin*, March 22, 1934; "Many Arrests in the Saar: Close Watch on Correspondence with Foreigners," *Manchester Guardian*, April 28, 1937.

100. Luther, "Wiederaufbau norwegischer Städte," 5. In a 1943 public lecture Stephan delivered in Berlin, he indicated that a *Reichshaus* would also be built in Molde (and house a post office). Hans Stephan, Vortrag von Baudirektor Stephan über Norwegische Baukunst gehalten am 7. Januar 1943, 18 Uhr im Meistersaal, Berlin, Köthener Strasse, typed manuscript, Lars Olof Larsson Collection, Kiel.

101. Sverre Pedersen, "Reguleringen av det Brente Sentrum i Narvik," *Byggekunst* 26, nos. 10–12 (1944): 85–108.

102. Hans Stephan, Wiederaufbau der norwegischen Städte. Besprechung vom 14.–16. Mai 1941 in Oslo, May 17, 1941, report, in Generalbauinspektor für die Reichshauptstadt, Norwegen—Neugestaltung und Bebauungspläne für den Wiederaufbau norwegischer Städte, 1940–1942, R 4606/3429, Bundesarchiv Berlin; Hans Stephan, Vermerk über das Ergebnis der Besprechungen in Oslo am 18.7.1941 über die Wiederaufbaupläne der zerstörten norwegischen Städte in "brente steders regulering"-Büro, report submitted to Albert Speer, August 4, 1941, Generalbauinspektor für die Reichshauptstadt, Trondheim—Stadtplanung, 1941–1942, R 4606/4007, Bundesarchiv Berlin; Stephan, "Wiederaufbau Norwegischer Städte," 126.

103. Pedersen, "Reguleringen av det Brente Sentrum i Narvik," 101.

104. Sverre Pedersen, Die neuen Pläne der Kriegsgeschädigten Städte Norwegens, text included with report to Edgar Luther, October 18, 1941, p. 5, Brente steders regulering, Kartmapper, Professor Dr. Sverre Pedersen, NTH, RA/S-1540/D/Da/L0047/0007, Riksarkivet, Oslo.

105. Hans Stephan, "Reise nach Norwegen," unpublished manuscript, c. 1941, Lars Olof Larsson Collection, Kiel, 76–77.

106. In some cases, Tvinnereim notes, buildings on the plans were labeled by BSR architects as simply "public" or "semipublic," which she interprets as a subtle form of resistance. Tvinnereim, *Sverre Pedersen*, 324, 345.

107. Sverre Pedersen, Die neuen Pläne der Kriegsgeschädigten Städte Norwegens, text included with report to Edgar Luther, October 18, 1941, pp. 5–6, Brente steders regulering, Kartmapper, Professor Dr. Sverre Pedersen, NTH, RA/S-1540/D/Da/L0047/0007, Riksarkivet, Oslo.

108. Stephan defines the communities as "oppositional" in Hans Stephan to Albert Speer, 5 August 1941, Generalbauinspektor für die Reichshauptstadt,

Trondheim—Stadtplanung, 1941–1942, R 4606/4007, Bundesarchiv Berlin.

109. Josef Terboven to Albert Speer, 7 June 1941; Albert Speer to Josef Terboven, 19 May 1941; Hans Stephan, Wiederaufbau der norwegischen Städte. Besprechung vom 14.–16. Mai 1941 in Oslo; all in Generalbauinspektor für die Reichshauptstadt, Norwegen—Neugestaltung und Bebauungspläne für den Wiederaufbau norwegischer Städte, 1940–1942, R 4606/3429, Bundesarchiv Berlin; and Hans Stephan, Vermerk über das Ergebnis der Besprechungen in Oslo am 18.7.1941 über die Wiederaufbaupläne der zerstörten norwegischen Städte in "brente steders regulering"-Büro, report submitted to Albert Speer, August 4, 1941, Generalbauinspektor für die Reichshauptstadt, Trondheim—Stadtplanung, 1941–1942, R 4606/4007, Bundesarchiv Berlin.

110. Kitchen, *Speer*, 76–77; Larsson, Larsson, and Lamprecht, *"Fröhliche Neugestaltung" oder die Gigantoplanie von Berlin 1937–1943*, 13.

111. "Forderungen der neuen Zeit an die Baukunst," German translation of an article published December 1940 in *Fritt Folk*, typed manuscript, Reichskommissariat, Hauptabteilung Volksaufklärung und Propaganda, Abteilung Presse, Avisutklipp. B. Innenpolitik, 1940–1943, 10 B II 1c Norwegen im neuen Europa, RA/RAFA-2174/E/Ed/L0016/0002, Riksarkivet, Oslo.

112. Ibid.

113. Gisela Hammer, "Der Weg des neuen Norwegen," *Deutsche Zeitung in Norwegen*, September 26, 1942.

114. Pedersen, "Reguleringen av det Brente Sentrum i Narvik," 106; Pedersen, "Regulering av det Brendte Sentrum i Molde," 15; Hans Stephan, Vortrag von Baudirektor Stephan über Norwegische Baukunst gehalten am 7. Januar 1943, 18 Uhr im Meistersaal, Berlin, Köthener Strasse, typed manuscript, Lars Olof Larsson Collection, Kiel.

115. Pedersen, "Regulering av det Brendte Sentrum i Molde," 15.

116. Ibid. See also Sverre Pedersen, Die neuen Pläne der Kriegsgeschädigten Städte Norwegens, text included with report to Edgar Luther, October 18, 1941, p. 3, Brente steders regulering, Kartmapper, Professor Dr. Sverre Pedersen, NTH, RA/S-1540/D/Da/L0047/0007, Riksarkivet, Oslo.

117. Josef Terboven, foreword, *Die Baukunst: Die Kunst im Deutschen Reich* (June 1942): 111; Stephan, "Wiederaufbau Norwegischer Städte," 119.

118. Hans Stephan, Vortrag von Baudirektor Stephan über Norwegische Baukunst gehalten am 7. Januar 1943, 18 Uhr im Meistersaal, Berlin, Köthener Strasse, typed manuscript, Lars Olof Larsson Collection, Kiel.

119. Ibid.

120. Luther, "Wiederaufbau norwegischer Städte," 8.

121. Willi Henne, memo, Baubeschränkung, December 2, 1942, Organisation Todt Collection, Generalbevollmächtigen für die Regelung der Bauwirtschaft (G.B. Bau), Grundlagen des Bauschaffens in Norwegen, 2194: Berichte der Abt. Technik der RK-Dienstst. Drontheim, RA/RAFA-2188/1/E/E1/E1a/L0004/0005, Riksarkivet, Oslo.

122. Abrahamsen, "Reconstruction of the Town of Molde," 164.

123. On Nordic classicism, see *Nordic Classicism 1910–1930* (Helsinki: Museum of Finnish Architecture, 1982).

124. Hans Stephan, Wiederaufbau der norwegischen Städte. Besprechung vom 14.–16. Mai 1941 in Oslo, report, in Generalbauinspektor für die Reichshauptstadt, Norwegen—Neugestaltung und Bebauungspläne für den Wiederaufbau norwegischer Städte, 1940–1942, R 4606/3429, Bundesarchiv Berlin. This approach to materials was also functional: since the catastrophic 1904 fire in Ålesund, the Norwegian

government had restricted the use of new timber construction in town centers to reduce the risk of fire.

125. Butenschøn, *Byen: en bruks-anvisning*, 69; Luther, "Wiederaufbau norwegischer Städte," 6. Pedersen was in agreement with standardizing the roof angle. In a 1941 report to Luther, he explained that the thirty-degree roof angle "is very practical for Norwegian roofing materials and a common roof inclination will contribute to a peaceful harmony." But it is not clear whether he initiated this requirement. Sverre Pedersen, Die neuen Pläne der Kriegsgeschädigten Städte Norwegens, text included with report to Edgar Luther, October 18, 1941, p. 5, Brente steders regulering, Kartmapper, Professor Dr. Sverre Pedersen, NTH, RA/S-1540/D/Da/L0047/0007, Riksarkivet, Oslo.

126. Stephan, "Wiederaufbau norwegischer Städte," 120.

127. Stratigakos, *Hitler at Home*, 57.

128. Butenschøn, *Byen: en bruks-anvisning*, 65.

129. Abrahamsen, "Reconstruction of the Town of Molde," 163.

130. Larsson, *Neugestaltung der Reichshauptstadt*, 95.

131. The orientation of buildings along Storgata was criticized for this reason (blocking views) in 1944 by Tage William-Olsson, the chief city-planning architect of Gothenburg, in his evaluation of the BSR plans for Molde made at the request of the Norwegian Building Committee in Stockholm: Tage William-Olsson, "Stadsplanechefen i Göteborg, Tage William-Olsson," *Byggekunst* 27, no. 1 (1945): 26–29.

132. The closest comparison would be Austria, where the Nazis planned vast new settlements for their industrial concerns as well as the transformation of Vienna and Linz. On National Socialist building plans for Vienna, see Ingrid Holzschuh and Monika Platzer, eds. *"Wien. Die Perle des Reiches": Planen*

für Hitler (Vienna: Architekturzentrum Wien; Zurich: Park Books, 2015).

133. Tvinnereim, *Sverre Pedersen*, 278; Stephan, "Reise nach Norwegen," 27–32.

134. For the itinerary, see Hans Stephan, "Planung Trondheim und Wiederaufbau der norwegischen Städte," report dated July 21, 1941, Generalbauinspektor für die Reichshauptstadt, Trondheim—Stadtplanung, 1941–1942, R 4606/4007, Bundesarchiv Berlin.

135. Hans Stephan, *Niederländisches Tagebuch* (Leipzig: Spamer, 1940), 7, 14–15, Lars Olof Larsson Collection, Kiel. In a letter about the book, Stephan refers to "about one hundred copies" being printed "for an inner circle." See Hans Stephan to Dr. Hettlage, 11 January 1941, Hauptabteilungsleiter Hans Stephan, Planungsstelle, Bd. 2: 1940–1941, R 4606/711, Bundesarchiv Berlin. The Lars Olof Larsson Collection also includes a self-published book by Rudolf Wolters, *Reise nach Lissabon* (Berlin: Müller and Sohn, 1941?), about a road trip taken by Speer, Walter Brugmann, and Wolters to Lisbon for the November 1941 opening of the "Neue Deutsche Baukunst" exhibition organized by Speer.

136. Stephan, *Niederländisches Tagebuch*, 49.

137. Stephan, "Reise nach Norwegen," 60, 62–63, 91, 100, 139, 140. When the security police investigated the fire at the Frostfilet, the cause was deemed to be negligence rather than sabotage. See Stein Ugelvik Larsen, Beatrice Sandberg, and Volker Dahm, eds., *Meldungen aus Norwegen 1940–1945: Die geheimen Lageberichte des Befehlshabers der Sicherheitspolizei und des SD in Norwegen* (Munich: R. Oldenbourg, 2008), 1:290–91. On the V-symbol in Norway, see Stokker, *Folklore Fights the Nazis*, 111–15. On the Norwegian Legion, see Sigurd Sørlie, "Norway," in *Joining Hitler's Crusade: European Nations and the Invasion of the Soviet Union, 1941*, ed. David Stahel (Cambridge: Cambridge University Press, 2018), 317–40.

138. Hans Stephan to Albert Speer, 5 August 1941, Generalbauinspektor für die Reichshauptstadt, Trondheim—Stadtplanung, 1941–1942, R 4606/4007, Bundesarchiv Berlin.

139. Stephan, "Reise nach Norwegen," 147.

140. Ibid., 39, 50, 51, 69; Speer to Müller, 24 August 1940, Generalbauinspektor für die Reichshauptstadt, NSDAP-Gauleitungen, 1937–1943, R 4606/469, Bundesarchiv Berlin; Andersen, *Grossraum*, 18–19; Speer, *Inside the Third Reich*, 181.

141. Stephan, "Reise nach Norwegen," 93–94, 105, 135a–136.

142. Ibid., 27–28, 36, 117, 143.

143. "Ho." to the Reichskommissar, June 25, 1942, in Generalbauinspektor für die Reichshauptstadt, Norwegen—Neugestaltung und Bebauungspläne für den Wiederaufbau norwegischer Städte, 1940–1942, R 4606/3429, Bundesarchiv Berlin; Tvinnereim, *Sverre Pedersen*, 346.

144. Hans Stephan, Vermerk über das Ergebnis der Besprechungen in Oslo am 18.7.1941 über die Wiederaufbaupläne der zerstörten norwegischen Städte in "brente steders regulering"-Büro, report submitted to Albert Speer, August 4, 1941, Generalbauinspektor für die Reichshauptstadt, Trondheim—Stadtplanung, 1941–1942, R 4606/4007, Bundesarchiv Berlin.

145. Hans Stephan, Wiederaufbau Norwegens: Besprechung mit Luther, Speer, Stephan, report dated April 15, 1941, Generalbauinspektor für die Reichshauptstadt, Trondheim—Stadtplanung, 1941–1942, R 4606/4007, Bundesarchiv Berlin; Hans Stephan to Edgar Luther, 20 January 1941, Generalbauinspektor für die Reichshauptstadt, Norwegen—Neugestaltung und Bebauungspläne für den Wiederaufbau norwegischer Städte, 1940–1942, R 4606/3429, Bundesarchiv Berlin; Edgar Luther, Bericht über den Stand der Planungsarbeiten für den Wiederaufbau der zerstörten norwegischen Städte, February 26, 1941, Generalbauinspektor für die Reichshauptstadt, Norwegen—Neugestaltung und Bebauungspläne für den Wiederaufbau norwegischer Städte, 1940–1942, R 4606/3429, Bundesarchiv Berlin; Stephan, "Reise nach Norwegen," 133–34; Hans Stephan, Vermerk über die Besprechung in Bergen am 16.7.1941 über das Wettbewerbsergebnis über die Bebauung des Stadtteiles Nordnes, report to Albert Speer, August 4, 1941, Generalbauinspektor für die Reichshauptstadt, Trondheim—Stadtplanung, 1941–1942, R 4606/4007, Bundesarchiv Berlin; Josef Terboven to Albert Speer, 10 October 1941, Generalbauinspektor für die Reichshauptstadt, Trondheim—Stadtplanung, 1941–1942, R 4606/4007, Bundesarchiv Berlin. Terboven's letter suggested that in the future Luther would review juries' decisions and confer with Stephan, without (presumably) Stephan traveling to Norway.

146. Luther, "Wiederaufbau norwegischer Städte," 6–7; Hans Stephan, memo, Wiederaufbau der norwegischen Städte, November 28, 1940, Generalbauinspektor für die Reichshauptstadt, NSDAP-Gauleitungen, 1937–1943, R 4606/469, Bundesarchiv Berlin; Albert Speer to Josef Terboven, 2 December 1940, Generalbauinspektor für die Reichshauptstadt, NSDAP-Gauleitungen, 1937–1943, R 4606/469, Bundesarchiv Berlin.

147. Tvinnereim, *Sverre Pedersen*, 348, 355.

148. Harald Hals, "Henvendelse til Regjeringen," *Byggekunst* 27, no. 1 (1945): 12–13; Abrahamsen, "Reconstruction of the Town of Molde," 165.

149. Hals, "Henvendelse til Regjeringen," 12–13; Edvard Heiberg, "Arkitekt Edvard Heiberg," *Byggekunst* 27, no. 1 (1945): 25–26; John Horntvedt, "Krigstidens Byplaner B.S.R.," *Byggekunst* 27, no. 1 (1945): 14–20; Abrahamsen, "Reconstruction of the Town of Molde," 165–66; Butenschøn, *Byen: en bruksanvisning*, 72. For further criticisms of Pedersen's

Molde plan with a focus on transportation infrastructure, see William-Olsson, "Stadsplanechefen i Göteborg."

150. Tvinnereim, *Sverre Pedersen*, 370–83; Butenschøn, *Byen: en bruksanvisning*, 74.

151. Abrahamsen, "Reconstruction of the Town of Molde," 167–68; Peter Butenschøn, "Sverre Pedersen—krigen, byplanene og moralen," *Arkitektnytt*, April 7, 2010. Accessed July 6, 2019: http://www.arkitektnytt.no/sverre-pedersen-krigen-byplanene-og-moralen.

152. Ingebjørg Hage, "Reconstruction of North Norway after the Second World War—New Opportunities for Female Architects?" *Acta Borealia* 22, no. 2 (2005): 99–127.

153. Somewhat more extensive changes were made to the plans of Namsos, Steinkjer, and Bodø. Butenschøn, "Sverre Pedersen—krigen, byplanene og moralen."

154. Abrahamsen, "Reconstruction of the Town of Molde," 167–68.

155. Ibid., 169–70.

156. Ingvar Mikkelsen, "BSR: faglig og moralsk," *Arkitektnytt*, March 20, 2010. Accessed July 6, 2019: https://www.arkitektnytt.no/nyheter/bsr-faglig-og-moralsk1; and Butenschøn, "Sverre Pedersen: krigen, byplanene og moralen."

Chapter Five: A German City in the Fjords

1. "Stützpunkt in Norwegen (Drontheim)," October 20, 1939, Norwegen (Handakte Großadmiral Erich Raeder), RM 6/88 Bundesarchiv-Militärarchiv Freiburg; Hans-Martin Ottmer, "Skandinavien in der deutschen marinestrategischen Planung der Reichs-bzw. Kriegsmarine," in *Neutralität und totalitäre Aggression: Nordeuropa und die Großmächte im Zweiten Weltkrieg*, ed. Robert Bohn, Jürgen Elvert, Hain Rebas, and Michael Salewski (Stuttgart: Franz Steiner, 1991), 50ff.; Keith W. Bird, *Erich Raeder: Admiral of the Third Reich* (Annapolis, MD: Naval Institute Press, 2006),

29. On the broader discussion among the German naval leadership about the need for bases with access to the Atlantic, see Gerhard Weinberg, *A World at Arms: A Global History of World War II* (Cambridge: Cambridge University Press,1994), 113; and Carl-Axel Gemzell, *Raeder, Hitler und Skandinavien: Der Kampf für einen maritimen Operationsplan* (Lund: CWK Gleerup, 1965), 220ff.

2. "Stützpunkt in Norwegen (Drontheim)," October 20, 1939, Norwegen (Handakte Großadmiral Erich Raeder), RM 6/88 Bundesarchiv-Militärarchiv Freiburg. For a detailed analysis of the rationale for a Norwegian base, see Gemzell, *Raeder, Hitler und Skandinavien*, 214ff. National Socialist documents use various spellings for Trondheim, including an older variant, "Drontheim." For the sake of simplicity, I have standardized the use of "Trondheim" in the quotations cited from German sources.

3. "Report of the C.-in-C., Navy, to the Fuehrer on October 10, 1939, at 1700," in *Fuehrer Conferences on Naval Affairs, 1939–1945*, foreword by Jak P. Mallmann Showell (London: Greenhill, 1990), 47; Erich Raeder, *My Life*, trans. Henry W. Drexel (Annapolis, MD: United States Naval Institute, 1960), 304; Ottmer, "Skandinavien in der deutschen marinestrategischen Planung," 65–66.

4. "Report of the C.-in-C., Navy, to the Fuehrer on December 12, 1939, at 1200," in *Fuehrer Conferences on Naval Affairs*, 66–67; Gemzell, *Raeder, Hitler, und Skandinavien*, 272–73; Dahl, *Quisling*, 150–52.

5. Hans Fredrik Dahl, "The Question of Quisling: Aspects of the German Occupation Regime in Norway," in *Neutralität und totalitäre Aggression: Nordeuropa und die Grossmächte im Zweiten Weltkrieg*, ed. Robert Bohn, Jürgen Elvert, Hain Rebas, and Michael Salewski (Stuttgart: Steiner, 1991), 196; John Kiszely, *Anatomy of a Campaign: The British Fiasco in Norway, 1940* (Cambridge: Cambridge University Press, 2017), 79–99.

6. Vorlage bei Chef Skl., December 13, 1943, Kriegstagebuch vol. 8, June 1943–December 1943, RM 7/98, p. 72, Bundesarchiv-Militärarchiv Freiburg; "2 Nazi Cruisers Hit, by Bombs, British Say," *New York Times*, June 12, 1940; "British Bomb Scharnhorst at Trondheim," *New York Herald Tribune*, June 15, 1940.

7. Entry for April 30, 1940, in *The Political Diary of Alfred Rosenberg and the Onset of the Holocaust*, ed. Jürgen Matthäus and Frank Bajohr (Lanham, MD: Rowman and Littlefield in association with the United States Holocaust Memorial Museum, 2015), 198.

8. "Features of Singapore Base: Vast Dockyard and 20 Sq. Miles of Anchorage," *Straits Times*, December 4, 1940; "The Biggest Naval Dock in the World," *Singapore Free Press and Mercantile Advertiser*, February 14, 1938.

9. Vorlage bei Chef Skl., December 13, 1943, Kriegstagebuch vol. 8, June 1943–December 1943, RM 7/98, p. 72, Bundesarchiv-Militärarchiv Freiburg.

10. Kriegstagebuch des Kommandierenden Admiral Norwegen Admiral Boehm, August 1–15, 1940, p. 11, PG 46859—NID, T1022 R2843, microfilm, US National Archives at College Park, Maryland; Fuchs, undated (1943), "Geschichtliche Entwicklung des Baues einer Großwerft in Drontheim," Kriegstagebuch vol. 8, June 1943–December 1943, RM 7/98, p. 86, Bundesarchiv-Militärarchiv Freiburg.

11. Ibid.

12. Albert Speer quoted in Hans-Dietrich Loock, *Quisling, Rosenberg und Terboven: Zur Vorgeschichte und Geschichte der nationalsozialistischen Revolution in Norwegen* (Stuttgart: Deutsche Verlags-Anstalt, 1970), 457.

13. Joseph Goebbels, entry for July 9, 1940, in *Die Tagebücher von Joseph Goebbels: Sämtliche Fragmente*, vol. 4, pt. 1: 1924 to 1941, ed. Elke Fröhlich (Munich: Saur, 1987), 234.

14. The anticipated population size of the new German city varies somewhat in the documentation, but Stephan and Speer based their planning on the figure of three hundred thousand. See Generalbauinspektor für die Reichshauptstadt, Trondheim—Stadtplanung, 1941–1942, R 4606/4007, Bundesarchiv Berlin. Population figures for Oslo and Trondheim are from: Hoppe, "Norwegens Auge in der Welt"; and Wg., "Drontheim: Die Hauptstadt des nördlichen Norwegen," *Deutsche Zeitung in Norwegen*, October 11, 1941.

15. Dr. Klein, memo, Relief Drontheim, July 10, 1940, Organisation Todt Collection, Trondheim—Neu Drontheim—om modeller/planer, 1940–1943, RA/RAFA-2188/2/H/Hf/Hfa/0031, Riksarkivet, Oslo.

16. This model was later shipped back to Oslo, where it was intended for display in the Storting. R. M. Williams to Dr. Leistritz, 10 July 1940; Fridtjof Kristiansen to Reichskommissar, 9 November 1940; Abteilung Technik und Verkehr, Gruppe Hochbau, memo, Trondheim Relief Modelle, April 1, 1941; all in Organisation Todt Collection, Trondheim—Neu Drontheim—om modeller/planer, 1940–1943, RA/RAFA-2188/2/H/Hf/Hfa/0031, Riksarkivet, Oslo.

17. Edgar Luther, memo, Geländerelief "Trondheimfjord," August 1, 1941; Karl Wenschow, Versandübersicht, undated; Edgar Luther to Albert Speer, 9 August 1941; Edgar Luther to Dipl. Ing. Fickert, 29 August 1941; Bonacker to Josef Terboven, 20 December 1940; all in Organisation Todt Collection, Trondheim—Neu Drontheim—om modeller/planer, 1940–1943, RA/RAFA-2188/2/H/Hf/Hfa/0031, Riksarkivet, Oslo; Taylor, *Word in Stone*, 137n38.

18. Kriegstagebuch des Kommandierenden Admiral Norwegen Admiral Boehm, August 1–15, 1940, p. 2, PG 46859—NID, T1022 R2843, microfilm, US National Archives at College Park, Maryland.

19. Josef Terboven to Albert Speer, 14 August 1941, Generalbauinspektor

für die Reichshauptstadt, Trondheim—Stadtplanung, 1941–1942, R 4606/4007, Bundesarchiv Berlin.

20. Kriegstagebuch des Kommandierenden Admiral Norwegen Admiral Boehm, August 1–15, 1940, pp. 5–6, PG 46859—NID, T1022 R2843, microfilm, US National Archives at College Park, Maryland.

21. Hans Stephan, memo, Vermerk über die Besprechung mit Leiter der Abteilung Technik des Reichskommissars in Oslo am 1.7.1941, August 4, 1941, Generalbauinspektor für die Reichshauptstadt, Trondheim—Stadtplanung, 1941–1942, R 4606/4007, Bundesarchiv Berlin.

22. Albert Speer to Josef Terboven, 24 April 1941, Generalbauinspektor für die Reichshauptstadt, Trondheim—Stadtplanung, 1941–1942, R 4606/4007, Bundesarchiv Berlin.

23. Hans Stephan, memo, Vermerk über die Besprechung mit Leiter der Abteilung Technik des Reichskommissars in Oslo am 1.7.1941, August 4, 1941, Generalbauinspektor für die Reichshauptstadt, Trondheim—Stadtplanung, 1941–1942, R 4606/4007, Bundesarchiv Berlin.

24. Albert Speer to Josef Terboven, 24 April 1941, Generalbauinspektor für die Reichshauptstadt, Trondheim—Stadtplanung, 1941–1942, R 4606/4007, Bundesarchiv Berlin.

25. Albert Speer to Martin Bormann, 26 November 1940 (including the attached proposal, Entwurf eines Organisationsplanes für einen "Beauftragten des Führers für Baukunst und Städtebau der NSDAP"), and Albert Speer to Martin Bormann, 20 January 1941, all in Reichsministerium für Rüstung und Kriegsproduktion, Ministerbüro Speer, R 3/1733, Bundesarchiv Berlin; Rudolf Wolters, entry for January 1941, Chronik des Generalbauinspektors für die Reichshauptstadt Albert Speer, 1941, N 1340/457, Bundesarchiv Koblenz;

26. Albert Speer to Josef Terboven, 24 April 1941, Generalbauinspektor für die Reichshauptstadt, Trondheim—Stadtplanung, 1941–1942, R 4606/4007, Bundesarchiv Berlin.

27. Albert Speer to Josef Terboven, 24 August 1940, quoted in Loock, *Quisling, Rosenberg und Terboven*, 457. Speer's use of the plural term for Hitler's architects suggests that he knew that he would have competition for this assignment from others, including Giesler.

28. Hans Stephan, Grösse einer Stadt von 300.000 Einwohner, ohne Industrie, April 3, 1941; Hans Stephan, Nachtrag: Grösse einer Stadt von 300.000 Einwohner, ohne Industrie, April 15, 1941; and Hans Stephan to Albert Speer, 30 April 1941; all in Generalbauinspektor für die Reichshauptstadt, Trondheim—Stadtplanung, 1941–1942, R 4606/4007, Bundesarchiv Berlin.

29. Population density statistics from worldpopulationreview.com and factfinder.census.gov, accessed March 22, 2019.

30. Hans Stephan to Albert Speer, 30 April 1941; Willi Schelkes, memo, Drontheim: Besprechung Speer—Schelkes, April 22, 1941; both in Generalbauinspektor für die Reichshauptstadt, Trondheim—Stadtplanung, 1941–1942, R 4606/4007, Bundesarchiv Berlin.

31. J.-S. L'Heureux, S. Glimsdal, O. Longva, L. Hansen, and C. B. Harbitz, "The 1888 Shoreline Landslide and Tsunami in Trondheimsfjorden, Central Norway," *Marine Geophysical Research* 32, nos. 1–2 (2011): 313, 315.

32. Dr. J. Schadler, Bauvorhaben Gulosen: Stand der Bodenuntersuchungen am 1. Dezember 1942, report, December 4, 1942, Organisation Todt Collection, B39.1: Gulosen, Øysan [sic], 1941–1945, folder with Dr. J. Schadler

reports, 1942, RA/RAFA-2188/2/H/Hj/ L0037, Riksarkivet, Oslo.

33. Hans Stephan, Trondheim: Besprechung mit Vizadmiral Fuchs und Begleitung, memo, May 2, 1941, and Hans Stephan to Albert Speer, 30 April 1941 (p. 79), both in Generalbauinspektor für die Reichshauptstadt, Trondheim—Stadtplanung, 1941–1942, R 4606/4007, Bundesarchiv Berlin; Rudolf Wolters, entry for May 1941, Chronik des Generalbauinspektors für die Reichshauptstadt Albert Speer, 1941, N 1340/457, Bundesarchiv Koblenz.

34. Oberkommando der Kriegsmarine to Albert Speer, 24 June 1941, Generalbauinspektor für die Reichshauptstadt, Trondheim—Stadtplanung, 1941–1942, R 4606/4007, Bundesarchiv Berlin.

35. Albert Speer to Oberkommando der Kriegsmarine, 15 August 1941, Generalbauinspektor für die Reichshauptstadt, Trondheim—Stadtplanung, 1941–1942, R 4606/4007, Bundesarchiv Berlin.

36. Memo concerning the planning of the new Drontheim base, stamped as received June 24, 1941, p. 232 (handwritten number), Persönlich (Handakten Großadmiral Erich Raeder), vol. 4, February 1 to June 30, 1941, RM 6/74, Bundesarchiv-Militärarchiv Freiburg.

37. Martin Moll, "Plan Z (1939–1943)," in Germany at War: 400 Years of Military History, ed. David T. Zabecki (Santa Barbara, CA: ABC-CLIO, 2014), 3:1002–3.

38. Grosswerft Drontheim, undated, pp. 237–38 (handwritten numbers), Persönlich (Handakten Großadmiral Erich Raeder), vol. 4, February 1 to June 30, 1941, RM 6/74, Bundesarchiv-Militärarchiv Freiburg.

39. Ibid.

40. Vorlage bei Chef Skl., December 13, 1943, Kriegstagebuch vol. 8, June 1943–December 1943, RM 7/98, p. 72; and Fuchs, "Geschichtliche Entwicklung des Baues einer Großwerft in Drontheim," undated (1943), Kriegstagebuch vol. 8,

June 1943–December 1943, RM 7/98, p. 86; both in Bundesarchiv Freiburg.

41. W. O. Henderson, Studies in German Colonial History (Chicago: Quadrangle, 1962), 34; Speer, Inside the Third Reich, 181.

42. Albert Speer to Josef Terboven, 23 April 1941, Admiral norwegische Nordküste, Marine-Planung Trondheim, RM 45-III/282, Bundesarchiv-Militärarchiv Freiburg; Albert Speer to Josef Terboven, 24 April 1941, Generalbauinspektor für die Reichshauptstadt, Trondheim—Stadtplanung, 1941–1942, R 4606/4007, Bundesarchiv Berlin; Hans Stephan to Ministerialrat Müller, 24 May 1941, Generalbauinspektor für die Reichshauptstadt, NSDAP-Gauleitungen, 1937–1943, R 4606/469, Bundesarchiv Berlin; Anlage zum Schreiben an Brt. Luther vom 24. Mai 1941, itinerary for Albert Speer's Norwegian trip, May 24, 1941, Generalbauinspektor für die Reichshauptstadt, NSDAP-Gauleitungen, 1937–1943, R 4606/469, Bundesarchiv Berlin; Hans Stephan, Wiederaufbau Norwegens, memo, April 15, 1941, Generalbauinspektor für die Reichshauptstadt, Trondheim—Stadtplanung, 1941–1942, R 4606/4007, Bundesarchiv Berlin; Albert Speer to Josef Terboven, 9 June 1941, Generalbauinspektor für die Reichshauptstadt, NSDAP-Gauleitungen, 1937–1943, R 4606/469, Bundesarchiv Berlin; "Big Norse Factory Reported Destroyed," New York Times, May 6, 1941.

43. Rudolf Wolters, entry for June 1941, Chronik des Generalbauinspektors für die Reichshauptstadt Albert Speer, 1941, N 1340/457, Bundesarchiv Koblenz; Raeder, meeting notes, Besprechung Ob. d. M. beim Führer am 21.6.1941 nachm., June 24, 1941, Persönlich (Handakten Großadmiral Erich Raeder), vol. 4, February 1 to June 30, 1941, RM 6/74, Bundesarchiv-Militärarchiv Freiburg; Albert Speer to Fritz Todt, 21 June 1941, Generalbauinspektor für die Reichshauptstadt,

Trondheim—Stadtplanung, 1941–1942, R 4606/4007, Bundesarchiv Berlin.

44. Rudolf Wolters, entry for July 1941, Chronik des Generalbauinspektors für die Reichshauptstadt Albert Speer, 1941, N 1340/457, Bundesarchiv Koblenz.

45. Umgebungskarte von Drontheim, OKM Hauptamt Kriegsschiffbau, Amtsgruppe Hafenbau, Generalbauinspektor für die Reichshauptstadt, Trondheim—Stadtplanung, 1941–1942, R 4606/4007, Bundesarchiv Berlin.

46. Hans Stephan, Kurze Beschreibung des Geländes, report, August 6, 1941, Generalbauinspektor für die Reichshauptstadt, Trondheim—Stadtplanung, 1941–1942, R 4606/4007, Bundesarchiv Berlin.

47. Josef Terboven to Albert Speer, 14 August 1941, Generalbauinspektor für die Reichshauptstadt, Trondheim—Stadtplanung, 1941–1942, R 4606/4007, Bundesarchiv Berlin.

48. Stephan, "Reise nach Norwegen," 21–23; Hans Stephan, Kurze Beschreibung des Geländes, report, August 6, 1941, Generalbauinspektor für die Reichshauptstadt, Trondheim—Stadtplanung, 1941–1942, R 4606/4007, Bundesarchiv Berlin.

49. Stephan, "Reise nach Norwegen," 25–26, 27–28, 122–24; Hans Stephan, Planung Trondheim und Wiederaufbau der norwegischen Städte, report addressed to Albert Speer, July 21, 1941, Generalbauinspektor für die Reichshauptstadt, Trondheim—Stadtplanung, 1941–1942, R 4606/4007, Bundesarchiv Berlin.

50. Hans Stephan, Planung Trondheim und Wiederaufbau der norwegischen Städte, report addressed to Albert Speer, July 21, 1941; and Albert Speer to Walter Brugmann and Hans Stephan, 21 June 1941; both in Generalbauinspektor für die Reichshauptstadt, Trondheim—Stadtplanung, 1941–1942, R 4606/4007, Bundesarchiv Berlin.

51. Hans Stephan to Albert Speer, 22 September 1941; and Venediger to Stephan, 24 October 1941; both in Generalbauinspektor für die Reichshauptstadt, Trondheim—Stadtplanung, 1941–1942, R 4606/4007, Bundesarchiv Berlin.

52. Werner Koeppens, entry for Saturday, September 20, 1941, in Herbst 1941 im "Führerhauptquartier," 28. Koeppens's wording, together with the Germans' use of "Trondheim" to refer to both the old (Norwegian) and new (German) city, has fostered the mistaken impression among some historians that Hitler planned to raze and rebuild the existing city of Trondheim. See below for a further discussion about the name of the new city.

53. Astrid Meland, "Trondheim om Hitler hadde vunnet," Dagbladet Magasinet, May 19, 2005. Accessed March 22, 2019: http://www.dagbladet.no/magasinet/trondheim-om-hitler-hadde-vunnet/66096461. Unfortunately, the article does not give a source for the photographs that Brovold, then aged eighty, recalled having seen. See also Gabriel Brovold, Neu Drontheim: i Hitlers regi og Øysand under krigen (Melhus: Snøfugl, c. 1996).

54. Speer quoted in Loock, Quisling, Rosenberg und Terboven, 457.

55. Heinrich Heims, entry for January 15–16, 1942, in Adolf Hitler Monologe im Führer-Hauptquartier 1941–1944: Die Aufzeichnungen Heinrich Heims, ed. Werner Jochmann (Hamburg: Knaus, 1980), 201.

56. Heims, entry for January 15–16, 1942, and entry for February 19–20, 1942, in Monologe im Führer-Hauptquartier 1941–1944, 201, 285.

57. Jost Dülffer, Jochen Thies, and Josef Henke, Hitlers Städte: Baupolitik im Dritten Reich (Cologne: Böhlau, 1978).

58. Frederic Spotts, Hitler and the Power of Aesthetics (Woodstock, NY: Overlook, 2009), 187–220; Hanns Christian Löhr, Das Braune Haus der Kunst: Hitler und der "Sonderauftrag Linz": Visionen, Verbrechen, Verluste (Berlin: Akademie, 2005), 19ff.

59. Vorschläge des OKH für

Ehrenfriedhöfe in Norwegen, 1941, folder with correspondence and proposals concerning war cemeteries in Norway, RH 13/27, Bundesarchiv-Militärarchiv Freiburg.

60. Rudolf Wolters, entry for March 1941, Chronik des Generalbauinspektors für die Reichshauptstadt Albert Speer, 1941, N 1340/457, Bundesarchiv Koblenz; M. Bormann, Anordnung 38/44, Aufgaben des Generalbaurats Professor Wilhelm Kreis bei der Errichtung von Feldengedenkstätten und Ehrenmalen der NSDAP, February 14, 1944, Partei-Kanzlei der NSDAP, Reichstagshandbuch, NS 6/346, Bundesarchiv Berlin. See also Gunnar Brands, "Bekenntnisse eines Angepaßten: Der Architekt Wilhelm Kreis als Generalbaurat für die Gestaltung der deutschen Kriegerfriedhöfe," in Architektur und Ingenieurwesen zur Zeit der nationalsozialistischen Gewaltherrschaft, 1933–1945, ed. Ulrich Kuder (Berlin: Gebr. Mann, 1997), 124–56.

61. Ekkehard Mai, "Von 1930 bis 1945: Ehrenmäler und Totenburgen," in Wilhelm Kreis: Architekt zwischen Kaiserreich und Demokratie, 1873–1955, ed. Winfried Nerdinger and Ekkehard Mai (Munich: Klinkhardt and Biermann, 1994), 163; Larsson, Neugestaltung der Reichshauptstadt, 49–50; Speer, Inside the Third Reich, 146.

62. Hans Stephan, Wiederaufbau Norwegens, memo, April 15, 1941, Generalbauinspektor für die Reichshauptstadt, Trondheim—Stadtplanung, 1941–1942, R 4606/4007, Bundesarchiv Berlin; Handt, Lagebericht der Abteilung Technik für den Monat August 1942, August 31, 1942, Organisation Todt Collection, Trondheim—Neu Drontheim—om modeller/planer, 1940–1943, Alt Trondheim Flächennutzungsplan folder, RA/RAFA-2188/2/H/Hf/Hfa/0031, Riksarkivet, Oslo. Kreis had originally selected Lade (a peninsula just east of Trondheim) as the site for the Trondheim war cemetery, but moved the location after Hitler chose the peninsula west of Trondheim for his new German city. Kreis may have already traveled to Norway in 1940 to search for locations for the war cemeteries. The proposal made by the Army High Command Norway in early 1941 mentions that the "chief architect" of the Volksbundes Deutsche Kriegsgräberfürsorge—the association cofounded by Kreis in 1919 to care for German war graves, which consulted on the project—had already traveled to Norway in 1940 to determine the sites. Kreis was, presumably, that chief architect. See Oberquartiermeister (für das Armeeoberkommando Norwegen) to Oberkommando der Wehrmacht, 6 January 1941, in Vorschläge des OKH für Ehrenfriedhöfe in Norwegen, 1941, folder with correspondence and proposals concerning war cemeteries in Norway, RH 13/27, Bundesarchiv-Militärarchiv Freiburg.

63. "Soldatenfriedhof und Ehrenmal bei Drontheim," Das Reich, August 24, 1941; Albert Speer, "Der Architekt Wilhelm Kreis," Die Baukunst: Die Kunst im Deutschen Reich (July 1941): 130ff.; Wilhelm Kreis, "Zu meinen Skizzen," Die Baukunst: Die Kunst im Deutschen Reich (July 1941): 135ff. Die Baukunst was the architecture supplement to the art journal Die Kunst im Deutschen Reich. On the design of Wehrmacht cemeteries in foreign countries more broadly, see Nina Janz, "From Battlegrounds to Burial Grounds: The Cemetery Landscapes of the German Army during the Second World War," in War and Geography: The Spatiality of Organized Mass Violence, ed. Sarah Kristina Danielsson and Frank Jacob (Paderborn: Schöningh, 2017), 152ff.

64. Eric Michaud, The Cult of Art in Nazi Germany, trans. Janet Lloyd (Stanford, CA: Stanford University Press, 2004), 66ff.

65. Christian Degn, Drontheim (Leipzig: Hirzel, 1942); Wg., "Drontheim."

66. Ibid.; Hoppe, "Norwegens Auge

in der Welt"; Brepohl, "Hauptstadt als Schmelztiegel."

67. In his 1970 book on National Socialism in Norway, Hans-Dietrich Loock already noted that Hitler's intention to build a German city near Trondheim seemed to undermine assertions made by other Nazi leaders of the eventual dissolution of national identities among Germans and Norwegians as they merged to become an integrated racial whole. See Loock, *Quisling, Rosenberg und Terboven*, 457.

68. Goebbels, entry for July 9, 1940, in *Tagebücher von Joseph Goebbels*, 234.

69. Albert Speer to Fritz Todt, 21 June 1941; Hans Stephan, Trondheim: Besprechung mit Vizadmiral Fuchs und Begleitung, memo, May 2, 1941; both in Generalbauinspektor für die Reichshauptstadt, Trondheim—Stadtplanung, 1941–1942, R 4606/4007, Bundesarchiv Berlin.

70. Fickert to Altinger, 21 October 1941, Organisation Todt Collection, B39.1: Gulosen, Øysan, 1941–1945, Korrespondanse Boringer Gulosenfjord 1941 folder, RA/RAFA-2188/2/H/Hj/L0037, Riksarkivet, Oslo; Josef Terboven to Albert Speer, 14 August 1941, Generalbauinspektor für die Reichshauptstadt, Trondheim—Stadtplanung, 1941–1942, R 4606/4007, Bundesarchiv Berlin.

71. Willi Henne to Hauptabteilung Verwaltung Storting, April 1, 1942, Organisation Todt Collection, Trondheim—Neu Drontheim—om modeller/planer, 1940–1943, Alt Trondheim Flächennutzungsplan folder, RA/RAFA-2188/2/H/Hf/Hfa/0031, Riksarkivet, Oslo.

72. For documentation on the extensive infrastructure changes planned for Old Trondheim and Pedersen's work on the merger of Trondheim and Strinda, see Alt Trondheim Flächennutzungsplan folder, Organisation Todt Collection, Trondheim—Neu Drontheim—om modeller/planer, 1940–1943, RA/

RAFA-2188/2/H/Hf/Hfa/0031, Riksarkivet, Oslo; and Sverre Pedersen Collection, Ms SP-116, General plan for Trondheim-Strinda, 1936–1944, University Library, Norwegian University of Science and Technology, Trondheim.

73. Handt to Reichskommissar, Abteilung Technik, 12 February 1942; Handt to Reichskommissar, Abteilung Technik, Oslo, 19 March 1942, copy; both in Organisation Todt Collection, Trondheim—Neu Drontheim—om modeller/planer, 1940–1943, Alt Trondheim Flächennutzungsplan folder, RA/RAFA-2188/2/H/Hf/Hfa/0031, Riksarkivet, Oslo.

74. B36.1: Øysand, Gaulabro, 1942–1943, Organisation Todt Collection, RA/RAFA-2188/H/Hj/L0034; Div. ang. Gaula-Bahnbrücke 1942, Organisation Todt Collection, Oberbauleitungen, OBL-Drontheim/Mittelnorwegen: Korrespondanse og regninger, RA/RAFA-2188/2/F/Fa/Fab/L0079/0001; B37: Øysand, flyplass, 1940–1945, Organisation Todt Collection, RA/RAFA-2188/H/Hj/L0036; all in Riksarkivet, Oslo. The Army Museum in Trondheim has wartime maps of Øysand's water and electrical systems. On the Luftwaffe's use of Øysand, see Brovold, *Neu Drontheim*, 23ff.

75. Dr. Bolle, Gutachtliche Äußerung über die Behebung von Umschlagschwierigkeiten in Drontheim, August 4, 1942, Organisation Todt Collection, Trondheim—Neu Drontheim—om modeller/planer, 1940–1943, Alt Trondheim Flächennutzungsplan folder, RA/RAFA-2188/2/H/Hf/Hfa/0031, Riksarkivet, Oslo.

76. On the construction of the Dora submarine bunkers, see Karl H. Brox, Hermann Hansen, and Knut Sivertsen, *Bunkeren: Trondheim under Hakekorset* (Trondheim: Communicatio, 2015), 205ff.

77. Dr. Bolle, Gutachtliche Äußerung über die Behebung von Umschlagschwierigkeiten in Drontheim, August 4, 1942, Organisation Todt Collection,

Trondheim—Neu Drontheim—om modeller/planer, 1940–1943, Alt Trondheim Flächennutzungsplan folder, RA/RAFA-2188/2/H/Hf/Hfa/0031; Oswald to Hesse, 20 April 1943, Organisation Todt Collection, Byggeprosjekter i Trøndelag/Møre og Romsdal, Diverse byggeprosjekter i Trondheim og omegn, OBL Trondheim: Reparasjoner av havneanlegg i Trondheim folder, RA/RAFA-2188/2/E/Ec/L0004/0001; both in Riksarkivet, Oslo.

78. Handt to Reichskommissar, Abteilung Technik, 12 February 1942, Organisation Todt Collection, Trondheim—Neu Drontheim—om modeller/planer, 1940–1943, Alt Trondheim Flächennutzungsplan folder, RA/RAFA-2188/2/H/Hf/Hfa/0031, Riksarkivet, Oslo.

79. Wg., "Drontheim."

80. Valdis O. Lumans, *Himmler's Auxiliaries: The Volksdeutsche Mittelstelle and the German National Minorities of Europe, 1933–1945* (Chapel Hill: University of North Carolina Press, 1993); Reagin, *Sweeping the German Nation*, 181ff.; Peter Longerich, *Heinrich Himmler: A Life*, trans. Jeremy Noakes and Lesley Sharpe (Oxford: Oxford University Press, 2012), 500.

81. Klein, memo, Erkundungen von Neutrondheim, October 21, 1941, Organisation Todt Collection, B39.9: Gulosen, Øysand, 1941–1943, RA/RAFA-2188/2/H/Hj/L0044, Riksarkivet, Oslo; Altinger to Dorsch, 2 January 1942, Generalbauinspektor für die Reichshauptstadt, Trondheim—Stadtplanung, 1941–1942, R 4606/4007, Bundesarchiv Berlin.

82. "R[uthe]," memo, Vermerk für S über Te., November 26, 1941; and Ruthe, memo, Vermerk für "Te," 19 December 1941; both Organisation Todt Collection, B39.9: Gulosen, Øysand, 1941–1943, RA/RAFA-2188/2/H/Hj/L0044, Riksarkivet, Oslo.

83. "R[uthe]," memo, Vermerk für S über Te., November 26, 1941, Organisation Todt Collection, B39.9: Gulosen,

Øysand, 1941–1943, RA/RAFA-2188/2/H/Hj/L0044, Riksarkivet, Oslo.

84. Ruthe, memo, Vermerk für O über Te., December 6, 1941, Organisation Todt Collection, B39.1: Gulosen, Øysan, 1941–1945, Korrespondanse Boringer Gulosenfjord 1941 folder, RA/RAFA-2188/2/H/Hj/L0037, Riksarkivet, Oslo.

85. Drechsler to Altinger, memo, Ausstattung der Büro und Wohnräume im Öysand, June 28, 1941, Organisation Todt Collection, B39.9: Gulosen, Øysand, 1941–1943, RA/RAFA-2188/2/H/Hj/L0044, Riksarkivet, Oslo.

86. Brovold, *Neu Drontheim*, 108.

87. In June 1943, for example, the Øysand camps held 381 Serbians and 1,220 Russian prisoners of war. Altinger, memo, Belegung des Grosslagers Oysand, June 8, 1943, Organisation Todt Collection, Oberbauleitungen, OBL-Drontheim/Mittelnorwegen: Korrespondanse og regninger, Korrespondanse ang. de forskjellige arbeids-/fangeleirene, H 33/16 Lager Øysand, RA/RAFA-2188/2/F/Fa/Fab/L0020/0001, Riksarkivet, Oslo. Historian Michael Stokke, who has researched POW camps on Øysand, notes that Soviet prisoners usually stayed only a few weeks before being transferred to northern Norway. Michael Stokke, email to author, August 17, 2016.

88. Lindenmayer, Tätigkeitsbericht, Gulosen: Fa. Eckhoff und Fa. Pollems, November 7, 1942, Organisation Todt Collection, B39.9: Gulosen, Øysand, 1941–1943, RA/RAFA-2188/2/H/Hj/L0044, Riksarkivet, Oslo.

89. Entwurf über Kriegsmarinehafenanlagen bei Trondheim, map signed Lindenmayer and dated December 19, 1942, Organisation Todt Collection, B39.3: Gulosen, Øysand, 1941–1942, RA/RAFA-2188/2/H/Hj/L0039, Riksarkivet, Oslo.

90. Lindenmayer, Tätigkeitsbericht, Gulosen: Fa. Eckhoff und Fa. Pollems, November 7, 1942, Organisation Todt Collection, B39.9: Gulosen, Øysand,

1941–1943, RA/RAFA-2188/2/H/Hj/ Loo44, Riksarkivet, Oslo.

91. Altinger, memo, Belegung des Grosslagers Oysand, June 8, 1943, Organisation Todt Collection, Ober- bauleitungen, OBL-Drontheim/ Mittelnorwegen: Korrespondanse og regninger, Korrespondanse ang. de for- skjellige arbeids-/fangeleirene, H 33/16 Lager Øysand, RA/RAFA-2188/2/F/Fa/ Fab/Loo20/oo01, Riksarkivet, Oslo.

92. Andersen, *Grossraum*, 39.

93. Fuchs, undated (1943), "Geschicht- liche Entwicklung des Baues einer Großwerft in Drontheim," Kriegs- tagebuch vol. 8, June 1943–December 1943, RM 7/98, p. 85, Bundesarchiv- Militärarchiv Freiburg. Hitler appears to have discussed construction of the dry dock with Todt already in April 1941. See Schelkes to Speer, 30 April 1941, General- bauinspektor für die Reichshauptstadt, Trondheim—Stadtplanung, 1941–1942, R 4606/4007, Bundesarchiv Berlin.

94. Vorlage bei Chef Skl., December 13, 1943, Kriegstagebuch vol. 8, June 1943– December 1943, RM 7/98, p. 74, Bundes- archiv-Militärarchiv Freiburg; Hartmut Schmidt, *Kriegswirklichkeit und Soldaten- alltag während des Zweiten Weltkrieges in Nordnorwegen* (Stuttgart: ibidem, 2006), 53.

95. Dr. J. Schadler, Bauvorhaben Gulosen: Stand der Bodenuntersu- chungen am 1. Dezember 1942, report, December 4, 1942, Organisation Todt Collection, B39.1: Gulosen, Øysan, 1941– 1945, folder with Dr. J. Schadler reports, 1942, RA/RAFA-2188/2/H/Hj/Loo37, Riksarkivet, Oslo.

96. In his memoirs, Albert Speer refers to this project as "a large underground submarine base," but the archival mate- rials do not mention submarines. Speer, *Inside the Third Reich*, 181–82.

97. Dr. J. Schadler, Bauvorhaben Gulosen: Stand der Bodenuntersu- chungen am 1. Dezember 1942, report, December 4, 1942, Organisation Todt

Collection, B39.1: Gulosen, Øysan, 1941– 1945, folder with Dr. J. Schadler reports, 1942, RA/RAFA-2188/2/H/Hj/Loo37, Riksarkivet, Oslo.

98. Ibid.; Vorlage bei Chef Skl., December 13, 1943, Kriegstagebuch vol. 8, June 1943–December 1943, RM 7/98, p. 74, Bundesarchiv-Militärarchiv Freiburg; Beyrer, memo, Gula-Bahn- brücke—Gründung und Vergebung des Überbaues, November 27, 1942, Organisation Todt Collection, Oberbau- leitungen, OBL-Drontheim/Mittelnor- wegen: Korrespondanse og regninger, Div. ang. Gaula-Bahnbrücke 1942, RA/ RAFA-2188/2/F/Fa/Fab/Loo79/oo01, Riksarkivet, Oslo; Beyrer, file memo, Lagerbelegungsmöglichkeit für Öysand und Bralia, July 22, 1942, B39.9 Gulosen, Øysand, Organisation Todt Collection, B39.9: Gulosen, Øysand, 1941–1943, RA/ RAFA-2188/2/H/Hj/Loo44, Riksarkivet, Oslo.

99. Ben H. Shepherd, *Hitler's Soldiers: The German Army in the Third Reich* (New Haven, CT: Yale University Press, 2016), 242–73.

100. Peter Longerich, *Goebbels: A Biog- raphy*, trans. Alan Bance, Jeremy Noakes, and Lesley Sharpe (New York: Random House, 2015), 558–62.

101. Vorlage bei Chef Skl., Decem- ber 13, 1943, Kriegstagebuch vol. 8, June 1943–December 1943, RM 7/98, p. 74, Bundesarchiv-Militärarchiv Freiburg. On the ending of the ground surveys in Øysand, see Dr. Schadler, memo, Besprechung mit Baurat Altinger am 29. März 1943, March 30, 1943, Organisation Todt Collection, B39.1: Gulosen, Øysan, 1941–1945, folder with Dr. J. Schadler reports for Øysand/Stjørdal, 1943, RA/ RAFA-2188/2/H/Hj/Loo37, Riksarkivet, Oslo.

102. Brovold, *Neu Drontheim*, 100, 115, 119.

103. Edgar Luther to Speith, 26 Janu- ary 1943, Organisation Todt Collection, Trondheim—Neu Drontheim—om

modeller/planer, 1940–1943, Alt Trondheim Flächennutzungsplan folder, RA/RAFA-2188/2/H/Hf/Hfa/0031, Riksarkivet, Oslo.

Conclusion: Ghosts in the Landscape

1. "Norse King Urges Allied Solidarity," *New York Times*, July 1, 1945.
2. "Germans to Leave Norway," *Hartford Courant*, July 7, 1945.
3. Tom Twitty, "Norway a Vast Picnic Ground," *New York Herald Tribune*, June 24, 1945; M. Lorimer Moe, "Patience of Norway Strained by Thousands of Nazi Soldiers," *Christian Science Monitor*, July 18, 1945.
4. "Gestapo's Terrible Work in Norway Being Revealed," *Globe and Mail*, August 11, 1945.
5. "Blames Quisling for Death of 1,000 Jews," *Jewish Exponent*, August 31, 1945.
6. Howard E. Kershner, "Northern Norway Left in Dire Need by Nazis," *Christian Science Monitor*, October 12, 1945. For accounts of the destruction of northern Norway, see Hunt, *Fire and Ice*.
7. Barbara Wace, "Norway Fears Quisling Taint on Youngsters," *Washington Post*, July 15, 1945.
8. Moe, "Patience of Norway Strained by Thousands of Nazi Soldiers"; Kershner, "Northern Norway Left in Dire Need by Nazis."
9. "Norwegians Regain Prizes from Nazis in Oslo Area," *Christian Science Monitor*, July 14, 1945.
10. Richard Martyn-Hemphill and Henrik Pryser Libell, "Trash in the Fjords? Norway Turns to Drones," *New York Times*, March 4, 2018.
11. "A German Camp in Norway: 'Forest of Arden' in Aspect and Atmosphere," *Scotsman*, July 5, 1945. On the long-term economic value of investments made by the occupiers in military and civilian infrastructure, see Harald Espeli, "The Economic Effects of the German Occupation of Norway, 1940–1945," in *Paying for Hitler's War: The Consequences of Nazi Hegemony for Europe*, ed. Jonas Scherner and Eugene N. White (New York: Cambridge University Press, 2016), 260–62.
12. "German Camp in Norway"; Albert D. Hughes, "Danish Stores Get Goods by Air Freight," *Christian Science Monitor*, November 6, 1946.
13. Hughes, "Danish Stores Get Goods by Air Freight."
14. "Huset som aldri ble bygd," *Verdens Gang*, July 14, 1945. I am grateful to Ingrid Roede for bringing this article to my attention.
15. Ibid.
16. Kjetil Fallan, *Designing Modern Norway: A History of Design Discourse* (London: Routledge, 2017), 51.
17. Organisation Todt Collection, Hochbau—Soldatenheimbau, Korrespondanse, mappe 1/9, 1941–1944, RA/RAFA-2188/2/H/Hf/Hfd/0004, Riksarkivet, Oslo.
18. Andersen, *Grossraum*, 51; Espeli, "Economic Effects of the German Occupation of Norway," 260–62.
19. Soleim, "Soviet Prisoners of War in Norway 1941–1945"; Andersen, *Grossraum*, 45, 49–50; Hunt, *Fire and Ice*, 165, 169; Steinar Aas, "Cold War Era Silence: The Movement of the Graves of Soviet Prisoners of War in Northern Norway," in *Beyond Memory: Silence and the Aesthetics of Remembrance*, ed. Alexandre Dessingué and Jay M. Winter (New York: Routledge, 2016), 112–13; Janz, "From Battlegrounds to Burial Grounds," 149ff.
20. Marianne Neerland Soleim, "Soviet Prisoners of War in Norway," in *Soviet Prisoners of War in Norway*, ed. Marianne Neerland Soleim, Ingeborg Hjorth, Arne Langås, and Åshild Karevold, trans. Tolk Midt-Norge (Ekne: Falstad Memorial and Human Rights Centre, 2010), 13. Accessed May 29, 2018: http://falstadsenteret.no/wp-content/uploads/2014/09/skriftserie_05b.pdf.
21. Aas, "Cold War Era Silence," 113.
22. Ibid., 115–16.

23. Hunt, *Fire and Ice*, 222; Aas, "Cold War Era Silence," 117–18; Soleim, "Soviet Prisoners of War in Norway 1941–1945," 28–29; Marianne Neerland Soleim, *Operasjon asfalt: kald krig om krigsgraver* (Oslo: Orkana, 2016), 124ff.

24. Jon Reitan, "The Nazi Camps in the Norwegian Historical Culture," in *Historicizing the Uses of the Past: Scandinavian Perspectives on History Culture, Historical Consciousness and Didactics of History Related to World War II*, ed. Helle Bjerg, Claudia Lenz, and Erik Thorstensen (Bielefeld: Transcript, 2011), 60.

25. Hunt, *Fire and Ice*, 220; Soleim, *Operasjon asfalt*, 134.

26. Aas, "Cold War Era Silence," 121–22.

27. "Norway Apologises to Women Punished for Relationships with German Soldiers," *Guardian*, October 17, 2018. Accessed July 16, 2019: https://www.theguardian.com/world/2018/oct/17/norwegian-women-get-apology-for-reprisals-over-wwii-friendships; "Norway Apologises to Its World War Two 'German Girls,'" *BBC News*, October 17, 2018. Accessed July 16, 2019: https://www.bbc.com/news/world-europe-45893490; Andrew Osborn, "Norway's Abused Children Move Step Closer to Compensation," *Guardian*, December 6, 2002. Accessed July 16, 2019: https://www.theguardian.com/world/2002/dec/07/andrewosborn1; Steve Rosenberg, "Living Hell of Norway's 'Nazi' Children," *BBC News*, March 8, 2007. Accessed July 16, 2019: http://news.bbc.co.uk/2/hi/europe/6432157.stm.

28. Terje Mosnes, *Jazz i Molde* (Ålesund: Nordvest Informasjon, 1980); Penny M. von Eschen, *Satchmo Blows Up the World: Jazz Ambassadors Play the Cold War* (Cambridge, MA: Harvard University Press, 2006).

Works Cited

a. "Norwegen zieht eine neue Bahn: Sprödes Land im Norden im Schmelztiegel der neuen Zeit." *Westfälische Neueste Nachrichten*, October 17/18, 1942.

Aas, Steinar. "Cold War Era Silence: The Movement of the Graves of Soviet Prisoners of War in Northern Norway." In *Beyond Memory: Silence and the Aesthetics of Remembrance*, edited by Alexandre Dessingué and Jay M. Winter, 111–24. New York: Routledge, 2016.

Abrahamsen, Olav Arild. "The Reconstruction of the Town of Molde: German Impact on Town-Planning during the Occupation." In *Der deutsche Historikerstreit: Stadtgeschichte und Stadtplanung: Bericht über das 3. deutsch-norwegische Historikertreffen in Trondheim, June 1988*, 150–72. Essen: Stifterverband für deutsche Wissenschaft, 1988.

Ades, Dawn, Tim Benton, David Elliot, and Ian Boyd White, eds. *Art and Power: Europe under the Dictators, 1930–45*. London: Thames and Hudson, 1995.

Adolf Hitler: Bilder aus dem Leben des Führers. Altona/Bahrenfeld: Cigaretten-Bilderdienst, 1936.

Aguiar, Marian. *Tracking Modernity: India's Railway and the Culture of Mobility*. Minneapolis: University of Minnesota Press, 2011.

Andås, Margrete Syrstad, Øystein Ekroll, Andreas Haud, and Nils Holger Petersen, eds. *The Medieval Cathedral of Trondheim: Architectural and Ritual Constructions in Their European Context*. Turnhout, Belgium: Brepols, 2007.

Andersen, Ketil Gjølme. *Grossraum: Organisation Todt and Forced Labour in Norway 1940–45*. Oslo: Norwegian Museum of Science and Technology, 2017.

———. "Teknisk æresoppdrag av høyeste orden: Organisation Todt og byggingen av Hitlers polarjernbane." *Historisk tidsskrift* 97, no. 3 (2018): 206–23.

Ascheid, Antje. *Culture and the Moving Image: Hitler's Heroines: Stardom and Womanhood in Nazi Cinema*. Philadelphia: Temple University Press, 2010.

Ashby, Charlotte. *Modernism in Scandinavia: Art, Architecture, and Design*. London: Bloomsbury, 2017.

"Auslandsfahrt des Kanzlers." *Berliner Lokal-Anzeiger*, April 15, 1934.

"Autobahn nach Norwegen und Schweden? Neue Verkehrswege erschliessen das zukünftige Europa." *Gelsenkirchener Zeitung*, September 29, 1940.

"Autostrada Trondheim-Svartehavet," *Fritt Folk*, October 28, 1940.

Baranowski, Shelley. *Strength through Joy: Consumerism and Mass Tourism in*

the Third Reich. New York: Cambridge University Press, 2004.

Barron, Stephanie, ed. *"Degenerate Art": Fate of the Avant-Garde in Nazi Germany.* Los Angeles: Los Angeles County Museum of Art; New York: Abrams, 1991.

Bartelsheim, Ursula. "Die Nordlandbahn." In *Unterwegs zum Polarkreis: Eisenbahnabenteuer in Skandinavien,* edited by Deutsche Bahn Nürnberg, 14–17. Nuremberg: DB Museum, 2008.

Bascomb, Neal. *The Winter Fortress: The Epic Mission to Sabotage Hitler's Atomic Bomb.* Boston: Houghton Mifflin Harcourt, 2016.

Bennett's Handbook for Travellers in Norway. 29th ed. Christiania: Thos. Bennet and Sons, 1902.

Berg, A. L. "Deutsche Baumeister in Norwegen." *Deutsche Zeitung in Norwegen,* July 2, 1942.

———."Jahrhunderte bauten an einem Dom: Ein deutscher Baumeister half das Werk vollenden." *Deutsche Zeitung in Norwegen,* June 25, 1942.

Berghoff, Hartmut. "Enticement and Deprivation: The Regulation of Consumption in Pre-War Nazi Germany." In *The Politics of Consumption: Material Culture and Citizenship in Europe and America,* edited by Martin Daunton and Matthew Hilton, 165–84. New York: Berg, 2001.

Bessel, Richard. *Germany 1945: From War to Peace.* London: Pocket, 2008.

"Biggest Naval Dock in the World, The." *Singapore Free Press and Mercantile Advertiser,* February 14, 1938.

"Big Norse Factory Reported Destroyed." *New York Times,* May 6, 1941.

"Bindeglied zwischen Heimat und Front." *Deutsche Zeitung in Norwegen,* May 25, 1943.

Bird, Keith W. *Erich Raeder: Admiral of the Third Reich.* Annapolis, MD: Naval Institute Press, 2006.

"Blames Quisling for Death of 1,000 Jews." *Jewish Exponent,* August 31, 1945.

Blom, Ida. "Voluntary Motherhood 1900–1930: Theories and Politics of a Norwegian Feminist in an International Perspective." In *Maternity and Gender Policies: Women and the Rise of the European Welfare States, 1880s–1950s,* edited by Gisela Bock and Pat Thane, 21–39. London: Routledge, 1991.

Bohn, Robert. *Reichskommissariat Norwegen: "Nationalsozialistische Neuordnung" und Kriegswirtschaft.* Munich: Oldenbourg, 2000.

Bohn, Robert, Jürgen Elvert, Hain Rebas, and Michael Salewski, eds. *Neutralität und totalitäre Aggression: Nordeuropa und die Großmächte im Zweiten Weltkrieg.* Stuttgart: Franz Steiner, 1991.

Boldorf, Marcel, and Tetsuji Okazaki, eds. *Economies under Occupation: The Hegemony of Nazi Germany and Imperial Japan in World War II.* Abingdon, Oxon: Routledge, 2015.

Borgersrud, Lars. "Meant to Be Deported." In *Children of World War II: The Hidden Enemy Legacy,* edited by Kjersti Ericsson and Eva Simonsen, 71–92. Oxford: Berg, 2005.

Brands, Gunnar. "Bekenntnisse eines Angepaßten: Der Architekt Wilhelm Kreis als Generalbaurat für die Gestaltung der deutschen Kriegerfriedhöfe." In *Architektur und Ingenieurwesen zur Zeit der nationalsozialistischen Gewaltherrschaft, 1933–1945,* edited by Ulrich Kuder, 124–56. Berlin: Gebr. Mann, 1997.

Brepohl, Wilhelm. "Die Hauptstadt als Schmelztiegel: Ist Oslo Norwegen?" *Deutsche Monatshefte in Norwegen* 3, no. 6 (1942): 12–16.

Brinkmann, P. "Bergen: Stadt der Hanse." *Deutsche Zeitung in Norwegen,* November 27, 1941.

"British Bomb Scharnhorst at Trondheim." *New York Herald Tribune,* June 15, 1940.

Brovold, Gabriel. *Neu Drontheim: i Hitlers regi og Øysand under krigen.* Melhus: Snøfugl, c. 1996.

Brox, Karl H., Hermann Hansen, and Knut Sivertsen. *Bunkeren: Trondheim under Hakekorset*. Trondheim: Communicatio, 2015.

Bruland, Bjarte. *Det norske Holocaust: Forsøket på å tilintetgjøre de norske jødene*. Oslo: HL-Senteret, Senter for Studier av Holocaust og Livssynsminoriteter, 2008.

Buderer, Hans-Jürgen. *Entartete Kunst: Beschlagnahmeaktionen in der Städtischen Kunsthalle Mannheim 1937*. 2nd ed. Mannheim: Städtische Kunsthalle Mannheim, 1990.

Butenschøn, Peter. *Byen: en bruksanvisning*. Oslo: Aschehoug, 2009.

———. "Sverre Pedersen—krigen, byplanene og moralen." *Arkitektnytt*, April 7, 2010. Accessed July 6, 2019: http://www.arkitektnytt.no/sverre -pedersen-krigen-byplanene-og -moralen.

Chapoutot, Johann. *Greeks, Romans, Germans: How the Nazis Usurped Europe's Classical Past*. Translated by Richard R. Nybakken. Berkeley: University of California Press, 2016.

Churchill, Winston. *The Hinge of Fate*. Vol. 4 of *The Second World War*. Boston: Houghton Mifflin, 1950.

Claasen, Adam R. A. *Hitler's Northern War: The Luftwaffe's Ill-Fated Campaign, 1940–1945*. Lawrence: University Press of Kansas, 2001.

Cohen, Maynard M. *A Stand against Tyranny: Norway's Physicians and the Nazis*. Detroit: Wayne State University Press, 1997.

Connelly, John. "Nazis and Slavs: From Racial Theory to Racist Practice." *Central European History* 32, no. 1 (1999): 1–33.

Crane, Ralph. "Reading the Club as Colonial Island in E. M. Forster's *A Passage to India* and George Orwell's *Burmese Days*." *Island Studies Journal* 6, no. 1 (2011): 17–28.

Custodis, Johann. "Employing the Enemy: The Economic Exploitation of POW and Foreign Labor from Occupied Territories by Nazi Germany." In *Paying for Hitler's War: The Consequences of Nazi Hegemony for Europe*, edited by Jonas Scherner and Eugene N. White, 67–100. New York: Cambridge University Press, 2016.

Dahl, Hans Fredrik. *A History of the Norwegian Press, 1660–2015*. Houndmills, Basingstoke, Hampshire: Palgrave Macmillan, 2016.

———. "The Question of Quisling: Aspects of the German Occupation Regime in Norway." In *Neutralität und totalitäre Aggression: Nordeuropa und die Grossmächte im Zweiten Weltkrieg*, edited by Robert Bohn, Jürgen Elvert, Hain Rebas, and Michael Salewski, 195–204. Stuttgart: Steiner, 1991.

———. *Quisling: A Study in Treachery*. Translated by Anne-Marie Stanton-Ife. Cambridge: Cambridge University Press, 1999.

Danielsson, Sarah Kristina, and Frank Jacob, eds. *War and Geography: The Spatiality of Organized Mass Violence*. Paderborn: Schöningh, 2017.

Daunton, Martin, and Matthew Hilton. *The Politics of Consumption: Material Culture and Citizenship in Europe and America*. New York: Berg, 2001.

Degn, Christian. *Drontheim*. Leipzig: Hirzel, 1942.

Deutsche Bahn Nürnberg, ed. *Unterwegs zum Polarkreis: Eisenbahnabenteuer in Skandinavien*. Nuremberg: DB Museum, 2008.

"Deutsche Bauernmädel in Norwegen." *Deutsche Allgemeine Zeitung*, October 8, 1942.

"Deutsches Soldatenheim in Andalsnes." *Gothaisches Tageblatt*, April 8, 1941.

"Deutsch-norwegische Zusammenarbeit 1941." *Deutsche Zeitung in Norwegen*, January 1, 1942.

Diehl, Paula. *Körper im Nationalsozialismus: Bilder und Praxen*. Munich: Fink; Paderborn: Schöningh, 2006.

Domarus, Max. Hitler: *Speeches and*

Proclamations, 1932–1945. Vol. 3. Wauc-onda, IL: Bolchazy-Carducci, 1990.

Donath, Matthias. *Architecture in Berlin, 1933–1945: A Guide through Nazi Berlin.* Berlin: Lukas, 2006.

Douglas, John. *Norway's Arctic Highway: Mo i Rana to Kirkenes.* Hindhead, Surrey: Trailblazer, 2003.

Drolshagen, Ebba D. *Der freundliche Feind: Wehrmachtssoldaten im besetzten Europa.* Munich: Droemer, 2009.

Dülffer, Jost, Jochen Thies, and Josef Henke. *Hitlers Städte: Baupolitik im Dritten Reich.* Cologne: Böhlau, 1978.

Durth, Werner, and Niels Gutschow. *Träume in Trümmern: Stadtplanung 1940–1950.* Munich: Deutscher Taschenbuch, 1993.

Eckhardt, Heinz-Werner. *Die Frontzeitungen des deutschen Heeres 1939–1945.* Vienna: Wilhelm Braumüller, 1975.

Eldal, Jens Christian. "Fritz Jordan." In *Norsk kunstnerleksikon,* 2:432. Oslo: Universitetsforlaget, 1983.

Emberland, Terje. "Pure-Blooded Vikings and Peasants: Norwegians in the Racial Ideology of the SS." In *Racial Science in Hitler's New Europe, 1938–1945,* edited by Anton Weiss-Wendt and Rory Yeomans, 108–28. Lincoln: University of Nebraska Press, 2013.

Ericsson, Kjersti. "Love and War: Norwegian Women in Consensual Sexual Relationships with German Soldiers." In *Women in War: Examples from Norway and Beyond,* edited by Kjersti Ericsson, 147–63. Farnham, Surrey: Ashgate, 2015.

———, ed. *Women in War: Examples from Norway and Beyond.* Farnham, Surrey: Ashgate, 2015.

Ericsson, Kjersti, and Dag Ellingsen. "Life Stories of Norwegian War Children." In *Children of World War II: The Hidden Enemy Legacy,* edited by Kjersti Ericsson and Eva Simonsen, 93–111. Oxford: Berg, 2005.

Ericsson, Kjersti, and Eva Simonsen, eds. *Children of World War II: The Hidden Enemy Legacy.* Oxford: Berg, 2005.

———. "Shame and Silence: The Experience of German-Norwegian War Children." In *Women in War: Examples from Norway and Beyond,* edited by Kjersti Ericsson, 201–15. Farnham, Surrey: Ashgate, 2015.

Eriksen, Anne. *Det var noe annet under krigen: 2. verdenskrig i norsk kollektivtradisjon.* Oslo: Pax, 1995.

"erste Soldatenheim in Norwegen, Das: Ein Treffpunkt für die Reichsdeutschen." *Frankfurter Zeitung,* April 15, 1941.

Eschen, Penny M. von. *Satchmo Blows Up the World: Jazz Ambassadors Play the Cold War.* Cambridge, MA: Harvard University Press, 2006.

Espeli, Harald. "The Economic Effects of the German Occupation of Norway, 1940–1945." In *Paying for Hitler's War: The Consequences of Nazi Hegemony for Europe,* edited by Jonas Scherner and Eugene N. White, 235–65. New York: Cambridge University Press, 2016.

———. "Incentive Structures and State Regulations of the Norwegian Economy." In *Industrial Collaboration in Nazi-Occupied Europe: Norway in Context,* edited by Hans Otto Frøland, Mats Ingulstad, and Jonas Scherner, 245–71. London: Palgrave Macmillan, 2016.

Evans, Richard J. *The Third Reich at War.* New York: Penguin, 2009.

———. *The Third Reich in Power, 1933–1939.* New York: Penguin, 2015.

"Fahrt des Führers in die norwegischen Gewässer, Die." *Völkischer Beobachter* (Berlin), April 18, 1934.

Falkenhorst, Nikolaus von. "Die Wacht im Norden." *Straubinger Tagblatt,* April 9, 1941.

Fallan, Kjetil. *Designing Modern Norway: A History of Design Discourse.* London: Routledge, 2017.

"Features of Singapore Base: Vast

Dockyard and 20 Sq. Miles of Anchorage." *Straits Times*, December 4, 1940.

Feder, Gottfried. *Die Neue Stadt: Versuch der Begründung einer neuen Stadtplanungskunst aus der sozialen Struktur der Bevölkerung.* Berlin: Springer, 1939.

Fest, Joachim. *Albert Speer: Conversations with Hitler's Architect.* Translated by Patrick Camiller. Cambridge: Polity Press, 2007

Fjågesund, Peter. *The Dream of the North: A Cultural History to 1920.* Amsterdam: Rodopi, 2014.

Fjågesund, Peter, and Ruth A. Symes. *The Northern Utopia: British Perceptions of Norway in the Nineteenth Century.* Amsterdam: Rodopi, 2003.

F. M. "Häuser der Kameradschaft: Vorbildliche Soldatenheime als Geschenk der Heimat." *Deutsche Zeitung in Norwegen*, February 4, 1941.

"første tyske soldathjem, Det." *Dagbladet*, April 7, 1941.

Forty, George, Leo Marriott, and Simon Forty. *Hitler's Atlantic Wall: From Southern France to Northern Norway, Yesterday and Today.* Havertown, PA: Casemate, 2016.

"Fremtidens Molde blir også 'Rosenes by.'" *Aftenposten*, September 9, 1940.

Friedrich, Thomas. *Hitler's Berlin: Abused City.* Translated by Stewart Spencer. New Haven, CT: Yale University Press, 2012.

Fritzsche, Peter. *Life and Death in the Third Reich.* Cambridge, MA: Harvard University Press, 2008.

Frøland, Hans Otto. "Nazi Germany's Financial Exploitation of Norway during the Occupation, 1940–45." In *Economies under Occupation: The Hegemony of Nazi Germany and Imperial Japan in World War II*, edited by Marcel Boldorf and Tetsuji Okazaki, 130–46. Abingdon, Oxon: Routledge, 2015.

Frøland, Hans Otto, Gunnar Damhagen Hatlehol, and Mats Ingulstad. "Regimenting Labour in Norway during Nazi Germany's Occupation." In

Working Paper Series A, No. 12, edited by Elizabeth Harvey and Kim Christian Priemel, 1–18. Working Papers of the Independent Commission of Historians Investigating the History of the Reich Ministry of Labour (*Reichsarbeitsministerium*) in the National Socialist Period (2017). Accessed June 22, 2019: https://www .historikerkommission-reichsarbeits ministerium.de/sites/default/files /inline-files/Working%20Paper%20 UHK%20A12_Fr%C3%B8land%2B Hatlehol%2BIngulstad_0.pdf.

Frøland, Hans Otto, Mats Ingulstad, and Jonas Scherner. "Perfecting the Art of Stealing: Nazi Exploitation and Industrial Collaboration in Occupied Western Europe." In *Industrial Collaboration in Nazi-Occupied Europe: Norway in Context*, edited by Hans Otto Frøland, Mats Ingulstad, and Jonas Scherner, 1–34. London: Palgrave Macmillan, 2016.

Frøland, Hans Otto, Mats Ingulstad, and Jonas Scherner, eds. *Industrial Collaboration in Nazi-Occupied Europe: Norway in Context.* London: Palgrave Macmillan, 2016.

Früchtel, Michael. *Der Architekt Hermann Giesler, Leben und Werk (1898–1987).* Tübingen: Altavilla, 2008.

"Frühling und Feldgrau in Westnorwegen." *Völkischer Beobachter* (Berlin), May 17, 1941.

Fuehrer Conferences on Naval Affairs, 1939–1945. Foreword by Jak P. Mallmann Showell. London: Greenhill, 1990.

"Für die Soldatenheime in Norwegen." *General-Anzeiger für Bonn und Umgebung*, June 16, 1941.

Galison, Peter. "The Cultural Meaning of Aufbau." In *Scientific Philosophy: Origins and Development*, edited by Friedrich Stadler, 75–93. Dordrecht: Kluwer, 1993.

Gammelien, Stefan. "Die Nordlandfahrten Wilhelms II." In *Hundert Jahre deutsch-norwegische Begegnungen: Nicht*

nur Lachs und Würstchen, edited by Bernd Henningsen, 224–26. Berlin: Berliner Wissenschafts-Verlag, 2005.

G. B. "Norwegen gefragtes Reiseland." *Deutsche Zeitung in Norwegen*, March 29, 1942.

"Gemeinschaftshäuser der NSDAP." Gesetzte, Verordnungen und Erlasse section, *Die Baukunst: Die Kunst im Deutschen Reich* (July 1941).

Gemzell, Carl-Axel. *Raeder, Hitler und Skandinavien: Der Kampf für einen maritimen Operationsplan*. Lund: CWK Gleerup, 1965.

"German Camp in Norway, A: 'Forest of Arden' in Aspect and Atmosphere." *Scotsman*, July 5, 1945.

"German Morale Reported Collapsing in Northern Norway." *News of Norway* 3, no. 36 (1943): 141–42.

"Germans to Leave Norway." *Hartford Courant*, July 7, 1945.

"German Suicides Continue." *News of Norway* 1, no. 34 (1941): 4.

"Germany Abusing Postal Rights; Seen as Threat against Privacy." *Jewish Daily Bulletin*, March 22, 1934.

"Gestapo's Terrible Work in Norway Being Revealed." *Globe and Mail*, August 11, 1945.

Gilfert, Carl W. "Betrachtungen zwischen weissen Nächten: Nationaler Arbeitsdienst als tragende Säule eines neuen Europa." *Deutsche Zeitung im Ostland*, August 11, 1942.

———. "Ghetto Juden und Ungeziefer gehören zusammen." *Donauzeitung* (Belgrade), November 22, 1941.

gl. "Norwegens Wendung zum Kontinent." *Westfälische Landeszeitung—Rote Erde*, February 17, 1942.

Gläser, Martin. "Besinnung in Norwegen: Das norwegische Kunstschaffen und die politische Neuordnung." *Pariser Zeitung*, May 21, 1942.

———. "Norwegens neues Gesicht: Wandlung zum neuen Europa." *Deutsche Ukraine-Zeitung*, February 17, 1942.

Goebbels, Joseph. *Die Tagebücher von Joseph Goebbels: Sämtliche Fragmente*. Vol. 4. Edited by Elke Fröhlich. Munich: Saur, 1987.

Graßmann, Antjekathrin. "Das Hansekontor zu Bergen: Kirche und Wohltätigkeit." In *Das Hansische Kontor zu Bergen und die Lübecker Bergenfahrer: International Workshop Lübeck 2003*, edited by Antjekathrin Graßmann, 78–93. Lübeck: Archiv der Hansestadt Lübeck, 2005.

———, ed. *Das Hansische Kontor zu Bergen und die Lübecker Bergenfahrer: International Workshop Lübeck 2003*. Lübeck: Archiv der Hansestadt Lübeck, 2005.

Grossmann, Atina. *Reforming Sex: The German Movement for Birth Control and Abortion Reform, 1920–1950*. New York: Oxford University Press, 1995.

"größte Soldatenheim in Norwegen, Das." *National-Zeitung* (Essen), March 24, 1942.

Günther, Hans. *Rassenkunde des deutschen Volkes*. Munich: Lehmanns, 1922.

Günther, Hans F. K. *Der Nordische Gedanke unter den Deutschen*. 2nd ed. Munich: Lehmanns, 1927.

Haarr, Geirr H. *The Battle for Norway: April–June 1940*. Annapolis, MD: Naval Institute, 2010.

Hage, Ingebjørg. "Reconstruction of North Norway after the Second World War—New Opportunities for Female Architects?" *Acta Borealia* 22, no. 2 (2005): 99–127.

Hake, Sabine. *Popular Cinema of the Third Reich*. Austin: University of Texas Press, 2001.

Hale, Oron J. *The Captive Press in the Third Reich*. Princeton, NJ: Princeton University Press, 1973.

Hall, Thomas, ed. *Planning and Urban Growth in Nordic Countries*. London: Chapman and Hall, 1991.

———. *Stockholm: The Making of a Metropolis*. Abingdon, Oxfordshire: Routledge, 2009.

Hals, Harald. "Henvendelse til Regjeringen." *Byggekunst* 27, no. 1 (1945): 12–13.

Hammer, Gisela. "Der Weg des neuen Norwegen." *Deutsche Zeitung in Norwegen*, September 26, 1942.

Hansen, Einar Richter. *From War to Peace: The Second World War at Nordkapp*. Honningsvåg: Nordkapplitteratur, 1994.

"Har Hitlers Norgesreise politisk bakgrunn?" *Tidens Tegn*, April 17, 1934.

Hassing, Arne. *Church Resistance to Nazism in Norway, 1940–1945*. Seattle: University of Washington Press, 2014.

Hegemann, Werner, and Harold Hammer-Schenk. *Otto Kohtz*. Berlin: Gebr. Mann, 1996.

Heiberg, Edvard. "Arkitekt Edvard Heiberg." *Byggekunst* 27, no. 1 (1945): 25–26.

Heims, Heinrich. *Adolf Hitler Monologe im Führer-Hauptquartier 1941–1944: Die Aufzeichnungen Heinrich Heims*. Edited by Werner Jochmann. Hamburg: Knaus, 1980.

Hellerud, Synnøve Veinan, and Jan Messel. *Oslo: A Thousand-Year History*. Translated by J. Basil Cowlishaw. Oslo: Aschehoug, 2000.

Henderson, W. O. *Studies in German Colonial History*. Chicago: Quadrangle, 1962.

Henningsen, Bernd, ed. *Hundert Jahre deutsch-norwegische Begegnungen: Nicht nur Lachs und Würstchen*. Berlin: Berliner Wissenschafts-Verlag, 2005.

Herf, Jeffrey. *Reactionary Modernism: Technology, Culture, and Politics in Weimar and the Third Reich*. Cambridge: Cambridge University Press, 1984.

Hesselberg, Th., and B. J. Birkeland. "The Continuation of the Secular Variations of the Climate of Norway 1940–1950." *Geofysiske Publikasjoner* 15, no. 5 (1956): 3–40.

Heynen, Robert. *Degeneration and Revolution: Radical Cultural Politics and the Body in Weimar Germany*. Leiden: Brill, 2015.

hg. "Norwegen: Alle Räder rollen für den Sieg." *Deutsche Zeitung in Norwegen*, April 15, 1943.

Hilberg, Raul. *The Destruction of the European Jews*. 3rd ed. Vol. 1. New Haven, CT: Yale University Press, 2003.

Hill, Kate, ed. *Britain and the Narration of Travel in the Nineteenth Century: Texts, Images, Objects*. Milton Park, Abingdon, Oxon: Routledge, 2016.

Hitler, Adolf. *Hitler, Mein Kampf: Eine kritische Edition*. Vol. 1. Ed. Christian Hartmann, Thomas Vordermayer, Othmar Plöckinger, and Roman Töppel. Munich: Institut für Zeitgeschichte, 2016.

"Hitler på besøk i Norge." *Bergens Tidende*, April 14, 1934.

"Hitler stod på broen og var begeistret over de norske fjorde." *Tidens Tegn*, April 17, 1934.

"Hitler war in norwegischen Fjorden." *Deutsche Allgemeine Zeitung*, April 18, 1934.

Hjeltnes, Guri. "Supplies under Pressure: Survival in a Fully Rationed Society; Experiences, Cases, and Innovation in Rural and Urban Regions in Occupied Norway." In *Coping with Hunger and Shortage under German Occupation in World War II*, edited by Tatjana Tönsmeyer, Peter Haslinger, and Agnes Laba, 61–82. Cham, Switzerland: Palgrave Macmillan, 2018.

Hlg. "Soldatenheime in Norwegen." *Die Post* (Munich), May 5, 1941.

Hoidal, Oddvar K. *Quisling: A Study in Treason*. Oslo: Norwegian University Press, 1989.

Holzschuh, Ingrid, and Monika Platzer, eds. *"Wien. Die Perle des Reiches": Planen für Hitler*. Vienna: Architekturzentrum Wien; Zurich: Park Books, 2015.

Hoppe, August. "Norwegens Auge in der Welt: Oslo—Emporkömmling unter Weltstädten." *Wacht im Norden*, August 1, 1942.

Horntvedt, John. "Krigstidens Byplaner B.S.R." *Byggekunst* 27, no. 1 (1945): 14–20.

Howard, Ebenezer. *Garden Cities of*

Tomorrow. Eastbourne, East Sussex: Attic Books, 1985.

H. S. "Ein Stück Heimat: Das Neue Soldatenheim in Kristiansand." *Wacht im Norden*, March 21, 1942.

Hughes, Albert D. "Danish Stores Get Goods by Air Freight." *Christian Science Monitor*, November 6, 1946.

Hunt, Vincent. *Fire and Ice: The Nazis' Scorched Earth Campaign in Norway*. Stroud, Gloucestershire: History Press, 2014.

Hüntemann, Hermann-Josef. "Festung Norwegen: Eine uneinnehmbare Bastion." *Deutsche Zeitung in Norwegen*, September 3, 1942.

"Huset som aldri ble bygd." *Verdens Gang*, July 14, 1945.

Hvattum, Mari. *Heinrich Ernst Schirmer: Kosmopolittenes arkitekt*. Oslo: Pax, 2014.

Ingulstad, Mats. "The Shovel Is Our Weapon: The Norwegian Labour Service and the Paradox of Nationalist Internationalism." *Scandinavian Journal of History* 43, no. 4 (2018): 1–27.

"Innvielse av det tyske soldaterhjem i Kristiansand." *Aftenposten*, March 16, 1942.

Janz, Nina. "From Battlegrounds to Burial Grounds: The Cemetery Landscapes of the German Army during the Second World War." In *War and Geography: The Spatiality of Organized Mass Violence*, edited by Sarah Kristina Danielsson and Frank Jacob, 147–62. Paderborn: Schöningh, 2017.

Johnson, Amanda. *Norway, Her Invasion and Occupation*. Decatur, GA: Bowen, 1948.

Johnston, S. Paul. "Box Score: An Appraisal of European Air Power." *Aviation* 38 (January 1939): 22–25, 80.

Kahrs, Otto. "Bilstamveien Halden-Oslo-Trondheim." *Teknisk Ukeblad* 87, no. 45 (1940): 465–69.

Kala. "Warum manche Norweger nicht verstehen." *Wacht im Norden*, August 16, 1941.

Kargon, Robert H., and Arthur P. Molella. *Invented Edens: Techno-Cities of the Twentieth Century*. Cambridge, MA: MIT Press, 2008.

Kaufmann, J. E., and H. W. Kaufmann. *Fortress Third Reich: German Fortifications and Defense Systems in World War II*. Cambridge, MA: Da Capo, 2007.

Kersaudy, François. *Norway 1940*. London: Collins, 1990.

Kershner, Howard E. "Northern Norway Left in Dire Need by Nazis." *Christian Science Monitor*, October 12, 1945.

Kirk, Dudley. *Europe's Population in the Interwar Years*. New York: Gordon and Breach, 1946.

Kiszely, John. *Anatomy of a Campaign: The British Fiasco in Norway, 1940*. Cambridge: Cambridge University Press, 2017.

Kitchen, Martin. *Speer: Hitler's Architect*. New Haven, CT: Yale University Press, 2015.

Klassen, Heinz. "Landjugendaustausch: Norwegische Jungbäuerinnen besuchen deutsche Höfe." *Deutsche Zeitung in Norwegen*, August 3, 1942.

Kleinkorst, Frank. "Oslo-Kirkenes: Die Geschichte einer Strasse." *Deutsche Zeitung*, October 27, 1940.

kn. "Et stykke Tyskland i Norge." *Fritt Folk*, March 16, 1942.

Knoller, Rasso. *Norwegen: Ein Länderporträt*. Berlin: Ch. Links, 2013.

Koch, Hans-Jörg. *Wunschkonzert: Unterhaltungsmusik und Propaganda im Rundfunk des Dritten Reichs*. Graz: Ares, 2006.

Koeppens, Werner. *Herbst 1941 im "Führerhauptquartier." Berichte Werner Koeppens an seinen Minister Alfred Rosenberg*. Edited by Martin Vogt. Koblenz: Bundesarchiv, 2002.

Kongssund, Anita. "Art and Non-Art: A Modern Iconoclasm." In *Art in Battle*, edited by Frode Sandvik and Erik Tonning, 76–97. Bergen: KODE Art Museums of Bergen, 2015.

Koshar, Rudy. "On the Road in Germany

between the World Wars." In *Unravelling Civilisation: European Travel and Travel Writing*, edited by Hagen Schultz-Forberg, 287–303. Brussels: Peter Lang, 2005.

Kramm, H. "Wo finden wir das Nordische im Norden? Das Bekenntnis der norwegischen Bauten—Erbe aus germanischer Zeit." *Wacht im Norden*, July 11, 1942.

Kreis, Wilhelm. "Zu meinen Skizzen." *Die Baukunst: Die Kunst im Deutschen Reich* (July 1941): 135–46.

Kusch, Eugen. "Norwegens mittelalterliche Kunst." *Revaler Zeitung*, March 9, 1943.

Lane, Barbara Miller. *National Romanticism and Modern Architecture in Germany and the Scandinavian Countries*. Cambridge: Cambridge University Press, 2000.

Larsen, Stein Ugelvik, Beatrice Sandberg, and Volker Dahm, eds. *Meldungen aus Norwegen 1940–1945: Die geheimen Lageberichte des Befehlshabers der Sicherheitspolizei und des SD in Norwegen*. Vol. 1. Munich: R. Oldenbourg, 2008.

Larsson, Lars Olof. *Die Neugestaltung der Reichshauptstadt: Albert Speers Generalbebauungsplan für Berlin*. Stockholm: Almqvist and Wiksell, 1978.

Larsson, Lars Olof, Sabine Larsson, and Ingolf Lamprecht. *"Fröhliche Neugestaltung" oder die Gigantoplanie von Berlin 1937–1943: Albert Speers Generalbebauungsplan im Spiegel satirischer Zeichnungen von Hans Stephan*. Kiel: Ludwig, 2008.

Lechner, Heinz. "Eisenbahnbau im hohen Norden: Statt zehn Jahre, nur zwei—Deutsche Eisenbahnpioniere am Werk." *Wacht im Norden*, February 15, 1941.

Lendvai-Dircksen, Erna. *Das germanische Volksgesicht: Norwegen*. Bayreuth: Gauverlag Bayreuth, 1942.

Leschke. "Jetzt fährt man zu Land nach dem Norden." *Deutsche Monatshefte in Norwegen* 1, no. 1 (1940): 23–25.

L'Heureux, J.-S., S. Glimsdal, O. Longva, L. Hansen, and C. B. Harbitz. "The 1888 Shoreline Landslide and Tsunami in Trondheimsfjorden, Central Norway." *Marine Geophysical Research* 32, nos. 1–2 (2011): 313–29.

Libbert, W. D. "Eine Insel der Heimat im fremden Land: Zwei Jahre Soldatenheim der Generaloberst-von-Falkenhorst-Kaserne." *Deutsche Zeitung in Norwegen*, July 31, 1943.

Lilienthal, Georg. *Der "Lebensborn e.V.": Ein Instrument nationalsozialistischer Rassenpolitik*. Stuttgart: Gustav Fischer, 1985.

Liulevicius, Vejas Gabriel. *War Land on the Eastern Front: Culture, National Identity and German Occupation in World War I*. Cambridge: Cambridge University Press, 2000.

Löhr, Hanns Christian. *Das Braune Haus der Kunst: Hitler und der "Sonderauftrag Linz": Visionen, Verbrechen, Verluste*. Berlin: Akademie, 2005.

Longerich, Peter. *Goebbels: A Biography*. Translated by Alan Bance, Jeremy Noakes, and Lesley Sharpe. New York: Random House, 2015.

———. *Heinrich Himmler: A Life*. Translated by Jeremy Noakes and Lesley Sharpe. Oxford: Oxford University Press, 2012.

Loock, Hans-Dietrich. *Quisling, Rosenberg und Terboven: Zur Vorgeschichte und Geschichte der nationalsozialistischen Revolution in Norwegen*. Stuttgart: Deutsche Verlags-Anstalt, 1970.

Lorange, Erik, and Jan Eivind Myhre. "Urban Planning in Norway." In *Planning and Urban Growth in Nordic Countries*, edited by Thomas Hall, 116–66. London: Chapman and Hall, 1991.

Lumans, Valdis O. *Himmler's Auxiliaries: The Volksdeutsche Mittelstelle and the German National Minorities of Europe, 1933–1945*. Chapel Hill: University of North Carolina Press, 1993.

Lunde, Henrik O. *Finland's War of Choice: The Troubled German-Finnish Coalition*

in World War II. Philadelphia: Casemate, 2011.

Luther, Edgar. "Wiederaufbau norwegischer Städte." *Deutsche Monatshefte in Norwegen* 3, no. 5 (1942): 2–8.

Lüttichau, Mario-Andreas von. "Entartete Kunst, Munich 1937: A Reconstruction." In *"Degenerate Art": Fate of the Avant-Garde in Nazi Germany*, edited by Stephanie Barron, 45–81. Los Angeles: Los Angeles County Museum of Art; New York: Abrams, 1991.

Mäckler, Hermann. "Die Heinkel-Werke Oranienburg: Architekt Herbert Rimpl." *Die Baukunst: Die Kunst im Deutschen Reich* (February 1940): 21–31.

Madajczyk, Czesław, ed. *Vom Generalplan Ost zum Generalsiedlungsplan.* Munich: Saur, 1994.

Mai, Ekkehard. "Von 1930 bis 1945: Ehrenmäler und Totenburgen." In *Wilhelm Kreis: Architekt zwischen Kaiserreich und Demokratie, 1873–1955*, edited by Winfried Nerdinger and Ekkehard Mai, 157–67. Munich: Klinkhardt and Biermann, 1994.

Makowski, Christine Charlotte. *Eugenik, Sterilisationspolitik, "Euthanasie" und Bevölkerungspolitik in der nationalsozialistischen Parteipresse.* Husum: Matthiesen, 1996.

Mann, Chris, and Christer Jörgensen. *Hitler's Arctic War: The German Campaigns in Norway, Finland and the USSR 1940–1945.* New York: Thomas Dunne Books, St. Martin's, 2003.

"Many Arrests in the Saar: Close Watch on Correspondence with Foreigners." *Manchester Guardian*, April 28, 1937.

Martyn-Hemphill, Richard, and Henrik Pryser Libell. "Trash in the Fjords? Norway Turns to Drones." *New York Times*, March 4, 2018.

Matthäus, Jürgen, and Frank Bajohr, eds. *The Political Diary of Alfred Rosenberg and the Onset of the Holocaust.* Lanham, MD: Rowman and Littlefield in association with the United States Holocaust Memorial Museum, 2015.

McElligott, Anthony. *The German Urban Experience 1900–1945: Modernity and Crisis.* London: Routledge, 2001.

McMahon, Richard. *The Races of Europe: Construction of National Identities in the Social Sciences, 1839–1939.* London: Palgrave Macmillan, 2016.

Meland, Astrid. "Trondheim om Hitler hadde vunnet." *Dagbladet Magasinet*, May 19, 2005. Accessed March 22, 2019: http://www.dagbladet.no/magasinet/trondheim-om-hitler-hadde-vunnet/66096461.

Meyer, Heinrich. "Norwegens Volk vor dem Aussterben?" *Deutsche Monatshefte in Norwegen* 2, no. 11 (1941): 7–13.

Michaud, Eric. *The Cult of Art in Nazi Germany.* Translated by Janet Lloyd. Stanford, CA: Stanford University Press, 2004.

Michelet, Marte. *Den største forbrytelsen ofre og gjerningsmenn i det norske Holocaust.* Oslo: Gyldendal, 2015.

Mikkelsen, Ingvar. "BSR: faglig og moralsk." *Arkitektnytt*, March 20, 2010. Accessed July 6, 2019: https://www.arkitektnytt.no/nyheter/bsr-faglig-og-moralsk1.

Milward, Alan S. *The Fascist Economy in Norway.* Oxford: Clarendon Press, 1972.

Minsos, Fred. "Sett og hørt i Tyskland. Inntrykk fra de norske arkitekters studiereise." *Norges Handels og Sjøfartstidende*, February 22, 1941.

———. "Vurdering av gjenreisningsproblemet." *Fritt Folk*, October 30, 1940.

Moe, M. Lorimer. "Patience of Norway Strained by Thousands of Nazi Soldiers." *Christian Science Monitor*, July 18, 1945.

Moll, Martin. "Plan Z (1939–1943)." In *Germany at War: 400 Years of Military History*, edited by David T. Zabecki, 3:1002–3. Santa Barbara, CA: ABC-CLIO, 2014.

Morris-Reich, Amos. *Race and Photography: Racial Photography as Scientific*

Evidence, 1876–1980. Chicago: University of Chicago Press, 2016.

Mosnes, Terje. *Jazz i Molde*. Ålesund: Nordvest Informasjon, 1980.

Myklebost, Tor. *They Came as Friends*. Translated by Trygve M. Ager. New York: Doubleday, 1943.

Naumann, Josef K. F. "Ausbau des Norwegischen Verkehrsnetzes in Deutsch-Norwegischer Zusammenarbeit." *Die Betonstrasse* 16, no. 3 (1941): 38–42.

Nedkvitne, Arnved. *The German Hansa and Bergen: 1100–1600*. Cologne: Böhlau, 2014.

Neuengamme Concentration Camp Memorial. *Norway under German Occupation*. Brochure for the exhibition *Traces of History: Neuengamme Concentration Camp 1938–1945 and Its Post-War History*. Hamburg: KZ Gedenkstätte Neuengamme, 2010. Accessed June 22, 2019: http://media.offenes-archiv.de /ha2_2_9_2_thm_2370_engl.pdf.

"Neues deutsches Soldatenheim in Kristiansand." *Deutsche Zeitung in Norwegen*, March 17, 1942.

"Neues Soldatenheim in Narvik." *Deutsche Zeitung in Norwegen*, August 29, 1942.

Nicholas, Lynn H. *Cruel World: The Children of Europe in the Nazi Web*. New York: Knopf, 2005.

Nilsen, Dag. "The Cathedral of Nidaros: Building a Historic Monument." *Future Anterior* 7, no. 2 (2010): xiv–17.

Nordic Classicism 1910–1930. Helsinki: Museum of Finnish Architecture, 1982.

"Nördliche Strasse vor der Vollendung: Zum erstenmal unter hervorragender deutscher Hilfe eine Landverbindung zu Europas hohem Norden." *Der Danziger Vorposten*, September 18, 1940.

"Norse King Urges Allied Solidarity." *New York Times*, July 1, 1945.

"Norway." In *The Statesman's Year-Book 1942*, 1146–60. London: Macmillan, 1942.

"Norway Apologises to Its World War Two 'German Girls.'" *BBC News*, October 17, 2018. Accessed July 16, 2019: https://www.bbc.com/news /world-europe-45893490.

"Norway Apologises to Women Punished for Relationships with German Soldiers." *Guardian*, October 17, 2018. Accessed July 16, 2019: https://www.theguardian.com /world/2018/oct/17/norwegian -women-get-apology-for-reprisals- over-wwii-friendships.

"Norwegen: Eckstein des neuen Europa." *Thorner Freiheit*, February 16, 1942.

"Norwegen erhält Soldatenheime: Der Führer stiftet eine Million Reichsmark." *Deutsche Zeitung in Norwegen*, February 4, 1941.

"Norwegen im Gestaltwandel: Das Erwachen des germanischen Gemeinschaftsgefühls." *Thüringer Allgemeine Zeitung*, January 5, 1943.

"Norwegens Strassenbau, Energiewirtschaft und Autobahnen-Planung." *Rheinisch-Westfälische Zeitung*, May 5, 1942.

"Norwegen zwischen gestern und morgen: Loslösung von westlichen Ideen." *Hildesheimer Beobachter*, September 23, 1942.

"Norwegians Regain Prizes from Nazis in Oslo Area." *Christian Science Monitor*, July 14, 1945.

Oelhafen, Ingrid von, and Tim Tate. *Hitler's Forgotten Children*. New York: Berkley Caliber, 2016.

Ognjenović, Gorana. "The Blood Road Reassessed." In *Revolutionary Totalitarianism, Pragmatic Socialism, Transition*, edited by Gorana Ognjenović and Jasna Jozelić, 1:205–32. New York: Palgrave Macmillan, 2016.

Ognjenović, Gorana, and Jasna Jozelić, eds. *Revolutionary Totalitarianism, Pragmatic Socialism, Transition*. Vol. 1. New York: Palgrave Macmillan, 2016.

ol. "Das nordische Holzhaus: Betrachtung über seine Geschichte und

Bauweise." *Deutsche Zeitung in Norwegen*, September 4, 1942.

Olsen, Kåre. "Under the Care of Lebensborn: Norwegian War Children and Their Mothers." In *Children of World War II: The Hidden Enemy Legacy*, edited by Kjersti Ericsson and Eva Simonsen, 15–34. Oxford: Berg, 2005.

———. *Vater: Deutscher; Das Schicksal der norwegischen Lebensbornkinder und ihrer Mütter von 1940 bis heute.* Translated by Ebba D. Drolshagen. Frankfurt: Campus, 2002.

"Organisation der norwegischen Kraftfahrzeugwirtschaft." *Deutsche Bergwerkszeitung*, August 15, 1943.

Osborn, Andrew. "Norway's Abused Children Move Step Closer to Compensation." *Guardian*, December 6, 2002. Accessed July 16, 2019: https://www.theguardian.com/world/2002/dec/07/andrewosborn1.

"Oslos Zukunft: Generalbebauungsplan für Gross-Oslo." *Deutsche Zeitung in Norwegen*, January 28, 1942.

Ottmer, Hans-Martin. "Skandinavien in der deutschen marinestrategischen Planung der Reichs- bzw. Kriegsmarine." In *Neutralität und totalitäre Aggression: Nordeuropa und die Großmächte im Zweiten Weltkrieg*, edited by Robert Bohn, Jürgen Elvert, Hain Rebas, and Michael Salewski, 49–72. Stuttgart: Franz Steiner, 1991.

ow. "Wie orientiert sich Nordeuropa: Die nordischen Länder und die Neuordnung." *N.S.Z. Westmark*, March 5, 1942.

Pantenburg, Vitalis. "Zum Dach Europas: Eine Reise in Europas arktische Zonen." *Kölnische Zeitung* (Reichsausgabe), printed in seven parts on January 5, 1941; January 12, 1941; January 19, 1941; January 26, 1941; February 2, 1941; February 9, 1941; February 16, 1941.

Passarge, Walter. "Ein Maler aus nordischem Geist: Edvard Munch zum 80. Geburtstag." *Deutsche Zeitung in Norwegen*, December 11, 1943.

Paus, C. L. *Report on Economic and Commercial Conditions in Norway*, no. 657, prepared for the Department of Overseas Trade. London: H.M. Stationary Office, 1936.

Pedersen, Sverre. "Brente Steders Regulering B.S.R.: Noen meddelelser om reguleringsarbeidet i de krigsherjede byer og steder." *Byggekunst* 25, no. 1 (1943): 1–10.

———. "Regulering av det Brendte Sentrum i Molde." *Byggekunst* 25, no. 1 (1943): 11–22.

———. "Reguleringen av det Brente Sentrum i Narvik." *Byggekunst* 26, nos. 10–12 (1944): 85–108.

"Permanent Centers for Nazis in Norway." *Christian Science Monitor*, February 3, 1941.

Petropoulos, Jonathan. *Artists under Hitler: Collaboration and Survival in Nazi Germany.* New Haven, CT: Yale University Press, 2014.

Peukert, Detlev J. K. *Inside Nazi Germany: Conformity, Opposition, and Racism in Everyday Life.* Translated Richard Deveson. New Haven, CT: Yale University Press, 1987.

Phleps, Hermann. "Stabbur in Norwegen—Stadel in den Alpen: Gleiche ländliche Bauweise im Norden und im Süden." *Deutsche Monatshefte in Norwegen* 2, no. 4 (1941): 10–13.

Piepenschneider. "Das 'Aufbauhaus' der Gemeinschaftssiedlung Braunschweig-Lehndorf." *Bauamt und Gemeindebau* 21, no. 2 (1939): 18–19.

———. "Die Gemeinschafts-Siedlung Braunschweig-Lehndorf." *Bauamt und Gemeindebau* 18, no. 16 (1936): 186–89.

Pihl, Per. "Tre Byer," *Byggekunst* 27, no. 1 (1945): 38.

Pommer, Richard. "The Flat Roof: A Modernist Controversy in Germany." *Art Journal* 43, no. 2 (1983): 158–69.

Privat, G. "Winterfahrt nach Norwegen," *Donau-Zeitung*, January 27, 1942.

"Quislings Also Adopt a Budget, The." *News of Norway* 2, no. 10 (March 28, 1942): 2.

Raeder, Erich. *My Life.* Translated by Henry W. Drexel. Annapolis, MD: United States Naval Institute, 1960.

Reagin, Nancy R. *Sweeping the German Nation: Domesticity and National Identity in Germany, 1870–1945.* New York: Cambridge University Press, 2007.

Rediess, Wilhelm. *Schwert und Wiege.* Oslo: Aas and Wahls, 1943.

Reitan, Jon. "The Nazi Camps in the Norwegian Historical Culture." In *Historicizing the Uses of the Past: Scandinavian Perspectives on History Culture, Historical Consciousness and Didactics of History Related to World War II,* edited by Helle Bjerg, Claudia Lenz, and Erik Thorstensen, 57–76. Bielefeld: Transcript, 2011.

Rieger, Bernhard. *The People's Car: A Global History of the Volkswagen Beetle.* Cambridge, MA: Harvard University Press, 2013.

"Rikskansler Hitler på besøk i Vestlandsfjordene med Deutschland." *Bergens Aftenblad,* April 16, 1934.

Rodemer, Heinrich. "Kleines Haus in Hammerfest: Im nördlischsten Soldatenheim der Welt." *Deutsche Zeitung in Norwegen,* November 28, 1942.

———. "Das neue Soldatenheim in Narvik." *Wacht im Norden,* September 1, 1942.

Roemisch, Bruno. "Deutsche Baukunst in Norwegen," *Deutsche Monatshefte in Norwegen* 2, no. 12 (1941): 5–9.

———. "Größtes Bauvorhaben in Norwegens Geschichte: Die Schaffung der deutschen Soldatenheime." *Krakauer Zeitung,* February 11, 1941.

———. "Truppenbetreuung in Norwegen." *National Zeitung* (Essen), October 16, 1942.

———. "Vier Monate Nachdenken in Oslo: Schrittweise Befriedung des öffentlichen Lebens: Das National theater als Beispiel." *Krakauer Zeitung,* September 19, 1940.

Rohde, Norbert. *Das Heinkel-Flugzeugwerk Oranienburg: Legende und Wirklichkeit.* Velten: Velten Verlag, 2006.

Röhl, John C. G. *Wilhelm II: Into the Abyss of War and Exile, 1900–1941.* Translated Sheila de Bellaigue and Roy Bridge. Cambridge: Cambridge University Press, 2014.

Rollins, William H. "Whose Landscape? Technology, Fascism, and Environmentalism on the National Socialist Autobahn." *Annals of the Association of American Geographers* 85, no. 3 (1995): 494–520.

Rosen, Leora N., Kathryn H. Knudson, and Peggy Fancher. "Prevalence of Seasonal Affective Disorder among U.S. Army Soldiers in Alaska." *Military Medicine* 167, no. 7 (2002): 581–84.

Rosenberg, Steve. "Living Hell of Norway's 'Nazi' Children." *BBC News,* March 8, 2007. Accessed July 16, 2019: http://news.bbc.co.uk/2/hi/europe/6432157.stm.

Rother, A. H. "Soldatenheime in Norwegen." *Deutsche Monatshefte in Norwegen* 3, no. 3 (1942): 23.

Ruben, Gunnhild. *"Bitte mich als Untermieter bei Ihnen anzumelden!" Hitler und Braunschweig 1932–1935.* Norderstedt: Books on Demand, 2004.

Sandvik, Frode, and Erik Tonning, eds. *Art in Battle.* Bergen: KODE Art Museums of Bergen, 2015.

Scharping, Karl. "Neuordnung zwischen Jütland und Nordkap: Norwegen lernt ein neues Tempo." *Warschauer Zeitung,* September 29–30, 1940.

Schenk, Gustav. "Narvik in Ausbau." *Frankfurter Zeitung,* January 17, 1941.

Scherner, Jonas, and Eugene N. White, eds. *Paying for Hitler's War: The Consequences of Nazi Hegemony for Europe.* New York: Cambridge University Press, 2016.

Schieferdecker, Joachim. "Besuch beim norwegischen Arbeitsdienst." *Völkischer Beobachter* (Norddeutsche Ausgabe), August 5, 1942.

Schipper, Frank. *Driving Europe: Building*

Europe on Roads in the Twentieth Century. Amsterdam: Aksant, 2008.

Schmidt, Hartmut. *Kriegswirklichkeit und Soldatenalltag während des Zweiten Weltkrieges in Nordnorwegen*. Stuttgart: ibidem, 2006.

Schmitz-Köster, Dorothee. *"Deutsche Mutter, bist du bereit . . .": Der Lebensborn und seine Kinder*. Berlin: Aufbau, 2010.

———. *Der Krieg meines Vaters: als deutscher Soldat in Norwegen*. Berlin: Aufbau, 2004.

Schmitz-Köster, Dorothee, and Tristan Vankann. *Lebenslang Lebensborn: Die Wunschkinder der SS und was aus ihnen wurde*. Munich: Piper, 2012.

Schmölders, Claudia. "Das Gesicht von 'Blut und Boden': Erna Lendvai-Dircksens Kunstgeografie." In *Körper im Nationalsozialismus: Bilder und Praxen*, edited by Paula Diehl, 51–78. Paderborn: Fink; Schöningh, 2006.

Schneider, Claudia. "Kraft durch Freude: Begegnungen auf Distanz." In *Hundert Jahre deutsch-norwegische Begegnungen: Nicht nur Lachs und Würstchen*, edited by Bernd Henningsen, 227–29. Berlin: Berliner Wissenschafts-Verlag, 2005.

Schorske, Carl E. *Fin-de-Siècle Vienna: Politics and Culture*. New York: Vintage, 1981.

Schultz-Forberg, Hagen. *Unravelling Civilisation: European Travel and Travel Writing*. Brussels: Peter Lang, 2005.

Schütz, Erhard, and Eckhard Gruber. *Mythos Reichsautobahn: Bau und Inszenierung der "Straßen des Führers" 1933–1941*. Berlin: Links, 1996.

Seidler, Franz W. *Fritz Todt: Baumeister des Dritten Reiches*. Schnellbach: Bublies, 2000.

S—el. "Soldatenheim Kristiansand." *Deutsche Zeitung in Norwegen*, March 17, 1942.

Shepherd, Ben H. *Hitler's Soldiers: The German Army in the Third Reich*. New Haven, CT: Yale University Press, 2016.

Sindt, Ruth Weih. "Alltag für Soldaten? Kriegserinnerungen und soldatischer Alltag in der Varangerregion 1940–44." PhD diss., University of Kiel, 2005.

Singer, Kurt. *Duel for the Northland: The War of Enemy Agents in Scandinavia*. New York: McBride, 1943.

———. *Spies and Traitors of World War II*. New York: Prentice Hall, 1945.

Sitte, Camillo. *City Planning according to Artistic Principles*. Translated by George R. Collins and Christiane Crasemann Collins. New York: Random House, 1965.

sol. "Kann Oslo schöner werden?" *Deutsche Zeitung in Norwegen*, May 13, 1942.

———. "Sinnvolle Freizeitgestalung." *Deutsche Zeitung in Norwegen*, April 24, 1942.

"Soldatenfriedhof und Ehrenmal bei Drontheim." *Das Reich*, August 24, 1941.

"Soldatenheimbau geht weiter." *Deutsche Zeitung in Norwegen*, March 27, 1942.

"Soldatenheime in Norwegen: Ein Spendenaufruf von Reichsminister Dr. Goebbels." *Frankfurter Zeitung*, February 4, 1941.

Soleim, Marianne Neerland. *Operasjon asfalt: kald krig om krigsgraver*. Oslo: Orkana, 2016.

———. "Soviet Prisoners of War in Norway." In *Soviet Prisoners of War in Norway*, edited by Marianne Neerland Soleim, Ingeborg Hjorth, Arne Langås, and Åshild Karevold, translated by Tolk Midt-Norge, 6–29. Ekne: Falstad Memorial and Human Rights Centre, 2010. Accessed May 29, 2018: http://falstadsenteret.no/wp-content/uploads/2014/09/skriftserie_05b.pdf.

———. "Soviet Prisoners of War in Norway 1941–1945: Destiny, Treatment and Forgotten Memories." *Modern History of Russia* [Novejsaâ Istoriâ Rossii], no. 1 (2016): 22–32.

———. *Sovjetiske krigsfanger i Norge 1941–1945: Antall, organisering og repatriering*. Oslo: Spartacus, 2009.

Sørlie, Sigurd. "Norway." In *Joining*

Hitler's Crusade: European Nations and the Invasion of the Soviet Union, 1941, edited by David Stahel, 317–40. Cambridge: Cambridge University Press, 2018.

Speer, Albert. "Der Architekt Wilhelm Kreis." *Die Baukunst: Die Kunst im Deutschen Reich* (July 1941): 130–34.

———. *Inside the Third Reich*. Translated by Richard and Clara Winston. New York: Macmillan, 1970.

Spotts, Frederic. *Hitler and the Power of Aesthetics*. Woodstock, NY: Overlook, 2009.

Spring, Ulrike. "Arctic and European In-Betweens: The Production of Tourist Spaces in Late Nineteenth-Century Northern Norway." In *Britain and the Narration of Travel in the Nineteenth Century: Texts, Images, Objects*, edited by Kate Hill, 13–36. Milton Park, Abingdon, Oxon: Routledge, 2016.

Stadler, Friedrich, ed. *Scientific Philosophy: Origins and Development*. Dordrecht: Kluwer, 1993.

Stahel, David, ed. *Joining Hitler's Crusade: European Nations and the Invasion of the Soviet Union, 1941*. Cambridge: Cambridge University Press, 2018.

Stephan, Hans. "Die Wiederaufbau norwegischer Städte." *Die Baukunst: Die Kunst im Deutschen Reich* (June 1942): 119–26.

Stokker, Kathleen. *Folklore Fights the Nazis: Humor in Occupied Norway, 1940–1945*. Madison: University of Wisconsin Press, 1997.

Storeide, Anette. *Norske krigsprofitører: Nazi-Tysklands velvillige medløpere*. Oslo: Gyldendal, 2014.

Storemyr, Per. "The Stones of Nidaros: An Applied Weathering Study of Europe's Northernmost Medieval Cathedral." PhD diss., Norwegian University of Science and Technology, 1997.

Storteig, Odd. *Krigsfangenes historie: Blodveien i Saltdal*. Bodø: Saltdal kommune, 1997.

Stratigakos, Despina. *Hitler at Home*. New Haven, CT: Yale University Press, 2015.

Taylor, Robert R. *The Word in Stone: The Role of Architecture in the National Socialist Ideology*. Berkeley: University of California Press, 1974.

Terboven, Josef. Foreword. *Die Baukunst: Die Kunst im Deutschen Reich* (June 1942): 111.

Tesch, Sebastian. *Albert Speer, 1905–1981*. Vienna: Böhlau, 2016.

Thomas Cook Ltd. *Cook's Handbook to Norway and Denmark*. 8th ed. London: Thos. Cook, 1911.

Tönsmeyer, Tatjana, Peter Haslinger, and Agnes Laba, eds. *Coping with Hunger and Shortage under German Occupation in World War II*. Cham, Switzerland: Palgrave Macmillan, 2018.

Tooze, Adam. *The Wages of Destruction: The Making and Breaking of the Nazi Economy*. New York: Viking, 2006.

Tvinnereim, Helga Stave. *Sverre Pedersen: Pioner i Norsk Byplanlegging*. Oslo: Kolofon, 2015.

Twitty, Tom. "Norway a Vast Picnic Ground." *New York Herald Tribune*, June 24, 1945.

"2 Nazi Cruisers Hit, by Bombs, British Say." *New York Times*, June 12, 1940.

Unterholzner, Anita. *Straubinger Juden, jüdische Straubinger*. Straubing: Attenkofer, 1995.

Uziel, Daniel. *Arming the Luftwaffe: The German Aviation Industry in World War II*. Jefferson, NC: McFarland, 2012.

Vahrenkamp, Richard. "Automobile Tourism and Nazi Propaganda: Constructing the Munich-Salzburg Autobahn, 1933–1939." *Journal of Transport History* 27, no. 2 (2006): 21–38.

Wace, Barbara. "Norway Fears Quisling Taint on Youngsters." *Washington Post*, July 15, 1945

"Was der Verkehr bringt." *Deutsche Zeitung in Norwegen*, July 4, 1942.

Weber, Friedrich, and Charlotte Methuen. "The Architecture of Faith

under National Socialism: Lutheran Church Building(s) in Braunschweig, 1933–1945." *Journal of Ecclesiastical History* 66, no. 2 (2015): 340–71.

Weinberg, Gerhard. *A World at Arms: A Global History of World War II*. Cambridge: Cambridge University Press, 1994.

Weiss-Wendt, Anton, and Rory Yeomans. *Racial Science in Hitler's New Europe, 1938–1945*. Lincoln: University of Nebraska Press, 2013.

"Wendepunkt in Norwegen." *Frankfurter Zeitung*, February 3, 1942.

Wendt, Gerda. "Nordmarkmädel im Land der Fjorde und Seen: Norwegenfahrt schleswig-holsteinischer BDM-Führerinnen." *Nordische Rundschau*, August 27, 1941.

Westlie, Bjørn. *Fangene som forsvant: NSB og slavearbeiderne på Nordlandsbanen*. Oslo: Spartacus, 2016.

———. *Fars krig*. Oslo: Aschehoug, 2008.

Wg. "Drontheim: Die Hauptstadt des nördlichen Norwegen." *Deutsche Zeitung in Norwegen*, October 11, 1941.

Wheatley, Ben. *British Intelligence and Hitler's Empire in the Soviet Union, 1941–1945*. London: Bloomsbury Academic, 2017.

White, Ian Boyd. "National Socialism and Modernism." In *Art and Power: Europe under the Dictators, 1930–45*, edited by Dawn Ades, Tim Benton, David Elliot, and Ian Boyd White, 258–69. London: Thames and Hudson, 1995.

Wildt, Michael. *Hitler's Volksgemeinschaft and the Dynamics of Racial Exclusion*. Translated by Bernard Heise. New York: Berghahn, 2012.

William-Olsson, Tage. "Stadsplanechefen i Göteborg, Tage William-Olsson." *Byggekunst* 27, no. 1 (1945): 26–29.

Winners, Fw. L. "Soldat und Kunst." *Deutsche Zeitung in Norwegen*, November 23, 1942.

Zabecki, David T. *Germany at War: 400 Years of Military History*. Vol. 3. Santa Barbara, CA: ABC-CLIO, 2014.

Zahra, Tara. *The Lost Children: Reconstructing Europe's Families after World War II*. Cambridge, MA: Harvard University Press, 2011.

Zausmer, Otto. "War Losses: Material Damage Heavy." *Christian Science Monitor*, August 30, 1941.

Zeller, Thomas. *Driving Germany: The Landscape of the German Autobahn, 1930–1970*. Translated by Thomas Dunlap. New York: Berghahn, 2007.

Zielinski, Hans. "Norwegens innerer Aufbau: Nach dem Grundsatz der autoritären Verantwortlichkeit." *Berliner Börsen-Zeitung*, April 9, 1942.

———. "Norwegens Wirtschaft besinnt sich." *Deutsche Allgemeine Zeitung*, February 17, 1942.

"'Zum Dach Europas': Lichtbildervortrag über die Strassenbauvorhaben in Norwegen." *Kärtner Grenzruf* (Klagenfurt), November 20, 1940.

"Zuhause in der Ferne, Ein: Leben in einem Soldatenheime in Norwegen." *Arbeitertum* (Berlin), July 2, 1942.

Archival Sources

Army Museum, Trondheim

German Federal Archives, Berlin

German Federal Archives, Koblenz

German Federal Archives—Military Archives, Freiburg

Lars Olof Larsson Collection, Kiel

Library of Congress, Washington, DC

National Archives of Norway, Oslo

Political Archive, Federal Foreign Office, Berlin

Special Collections, Norwegian University of Science and Technology, Trondheim

US National Archives at College Park, Maryland

Index

Note: Page numbers in italic type indicate illustrations.

propaganda: (*continued*)
 occupation's benefits for Norway
 celebrated by, 13–14, 28–33, 51, 76, 87,
 173–74; Oslo as subject of, 21–23; poli-
 tics as subject of, 32–35; race as subject
 of, 14–20; railway as subject of, 57, *58*;
 roads and travel as subject of, 45–46,
 48, 50–52; *Soldatenheime* as subject of,
 84, 87, 89, 119–20; town planning and
 reconstruction as subject of, 173–74;
 Trondheim as subject of, 211–13
Protestantism, 161
Puricelli, Piero, 53
Puttkamer, Karl-Jesco von, 205

Quisling, Vidkun, 6, 30, 32–34, 62, 118,
 148, 162, 194, 224, 226, 238n15, 238n21,
 241n48

race: art linked to, 19–20; environment
 linked to, 15, 24; labor linked to, 59–60;
 Lebensborn program and, 63–73; Oslo
 culture and, 21–22; purity of, 14; roads
 linked to, 52–53; travel and tourism
 linked to, 45–46; visual characteristics
 of, 15. *See also* Nordic/Aryan race/blood
radios, 27, 241n45
Raeder, Erich, 1–2, *3*, 5, 193–95, 201, 203–5
railway (polar): aftermath of Nazi work
 on, 247n65; challenges for construc-
 tion of, 57, 59; construction of, *55*, *56*, *58*,
 247n65; costs of constructing, 56, 57;
 goals in constructing, 56, 57; Hitler's
 plans for, 55–59; ideological signifi-
 cance of, 59; Norwegian plans for, 57;
 propaganda about, 57, *58*
Rediess, Wilhelm, 63–64; *Sword and Cra-
 dle, Plate 5*, 66, *65*–67, 68, *73*, 74
Das Reich (newspaper), 211
Reich Bride Schools, 69
Reich Church, 161
Reich Commissariat: as civilian occu-
 pation regime, 6, 137; Department
 of Public Enlightenment and Propa-
 ganda, 8, 13, 239n3; Engineering and
 Transport Department, 47, 137, 197–98;
 family planning clinics closed by,
 17–18; and *Lebensborn* program, 69,
 73; magazine of, 12–13, 41, *42*; plan for

Trondheim's incorporation of Strinda,
 215; propaganda directed by, 12–13;
 road construction by, 43–44, 47–48,
 246n57; and *Soldatenheime*, 82–83, 87,
 89, 117, 261n137; and Trondheim naval
 base/New Trondheim construction,
 196–99. *See also* Terboven, Josef
Reich Labor Service, 29
Reich Mothers' Service, 69
Reichshäuser (state houses), 164–65, 167,
 172, 189, 268n97
Reichswerke Hermann Göring, 143
religion: in Nazi Germany, 161–62; and
 the New Order, 141, 161–63; in occu-
 pied Norway, 162
Reznicek, Paula Stuck von, 258n104
Rheinisch-Westfälische Zeitung
 (Rhine-Westphalia News), 49
Riksvei 50, 37–38, 44–45, 60, 62, 76, 244n22
Rimpl, Herbert, 142–43
roads: challenges for construction of, 41,
 43, 44, 47–48, 54, 246n57, 247n59; collab-
 oration in construction of, 41, 43, 47, 52;
 construction of, 41–45, 47–49, 60, 62;
 costs of constructing, 52; in Germany,
 50; goals in constructing, 49–50, 52–53,
 157–58; Hitler's plans for, 46–48, 52–54;
 ideological significance of, 37–38, 43,
 48–49, 51–55; labor for construction of,
 50, 60, 62; map of, *42*; military consid-
 erations in constructing, 49–50; pre-
 invasion, 37–38, 43; propaganda about,
 46, 48, 50–52, 54; proposed European
 network of, 53, 157–58; race linked
 to, 49, 52–53; safety of, 50–51; scenic,
 Plate 4, 37, 47–49, 54; tourism linked to,
 Plate 4, 45–47, 50, 54
Roemisch, Bruno, 11–12, 25, 34, 83–84, 95,
 104, 107, 110
Rohland, Heinrich (ambassador), 5, 237n5
Röhm, Ernst, 2
Rolfsen, Erik, 186
Romano, Mario, Palace of Italian Civi-
 lization, Rome (with Guerrini and La
 Padula), 228–29
Rome, as model for German Reich, 131,
 140, 243n7
ruin value, 243n7
rural areas, linked to racial purity, 24

Ruthven, Ianthe, double-torpedo bunker on the Bøkfjord overlooking the Barents Sea, *Plate 2*

Sagebiel, Ernst, Tempelhof Airport, Berlin, 139
Sámi, 64, *183*, 184, 241n43
Schelkes, Willi, 133
Schirmer, Heinrich Ernst, 25–26
Schleswig-Holstein (flagship), 5
Schmitz, Rudolf, 79
Scholtz-Klink, Gertrud, 79
Schön, Reinhold, 122
Schönheit der Arbeit (Beauty of Labor), 118
Schulte-Frohlinde, Julius, 142
scorched-earth campaign, *75*, 76, 189, 224
Scotsman (newspaper), 225
Seifert, Alwin, 49
Siegfried Line, 40
Singapore, 194–95
Sitte, Camillo, 141, 155, 156
Slavic peoples, alleged inferiority of, 7, 52, 60, 63
Sola airport, 226
Solberg, Erna, 234
Soldatenheime (cultural and recreational centers for German soldiers), 8–9, 77–124; activities/recreation rooms of, 81, 83, 91, *105*, 107, *112*; Anglo-Indian clubs compared to, 113, 116–17; art in, 95, 101, *101–6*, 104, 107, *108–11*, 110, *114–16*, 122; authority issues concerning, 82; challenges for construction of, 81–82, 88–90, 120–22; collaboration in construction of, 80–81, 86–87, 89–90; common rooms (with restaurant-pub) of, 83, 90, 100–101, *104*, 107, *108–11*, 110, *114–16*, *123*; construction of, 83–84, 88–89, 119, 121–22, 251–52n24, 260n129; contributions from German citizens for, 77, 83, 88, 119–20; costs of, 81, 82–83, 99, 118–19; design of, *Plate 6*, 81, 83, 85–88, 90–95, 100–101; domesticity of, 94–96, 99, exterior views of, *85*, 90, 94, *100*; in First World War, 98–99; Hitler's promotion of, 77, 81, 84–85, 101, 117, 120, 121; ideological significance of, 86, 93–95, 98–99, 113, 117, 119–20, 122–23; interiority of, 93–95, 99–101, *101–6*, 104, 107, *108–12*, 110, 113, *114–16*, 118–19, 122–23; long-term plans for, 123; materials for constructing, 82–83, 88–89, 120–21; models of, *80*, *91*, *92*, *93*; need for, 78–79, 94–95, 98–99; origins of, 77, 79–80, 98–99; propaganda about, 84, 87, 89, 119–20; regulations for, 97–98; siting of, 85, 87, 92–93, 117; size of, 83–86, 95; sponsorship of, 100; theaters of, 83, 90–92, 101, *102–3*, 110, 113; women's roles in, 95–97, *96*, 99, 256n79, 256n81
soldiers: behavior of, 96–97, 223–25; evacuation of, 223–24; exhibitions of art work by, 107; fathering of children by, 64, 73–74; morale of, 78–79, 94–96, 99, 110, 113, 119; Norwegian girlfriends of, 64, 73–74, 97, 181, *181*; Norwegians' relations with, 27–28, 97–100, 117–18, 123–24; in occupied Norway, 6, 12, 78, 121
soldiers' homes. *See Soldatenheime*
Soleim, Marianne, 62
Soviet Union: invasion of, 7, 57; Nazi flight from, 76; Nazis' plans for resettlement of western, 52; Norway's postwar relations with, 231–34; prisoners of war from, 40, 60, *61*, 219, 224, 225–26, 231–34, *233*, 243n9
Speer, Albert: as Berlin's chief architect, 128, 133, 139, 170, 174, 177, 178, 198–99, 208, 243n7; as editor of *Die Baukunst*, 211; and Germania, 7, 128, 139, 158, 177, 208; influences on, 177; as minister of armament and war production, 59, 120, 221; and monumental architecture, 7, 86, 140, 178; New Reich Chancellery, 139; New Trondheim commission granted to, 198–209; New Trondheim design by, *Plate 10*, *Plate 11*; Nuremberg Rally Grounds, 131, 140; and railway construction, 59; and *Soldatenheime*, 85–88, 91, 117, 120–21; supervision by, of Norwegian town planning and reconstruction, 9, 85, 97, 117, 128, 132, 137–39, 142, 148–49, 156, 161, 163, 167, 170, 175, 185–86, 190; Volkshalle, 139

Photo Credits

Fig. i.1 *Adolf Hitler: Bilder aus dem Leben des Führers.* Altona/Bahrenfeld: Cigaretten-Bilderdienst, 1936.

Fig. i.2 242-HLB-289-37, Heinrich Hoffmann Collection, US National Archives at College Park, MD.

Fig. i.3 242-HLB-297-2, Heinrich Hoffmann Collection, US National Archives at College Park, MD.

Fig i.4 *Adolf Hitler: Bilder aus dem Leben des Führers.* Altona/Bahrenfeld: Cigaretten-Bilderdienst, 1936.

Figs. 1.1 through 1.4 Erna Lendvai-Dircksen, *Das germanische Volksgesicht: Norwegen.* Bayreuth: Gauverlag Bayreuth, 1942.

Fig. 1.5 *Wacht im Norden,* May 23, 1942.

Fig. 1.6 *Wacht im Norden,* August 1, 1942.

Fig. 1.7 Hermann Phleps, "Stabbur in Norwegen—Stadel in den Alpen: Gleiche ländliche Bauweise im Norden und im Süden," *Deutsche Monatshefte in Norwegen* 2, no. 4 (1941): 10.

Fig. 1.8 Gerda Wendt, "Nordmarkmädel im Land der Fjorde und Seen: Norwegenfahrt schleswig-holsteinischer BDM-Führerinnen," *Nordische Rundschau,* August 27, 1941.

Fig. 2.1 Hermann-Josef Hüntemann, "Festung Norwegen: Eine uneinnehmbare Bastion," *Deutsche Zeitung in Norwegen,* September 3, 1942.

Fig. 2.2 *Deutsche Monatshefte in Norwegen,* November 1940.

Fig. 2.3 RA/RAFA-3309/U/L0051a/0001, Riksarkivet, Oslo.

Figs. 2.4 and 2.5 RA/RAFA-3309/U/L0067b, Riksarkivet, Oslo.

Fig. 2.6 Heinz Lechner, "Eisenbahnbau im hohen Norden: Statt zehn Jahre, nur zwei—Deutsche Eisenbahnpioniere am Werk," *Wacht im Norden,* February 15, 1941.

Fig. 2.7 RA/RAFA-3309/U/L0067b, Riksarkivet, Oslo.

Fig. 2.8 RA/PA-0276/U/L0001, Riksarkivet, Oslo.

Figs. 2.9 through 2.11 Courtesy of the National Library of Norway.

Fig. 2.12 RA/RAFA-3309/U/L0064, Riksarkivet, Oslo.

Figs. 2.13 and 2.14 RA/RAFA-3309/U/L0068c, Riksarkivet, Oslo.

Fig. 2.15 Courtesy of the National Library of Norway.

Fig. 2.16 North Cape Museum, Honningsvåg, Norway.

Fig. 3.1 RA/RAFA-3309/U/L0045a/0005, Riksarkivet, Oslo.

Fig. 3.2 "Das erste deutsche Soldatenheim in Norwegen," *Gothaisches Tageblatt,* April 17, 1941, press clipping in RA/RAFA-2174/E/Ed/L0024, Riksarkivet, Oslo.

Fig. 3.3 Courtesy Tore Greiner Eggan.

Figs. 3.4 through 3.7 RA/RAFA-3309/U/L0045a/0005, Riksarkivet, Oslo.

Fig. 3.8 Hlg., "Soldatenheime in Norwegen," *Die Post* (Munich), May 5, 1941, press clipping in RA/RAFA-2174/E/Ed/L0024, Riksarkivet, Oslo.

Figs. 3.9 and 3.10 RA/RAFA-3309/U/L0068b, Riksarkivet, Oslo.

Fig. 3.11 RA/RAFA-3309/U/L0045b/0008, Riksarkivet, Oslo.

Figs. 3.12 and 3.13 RA/RAFA-3309/U/L0064, Riksarkivet, Oslo.

Fig 3.14 RA/RAFA-3309/U/L0068c, Riksarkivet, Oslo.

Figs. 3.15 and 3.16 RA/RAFA-3309/U/L0064, Riksarkivet, Oslo.

Figs. 3.17 through 3.21 RA/RAFA-3309/U/L0045b/0008, Riksarkivet, Oslo.

Figs. 3.22 through 3.24 RA/RAFA-3309/U/L0064, Riksarkivet, Oslo.

Figs. 3.25 and 3.26 RA/RAFA-3309/U/L0045b/0008, Riksarkivet, Oslo.

Figs. 4.1 through 4.3 Lars Olof Larsson Collection, Kiel.

Fig. 4.4 Dr. Piepenschneider, "Die Gemeinschafts-Siedlung Braunschweig-Lehndorf," *Bauamt und Gemeindebau* 18, no. 16 (1936): 186.

Fig. 4.5 Dr. Piepenschneider, "Das 'Aufbauhaus' der Gemeinschaftssiedlung Braunschweig-Lehndorf," *Bauamt und Gemeindebau* 21, no. 2 (1939): 19.

Fig. 4.6 TEK-0028-MS-SP-606-02, Special Collections, Norwegian University of Science and Technology, Trondheim.

Fig. 4.7 Lars Olof Larsson Collection, Kiel.

Fig. 4.8 TEK-0028-MS-SP-640-023, Special Collections, Norwegian University of Science and Technology, Trondheim.

Fig. 4.9 Lars Olof Larsson Collection, Kiel.

Fig. 4.10 RA/RAFA-2188/2/H/He/0011, Riksarkivet, Oslo.

Fig. 4.11 "Fremtidens Molde blir også 'Rosenes by,'" *Aftenposten*, September 9, 1940, press clipping in RA/RAFA-2174/E/Ed/L0016/0002, Riksarkivet, Oslo.

Figs. 4.12 and 4.13 RA/RAFA-2188/2/H/He/0011, Riksarkivet, Oslo.

Fig. 4.14 TEK-0028-MS-SP-287-01, Special Collections, Norwegian University of Science and Technology, Trondheim.

Fig. 4.15 Sverre Pedersen, "Reguleringen av det Brente Sentrum i Narvik," *Byggekunst* 26, nos. 10–12 (1944): 106.

Fig. 4.16 Lars Olof Larsson Collection, Kiel.

Fig. 4.17 RA/RAFA-3309/U/L0041a/0004, Riksarkivet, Oslo.

Fig. 4.18 Lars Olof Larsson Collection, Kiel.

Fig. 4.19 RA/RAFA-2188/2/H/He/0011, Riksarkivet, Oslo.

Fig. 4.20 TEK-0028-MS-SP-586A-III-031, Special Collections, Norwegian University of Science and Technology, Trondheim.

Fig. 4.21 through 4.24 Lars Olof Larsson Collection, Kiel.

Fig. 4.25 RA/RAFA-3309/U/L0051b, Riksarkivet, Oslo.

Fig. 4.26 Per Pihl, "Tre Byer," *Byggekunst* 27, no. 1 (1945): 38.

Fig. 5.1 Mit dem Reichskommissar nach Nordnorwegen und Finnland 10. bis 27. Juli 1942, RA/RAFA-3309/U/L0071, Riksarkivet, Oslo.

Fig. 5.2 Lars Olof Larsson Collection, Kiel.

Figs. 5.3 and 5.4 Portfolio: Generalbaurat für die Gestaltung der Deutschen Kriegerfriedhöfe: Gedanken und Gestalten, LOT 8441 (H) [P&P], Library of Congress, Washington, DC.

Fig. 5.5 RA/RAFA-3309/U/L0046/0001, Riksarkivet, Oslo.

Figs. c.1 and c.2 ©*Verdens Gang*.

Fig. c.3 Mittet/Oslo Museum.

Fig. c.4 FPG, #450833053, Getty Images.

Fig. c.5 Telemark Flyselskap/flyfotoarkivet.no.

Plate 1 *Deutsche Monatshefte in Norwegen,* March 1942.

Plate 2 © Ianthe Ruthven 2014.

Plate 3 Hugo Jaeger, LIFE Picture Collection, #50714890, Getty Images.

Plate 4 Deutsches Historisches Museum, Berlin.

Plate 5 Courtesy of the National Library of Norway.

Plate 6 RA/RAFA-2188/1/G/G4/G4a/L0010/0002, Riksarkivet, Oslo.

Plate 7 Record No. XX343.12143, Poster Collection, Hoover Institution Archives and Library, Stanford, CA.

Plate 8 ©Erik Birkeland.

Plate 9 RA/RAFA-2188/2/H/Hf/Hfa/0031, Riksarkivet, Oslo.

Plates 10 and 11 R 4606/4007, Bundesarchiv Berlin.

Plate 12 Document 1410, Rustkammeret Trondheim.

Plate 13 RA/RAFA-2188/2/T/Ta/L0005, Riksarkivet, Oslo.